If the characters in a game have depth, complexity, consistency, sympathy, and charm, then they are going to feel real to the player, and that helps the whole game world feel real, and allows the player to suspend his or her disbelief and get lost in the world. Everything the player does will be more exciting if they're doing it for someone, *or with* someone, *or in opposition to* someone *who feels real. Simply put, good character design helps the player to have what we all know can be an amazing, unforgettable experience. This book is not just about making great characters, but also about making great games.*

—from the foreword by Tim Schafer, Double Fine Productions

Katherine Isbister skillfully draws upon various psychological constructs elevating game development to a more comprehensive level. Taking a Psych 100 class? This book transforms the sometimes stuffy theories of Freud, Skinner, Rogers, and Maslow into fresh and entertaining relevancy as the author weaves these ideas into game content. The next time you play a favorite video game, read this book—that game will take on a whole new light and who knows? You may be able to ace that psychology final.

—Pauline Pedersen, Course Director, Full Sail Real World Education

The notion of using psychological principles in games continues to be of great interest to the games industry, but few researchers have been able to discuss in depth how psychological research can actually be applied to game design. Katherine Isbister's book not only makes complex psychological concepts accessible to the games community, but also demonstrates its application in current games through the use of concrete examples (on retail products), and possible design tips and recommendations.

—Randy Pagulayan, PhD, User Research Lead, Microsoft Game Studios

Katherine Isbister has crafted a text that covers a far greater scope of psychological concerns than I would've previously thought possible, and each area of psychology she covers has the potential to bring games to a higher level. For any individual studying, teaching, or working in Game Design this is a must-have text.

—Robin Koman, Associate Course Director, Full Sail Real World Education

A valuable tool for applying effective principles of psychology to create readable, entertaining, and high-impact game characters—a must-have for today's game developer.

—Andrew Stern, co-creator of the interactive drama *Façade* and
the virtual pets *Dogz* and *Catz*

Well researched and perceptive, this book offers new insights on creating more emotionally engaging game characters. If you have ever been curious about the psychology behind better character design, this book is a must read!

—Nicole Lazzaro, President, XEODesign, Inc.

D0223047

Better Game Characters by Design

The Morgan Kaufmann Series in Interactive 3D Technology

Series Editor: David H. Eberly, Geometric Tools, Inc.

The game industry is a powerful and driving force in the evolution of computer technology. As the capabilities of personal computers, peripheral hardware, and game consoles have grown, so has the demand for quality information about the algorithms, tools, and descriptions needed to take advantage of this new technology. To satisfy this demand and establish a new level of professional reference for the game developer, we created the *Morgan Kaufmann Series in Interactive 3D Technology*. Books in the series are written for developers by leading industry professionals and academic researchers, and cover the state of the art in real-time 3D. The series emphasizes practical, working solutions and solid software-engineering principles. The goal is for the developer to be able to implement real systems from the fundamental ideas, whether it be for games or for other applications.

Better Game Characters by Design: A Psychological Approach
Katherine Isbister

Artificial Intelligence for Games
Ian Millington

Visualizing Quaternions
Andrew J. Hanson

3D Game Engine Architecture: Engineering Real-Time Applications with Wild Magic
David H. Eberly

Real-Time Collision Detection
Christer Ericson

Physically Based Rendering: From Theory to Implementation
Matt Pharr and Greg Humphreys

Essential Mathematics for Games and Interactive Applications: A Programmer's Guide
James M. Van Verth and Lars M. Bishop

Game Physics
David H. Eberly

Collision Detection in Interactive 3D Environments
Gino van den Bergen

3D Game Engine Design: A Practical Approach to Real-Time Computer Graphics
David H. Eberly

FORTHCOMING

Real-Time Cameras
Mark Haigh-Hutchinson

X3D: Extensible 3D Graphics for Web Authors
Leonard Daly and Donald Brutzman

Game Physics Engine Development
Ian Millington

Better Game Characters by Design

A Psychological Approach

Katherine Isbister, PhD

Rensselaer Polytechnic Institute

AMSTERDAM • BOSTON • HEIDELBERG • LONDON
NEW YORK • OXFORD • PARIS • SAN DIEGO
SAN FRANCISCO • SINGAPORE • SYDNEY • TOKYO

Morgan Kaufmann Publishers is an imprint of Elsevier

Senior Editor	Tim Cox
Publishing Services Manager	Simon Crump
Project Manager	Dawnmarie Simpson
Assistant Editor	Rick Camp
Editorial Assistant	Jessica Evans
Cover Design	Chen Design Associates
Cover Illustration	Chen Design Associates
Text Design	Yvo Riezebos Design
Composition	Integra Software Services Pvt. Ltd.
Technical Illustration	Dartmouth Publishing, Inc. and Thomas Burns
Copyeditor	Elisabeth Beller
Proofreader	John Bregoli
Indexer	Broccoli Information Management
Interior printer	The Maple-Vail Book Manufacturing Group
Cover printer	Phoenix

Morgan Kaufmann Publishers is an imprint of Elsevier.
500 Sansome Street, Suite 400, San Francisco, CA 94111

This book is printed on acid-free paper. ∞

Library of Congress Cataloging-in-Publication Data
Isbister, Katherine, 1969–
 Better game characters by design: a psychological approach/by Katherine Isbister.
 p. cm.
 Includes bibliographical references and Index.
 ISBN-13: 978-1-55860-921-1 (pbk. : alk. paper)
 ISBN-10: 1-55860-921-0 (pbk. : alk. paper)
 1. Computer games—Design—Psychological aspects. 2. Computer games—Design—Social aspects.
I. Title.
QA76.76.C672I72 2005
794.8′1536′0019—dc22 2005024294

ISBN 13: 978-1-55860-921-1
ISBN 10: 1-55860-921-0

DVD ISBN 13: 978-0-12-369535-2
DVD ISBN 10: 0-12-369535-X

For information on all Morgan Kaufmann publications,
visit our Web site at www.mkp.com or www.books.elsevier.com

Printed in the United States of America
06 07 08 09 10 5 4 3 2 1

This book is dedicated to my students, who remind me everyday of the delight and thrill of creative work. And to my Dad, who passed along his curiosity and love of learning to me.

ABOUT THE AUTHOR

Katherine Isbister is an associate of the Social and Behavioral Research Laboratory and an associate professor in the Department of Language, Literature and Communication at the Rensselaer Polytechnic Institute. Her research focus is social psychological and affective approaches to HCI (Human-Computer Interaction), with special attention to games and other leisure and social technologies. In autumn 2004, she established the Games Research Lab at Rensselaer. Initial studies in the lab have explored the social and physical aspects of party games. She has presented insights from this research at the *Game Developers Conference* and at the *DiGRA* (Digital Games Research Association) conference.

Before joining the RPI faculty, Katherine developed and taught a course in Stanford University's HCI series—Designing Characters for Computer Games—now part of Rensselaer's games curriculum. She has also created and exhibited games-related artwork in venues including San Francisco's Yerba Buena Center for the Arts, Toronto's Design Exchange, and San Jose's Works Gallery. See *www.simgallery.net* for an overview of this artwork which is a collaboration with sculptor Rainey Straus.

Katherine is also part of the European Network of Excellence project HUMAINE, devoted to evolving appropriate usability and evaluation strategies for assessing affective interfaces. As part of this work, she has an ongoing research collaboration with the Royal Institute of Technology in Stockholm, Sweden. In 1999, she was selected as one of *MIT Technology Review's* "100 Young Innovators" most likely to shape the future of technology.

TABLE OF CONTENTS

I First Impressions

1 Social Surface

2 Practical Questions—Dominance, Friendliness, and Personality

II Focus on the Player

3 Culture

4 Gender

III Using a Character's Social Equipment

5 The Face

6 The Body

7 The Voice

IV Characters in Action

8 Player-Characters

9 Nonplayer-Characters

V Putting It All Together

10 Process

11 Evaluation

Not to sound too much like a grumpy old man, but when I was in college we didn't have courses in game design. Oh, I thought we did. There was a class in the course catalog that was called "Game Theory." I excitedly signed up for it, even while wondering in the back of my mind why it was being taught by a statistics professor. And then I found out. On the first day we looked at a little chart that calculated all the possible outcomes for a game of "rock, paper, scissors." And then at another chart for a variation of that game, something like "*blind* rock, paper, scissors." And "Spanish rock, paper, scissors," and "rock, paper, scissors if everybody has three hands." And so on. FOR AN ENTIRE SEMESTER.

I don't want to bum anybody out who teaches game theory for a living, but for crying out loud that stuff is boring. And after all was said and done, I'm still no better at that stupid game.

Maybe that is why I am, to this very day, a little uncomfortable around academics when they are talking about video games. Or maybe it is just because of the drastically different perspectives we have on the whole medium. I spend all day wading through the neck-high muck of games and the ugly business of making them, so it's always strange to talk with people at universities and to hear them discuss games as abstract, distant concepts. It often sounds to me as if they are scientists looking through a powerful telescope at a fascinating, amusing, mysterious, and primitive life form they've just found on a distant planet—a planet that many of us have been living on for years.

Don't get me wrong—I love to see games talked about in a serious academic setting. I'm just saying I don't always feel like I fit in. It's like I'm attending a zoology lecture, hoping no one notices that I'm wearing a bloody butcher's apron and carrying a cleaver.

(Wait—is that too many similes in a row? Once I get started it's hard to stop. It's like eating potato chips. Or rolling a snowball down hill. Or . . .)

But then I was invited down to Stanford to visit Katherine Isbister and her class full of students. Amazingly, these students were studying not just game design, but *character design* for games. A topic near and dear to my heart! I had no idea this kind of thing went on. How amazing! And what good news for the future, right? If kids in college today are studying character design for games, then maybe the industry will be flooded with fresh talent just dying to make better characters and better games! (Not to say anything bad about games today—except that the characters in them are really flat and boring and derivative clichés most of the time. But I digress.)

Anyway, the point is that I met Katherine and was surprised to find someone in academia who really plays games! And really likes games! I think you can see that in her book. Katherine's examples are from games that she has obviously played, and you have probably played as well. Her advice comes from first-hand knowledge of what makes games fun.

Katherine discusses character design not just in terms of what is interesting to dissect, but also in terms of what will actually enhance the game experience. After all, we're not just making up characters for the sake of showing off, right? Well, maybe we're doing that just a little bit. But mostly we're trying to make a rich experience for the player. If the characters in a game have depth, complexity, consistency, mystery, humanity, and charm, then they are going to feel real to the player, and that helps the whole game world feel real, and allows the player to suspend his or her disbelief and get lost in the world. Everything the player does will be more exciting if they're doing it *for* someone, or *with* someone, or *in opposition to* someone who feels real. Simply put, good character design helps the player to have what we all know can be an amazing, unforgettable experience. This book is not just about making great characters, but also about making great games.

So if you are reading this in college, pay attention! And be happy that you have books like this and classes like the one you are in because we didn't back when I was in school! (*Bangs cane on ground. Puffs angrily on long, gnarled pipe.*) And if you're reading this because you're in the games industry, well, be happy that you get free sodas at work.

Tim Schafer
September 2005
San Francisco, CA

PREFACE

This book is an introduction to psychological principles that have direct applications to improving game character design. Designers can use these principles to make characters that are more socially and emotionally powerful for the player and that are also more fun, engaging, and believable—all qualities that help enhance the game-play experience.

Reading this book will help any design team learn what great character designers do instinctively. Each chapter includes relevant examples from games with outstanding, often award-winning character designs, highlighting how the principles can be applied. Checklists and other tools make it simple to build psychological considerations into the design process itself; those looking for a quick overview can take a glance at Chapter 10, which arrays all the design suggestions in the book along the typical development timeline.

The desire to write this book emerged from my own work during the last ten years or so in the research field of embodied conversational agents. My projects in graduate school, as a postdoctoral researcher in Japan, and in subsequent years in both industry and academe convinced me that social psychology offers important lessons for anyone trying to design engaging imitation humans. Most design books written about creating characters seem to come out of the animation, filmmaking, and fiction traditions. None of these media are interactive (except for the occasional experimental form). As I learned when crafting characters for both task-based and entertainment applications, engagement and believability emerge in large part through the interaction. The surface impact of a character's movement, appearance, and words cannot really be separated from consideration of how these unfold in relation to the user/player's actions.

When designing, I found myself increasingly applying principles I'd learned during graduate school from social psychology and other related fields. When I got stuck, I'd burrow into the research literature to look for inspiration and for clues as to why something was not working. This book is my effort to save you, the reader, from this labor. It is a walk through those theories and working principles that I found most helpful in creating characters.

The Value of Improving Characters with Psychology

There are plenty of things to worry about in the game-design process, and there are already models and advice books from cinema and fiction writing that can be

drawn upon when creating a game's characters. Why add another layer of complexity? Will this really help?

Have you ever played a game in which the cut scenes seemed boring, tiresome, annoying, or one in which you found yourself trying to ignore the player character in order to get more immersed in game play? In these cases, the development team wasted effort on crafting characters for you to enjoy that instead became nuisances.

I believe we can lay the blame for these frustrations at the door of those who use film, fiction, or other passive, linear-media design principles as their primary guidelines. Using these principles can produce well-wrought dialogue, emotionally evocative cut scenes, or startlingly lifelike motion in a character, but it does not address the core of the experience—the player's active and unfolding engagement with the game world and the characters within it. A character in a game should reveal itself in relation to the player and his or her actions and motivations. The player's character is that person's physical, social, and emotional suit within the game. A non-player character (NPC) exists most vividly for the player in the moments in which she or he interacts with the character. To craft truly integrated and engaging characters, we must begin with goals in mind for the player's experience of the characters.

The great value of using a psychological approach is that we do not have to invent the design principles for crafting character interactions (and managing first impressions) from "scratch." Generations of social scientists have closely observed how people perceive and engage with one another, and these findings turn out to be extremely valuable rules of thumb and inspirations for character designers.

Using the principles in this book can help take the guesswork out of character design—making it far more likely that a game's characters will be appealing both at the surface level and also within the ongoing context of game play itself, where a character is truly judged by players. Better character interactions make the game more appealing, and that encourages the kind of word-of-mouth marketing that all game publishers hope for. Making choices based on the player's social experience of characters will also help eliminate wasted development time spent on assets that the player is eager to skip. And it can broaden the audience of a game by including players who care more about social interaction than the hard-core gamer might (see Part II for a discussion of taking multiple audiences into account when designing characters).

How to Read This Book

Here are some suggestions to help guide busy readers in getting the most from this book:

- *For those new to game design.* If this book is a textbook for a class you are taking, or if you are new to the field and reading to gain a general mastery, you will want to read from beginning to end. The concepts build upon one another, and this will give you the best framework for engaging with character design in a

thoughtful way. This is true regardless of which specialty you think you do have or will acquire (programming, art, writing, etc.). The principles in this book are part of an integrated approach. You may find the exercises at the end of each chapter particularly helpful.

- *For seasoned professionals*. You may want to start with a look at Part V, which provides an overview of where the ideas in this book can be incorporated into the existing development process and also offers some rationales for why it is worthwhile to include these steps in a tight development timeline. You may also want to browse each section's introduction to get a high-level view of the concepts that will be discussed. This will help you to scan for things that are directly relevant to the issues you are having at the moment.

 You will probably find the material in this book most helpful during the preproduction stages of a project, when the overall design vision of a game is still flexible. However, Part III will be quite useful during production for those creating character assets, and the principles in the rest of the book will certainly still be helpful in tweaking and refining character interactions during production itself.

- *For those unfamiliar with games*. Perhaps you picked this book up thinking the ideas might be relevant to your design work in another area besides gaming. You will probably particularly benefit from reading the game descriptions in the Appendix, and from watching the video clips on the accompanying DVD, to help you gain context for the range of game genres and character-design options there are in the games space.

A Note about Psychology and Its Many Subfields

It is worth clarifying that this book draws primarily from social psychology, which is the empirical study of how people interact socially with one another, with an emphasis on the individual as the unit of study (as opposed to looking at groups). Social psychologists look at the ways we form impressions of one another, biases that affect how we perceive others, and the mechanisms of social interaction in general, among other related topics. This is only one of the subfields of psychology. Others may also be helpful to the design of games, and perhaps even to the design of characters, but are beyond the scope of this book. Here is a breakdown of some of the most relevant strands of thought in and near the social sciences that are not covered in this book:

- *Neuropsychology*. Work at the nexus between neuroscience and psychology. As scientists learn more about the chemistry and biological structuring of the brain itself, they are working to link these findings to observable differences in behavior and in thinking. Research in this area includes investigating the physiological workings of emotions, blood flow in the brain and what it can indicate about brain function, neurotransmitters and other brain chemistry and how altering them can change

functioning, and related concerns. It's possible that game researchers may begin to use some of this knowledge to influence how they evaluate gaming experiences (see Chapter 11, Evaluation, for a mention of brain imaging and emotion).

- *Cognitive psychology/science*. Work in which the focus is understanding thought processes, often incorporating the use of computer modeling to better understand how thought unfolds. Cognitive scientists try to understand perception, attention, and action, and their findings have a great deal of relevance to general game design issues—understanding how a player thinks and using this knowledge to anticipate and test ideas for game physics, graphics behavior, game-play mechanisms, enemy AI construction, and related design choices.

- *Behaviorism*. An older (and somewhat discredited) approach to understanding human psychology from a purely behavioral standpoint. Psychologists in this line of research were reacting to the highly theoretic and often untestable approaches of the psychoanalytic tradition (i.e., Freud and his colleagues). The most extreme behaviorists thought that human behavior could be infinitely modified and adapted through manipulation—the stereotypical rat in a maze experiments are a part of this tradition. There is some value in understanding this work for game designers because behaviorists spent a great deal of time investigating reward structures—exactly what sorts of reward schedules would produce the best response. This turns out to be applicable to the design of game levels and powerups and so forth. (Power up: Item which the player can acquire that provides additional strengths or abilities.) http://www.gamaSutra.com/features/20010427/ hopson-01.htm

- *Sociology and anthropology*. Social sciences that examine social interaction with a focus on aggregate groups and systems. These areas of research may be especially helpful in thinking about social interaction and community formation among large groups, such as those found in massively multiplayer online role-playing games (MMORPGs).

- *Media studies/humanist approaches*. There is substantial scholarship offering a critical perspective on the cultural function of media such as games, which seeks to elucidate individuals' relationships to media, technologies, and to each other in a broader sense. Learning more about these areas may help define the socio-cultural impact of games. Relevant work includes discussion of gender and race stereotypes and games, violence and notions of play that are supported or frowned upon by society at large, and the like.

Acknowledgments

Special thanks to Sarah Walter and Kevin Hartman—Stanford students who provided helpful and tactful commentary and ideas, endless digitized game examples, and much needed perspective. Thanks to Patrick Doyle, who co-taught the first version of the Stanford class with me, and who has been an invaluable discussion partner and

a true friend. Galen Davis was a wonderful Teaching Assistant, and added depth to the book, in particular with his insightful analysis of Max Payne. Thanks also to the Stanford and Rensselaer undergraduate students who served as interns and assistants on the project—collecting game examples and providing valuable feedback and refinement to the ideas in the book: Arturo Caballero, Daniel Condaxis, Paul Echevarria, Tim Gregorio, Marina Kassianidou, Chris Mortonson, Andrew Parker, Gautham Raghavan, Kirk Shimano, Michelle Walker, and Jerry Yu. Nina Neulight and Kelli Millwood of UCLA provided some helpful contributions to the chapter on Gender, Michael Sharp read over some of the later drafts and offered helpful comments, and Marc Destefano helped me with some last-minute game example capture, and kept my sense of humor intact during the tail end of the process. Jay McGlothlin provided helpful technical support for video capture, and Ken Bowen helped get the website up and running. Thanks to those who reviewed the book and its ideas in various stages: Elizabeth Churchill, Eric DeSantis, Jason Harlow, Carol Hobson, Adriene Jenik, Anthony Jules, Jesper Juul, G. Christopher Klug, Robin N. Koman, Henry Lowood, Celia Pearce, Pauline Pedersen, Stefan Scandizzo, Tim Schafer, Jesse Schell, Nicole Shechtman, Robb Thomas, Bill Tomlinson, and other anonymous reviewers. Thanks to Tim Cox at Morgan Kaufmann for his endless patience and support. Thanks to my family and friends for helping me keep going on this project—especially Tony, whose impromptu, after-hours side research sparked some of the most interesting bits of the book. Finally, thanks to my husband for his patience and good cheer—especially miraculous and appreciated given that his idea of an engaging videogame is chess on his Palm Pilot.

ABOUT THE DVD-ROM

This book is accompanied by a DVD-ROM that contains video clips (~1.8 GB) illustrating concepts discussed in the chapters. Each clip was digitally captured by the author and her assistants, and formatted as a QuickTime file viewable from both Macintosh and Windows operating systems. See *http://www.apple.com/quicktime* to download a free QuickTime player. Clips are numbered according to the chapter they reference. For more detailed information about any particular clip's context, please refer to the book itself.

Elsevier DVD-ROM License Agreement

Please read the following agreement carefully before using this DVD-ROM product. This DVD-ROM product is licensed under the terms contained in this DVD-ROM license agreement ("Agreement"). By using this DVD-ROM product, you, an individual or entity including employees, agents and representatives ("you" or "your"), acknowledge that you have read this agreement, that you understand it, and that you agree to be bound by the terms and conditions of this agreement. Elsevier inc. ("Elsevier") expressly does not agree to license this DVD-ROM product to you unless you assent to this agreement. If you do not agree with any of the following terms, you may, within thirty (30) days after your receipt of this DVD-ROM product return the unused DVD-ROM product, the book, and a copy of the sales receipt to the customer service department at Elsevier for a full refund.

Limited Warranty and Limitation of Liability

NEITHER ELSEVIER NOR ITS LICENSORS REPRESENT OR WARRANT THAT THE DVD-ROM PRODUCT WILL MEET YOUR REQUIREMENTS OR THAT ITS OPERATION WILL BE UNINTERRUPTED OR ERROR-FREE. WE EXCLUDE AND EXPRESSLY DISCLAIM ALL EXPRESS AND IMPLIED WARRANTIES NOT STATED HEREIN, INCLUDING THE IMPLIED WARRANTIES OF MERCHANTABILITY AND FITNESS FOR A PARTICULAR PURPOSE. IN ADDITION, NEITHER ELSEVIER NOR ITS LICENSORS MAKE ANY REPRESENTATIONS OR WARRANTIES, EITHER EXPRESS OR IMPLIED, REGARDING THE PERFORMANCE OF YOUR NETWORK OR COMPUTER SYSTEM WHEN USED IN CONJUNCTION WITH THE DVD-ROM PRODUCT. WE

Notices

PART One

First Impressions

What Is Covered and Why

Part I starts where players first experience characters—with first impressions. Bad first impressions can be difficult to overcome, so the conscious management of any first encounter is important. Social psychologists have devoted much study to impression formation and how it works among human beings. Chapters 1 and 2 provide the reader with a foundation for making choices about the appearance and early behavior of characters. Using these principles will enhance later game-play experience of these characters and the level of overall social and emotional engagement with the game itself.

Who Will Find Part I Most Useful

Part I will be of greatest value to game designers, artists, and animators. Programmers, audio specialists, and dialogue writers may also find it interesting, though there are few design tips specifically related to their work.

Overview of Key Concepts

Attractiveness

Chapter 1 addresses what makes someone "attractive" from a psychological point of view and how this can influence player impressions of characters in surprising ways.

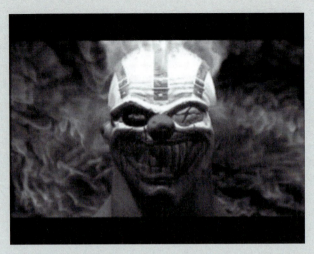

Sweet Tooth the Clown (of *Twisted Metal: Black*) is an unattractive character. *Twisted Metal: Black* is a registered trademark of Sony Computer Entertainment America Inc. ©2001 Sony Computer Entertainment America Inc.

The Babyface Effect

Link (of *The Legend of Zelda: The Windwaker*), like many of Miyamoto's player-characters, has babyface characteristics. Image courtesy of Nintendo.

Chapter 1 also includes a discussion of the *babyface effect*—the tendency to react to adults with babyish features as if they were childlike. The chapter examines babyface cues in detail and how they impact choices about character design.

Stereotypes

Chapter 1 concludes with a discussion of stereotypes—how they function psychologically and the benefits and limitations they impose. It covers ways character designers use stereotypes to make characters more immediately accessible, memorable, and surprising. Chapter 1 concludes with an interview of Gonzalo Frasca, a game designer who made interesting use of stereotypes in his online simulation titled *September 12*.

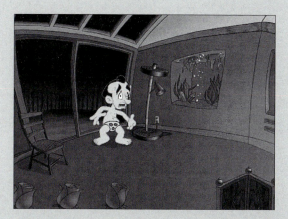

Leisure Suit Larry (of *Leisure Suit Larry 7*) makes use of the 1970s bachelor stereotype. *Leisure Suit Larry* is provided courtesy of Sierra Entertainment, Inc.

Practical Questions: Friendliness, Dominance, and Personality

Chapter 2 moves one step deeper into impression formation, addressing practical questions that arise when meeting someone new: Is "the other" a friend or a foe? Just where are they in the pecking order in relation to myself? And what sort of person are they to try to work alongside? The chapter discusses cues of friendliness, dominance, and personality in detail and offers tactics for making the best use of these important social signals.

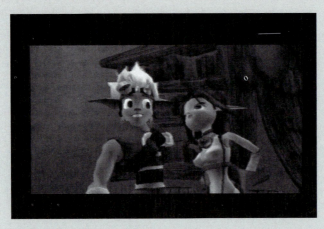

Jak and Kira (of *Jak and Daxter: The Precursor Legacy*). Kira is acting friendly toward Jak. Like many heroic player-characters, Jak displays several dominance cues. *Jak and Daxter: The Precursor Legacy* is a registered trademark of Sony Computer Entertainment America Inc. Created and developed by Naughty Dog, Inc. ©2001 Sony Computer Entertainment America Inc.

Take-Aways from Part I

After finishing these chapters the reader should have a good feel for the psychology of first impressions and will be better able to take apart just why characters in competitors' games either do or don't seize player attention artfully. The reader will leave with tools for making good use of these psychological principles in character design. A warning: Reading this section may have the side effect of making the reader curiously aware of what is happening when next meeting someone new—a form of double consciousness that plagues social psychologists as well.

Social Surface

1.1 What Is Covered and Why

This book begins where players will begin with characters: the moment in a social encounter before the first word is spoken—the first glance—surface impressions. Human beings automatically and instinctively apply interpretive strategies from the moment they lay eyes upon one another. Players do the same with game characters. Knowing how and why the social surface works can help designers make wise choices about the physical appearance and early game behavior of characters.

This chapter describes some powerful social biases that can have an impact on a player's first impressions of characters. Surface effects discussed in this chapter include attractiveness, the babyface effect, and stereotypes, with illustrations of their use in games from various genres: *Jak and Daxter*, *The Legend of Zelda: The Windwaker*, *Twisted Metal: Black*, and *Leisure Suit Larry 7*. The chapter ends with design tips for making use of social surface effects and an interview with Gonzalo Frasca, a game developer and researcher who explores stereotypes in *September 12*, a flash-based simulation "toy."

1.2 The Psychological Principles

1.2.1 *Reacting to Social Surface*

Appearance profoundly affects how a person will be perceived and treated by others. This sometimes uncomfortable truth is the subject of countless fictional works (*Cyrano de Bergerac*, *The Elephant Man*, and others). People cannot seem to help reacting to the surface of another person, in predictable and suprisingly enduring ways, even in the face of contradictory information emerging from ongoing interaction. The saying "beauty is only skin deep" would not exist if we did not think it necessary to struggle past this bias.

Take a moment to look at Figures 1.1–1.3, considering the questions below each to directly experience the effects discussed in the chapter before reading further.

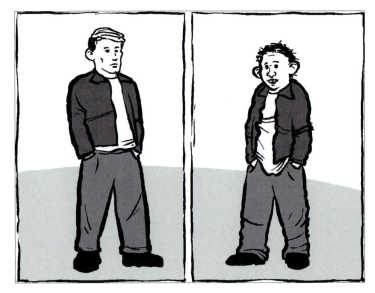

Who would you rather work with on a project? What qualities do you think each would bring to their work? How would the interaction go?

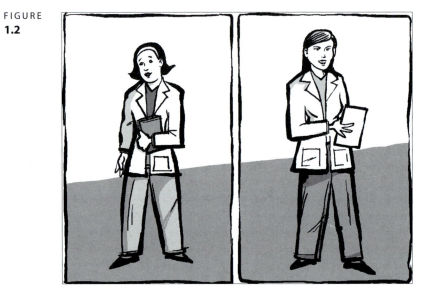

Who would you rather have as your doctor? What about as your nurse? Do you think these women would be warm in their interaction with you or not? How responsible would you hold them for their actions?

FIGURE
1.3

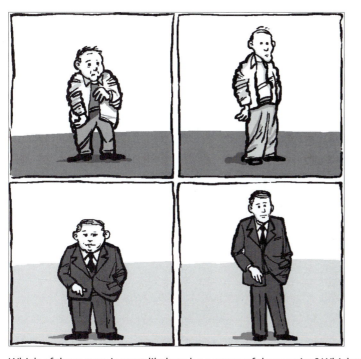

Which of these men is most likely to be a successful executive? Which would you want running a company that you worked for?

1.2.2 *Attractiveness*

A glance at any Hollywood movie poster seems to underscore the power of attractiveness—even when the subject matter is a gritty, everyday life situation, the cast members are extremely attractive. Studies have shown that many qualities are attributed to people with attractive features—sometimes referred to as the *halo effect*. These qualities include being seen as warmer, kinder, stronger, more sensitive, more outgoing, more socially persuasive and dominant, and even smarter than others. It's even the case that attractive people get more lenient sentences in court, and they may get preference in hiring decisions.

These effects occur not just for supermodels or movie stars but for regular people with "attractive" features. Most people would prefer to work with the man on the left in Figure 1.4. Why? Because he has the more attractive features of the two. His healthy, symmetrical face and body and straight profile are features that have been shown to produce higher attractiveness ratings. His strong chin is a mature facial feature often associated with attractiveness in men. His counterpart on the right, with asymmetry in body and features, a snaggle-toothed smile, unhealthy skin,

FIGURE
1.4

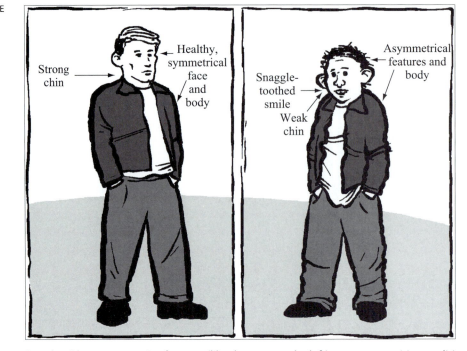

People with more attractive features (like the man on the left) get many positive qualities attributed to them that may not really be present.

weak chin, and convex profile is loaded with cues that have led to lower ratings of attractiveness.

Why do human beings have such a powerful bias toward those who are attractive? Some researchers feel it may be a part of the evolutionary process—that attractiveness is an indicator of healthiness. A person with asymmetry, obvious signs of disease, or a profile that indicates they may have trouble keeping their teeth in the long run would be a less attractive companion. Other researchers point out that gazing at attractive features puts people in a positive frame of mind from which they are more likely to evaluate anything about the person, or even what's happening in general, more positively.

Whatever the reason, it is the case across cultures that myriad traits considered positive tend to be associated with more attractive people. Of course, what is considered attractive, beyond the basic traits listed above, can vary widely across cultures as shown in Figure 1.5. From eyebrow piercings to lip plates, human beings have evolved culturally and historically specific modifications of what "ideal" beauty is, and these traits also come into play when making an attractiveness judgment.

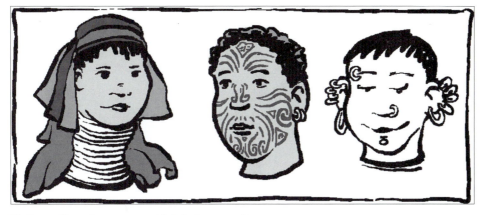

FIGURE
1.5

Notions of beauty can vary widely between cultures.

Jak and Kira (Figure 1.6), from *Jak and Daxter: The Precursor Legacy*, are good examples of attractive characters—healthy, and with symmetrical features and straight profiles. Jak's strong chin and relative height are additional markers of masculine attractiveness. It is important in this game that the player identifies with Jak, as he is the player character, and that the player finds Kira attractive, as she is Jak's love interest. Making them both conventionally attractive improves the odds of this happening for the player. Most videogame heroes and heroines are attractive, and this encourages the player to see them as smarter, stronger, kinder, and more socially skilled—all benefits of the halo effect.

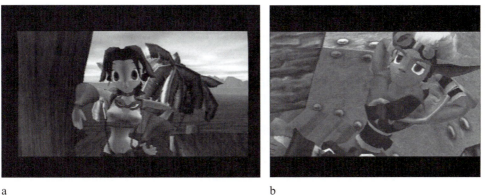

FIGURE
1.6

a b

(a) Kira and (b) Jak (of *Jak and Daxter*) are attractive characters. *Jak and Daxter: The Precursor Legacy* is a registered trademark of Sony Computer Entertainment America Inc. Created and developed by Naughty Dog, Inc. ©2001 Sony Computer Entertainment America Inc.

FIGURE
1.7

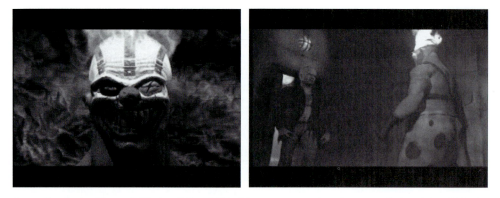

Sweet Tooth the Clown (of *Twisted Metal: Black*) is an unattractive character. *Twisted Metal: Black* is a registered trademark of Sony Computer Entertainment America Inc. ©2001 Sony Computer Entertainment America Inc.

Contrast Jak and Kira with Sweet Tooth the Clown from *Twisted Metal: Black* (Figure 1.7). His unhealthy complexion, puffy eyes, enlarged teeth, and sparse (and flaming) hair are quite unattractive. Sweet Tooth is the worst of the cast of evil murderers in this game, all of whom are meant to be delightfully awful for the player. Here, cues of unattractiveness are used to create repugnance in the player, which is instrumental in creating the proper mood in the game. Sweet Tooth's appearance also helps underscore his dissociation from everyday society—he is visually frightening and unappealing, making it plausible that he would become an outcast and an evil figure.

1.2.3 *Babyfaces*

Most people assume that the woman on the left in Figure 1.8 would be a better nurse than a doctor. They see her as likely to be warmer, and perhaps less accountable for her actions. Why? She has classic babyface features. Her large eyes and pupils, small chin, high eyebrows and forehead, small nose, and full lips and cheeks, all resemble the features of an infant. The woman on the right has smaller eyes, a stronger chin, lower thicker eyebrows and lower forehead, larger nose with prominent bridge, and thinner lips—all qualities of a more biologically mature face.

The human bias is to assume that those who have babyfaces will be warmer and more trustworthy but also may be more dependent, less responsible, and more submissive and manipulable. Psychologists call this an *overgeneralization*: attributing traits of a child to adults with childlike features. The babyface bias has been shown to affect judgments of people from infancy to old age. The babyface effect transcends cultural and even species lines—people find baby animals just as cute and nurturable as baby humans.

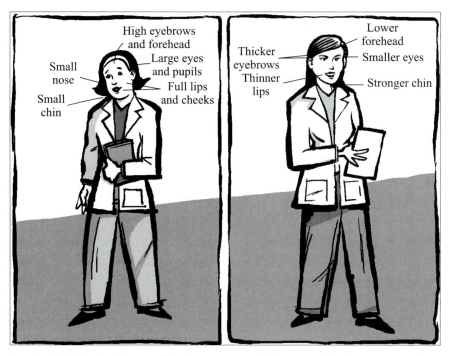

FIGURE
1.8

People with babyface features (like the woman at left) are perceived as warmer and more trustworthy, but less responsible.

Why is this so? As with attractiveness, some researchers posit that there are powerful evolutionary forces in play—it is very important to nurture infants, so humans have adapted to have powerful and immediate responses to baby features that encourage them to care for babies and to inhibit any aggression toward them. It has been demonstrated in other species that a baby with mature features does not get cared for as well as other babies and may be rejected. Research on premature infants—ones who are born with smaller eyes and less chubby cheeks—has also shown that nurturing impulses and liking are lower when looking at a preemie's face than at a full-term infant's face.

In any case, there is documentation across cultures showing that those with babyface features evoke more nurturing and trust, and are more readily absolved of responsibility. This extends even to granting babyfaced people more lenient sentences in criminal convictions.

Many game characters have exaggerated babyfaces. Here are two examples in Figure 1.9: Daxter, from *Jak and Daxter*; and Link, from *The Legend of Zelda: The Windwaker*. Both have the large eyes, small chins, round cheeks, high eyebrows, and large head size typical of a baby. Early videogame designers used these proportions so that players could still make out a face onscreen, despite limited resolution. But these designs have persisted into the era of high polygon count 3D

FIGURE
1.9

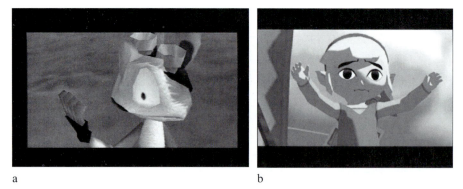

a b

(a) Daxter and (b) Link have babyface features, which tend to evoke trust and warmth from players. (a) *Jak and Daxter: The Precursor legacy* is a registered trademark of Sony Computer Entertainment America Inc. Created and developed by Naughty Dog, Inc. ©2001 Sony Computer Entertainment America, Inc. (b) Image courtesy of Nintendo.

environments. This may be because such characters take advantage of the babyface effect, evoking additional player sympathy and warmth and reducing expectations.

1.2.4 *Stereotypes*

Most people say that the man at the bottom right in Figure 1.10 is most likely to be a successful executive. They may also guess that the man at the bottom left could be an executive but is perhaps not as successful. The top two men are far less likely to be first choices for a successful executive.

Why? The man at the bottom right displays stereotypical cues that read "executive"—his clothes and grooming are expensive and meant to impress and intimidate. His height is something associated (for males) with responsibility and social dominance—qualities a high-powered leader has to project. The man at the bottom left also wears the proper uniform, but his height may indicate that he will have a tough time being taken seriously. The two middle figures, with their frumpy casual dress, are far less likely to fit into a corporate environment.

To the extent that you made any judgment about these images, you made it based on stereotypes—schemas or prototypes in your memory that associate a pattern of cues with a typical set of qualities in a person. These cues can include dress, build, posture, grooming, age, gender, race, style of speaking and moving, as well as the company in which a person is seen.

Stereotypes are a sensitive subject, and for good reason—they are powerful social tools that guide unconscious decisions that can perpetuate an inequitable situation. Once a stereotype has been "primed" in a person's mind, he or she tends to look for and mostly see the qualities in a person that support that stereotype, overlooking qualities that do not fit. This happens below the level of awareness. It has been observed in research settings, for example, that some people who state they are not

FIGURE
1.10

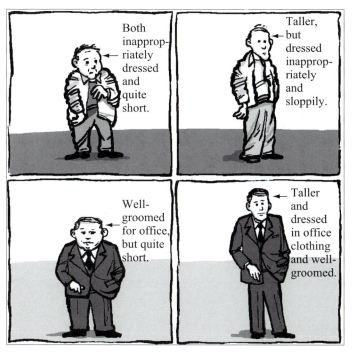

People unconsciously make use of visual cues to come to quick judgments about a person's role and abilities—such as who here is most likely to be a successful executive.

at all racist (and do not think of themselves as racist at a conscious level) can have racially biased, stereotype-driven, unconscious reactions nonetheless.

Despite their drawbacks, stereotypes do serve an important purpose—they help people make quick assessments so that they do not have to evaluate each person completely "from scratch." The unconscious process of comparing what is seen with prototypes already in the mind and then using matches to make assumptions about that person, saves time and effort. This is important, given the short window of time normally available when meeting someone new. Stereotypes also help make everyday social encounters more comfortably predictable. If we and others adopt a given stereotypic code in our dress and behavior, we can be pretty confident that we will be "read" the way we have planned.

Game character designers rely heavily on stereotypes, a fact that has generated critique (see the *Fair Play Report* mentioned in Section 1.7, *Further Reading*, at the end of this chapter). Yet in a fast-paced game environment it can be helpful for a player to draw upon stereotypes to gauge a character's intentions and likely actions. For example, the endless hoards of enemies in many games work because they capitalize on the human tendency to assign common traits to those who display similar cues (as in Figure 1.11).

FIGURE
1.11

After engaging one of these villainous creatures in *Jak and Daxter*, the player assumes all others will have the same motivation and tactics, thereby forming a working, in-game stereotype. *Jak and Daxter: The Precursor legacy* is a registered trademark of Sony Computer Entertainment America Inc. Created and developed by Naughty Dog, Inc. ©2001 Sony Computer Entertainment America Inc.

Some games take advantage of stereotypes, while remaining fresh for players, by importing unlikely types into the gaming environment. The *Leisure Suit Larry* series is a good example. Larry, an unexpected choice for a heroic player-character, derives comic value and appeal through leveraging a cultural stereotype: the aging bachelor (Figure 1.12).

Good designers also build memorable characters by taking well-worn stereotypes and crafting characters that have a few traits that go against type. Consider these two examples of pirate characters that break stereotype shown in Figure 1.13.

FIGURE
1.12

Leisure Suit Larry (of *Leisure Suit Larry 7*) is a character that relies on stereotype for definition. *Leisure Suit Larry* is provided courtesy of Sierra Entertainment, Inc.

14

FIGURE
1.13

a

b

(a) Guybrush Threepwood (of *The Curse of Monkey Island*), holding sword, and (b) Tetra (of *The Legend Of Zelda: The Windwaker*) are two memorable examples of pirates that break traditional stereotypes. (a) ©1997 Lucasfilm Entertainment Company Ltd. All rights reserved. (b) Image courtesy of Nintendo.

Guybrush Threepwood, from *The Curse of Monkey Island*, is a spindly, talkative pirate who relies more on his wit than his sword. Tetra, from *The Legend of Zelda: The Windwaker*, although female, is the head of her pirate band. Both characters are more memorable because of their counter-stereotype qualities.

1.3 Design Pointers

Here are a few simple rules of thumb for leveraging social surface effects in character design.

1.3.1 Make (Almost) Everyone Attractive

In most games, every character, even the villain, has attractive features. A game like *Twisted Metal: Black*, which seeks to evoke an uneasy and disturbing atmosphere, is the rare exception. Given the notion that looking at attractive faces makes people feel more positive in general, this bias makes sense. A designer wants players to get a positive feeling from playing the game. Even villains can add to this effect through their attractive features. Use unattractive features sparingly, and be aware of their effects on the player's social impressions of characters.

1.3.2 Use Babyfaces to Inspire Care and Warmth, Not Respect

Babyfaced characters will be seen as socially warm and appealing and will evoke a caring response, but they are not perceived as socially dominant. So use these features with care. A babyfaced player-character is probably not an appropriate choice, for example, for getting the player to feel extremely dominant and competent.

1.3.3 Trigger Stereotypes for Speed and Break Them for Depth

Stereotypes are a great way to leverage things a player already knows, thereby suggesting how to react to a character. If creating hoards of enemies, or minor roles for NPCs (non-player characters), consider leveraging real-life or media stereotypes that are familiar to the player. One important caveat to keep in mind: make sure to consider whether a stereotype will inadvertently alienate someone in your audience. (Audience factors will be discussed further in Part II.)

When using stereotypes, particularly for major characters such as the player's character, consider breaking the stereotype with a few odd traits, or choosing one that has not often been used in games. Both of these tactics are likely to create richer, more memorable experiences for players.

1.4 Interview: Gonzalo Frasca

Gonzalo Frasca (see Figure 1.14) is a videogame researcher and developer. He publishes *Ludology.org*, and is a review editor at *Game Studies*, the international journal of computer game research. In 2003, he and a team from *newsgaming.com* published a Flash-based "toy world" that inspired great discussion and debate in the games research community. Titled *September 12*, the simulation offers the player a chance to "explore some aspects of the war on terror," through choosing to shoot

FIGURE
1.14

Gonzalo Frasca, the creator of *September 12*.

FIGURE
1.15

In *September 12*, the player chooses whether and when to shoot at terrorists and observes the outcome of these tactics. (See *http://www.newsgaming.com/games/index12.htm* to try it out.) *September 12* created and developed by Powerful Robot Games.

(or not shoot) terrorists depicted wandering among civilians in a village. Here is what he had to say about the use of stereotypes in *September 12*.

**Q: Many games make use of stereotypical qualities (uniforms; physical characteristics such as size, gender, muscles, skin color) to show the player who is a "good guy" and a "bad guy." September 12 *seems to use some of these qualities (terrorists carrying guns, the sounds of women wailing) in different ways. . . . Could you talk about your intentions here?*

Since this game is intended to provide a broad panorama, with over a 100 characters onscreen, we wanted to make it easy for players to grasp the differences between civilians and terrorists. Therefore, we made all the civilians in tones of blue (which contrasts well with the yellow sandy background). Since the terrorists are radical, we played with the colors black and white, in order to show how they view the world. We also included dogs (very few). At first, it was just for fun, but later we had to decide if people would turn into terrorists because somebody killed their dogs. Of course, we thought it was too far-fetched, and they are the only nonterrorist characters that you can kill and nobody will mourn. But the fact that there are so few dogs in the game catches the attention of the player and gives the game a little bit extra. I recall a player saying "Take that, Osama Bin Lassie!" Some could say that this is a bit risky because it takes the focus away from my "message." Well, I disagree. The so-called "message" is there, and I think almost everybody was able to understand my intentions, even if several times the interpretations were somehow unexpected. Once the players understood what the game was aiming at, many kept playing with it just as a little fun shoot-them-up. I think that that is natural, too, and does not go against the goal of editorial videogames.

Of course, most of the criticism was because many players thought that the game was taking sides. It certainly was, but not the side of terrorists. The problem with this game is that it does not show terrorists performing terrorist acts. On the other hand, I think that both in the media and in the videogames we do have plenty of depictions of terrorists as being the bad guys. My focus was on the civilian victims, not on the terrorists. These people keep getting killed as "collateral damage" and that only fuels the birth of more terrorism (the working title of this game was "The Birth of Terror," maybe an allusion to Griffith's movie. Later I stumbled onto "September 12," and I thought it did the job pretty well in order to connect all the attacks as a succession of events (I kill you, then you kill me, then I kill you back, and so on).

Q: Who do you want the player to empathize with in this game? How did you control this with choices you made about the characters (if at all)?

Maybe I could say that there are some Brechtian elements in the game. I wanted players to be able to take a critical distance from the game. This is why we didn't want to have graphics that were too "videogamy" and that influenced us as well in the choice of colors. I think that one of the most important devices is the target. At first, it looks like a sniper target, supposedly for a "surgical" kind of attack. And that is what a lot of players

expected, based on their comments. But instead of shooting a single bullet, it sends out a missile that makes a big mess, killing not only the target but a lot of the surrounding people. In addition to that, I included a timer to prevent people from shooting constantly. This pisses off a traditional player, but during those few seconds, I hope that he is able to think about what is going on in this game. And based on all the feedback that I got, it worked as expected.

This is my favorite comment about the game, posted by somebody at *GameGirlAdvance.com*:

Interesting. . . . I found myself first thinking "Wow, this is a lot of work to go to in order to say one 'little' thing." Which led me to believe that that's not what the authors were trying to do. Which led me to think about the fact that I don't necessarily care what the authors were trying to do; it's how I incorporate it into my own context that is what matters more to me. Which led me to realize that even a simple simulation gives me room to actively participate in creating meaning in a different way than static textual or visual presentations like editorials and cartoons. Which led me to think more deeply about these issues [. . .]

That path of thought was exactly what I was looking for.

Q: It is interesting that ordinary citizens can morph into terrorists after a bombing within the game. What were you hoping to show with this transition?

We explored different visual techniques in order to show the transition. Yesterday night, I was watching the news on TV about a Palestinian who blew himself up in a bus, killing 11 people, including children. Later they showed a letter that the young man left behind, saying that he decided to do that in order to avenge the death of nine Palestinians killed earlier that week. What I wanted to show is simply this circle of terror that seems to not have an ending. We tried a traditional morph between the two characters, but we felt it was not clear enough. The technique that we ended up using flashes back and forth between the two characters, and I think works pretty well. We certainly wanted to avoid written text. It had to be done with visuals and audio.

Q: Have you gotten responses to the game from anyone in the Muslim community? If so, did they comment at all upon the figures in the game—the depictions of the people?

Hard to tell. The only Arab responses were from Arabs living in the Western world (notably the States). They were just about a dozen, so I am not sure if they can count as relevant, but all of them loved the game. I recall one of them saying: "It's just like that." I did not get any comments/criticisms about the depictions of the people, so I assume they were not bothered by the stereotypes in clothing, etc. (That is one of the design advantages of a cartoony look. If I had aimed at a more realistic kind of illustration, I am sure the situation would have been different.)

Q: With the distant point of view (as in many games), the player may feel a bit detached from the individuals she or he is acting upon. Did you think about this as you created the game? How (if at all) did you try to counteract or to play with this tendency?

From the beginning, I wanted to provide the "big picture" of the situation. That explains the perspective. In addition to this, it makes a statement about how these people are usually attacked (by a detached target, from very far away, in order to avoid messy face-to-face involvements). What I wanted to convey with this game is a behavior (violence produces more violence), and I think that it can become clear if you see it happening not only once but several times within a small world such as my fictional Middle Eastern village.

I believe that one of the most overhyped ideas in game design is immersion. Immersion is good if you want to be outside of the real world, but in order to explore reality you need to break it. However, political games cannot do without immersion (in order to break immersion, first you need people to get immersed). So most of the techniques that I used tried to play back and forth between this getting "inside" and "outside" of the game.

Q: Any other thoughts about your design work and stereotypes—particularly in terms of character-design choices?

My goal was to state that you can't combat violence with more violence and that's it. I didn't want to say that either side is good or bad or to reflect any specific view about Arabs, Muslims, Israelis, Jews, Americans, U.S. foreign policy, etc. (even though, since the game is open ended, each player will fill in the blanks by herself). That is quite funny, because when I started thinking about the game, in late 2002, what I had in mind was basically the War on Terror in Afghanistan. But a lot of people saw in it a depiction of the Israeli-Palestinian conflict or the current war on Iraq. Another interesting thing is that the game's launch (late September) happened at the same time that the Iraq war was resulting in more and more American casualties and the U.S. public started wondering if so many body bags were worth it. A lot of people read the game in this way, too.

With videogames, and particularly with open-ended simulations, the author simply sets the limits and certain parameters. It is a genre where you have to trust your players and, more importantly, be aware that games, unlike stories, do not have to hit their target always. A joke or a story, you either get it or you don't. But games are about repetition, so you may experience a lame match of a great game, only to later have great experiences with it. My advice to designers: trust your players and don't worry too much if they read the game differently from what you intended; the fact that they can read it personally means that they can construct with it something that is important to them, and that is the most clear sign that your game has succeeded.

1.5 Summary and What Is Next

Chapter 1 began this book's overview of social psychological theory with a look at three social surface effects: attractiveness, the babyface effect, and stereotypes. The chapter ended with a few rules of thumb for making use of these surface effects in game character design. The next chapter continues the study of first impressions with a look at some key questions that human beings want answers to when they begin interacting with another person.

1.6 Exercises

1.6.1 Babyface Assessment

Photograph five or more familiar faces, and then array these images along a continuum: clear babyface features to clear mature features. Compare these images with the people as you know them in social interaction—can you see differences in people's demeanor and strategies for getting along with others that might correlate with the babyface phenomenon? People whose faces are at either extreme may want to discuss the impact that this has had (if any) on their own social style and encounters.

1.6.2 Unattractiveness Search

Each person should consider the videogames he or she has played and try to find examples of characters that could be considered unattractive by the standards discussed in this chapter. Bring a screenshot of the character to group discussion, and be ready to talk about what role this character plays in the game. Is the character's unattractiveness appropriate and effective in the game? How so?

1.7 Further Reading

On Babyface and Attractiveness Effects

Zebrowitz, L.A. 1997. *Reading Faces: Window to the Soul?* Boulder, CO: Westview Press.

On Stereotypes

Children Now. 2001. *Fair Play? Violence, Gender, and Race in Video Games.* A report issued by the Children Now organization, available online at *http://www.childrennow.org/media/video-games/2001/index.cfm*

Hilton, J. L., and W. von Hippel. 1996. Stereotypes. *Annual Review of Psychology* 47, 237–271.

Practical Questions— Dominance, Friendliness, and Personality

2.1 What Is Covered and Why

This chapter begins the discussion of how interaction-based social qualities can be helpful in guiding character design. Forming an impression of another person is a practical process. There are some questions a person wants to answer about another quickly, to help decide how to engage socially. These questions are not asked consciously or literally; rather, the answers are sought intuitively and surreptitiously. Yet if asked, a person could answer these questions about another person shortly after meeting them, in most cases with surprisingly high accuracy.

On a general level, each social encounter with an unknown person begins with some rapid assessment of possibilities. Among the questions in mind are two primal ones: Is the other person a friend or foe? How powerful is she or he in relation to me? This chapter examines why this is so, how people make assessments of these qualities in others, and how this should impact game character design.

On an individual level, each person has characteristic patterns of reaction to others and the world. From the first encounter, others look for these patterns and develop an impression of how this person will react to them and to the world— "personality." Social psychologists have identified some core personality traits that describe the major differences among people, and this chapter will present these and discuss their implications for character design.

Players ask these social questions when they encounter a game character for the first time. The player wants to know what to expect: How will this guy react in a crisis? Is he on my side as I go through this world? Does he have powers I can use?

Is he flaky or dependable? This chapter helps to bring to the surface why character-design tactics that take these questions into account work so well. The tactics described make it possible for any designer to create strong character interactions on a more consistent basis. Examples from *Jak and Daxter: The Precursor Legacy* and *Grim Fandango* help to illustrate the points made. The chapter ends with specific design pointers for using dominance, agreeableness, and personality traits.

2.2 The Psychological Principles

2.2.1 *Agreeableness and Dominance*

To understand how social impressions form, it is helpful to step back for a moment to consider the underlying motivations for social interaction. *Why* do people interact with one another? From a functional point of view, human beings interact so that each person's basic physiological and safety needs are met. Children rely on parents to provide food, shelter, and protection; adults work together to meet these basic needs.

Even when there is plenty to eat and a safe environment, people interact looking for love, a sense of belonging, and self-esteem. Each person develops an identity through engagement with others and through contributions to the larger social group. Being social serves many needs.

Figure 2.1 shows a hierarchy of needs proposed by Abraham Maslow. He believed that people worked their way up this pyramid, tending to focus on "higher" needs only once the lower ones had been addressed. Notice that safety

FIGURE
2.1

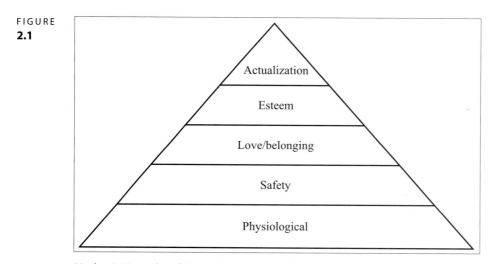

Maslow's Hierarchy of Needs. A person usually does not focus on higher-level needs in this pyramid unless lower-level needs have been addressed.

comes before love and belonging. Using this framework, it makes sense that "Is this person friendly toward me?" is one of the first social questions asked. Making a solid assessment of friendliness has an impact on a person's well being and maybe even his or her survival.

Closely intertwined with this first question is a second one: "How socially powerful is this person in relation to me?" Social power determines how large a threat someone may be, or if they are helpful, in what ways they may help. For example, someone might be very hostile toward you but not very powerful and hence not much of a threat.

Human beings share an interest in the answers to these two questions with other primates. There is strong evidence from animal studies that quick assessment of potential threat, and fine attunement to hierarchy are traits that ensure survival within primate social structures (see [Mazur December 1985] for more details on primate studies). Psychologists have studied these two social questions in human behavior, creating names for them: agreeableness and dominance. These qualities emerged as primary social variables within two different areas of psychology: the study of interpersonal behavior and the study of personality.

Social psychologists studying interpersonal interaction realized through observation and experimentation that descriptions of how people interact could be arrayed in an *interpersonal circumplex*. The two axes of this circle are dominance and agreeableness. Figure 2.2 shows where various social stances fall along these two dimensions. It turns out that these two variables are a powerful organizing principle with which to understand social encounters.

In a parallel effort, personality psychologists gave out questionnaires (for self-rating and for rating others) made up of traits that describe people's personalities, then looked for patterns and clusters in rankings, using statistical analysis. Two of the stable personality factors from multiple studies in this area are extroversion and agreeableness. Figure 2.2 shows that extroversion is a combination of dominance and agreeableness. So the two research areas ended up converging upon similar pictures of the social qualities of human beings. (For a longer discussion of the intersection of these two sets of research concepts, see [McCrae and Costa 1987]. For a broader discussion of the application of these variables to creating media, see [Reeves and Nass 1996].)

Thus, the two practical social questions—Is this person friendly? How powerful are they?—can be reframed using two concepts from psychology literature:

- *Agreeableness.* Cues that a person is socially receptive and friendly.
- *Dominance.* Cues that a person believes they are, can, or should be higher in the social status hierarchy.

This is not to say that there are not many other qualities human beings investigate about one another as they interact, but these are among the first, for survival reasons. People are remarkably quick about reading these qualities in others, and

FIGURE
2.2

One version of the interpersonal circumplex. Social behavior is arranged along the axes of friendliness and dominance (based on Strong et al. 1988).

from very subtle signals. For example, a person can be shown a brief clip (one or two minutes) of a stranger on videotape, without sound, and then can say reliably if the stranger is generally socially dominant or not (DePaulo and Friedman 1989). Interestingly, people are often not fully aware that they send and receive such signals. Sometimes, a researcher will ask participants in a study if they noticed cues of dominance and friendliness, and they will say "no," yet their answers on a questionnaire as well as their behavior will indicate that they did in fact notice and interpret the cues accurately (Isbister and Nass 2000; DePaulo and Friedman 1989). Human beings seem to notice these qualities below the level of everyday awareness.

As an example, consider Figure 2.3. What would it be like to talk to the person on the left? How about the person on the right? You are picking up subtle indicators of agreeableness and dominance as you make these decisions. The next two subsections will go into more detail about specific signals of each of these qualities.

FIGURE
2.3

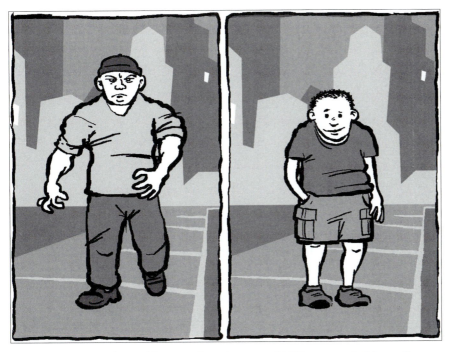

Which of these people would you prefer to interact with? You are probably reading cues of
dominance and agreeableness in order to make your answer.

Agreeableness

How does a person telegraph friendliness and willingness to engage? They do so
with face, body, and voice, as well as the overall pattern of behavior toward the
other person. All of these signals work together to create a general impression
in the person who is being approached. Part III goes into more detail about each
element of the social equipment that a person uses to communicate. This chapter
uses agreeableness and dominance as an introduction to how all these cues work
together. Please be aware that these cues can be modulated by cultural differ-
ences—for example, interpretation of friendliness cues depends upon culture.
A very friendly Japanese person may seem much more subdued than a very
friendly Brazilian person to an American because of local differences in norms for
the range of gestures and facial expressions used to indicate friendliness. Cultural
differences and how they affect character design will be discussed further in Part II.

Cues of agreeableness (drawn from U.S.-based research) include (see also
Table 2.1):

- *Face.* A friendly person will probably have a smile on their face or at least the
 hint of a smile in their eyes. They will make eye contact, but they will not be
 giving an intense stare.

- *Body.* A receptive person will have a relaxed, open posture. If already sitting or standing near another, they are likely to be closer than someone who is indifferent. They may also lean forward during conversation.

- *Voice.* A friendly person will use a warmer and more energetic tone of voice than someone who is indifferent.

- *Overall engagement patterns.* A friendly person will acknowledge the other, and will use all of their social equipment to signal that it is okay to interact. A friendly person will be open to whatever social moves are made, and will not be negative or judgmental. A friendly person will try to get in sync with the other person, unconsciously adjusting movement speed, postures, and gestures to mesh well with those of the other person.

It helps to highlight cues of friendliness to see cues of the alternatives: hostility or outright indifference.

In Figure 2.4, the friendly person on the left has a relaxed posture and small smile; the hostile person at center approaches and engages with energy, but instead of warmth, openness, and calm, displays tension and hostility through face, gaze, and body. The indifferent person on the right shows with their face, body, and voice that they are not at all engaged and want no contact.

The character design in *Jak and Daxter: The Precursor Legacy* is an example of the clear use of agreeableness cues. By the time the player has watched the first

FIGURE
2.4

Friendliness, hostility, and indifference are reflected in body posture as well as facial expression.

TABLE **2.1** Friendliness cue list.

	Friendly	Hostile	Indifferent
Face	Smile; steady but not overly intense eye contact	No smile; intense eye contact	No smile; not much eye contact
Body	Open, relaxed stance; closer in and may lean toward	Tense stance; may be closer in and lean toward	Closed, relaxed stance; may stay further away and lean away
Voice	Warm, energetic	Cold, energetic	Cold, less energetic

cut-scene*, she has a clear idea of who among the nonplayer characters are friends or foes.

For example, Kira is quite obviously friendly to Jak (the player's character). Kira is the daughter of Jak's mentor, the Green Sage. She is introduced in the game's opening cut-scene as someone who can help Jak accomplish his goals by providing tools and know-how. In Figure 2.5, and in Clip 2.1 from the DVD that accompanies this book, you can easily spot the cues of friendliness. Kira is smiling, leaning toward, and gazing at Jak, with a relaxed, open body posture. In the clip, her tone of voice is warm and energetic. All these cues send a clear message to the player that this character is on the player's side.

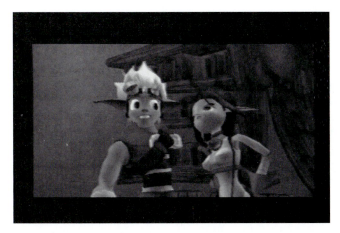

FIGURE **2.5**

Kira's gaze and open and leaning body posture indicate that she is very friendly toward Jak. (See Clip 2.1 to watch the game's opening scene, with both characters in action.) *Jak and Daxter: The Precursor Legacy* is a registered trademark of Sony Computer Entertainment America Inc. Created and developed by Naughty Dog, Inc. ©2001 Sony Computer Entertainment America Inc.

*Cut-scene: *Cut-scenes* or *cinematics* are prerendered animated sequences used in games to help frame the story and motivation for the player of the game. During most cut-scenes, no actions by the player are possible. Often cut-scenes can be skipped by players who are not as interested in the story of the game or who have seen them already in another play session.

FIGURE
2.6

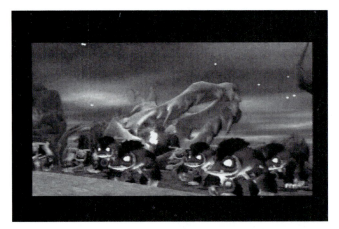

These creatures from *Jak and Daxter* have hostile body language and menacing stares.
(See Clips 2.2 and 2.3 for more examples of hostile signals.) *Jak and Daxter: The Precursor Legacy*
is a registered trademark of Sony Computer Entertainment America Inc. Created and developed
by Naughty Dog, Inc. ©2001 Sony Computer Entertainment America Inc.

In contrast, enemy characters introduced in the opening cut-scene quickly and
clearly demonstrate their unfriendliness. The menacing stares, frowns, and tensed
body postures of the creatures in Figure 2.6 all indicate hostility. In Clip 2.2, an
enemy creature approaches and attacks Jak. Its frown, stare, and quick and aggres-
sive approach spell out threat. This combination of stare and body language is often
used to signal hostility in games. In Clip 2.3, the creatures that were menacing in
the opening cut-scene are now performing the same kinds of attacks on the player-
character. Everything about their faces, body language, and even their grunts
says "hostile."

Another game that makes artful use of friendliness cues is *Grim Fandango*.
In this game, the player must sometimes win the loyalty of a nonplayer-character
(or vice versa). Seeing a noticeable shift in friendliness cues after earning trust is
a source of fun and gratification for the player. For example, in Clips 2.4 and 2.5,
the player-character, Manny, negotiates with the revolutionary Salvador Limones
(Figure 2.7).

Notice the difference in Salvador's behavior before and after Manny says the
"right" thing to indicate his loyalties (again, in Clips 2.4 and 2.5). Initially, Salvador
shows his skepticism through his closed and incredulous tone of voice. After Manny
signs up for the revolution, Salvador's smile, tone of voice, and welcoming body
language send a friendly message to the player.

Dominance

How does a person determine whether another person is (or at least thinks they are
or should be) higher in the social hierarchy? There are two general categories of

FIGURE
2.7

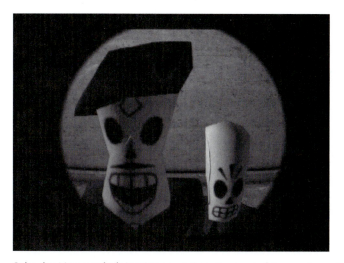

Salvador Limones helping Manny gain entrance to his secret revolutionary headquarters (in *Grim Fandango*). Manny must win Salvador's trust and cooperation. (See Clips 2.4 and 2.5 to witness this process.) ©1998 Lucasfilm Entertainment Company Ltd. All rights reserved.

cues of dominance. One type is more permanent—the enduring marks of status (Mazur 1985). These include things such as age, gender, race, family lineage, profession, health, wealth, physical size and strength, and education. So, for example, within mainstream U.S. culture, you might assume someone like George W. Bush—older, Caucasian, male, wealthy, and from a prominent family—has a high degree of social dominance. As with friendliness cues, these enduring status markers vary from culture to culture as well as within subcultures and over time.

There are also more controllable cues of dominance—those in a person's face, body, voice, and overall engagement patterns (DePaulo and Friedman 1989; Mazur 1985) (see also Table 2.2):

- *Face.* A dominant person makes more eye contact and is comfortable staring. However, they may look at the speaker less when listening than a less dominant person would.

- *Body.* A dominant person takes up more physical space—for example, sitting with limbs spread out. They may also require more physical space around them. They may sit or stand at a physically higher level than others. In general, dominant people move their heads less and tend to have calmer body movements than less dominant people, though their gestures can be more emphatic.

- *Voice.* A dominant person speaks more loudly and tends to control the conversation more often than others—taking more turns, setting the tone, and choosing the topics of conversation.

31

TABLE **2.2** Dominance cue list.

	Dominant	Submissive
Face	More eye contact; may stare; looks away more often when listening	Less eye contact (but more when listening); avoids staring; more smiling
Body	Open, calm stance; takes up more physical space; moves less; may use emphatic, large gestures; may touch less dominant people occasionally	Nervous, closed stance; may frequently touch self (hair, face, etc.); may keep head lower
Voice	Louder; more controlling of the conversation	Softer; follows other's lead in conversation

It helps, when highlighting cues of dominance, to see cues of the alternative: submissiveness. Figure 2.8 illustrates these differences.

Jak and Daxter makes use of dominance cues to manage the player's reactions to characters. The player-character (Figure 2.9) is a stereotypically dominant figure— tall, healthy, and strong; he uses wide body movements and has a calm, steady

FIGURE
2.8

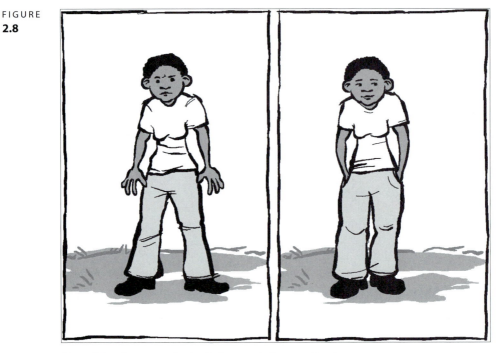

Cues of dominance and submissiveness in face and body.

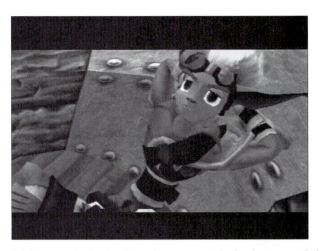

FIGURE
2.9

Jak has a typically dominant larger, muscular body type and also displays cues of dominance in his posture—calm, taking up extra space. *Jak and Daxter: The Precursor Legacy* is a registered trademark of Sony Computer Entertainment America Inc. Created and developed by Naughty Dog, Inc. ©2001 Sony Computer Entertainment America Inc.

demeanor during game play. He stares openly at other characters and does not make any of the nervous movements expected of a less dominant figure.

In contrast, the Egg Lady (Figure 2.10), a villager that Jak encounters, has a much more submissive demeanor. A small, oddly dressed old woman, she starts out lower than Jak in the stereotypical social hierarchy. Her submissive gestures add another

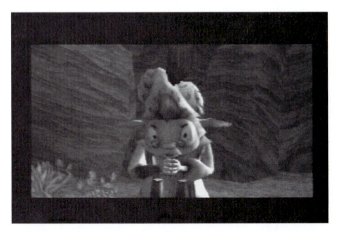

FIGURE
2.10

The Egg Lady has a much less dominant body posture than Jak has. (See Clip 2.6 to watch her in motion.) *Jak and Daxter: The Precursor Legacy* is a registered trademark of Sony Computer Entertainment America Inc. Created and developed by Naughty Dog, Inc. ©2001 Sony Computer Entertainment America Inc.

layer to the impression of submissiveness—hands close to the body, head tilted, and more frequent smiling (see Clip 2.6 on the DVD).

Both *Jak and Daxter* and *Grim Fandango* also use dominance cues for humorous purposes.

Daxter's character won the IGDA's Original Game Character of the Year Award when the game was released. Daxter has a small body but behaves like the boss. Daxter uses broad gestures, stares, and takes on others far larger than himself. In Clip 2.7, he is very loud and dominates the conversation, despite his small size (See also Figure 2.11). Other characters are not intimidated by him but rather seem to find him amusing. Players also find Daxter amusing because of the contrast between his diminutive size and his dominant behavior.

In *Grim Fandango*, Lucas Arts broke the typical hero mold by casting a relatively powerless guy low on the status hierarchy as the player's character (Figure 2.12).

FIGURE
2.11

Daxter is funny partly because he is small but acts very dominant. (See Clip 2.7 to watch Daxter in action.) *Jak and Daxter: The Precursor Legacy* is a registered trademark of Sony Computer Entertainment America Inc. Created and developed by Naughty Dog, Inc. ©2001 Sony Computer Entertainment America Inc.

FIGURE
2.12

Manny from *Grim Fandango,* before and after his transformation into a less dominant and more "regular" guy. (See Clip 2.8 to watch the shift occur.) ©1998 Lucasfilm Entertainment Company Ltd. All rights reserved.

In the course of the opening cut-scene, the player first sees Manny Calvera in a rather imposing Grim Reaper outfit—tall and menacing. However, the camera soon follows Manny behind the scenes at his workplace, where he removes the robe, puts away the scythe, and reveals stilts that give him his towering height. For the rest of the game, Manny is the little guy who could. (Clip 2.8 shows the transformation of Manny.)

In both cases, the designers made use of the human tendency to attune to dominance cues, to create humorous juxtapositions of traits.

2.2.2 *Personality*

The everyday sense of the word "personality" is a person's typical patterns of behavior—what they are like to interact with and how they generally engage with everyday life and other people. Are they outgoing? Shy? Reliable? Flaky? Silly? Serious? Describing someone's personality is a way of telling other people what to expect when they interact with that person.

Psychologists who have studied personality find it to be a complex and difficult concept to pin down. Human beings show different sides of themselves in different situations, and it is difficult to come up with a consistent picture of any one person's behavior and tendencies. People are also profoundly affected by circumstances—behavior is just as much a product of situation as it is of internal traits. So it is hard to find reliable indicators of personality that do not get affected by circumstance and setting.

And yet, we are all able to discuss one another's personalities in a useful way. One particular line of personality research focused on these trait descriptions, looking for patterns—for clusters of traits that seemed to indicate an underlying dimension that was important in describing personality. They found clusters of words that form consistent factors that seem to hold across cultures. They called these factors 'the big five' (see McCrae and Costa for an excellent overview of this research area). To help people remember the factors, they use the acronym OCEAN, which stands for openness, conscientiousness, extroversion, agreeableness, and neuroticisim. Two of these—extroversion (see discussion of Figure 2.2) and agreeableness—have already been discussed because they overlap with interpersonal psychology theories. These also happen to be the most legible traits—easy to spot very quickly in the first few interactions with another person. The other three traits—openness, conscientiousness, and neuroticism—manifest themselves over longer interactions and have to do with a person's ongoing reactions to the world and others. These personality traits can be characterized as follows:

- *Openness.* Open to new experiences, broad-minded, creative, and daring. Most (though not all) player-characters have this personality trait because part of gaming is diving right in and being open to the next adventure. For example, both

35

Jak (from *Jak and Daxter*) and Manny (from *Grim Fandango*) display a high degree of openness.

- *Conscientiousness.* Thorough and directed, acts based on planning versus impulse, follows through on plans. This is a trait that often shows up in nonplayer-characters (NPCs) that act as guides or mentors to the player (more on these in Part IV, which highlights NPCs).

- *Neuroticism.* Tendency to worry, become wrapped up in self-consciousness versus outward-facing attention, also displays more emotional ups and downs. This personality trait shows up in memorable and humorous NPCs, such as the ocean bottom walker in *Grim Fandango*. (See Figure 2.13; Clip 2.9 shows an interaction which highlights his charms.)

In contrast to the data on extroversion and agreeableness, there is far less research consistently linking specific physical cues to these three traits. However, Chapter 6, which focuses on body cues, includes movement-analysis techniques that begin to address the expression of these qualities through movement.

Despite the lack of prescriptive advice about specific cues, it should still be helpful to consider each of the "big five" traits when making design decisions. Exaggerating or highlighting these traits can help make characters more engaging and widely appealing because these factors have been shown to be widely legible and relevant.

FIGURE
2.13

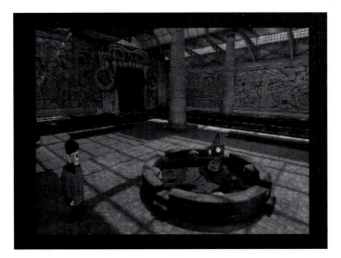

This character in *Grim Fandango* walks in circles on the ocean floor, demonstrating a lack of outward focus typical of someone with high neuroticism. (See Clip 2.9 also.) ©1998 Lucasfilm Entertainment Company Ltd. All rights reserved.

2.3 Design Pointers

Here are a few techniques for using the social interaction traits in this chapter in character designs.

2.3.1 Sketch a Relationship Diagram for the Game

One way to bring agreeableness and dominance cues into play is to plan out the relationships among characters in a game, as well as the evolution of those relationships. Making a relationship diagram is a quick and easy way to sketch this out for everyone on the development team to use as a guide. This need not be a polished diagram—it is meant to serve as a tool during the early design process.

Put the player-character in the center, and then draw lines out to all the major characters that will be a part of the game. Along the lines radiating out from the player's character to the others, indicate whether each character is friendly or hostile toward your player-character and whether the character is more or less dominant. Next, think about shifts in friendliness or status that will happen during the course of the game between these characters and the player-character. Circle the lines that will shift, and jot down how and why.

As an example, Figure 2.14 is a diagram for *Jak and Daxter,* outlining the major relationships and arranged vertically by dominance.

Doing this exercise helps clarify the social landscape in the game from a 10,000-foot perspective. The diagram itself will be a visual reminder for everyone on the design team that characters exist in relation to one another. It is easy when animating, programming, or working on dialogue to forget that this is the case and create assets that stand well alone but make less sense all together. Circling the important relationship transition points may also help to focus efforts during limited development time—planning more storage, processing, and design and production time for illustrating key transitions in relationships between characters.

2.3.2 Use Cue Lists to Help Guide Animation and Dialogue Reviews

The friendliness and dominance cue lists (Tables 2.1 and 2.2) can be used as checkpoints for evaluating animations and voice recordings as a game's cutscenes and in-game asset development progress. They may help everyone clarify just why a character is not "working." For example, a transition in relationship will have much more punch if the cues shift quickly and obviously all at once—from voice, face, and body. Using the cue checklists can

FIGURE
2.14

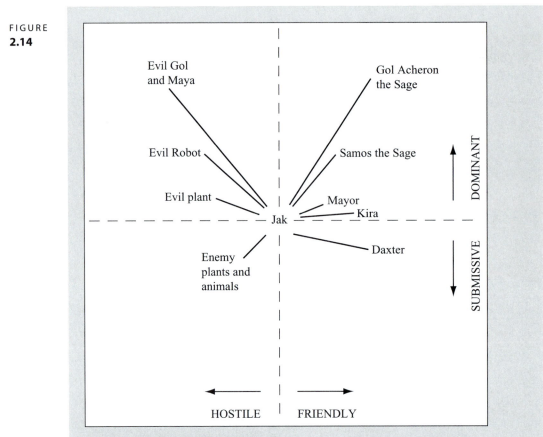

A relationship diagram for *Jak and Daxter*.

help ferret out inconsistencies that muddy the player's impressions of a character's reactions.

2.3.3 Know All Five Personality Dimensions for Every Character

When planning out the cast of characters in a game, consider and record where each falls within the "big five" personality dimensions. Making a character's agreeableness and dominance positions clear from the start can help players interact more intuitively and easily. Highlighting the dimensions that unfold over time (openness, conscientiousness, and neuroticism) can help give characters more depth. Consider breaking type when crafting a character's personality—what might it be like to have a completely unconscientious and capricious guide or mentor (e.g., the King in *Katamari Damacy*, page 61)? How about an utterly introverted and closed player-character?

2.4 Summary and What Is Next

This chapter discussed some impression formation theory most relevant to the crafting of early encounters with characters, including research on dominance and agreeableness, and the "big five" theory of personality. Examples from *Jak and Daxter: The Precursor Legacy* and from *Grim Fandango* helped to illustrate the points made. Readers are encouraged to use the design tools in the chapter to apply these theories.

Part Two focuses on player characteristics and their impact on character design.

2.5 Exercises

2.5.1 Characters with Personality

Brainstorm NPC (nonplayer-character) ideas that make use of the five personality factors. Consider the potential for humor and/or drama in extreme traits—someone very neurotic, someone very open to experience, someone extremely conscientious. Present your concepts in storyboard form to others and see if the character traits you aimed for are legible: Can people easily identify the character's personality? Is it appealing to them? Why so? Which details helped them to get a feel for the trait—visuals, dialogue, situations? How so?

2.5.2 Dominance/Agreeableness Role Play

Form groups of three for this exercise. One person will observe and the other two will take turns playing a very dominant or very submissive person. Pick a situation that has a big power differential—boss talking to employee, lord talking to peasant, and so on. You may want to use *Impro* (Johnstone 1979) as a reference book for choosing situations. Use the cue lists in the chapter to help inspire you, but add your own improvised actions—movement, posture, facial expressions, and tone of voice. The third person takes notes about which actions seem to contribute most to the impression of dominance or submissiveness. Change roles so that everyone gets a chance to take notes and to play-act both sides of the spectrum. Come together as a group and compare notes. Compile a list of successful and interesting dominance and submissiveness cues to use for inspiration when coming up with character concepts later on.

2.6 Further Reading

On Cues of Friendliness and Dominance

Burgoon, J. K., D. B. Buller, J. L. Hale, M. A. deTurck. 1984. Relational messages associated with nonverbal behaviors, *Human Communication Research* 10(3): 351–378.

DePaulo, B. M., and H. S. Friedman. 1989. Nonverbal Communication. In *The Handbook of Social Psychology,* volume II, edited by D. T. Gilbert, S. T. Fiske, and G. Lindzey, 3–40. Boston, MA: The McGraw-Hill Companies, Inc.

Isbister, K., and C. Nass. 2000. Consistency of personality in interactive characters: Verbal cues, non-verbal cues, and user characteristics, *International Journal of Human Computer Studies* 53(2):251–267.

Johnstone, K. 1979. *Impro: Improvisation and the Theatre.* New York: Theatre Arts Books.

Mazur, A. Dec. 1985. A biosocial model of status in face-to-face primate groups, *Social Forces* 64(2):377–402.

On Treating Media Like Real People

Reeves, B., and C. Nass. 1996. *The Media Equation: How People Treat Computers, Television, and New Media Like Real People and Places.* Stanford, CA: CSLI Publications.

On Personality

McCrae, R. R., and Costa, P. T. 1987. Validation of the five-factor model of personality across instruments and observers, *Journal of Personality and Social Psychology* 52(1).

Orford, J. 1994. The Interpersonal circumplex: A theory and method for applied psychology. Human Relations 47(11), Nov. 1994, 1347–1375.

Strong, S. R., Hills, H. I, Kilmartin, C. T. 1988. The dynamic relations among interpersonal behaviors: a test of complementarity and anticomplementarity.

PART Two

Focus on the Player

What Is Covered and Why

Chapters 3 and 4 provide a starting point for designers hoping to reach broader audiences with their characters, replacing some of the guesswork involved at present with recommendations for how to proceed. It is my belief that true cross-gender and cross-cultural character appeal arises from understanding of and respect for the differences that shape social perception and behavior.

Psychologists aim to conduct research and produce results that apply to all human beings, and the findings in this book have been selected with an eye toward generalizability—forming first impressions, noticing and caring about dominance and agreeableness, seeking social information from faces, bodies, and voices, and so forth. Yet within this broader context of being human, there are important variations. Each person is as unique as a snowflake in their perceptions and assumptions.

It is impossible to draw an adequate picture of each and every person's psychology. Instead, researchers look for results that are generalizable across all people, and where this fails, they look for variables that help to explain broad swaths of difference among people. Marketers do the same thing when researching audiences—they look for broad groups and for variables to help predict what will appeal to these groups. In both cases, a characteristic that is true of many people, and which helps predict aspects of their behavior, becomes a useful tool.

Designers face the same dilemma as researchers and marketers—they must make choices about characters, knowing that each player will react in a different way. Descriptive categories employed by marketers, such as gender or culture, are a start, but segmenting audiences does not solve the problem of providing useful guidance for designers. Chapters 3 and 4 work to delve deeper into these broad demographic categories toward a richer understanding of how these dimensions of a person's experience impact expectations and perceptions of self and others and toward targeted recommendations for shaping character designs.

Who Will Find Part II Most Useful

The concepts and recommendations in these chapters will be especially useful to designers who shape the early focus of a game and its characters, as well as to project team leaders and marketers. They will also be useful to team members involved in character production decisions along the way—artists, programmers, writers, and animators—as broader audience appeal emerges from the bottom up through design detail (not just through initial conceptual choices).

Overview of Key Concepts

Both chapters emphasize that demographic variables are a shifting terrain—what it means to be "Japanese" or to be "female" changes over time and fluctuates even within a given time period. The two chapters also point out the role that designers themselves can play in shaping notions of culture, subculture, and gender given that games have the power to actively transform the social landscape.

Chapter 3 includes interviews with both industry and research figures who deal with cultural differences in characters, in Chapter 4, several gamers (female and male) are interviewed about their play preferences to illustrate the individual differences possible within the broad category of gender.

Culture

Expression and Physical Characteristics

Chapter 3 begins with a discussion of the ways in which everyday social expression can differ among cultures and subcultures. This chapter also includes a discussion of differences in appearance, such as ethnic features, and the role these can play in identification with game characters.

Posture and gesture norms for conversation are quite different in Japan and the United States.

Roles and Expectations

Another important factor for character design, and one that varies among cultures and subcultures, are the roles people learn about and the expectations they form about how to behave to fit a role. The discussion in Chapter 3 includes some dimensions along which cultures tend to vary, in terms of role behavior.

The player character in *Halo*—Master Chief—is an individualistic hero that fits American role expections. Screenshot from *Halo®: Combat Evolved*. ©2005 Microsoft Corporation. All rights reserved.

Media Contexts and Their Impact on Expectations

Chapter 3 also includes a discussion of the ways in which culture is shaped and reflected in media and the importance of understanding the local media landscape when designing characters for a particular audience. This chapter includes discussion of characters and contexts that have evolved a global reach, including experiments such as SquareEnix's *Kingdom Hearts*, which combines Disney and anime-style characters.

Kingdom Hearts blends Disney characters and environments with anime-style characters from the *Final Fantasy* tradition. ©2002 Disney. Developed by Square Enix Co., Ltd. Character Design: Tetsuya Nomura. ©Disney Enterprises, Inc.

Gender

Nature versus Nurture: Biology and Gender

Chapter 4 begins with a clarification of the concept of gender, making a distinction between biology and the process by which men and women are socialized to be masculine or feminine. While a few biological factors that may have an impact on game play are briefly cited in Section 4.2.2, the bulk of the chapter deals with the enculturation of being male or female, not with biological differences.

Play Styles

This subsection (page 111) summarizes research investigating differences in the way girls and boys play that could have an impact on character design choices.

The Sims™ offers players domestic settings and non-violent, socially-oriented game play that may have greater appeal to some female players. ©2005 Electronic Arts Inc. All rights reserved.

Roles for Girls

One important aspect of enculturation of girls and boys is offering them role models and fantasy personas that they can imagine being. This subsection (page 115) discusses the importance of providing accessible fantasy personas for girls, including providing the capacity to self-generate player-characters to allow for a wider range of role play.

Reactions to Girls

Chapter 4 also discusses the importance of socially appropriate reactions of NPCs to female players, particularly in the case of the kinds of interest and attraction cues that a character uses. Narrow use of sex appeal and gender-based assumptions can inadvertently skew a game toward a male-only audience.

Non-player characters in *Animal Crossing* react to the player-character in gender neutral ways. Image courtesy of Nintendo.

Take-Aways from Part II

After reading Part II, designers will feel more confident approaching character design for an audience with members who are not from their own gender and culture—mostly because they will have a healthy respect for the subtlety and depth of differences in how people respond socially to game characters. Designers will also leave with some ideas for how to design games to support both genders and games that can travel across cultures well. One key message in both chapters is the need to include a broader base of design-team members from target audiences in the process, from the very beginning, because designers do best when they create from and for what they deeply know.

CHAPTER Three

Culture

3.1 What Is Covered and Why

This chapter offers a brief and targeted introduction to culture as it affects people's perceptions and interpretations of one another. Particularly for those who have never lived in another culture (or in a setting with a diverse population of subcultures), it is dangerously easy to resort to over-simplified stereotypical notions of what someone from another culture is like, or would like, when designing characters. My hope is that reading this chapter will eliminate this possibility for the reader, substituting instead a respect for the complexity and layers of culture and a desire to incorporate this understanding into character design.

Culture is far too broad a topic to cover coherently in a few pages, so this chapter focuses on the aspects of culture that relate specifically to the crafting of game characters, with findings that modulate the theory and design practices in the subsequent sections of the book. The chapter concludes with design recommendations for dealing with culture well when crafting characters and with two interviews—the first with two localization experts for Sony and the second with researchers who have been developing characters to train cross-cultural awareness in language learners.

3.2 The Psychological Principles

3.2.1 *Culture: Getting Clear on the Concept*

In the game industry, discussion of culture is often reduced to reference to nations or continents—designing for "the Japanese" or for "the European" markets. In fact, these national and supranational identities are fairly recent in human evolution and are only one of the many social groupings that make up cultures. In many cases (for example, in Japan), ethnicity is intertwined with national cultural identity, creating outsider subcultures of ethnically different groups. Within nations, there are other identifiable subcultures (for example, the cultural differences between the East and West coasts in the United States or between the South and the North; or the contrast between Kanto and Kansai dwellers in Japan). Aspects of a person's

environment, personal qualities, and history can have an affect on his or her cultural identifications. There are subcultures that have economic status, life-stage, gender, and many other characteristics as their predominant markers of identification.

Each person may simultaneously belong to several cultural contexts. Some of these transcend national boundaries—consider, for example, the subculture of motorcycle bikers, which has members around the globe who share common points of reference and rituals (see Figure 3.1). There is also the subculture of airline pilots, who may be from very different national cultures but who share training, procedural knowledge, and daily experiences that lead to a shared set of assumptions and beliefs.

Culture, even at the national level that we often think of first, is something that shifts over time. What was true of the typical American or the typical Japanese a generation ago may not be true today. It is also clear that people as individuals and as groups can get more familiar with, adjust to, and appropriate one another's forms and expectations—in this way blending formerly distinct cultures. For example, the proliferation of Japanese gardens in the West, or the global distribution of American serial television.

Despite all the distinctions among subcultures, there are fundamental qualities and situations that human beings share that produce similarities among cultures. Meeting basic survival needs, having and raising children, caring for the sick, adjusting to changes in the environment, and managing the distribution of labor and property within groups, are all shared circumstances. The bedrock of culture is made up of such universal concerns that spring from being human.

What does all this mean for designing culture-appropriate game characters? In order to design characters that have appeal beyond your own culture and

FIGURE
3.1

Accoutrements are an important part of getting subcultures right in character design. *Full Throttle* captures the costumes and atmosphere of the biker world. ©1995 Lucasfilm Entertainment Company Ltd. All rights reserved.

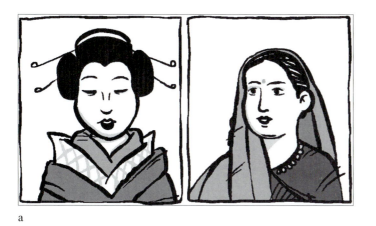

FIGURE
3.2

a

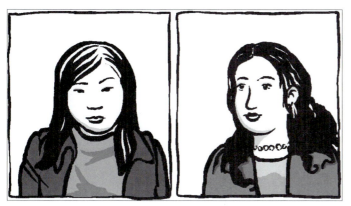

b

(a) Commonly held American stereotypes of Japanese and Indian people contrasted with
(b) depictions that do not reflect any of these stereotypical qualities.

subcultures, it is crucial to move past broad stereotypes of national markets toward a
richer understanding of the complexities of culture that can affect player reactions to
design (Figure 3.2 a,b). Here are a few reasons for taking this approach:

- *All gamers from any given national culture are not alike.* Each culture has clus-
 ters of subcultures within it, and it can be misleading to use generalizations
 about a single national group as though it was a monoculture.
- *The terrain of culture (and games) is always shifting.* Cultures change and
 blend into one another. What may have been true even five years ago may be
 quite different now.
- *People of other cultures and subcultures may enjoy culture-hopping.* People do
 crave knowledge and exposure to one another's cultures, so it is not necessarily

the case that you need to design to fit each particular culture to create a globally appealing game. Designs that address basic human issues and qualities can be appealing even when the details of the characters' appearance and behavior come from an unfamiliar subculture.

Given this complex web of culture and subcultures, how is it possible to make good design decisions? The more you know about which aspects of behavior tend to vary based upon culture, the more attuned you will be to making good choices in character design, on a case-by-case basis. Also, there are a few broader patterns that social scientists have found in cultures that can help to predict how a game's characters will be perceived. Section 3.2.2 will highlight useful dimensions of difference and will discuss applicable patterns.

3.2.2 Culture: Research Findings and Characters

The full range of differences in cultural behavior and acculturation across nations and ethnic and racial groups could and does fill many volumes. The aim here is to share a few concepts directly related to character design. These can be divided into

- social norms about expression and physical characteristics,
- social norms about roles and expectations, and
- local media contexts and their impact on expectations and interaction.

Social Norms about Expression and Physical Characteristics

Human beings in every culture share the same basic biological equipment for social communication: body, face, and voice (discussed in more detail in Part III). While there is evidence that many aspects of social communication are universal—for example, the basic emotional expressions of the face (Ekman 1973)—there is also evidence that cultures develop local norms for modulating these displays. For example, among mainstream Japanese it is expected that one controls facial expression, gestures, and tone of voice to a far greater degree than is expected in the United States. This cultural difference can cause misunderstandings among people—Americans may perceive Japanese as cold or unemotional; Japanese may perceive Americans as childish and selfish. It also means that Japanese may attribute greater emotion to a person based upon a more mild expression (e.g., a slightly sad look may indicate that a person is in great distress). See Figure 3.4 for a comparison of conversational distance and gesture.

 The use of bowing, and the (by American norms) subdued expression of powerful emotions such as grief, come through as culturally Japanese in *Final Fantasy X* even when the voices themselves are dubbed into American English (see Figure 3.3).

FIGURE
3.3

The characters in *Final Fantasy X* use body language characteristic of the Japanese culture, such as bowing, and expressions of grief that might seem subdued to someone from the United States. ©2001 Square Enix Co., Ltd. Character Design: Tetsuya Nomura.

In addition to an individual's use of body, face, and voice, there are differences in how interpersonal distance is handled and how touch is used and what it may mean. For example, in conversation, people from Arabic cultures tend to stand far closer to one another than people from the United States might (less than 18 inches), and consider hand-holding between men to be normal and acceptable. American men may find this closeness and hand-holding quite uncomfortable and too intimate. Arabic men may find the American tendency to stand further away and avoid touch to indicate coldness or untrustworthiness.

Social psychologists who specialize in cultural difference have proposed two dimensions that are useful in understanding these patterns of physical display and of interpersonal distance—high context and low context (Hall 1976) and individualist versus collectivist (Hofstede 1980). High-context cultures are those in which communication happens through indirect cues, such as emotional expressions and body language, where much that is communicated happens outside words themselves. Low-context cultures are those in which communication occurs mainly through what is spoken, where there is an emphasis on overt clarity of message. There is some evidence linking a preference for overt clarity to a culture's individualistic nature. Cultures (such as that of the United States) that value an individual's independence and freedom of expression seem to lean more toward thinking about communication as something that occurs in an explicit way. Collectivist cultures—those that value the harmony of the group and protecting each person's feelings during communication (such as that of Japan)—seem to lean more toward using lots of nonverbal communication—a method that helps to preserve each person's "face."

Researchers have attempted to array many national cultures along these dimensions (e.g., Hofstede 1983), so it might be helpful to take a look at this data to find out where the countries one is designing for fall along this spectrum. If the

51

FIGURE
3.4

a

b

Illustrations of conversational distance and gesturing (a) in Japan versus (b) in America.

audience includes high-context, collectivist cultural groups, it becomes even more important to consider local nonverbal communication styles and norms when designing characters. Ideally, designs and interactions between characters should be crafted with the help of one or more designers from the audience culture; they will be in the best position to help tune how relationships are acted out among the characters, to make sure they make sense locally.

Another important cultural factor in social perception and interaction is shared physical identity. There is research showing that people who look like oneself ethnically are perceived as more socially attractive, are better liked, seem more trustworthy and competent, and are perceived as having the same values as oneself. This effect seems to carry over to the perception of computer-based characters (Nass, Isbister, and Lee 2000).

This may become especially important in the design of player-characters who stand in socially for the player in a game. When games are taken to new cultural contexts, player characters sometimes get "localized" to reflect this same-as-me bias. See, for example, Figure 3.5. *Crash Bandicoot* was redrawn for sale in Japan with black, instead of green eyes (a feature that would seem far more strange in Japan than in the United States). The packaging of the U.S. release of the Playstation 2 game *ICO* (see Figure 3.6) shows a more Caucasian set of features on the young boy, who is the player-character, than within the game itself where the player-character is still a boy with Asian features.

The impossibility of truly reflecting ethnic identities across multiple cultural groups may help to explain the prevalence of nonhuman characters in games that travel successfully across cultural borders.

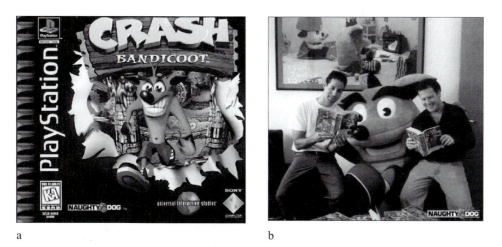

a b

FIGURE
3.5

When *Crash Bandicoot* migrated to Japan, his green eyes became black: (a) the American *Crash;* (b) two of *Crash's* developers look over Japanese magazines with the Japanese version of *Crash. Crash Bandicot* and related characters are ® and © Universal Interactive, Inc. and are utilizeed with permission.

FIGURE
3.6

The face of the player-character in *ICO* was altered to have Causasian features on the cover of the U.S. release of the game. *ICO* is a trademark of Sony Computer Entertainment America Inc. ©2001 Sony Computer Entertainment America Inc.

Social Norms about Roles and Expectations

People rely on social roles to structure interaction possibilities in everyday life: a role helps guide what is expected of each person and prescribes aspects of what can be said and how. Each of us plays many roles, depending upon the social situation and the company we are in. For example, one woman may play the roles of employee, mother, daughter, sister, and friend, among others. Roles are a part of the social fabric that arises from everyday relationships and situations. Some aspects of these relationships and situations are universally human—family relationships, getting work done in an organized way, and relying upon one another for survival. However, the nuances of social roles vary a great deal among cultural groups (Rosman and Rubel 1989). For example, in some cultures a newly married woman moves in with her husband and his parents and is expected to fit into their family's existing social fabric, whereas in other cultures (such as in the United States) the expectation is that a newly married couple will set up their own independent household. These differences in expectation in turn set up behavioral expectations in everyday interaction.

One reason social roles differ is that they reflect underlying value systems within cultures—religious or other beliefs that dictate the "proper" structure of society and the place of an individual. As a culture or subculture's values and environmental context shift, social roles shift accordingly. For example, the import of Confucianism to Japan in the Middle Ages profoundly shifted social role expectations, reinforcing a patriarchal (father-as-leader) structure both in families and in the larger political realm (Ko, et al. 2003).

Social roles are important to character design because they shape a player's expectations about how characters should interact with one another (and the player) in a game (a topic covered in more detail in Part IV). If a character has a particular social role, the player will unconsciously apply his or her own cultural expectations for fulfilling that role and may be confused, annoyed, or alienated if the character diverges from these expectations without explanation. This may be especially true if the character looks as if she or he belongs to the player's own cultural group.

How is it possible to sort through myriad cultural expectations to find patterns that can have an impact on character social role design in a coherent way? The previously mentioned cultural dimension of collectivism versus individualism is one pattern to keep in mind. Valuing group over individual creates very different role behavior. For example, in Japan (which has a strongly collectivist cultural style) the boss is seen as someone who should look out for and nurture the group of employees, who should be present until the last worker goes home for the night. Knowing about collectivist assumptions can help a design team think through how characters are behaving with one another and whether they will be compelling and appealing to people with a background that includes these values.

In *Final Fantasy X,* supporting Yuna (the Summoner) is the task of the player's primary character, Tidus, as well as of other members of the player's fighting party (see Figure 3.7). Tidus's responsibilities suit collectivist expectations for a hero.

In contrast to Tidus, Master Chief of *Halo* is a traditional tough-guy hero in the John Wayne and Clint Eastwood American tradition (see Figure 3.8). As the Master Chief, the player makes decisions alone about what to do next and has the admiration and support of the troops for his fiery independence and know-how. Master Chief fits individualistic cultural expectations for a hero.

Another dimension that helps make sense of differences in social role expectations is *power distance.* Cultures with high power distance tend to support and accept great differences in individuals' personal power within the social fabric as a

FIGURE
3.7

The player's primary character, Tidus, supports Yuna along with the other members of their party as she works to defeat the evil Sin. ©2001 Square Enix Co., Ltd. Character Design: Tetsuya Nomura.

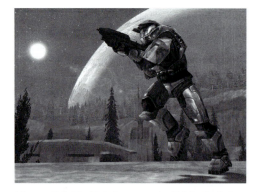

Master Chief in *Halo* is a more individualistic hero. Screenshot from *Halo®: Combat Evolved*. ©2005 Microsoft Corporation. All rights reserved.

normal part of life. High power-distance cultures have a greater tolerance for use of coercive tactics and borrowing status from superiors than cultures with low power distance. People in low power-distance cultures tend to feel that power should be used only when it is legitimated in some way—when the person is an expert or has somehow "earned" power. It is easy to see that this difference could have a profound impact on social role behavior of characters. For example, a person from a high power-distance culture (such as much of India) may not be outraged at a capricious mastermind villain's action to the degree that someone from a low power-distance culture (such as the United States) would be.

One place to look for variance in social roles and values is in the stories told to children in a culture. Roles and expectations are often embedded in these tales and can give a clue to someone from outside the culture about expectations. Here, one Japanese expert in cross-cultural studies shares her surprise when she first saw a cartoon version of Aesop's fable of *The Grasshopper and the Ants* in the United States:

> One ant, bigger than the rest, steps out and asks the grasshopper what happened to his own store of food for the winter. The grasshopper says that it doesn't have a store because it was busy singing during the summer. To this the ant responds: "Since you were so busy singing this summer, I guess you'll have to dance for your food this winter!" All the ants laugh and the grasshopper goes off hungry. . . . The ending of the story I remember is completely different. In the version my grandmother read to me as a child, the ants invite the hungry cicadas in when they show up at their mound, and the story ends with the moral: "All summer long, the ants worked as hard as they could and the cicadas sang with all their might. Now it was time for the ants and the cicadas to join together in a winter feast." . . . The American story demonstrates the importance of fending for yourself. . . . The point of the American story is that each person is responsible for his or her own destiny. On the other hand, the Japanese story about hard work shows how everyone has a role in society, and encourages the idea of depending on each other in times of need. . . . The lesson

in the Japanese story is that each person is responsible for everyone else. . . . The American story promotes independence, but the Japanese story, interdependence. (Yamada 1997, 3–4)

Local Media Contexts and Their Impact on Expectations and Interaction

Yamada's surprise at the different endings of the ant and grasshopper/cicada story illustrates the importance of familiar stories and forms as a backdrop upon which people experience everyday life (and their interactions with any new person or situation, including mediated ones). When a player starts up a game for the first time, he or she is not coming to it with a blank mind. Instead, the player has years of accumulated experiences with media of all kinds and has developed expectations about what is to come. A player's cultural and subcultural backgrounds have a profound effect on how she or he perceives the game because of these existing expectations. One word psychologists use to describe these expectations is *schemas*. Schemas are patterns that a person has learned and can reaccess to help guide perception and interaction. If an experience matches some of the aspects of a schema, the person may be "primed" to start using his or her mental model of this type of experience to predict and plan for what will happen next. For example, if a person enters a restaurant she or he will use learned schemas for dealing with waiters and waitresses to help plan and predict what is to come: first he will show me to my table, then give me a menu, then take my drink order, and so forth. Problems can arise when a customer is from a different culture and does not know the local restaurant schema. This can cause confusion and misinterpretation of actions by both people. The customer and the waiter are looking for next actions from the other that do not occur—they are tripping over the tools which are normally so useful in streamlining interaction.

Because human minds work in this way, a designer ignores the local cultural media forms at his or her peril. Ideally, a designer should be immersed in the media landscape of the player audience for which she or he is designing. Even in this time of global media, there are many important local forms that differ among populations. Consider manga and anime in Japan, Bollywood musical films, or telenovellas in South America. Each of these forms has intricate details that regular consumers know intimately. Anything that evokes these forms must be true to the details or make knowing reference to them and make sense in contrast to them. Most successful anime- and manga-style video games come from Japan because it is very difficult for outsiders to execute the form properly (see Figure 3.9 for an example of a Japanese anime-style game).

Particular subcultures have their own media landscapes as well and actively contribute to the shaping and reshaping of local and global media cultures. If a design is targeted toward a distinct subculture, it must reference the media authentic to that group's experience while keeping the background noise of mainstream culture in mind. *Full Throttle,* an adventure game from LucasArts, combines the biker subculture and American mainstream culture (see Figure 3.10).

FIGURE
3.9

Guilty Gear uses anime-style character designs. ©1998 Atlus Company Ltd. All rights reserved.

Global media have taken such schemas from a local to an international phenomenon. Now it is possible for a form to become part of the cultural landscape of people from around the world. Global media forms, such as American situation-comedy television programs, get layered onto local cultural contexts. Games such as *The Sims*™ take advantage of the broad saturation of the sitcom form (see Figure 3.11a). Player-created content tools have allowed players to add even more layers of cultural forms onto *The Sims* itself, for example, anime-style character skins (see Figure 3.11b).

FIGURE
3.10

Ben, at left (from LucasArts' *Full Throttle*) has a persona and appearance drawn from the biker subculture. ©1995 Lucasfilm Entertainment Company Ltd. All rights reserved.

Commercial game developers have also played with blended forms: for example, the *Kingdom Hearts* game combines anime-style characters from SquareEnix's *Final Fantasy* series with Disney characters (see Figure 3.12).

Games themselves have created transcultural media forms—Mario (see Figure 3.13) and other early platform characters from Japan are recognized all over the world.

a b

FIGURE
3.11

(a) *The Sims*™ takes advantage of the familiarity of American television's situation-comedy form, making the game accessible to the global community of syndicated television viewers.
(b) Players can also layer other cultural forms onto the game, such as the anime-style representation of Sailor Moon rendered as a Sim "skin," using tools released by the game's creators. *The Sims*™ *Unleashed* image ©2005 Electronic Arts Inc. *The Sims* is a registered trademark of Electronic Arts Inc. in the U.S. and other countries. All rights reserved.

FIGURE
3.12

Kingdom Hearts blends Disney characters and environments with anime-style characters from the *Final Fantasy* tradition. ©2002 Disney. Developed by Square Enix Co., Ltd. Character Design: Tetsuya Nomura. ©Disney Enterprises, Inc.

FIGURE
3.13

Though created in Japan, Mario is a character familiar to audiences worldwide. Image courtesy of Nintendo.

To summarize, it is critical to realize that your work will be encountered by players within their own media landscapes. Understanding the player's expectations and patterns as a result of this media landscape is an important step on the path to creating successful designs.

3.3 Design Pointers

There are no easy answers in designing game characters that have appeal across cultural groups, and there is little systematic information available either in the research community or in the game-developer community about what works, from a general point of view. However, here are some suggestions that may help aim character designs in a direction that supports transcultural appeal:

- *Use simple human universals in character relationships.* Everyone has family struggles. The Japanese game *Katamari Damacy* (see Figure 3.14)—which traveled easily from Japan to the United States—features an imperious father directing his tiny son (the player's character) to clean up the mess that he has made. Such a simple situation avoids cultural complexities yet takes advantage of the powerful emotions that attach themselves to these familiar social relationships.

- *Consider avoiding real races and cultural moments.* Cartoonish, nonhuman characters such as Pokemon, Pacman, and Kirby travel well across national boundaries. These characters avoid activating ethnicity, and they are forgiven for behaving in odd ways because they are so clearly not part of

FIGURE
3.14

Katamari Damacy centers upon a father-son relationship, relevant in any culture. *Katamari Damacy*™ and ©2003 NAMCO LTD. All rights reserved.

the usual human social structure. Their worlds do not correlate to any specific culture's time and place. Similarly, alien races from far-distant stars or mythic races of beings from fantasy literature help avoid localization issues. Playing these characters is equally alien to all.

- *Borrow from existing transmedia.* The global media culture can be leveraged for game character concepts—hence the proliferation of Hollywood movie tie-in games. Recognizable characters and types—gangsters, rappers, martial artists, and the like—take advantage of the fact that most players can apply what they have learned from other media to know what to expect from the characters. Social roles, nonverbal cues, and value systems have already been learned by the player from prior exposure. Designers can also feel more secure about the success of their designs knowing that players already enjoy imagining being a part of these worlds.

- *Be true to the localization of your characters in their own world.* Whatever the cultural setting is for the characters, make sure to work it out thoroughly and to have an internally coherent, rich, and realistic social world for the characters that the design team knows like the backs of their hands. Part of the reason for the success of the *Star Wars* movie series was the great care its creators took in working out the details of the *Star Wars* universe. Players are far more likely to accept the social dynamics among characters when they are well grounded in the local setting and values of the world you have crafted.

- *Do not try to take on a subculture or media form your team does not know well.* The worst choice you could make would be to try to add a few

61

elements of an unfamiliar culture or subculture to a game's characters, or to try to wholly craft something within a media genre that is not a native format for the design team. People from the target culture or subculture will find these attempts jarring and unappealing. There are too many nuances involved for any team new to a form or a culture to appropriately include the right social signals. It is simply not possible. Far better to create a coherent character social system working from what the designers know intimately themselves.

- *Include designers from the target culture.* If the team wants to build for multiple cultures, or wants to build a game that works well for a particular subculture, the safest way to do this is to include full-fledged design team members from the target group in the design process, from the beginning. Nothing can substitute for having a high level of involvement from one (or more) members of the target group when the crucial design choices are getting made. These people can explain why concepts do or do not feel right, can nix obvious false notes, and can help nudge the design through the iteration cycle.

- *Test early and often with members of the target culture.* Even when a team does include members from the target culture, it is important to put ideas in front of players from that culture as early and often as is feasible. Remember that cultures are not homogeneous—there will be many perspectives within a given group, and it is important to get a range of reactions to ensure that the game's characters will have the proper appeal.

3.4 Interview: Ryoichi Hasegawa and Roppyaku Tsurumi of Sony Computer Entertainment Japan (conducted by Kenji Ono)

Tsurumi Roppyaku (600 Design)
http://www.mrspider.net/0600design/0600design.html

Hasegawa Ryoichi (SCEJ)
http://www.scei.co.jp/

Q: At a GDC 2003 lecture, it was explained that Japanese video game character design developed out of the manga and anime cultures.

Hasegawa: Yes, they have profoundly influenced game character design.

Tsurumi: It's a very strong influence.

Hasegawa: They have had a heavy influence on it.

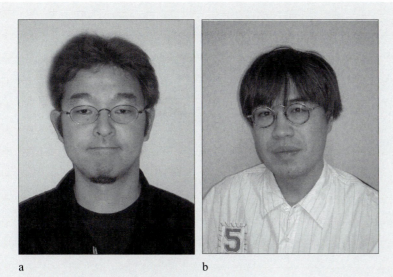

FIGURE
3.15

a b

(a) **Ryoichi Hasegawa** and (b) **Roppyaku Tsurumi** of Sony Computer Entertainment Japan.

Q: What about American video game character design? Do you think it's influenced by Hollywood movies?

Tsurumi: I think that the influence of Hollywood movies is pervasive throughout the world. Of course, it influences the Japanese people as well, but for some reason they are not accustomed to game characters that are derived from similar types found in film. Quite often Japanese people respond to such characters by just strongly rejecting them.

Hasegawa: From 2002 to 2003 I spoke with many overseas production companies at the E3 meeting hall and frequently heard something like the following. Even if they don't alter their character designs, Japanese games still sell in the overseas market. In contrast, when overseas production companies gave presentations to Japanese publishers and distributors, they were often told that their characters were not suitable for the Japanese market. At that time, I was asked about what types of characters are acceptable for the Japanese market. Sometime later, a request for a lecture came to Tsurumi from the GDC offices through Mark Cerny*. It seemed interesting to me, and I thought I would give it a try.

http://www.cernygames.com/

I don't mean to say that the Japanese game industry is closed to the world market. But it does have an image of being pretty biased. While Japanese products are distributed overseas, overseas products don't sell in Japan. For example, the production companies with whom we have worked, such as Naughty Dog, which produced *Crash Bandicoot* (SCE/Vivendi Universal Games 1996), and Insomniac Games, which made *Spyro the Dragon* (SCE 1999) and *Ratchet & Clank* (SCE 2002), often talked with Tsurumi

*Mark Cerny is the game designer of *Crash Bandicoot*. He is currently president of Cerny Games.

FIGURE
3.16

a

b

c

d

The cover of the newest *Ratchet & Clank* game was tailored for different audiences: (a) Japan, (b) Korea, (c) United States, and (d) Europe. *Ratchet & Clank* is a registered trademark of Sony Computer Entertainment America Inc. Developed by Insomniac Games, Inc. ©2002 Sony Computer Entertainment America Inc.

about the conditions for character designs that are accepted by the Japanese market. I thought it would be good to share the knowledge we gained from these discussions with other companies.

Naughty Dog
http://www.naughtydog.com/

Insomniac Games
http://www.insomniacgames.com/index.php

In Japan, there is a tendency to not want to publish such information outside of one's own company. But when we went to GDC 2003, we felt a responsibility to share some of our know-how to raise the bar of the entire industry. We felt very good about this, and were in strong agreement about this matter.

Q: Was the 2003 conference the first GDC you attended?

Hasegawa: Yes.

Tsurumi: I was initially contacted by Mark Cerny. At first I was not sure if I would attend the conference because I do not speak English very well. But because Hasegawa is very good at English, I convinced him to attend the conference with me. Then we were told by Mark Cerny that we should attend without any worries because at GDC 2003 they would be trying out simultaneous Japanese-to-English interpretation. Originally we were working on an English manuscript, but now we could just speak in Japanese. The simultaneous interpretation at the conference was superb; I did not feel uncomfortable with the discussion as I listened to the translation and responded in Japanese.

However, due to time constraints we were only able to talk about our ideas in outline. We introduced several cases, but we could only sketch the fundamentals of our ideas. But after that, we discussed by email the things we touched upon in our lecture with people we met at the conference.

Hasegawa: We still get email from game production companies from all over the world. Just the other day I got an email from a female game designer in Germany.

Q: Hollywood movies are appreciated throughout the world, and even American movie characters are popular in Japan. For example, C-3PO and R2-D2 from Star Wars, and various Disney characters. But it's strange that there is an aversion to such characters when they appear in video games.

Tsurumi: But there have also been times when the Japanese market had difficulty with even Disney films. I heard that this was the case for *Mulan* (1998).

Q: Yes, that's right.

Tsurumi: The design of the Mulan character was unacceptable for Japanese people.

Hasegawa: It was a little beyond the permissible range of Japanese sensibilities.

On the flipside, although the character design work in Pixar's *Finding Nemo* (2003) and *The Incredibles* (2005) was similar to that of *Mulan,* they were within the permissible range of the Japanese. Many Japanese people accepted them without feeling uncomfortable at all.

Q: To be sure, the characters in **Monsters, Inc.** *(2001) were easy for me to enjoy. But I did not think that* **The Incredibles** *would be such a hit in Japan.*

Tsurumi and **Hasegawa:** *The Incredibles* was a fun film.

Hasegawa: But it has already been fifteen years since the advent of the full CG (Computer Graphics) film. The first was *Toy Story* (1995). Since then there has been a string of pure CG films, and I think that the Japanese have grown accustomed to them. So if *The Incredibles* had been the first of such films to be released in Japan, it might not have been such a big hit.

Q: That's right.

Hasegawa: For the past fifteen years full CG films and their character designs have been easier for Japanese people to accept. And *The Incredibles* was such a hit because the story and animation techniques were excellent.

Q: That's true.

Tsurumi: I might also mention that, with the exception of the father's character design, Japanese people may not react differently to the characters appearing in *The Incredibles.*

Hasegawa: That is true. The father's face was the most removed from the types that the Japanese are fond of.

Tsurumi: The father was the only character design that was entirely off the mark. That might be why it was such a hit in Japan.

Hasegawa: Among the things that we talk about the most is the difference between the facial structures of Japanese and westerners. The faces of Japanese and other Asian characters look flat, but the cuts of foreign faces, especially Caucasians, are clear, and their brows are very prominent. From just that one difference people have felt a sense of incongruity for some time now.

Tsurumi: Suggested, exaggerated, and abstracted faces of Caucasians are facial features that the Japanese feel no affinity with. Additionally, that is a style or symbol that we are not very fond of.

There are some things I feel should be emphasized about a character. The distinguishing feature of the Lilo character in *Lilo and Stitch* (2003) is her large, South Pacific nose, but that is a symbolic type that we do not emphasize. The beautiful young girls depicted in manga and anime are all drawn with small noses. For me, the Lilo character was not cute at all. But children in Japan loved Lilo too. What I have felt over the years as I worked on video games is that children are very tolerant of variations of character design.

Hasegawa: They are ready for anything.

Q: That's true.

Tsurumi: Of course, there are some colors and styles that children prefer. But they are more tolerant than adults. Conversely, however, when they enter upper school they become very intolerant.

Hasegawa: I think that in the case of children, perhaps when they see an image of a character, even if they don't feel fond of it at first, there are instances that they will like it when they see the character in action. We have both had such an experience.

Q: Uh-huh.

Hasegawa: However, the moment we see a character, we exclude that object from our range of interest when we feel that it is something we cannot accept. But in the case of children, there are times when children go to see a film with their parents at their parents' recommendation. There are also times when one's ambivalence about a character vanishes once they see the work.

 When adults like us judge a work based on images of the characters, we are just judging it before actually seeing it, and, more than children, we are missing out on something. Maybe that's because there is nothing like enjoying something once you have seen it.

Tsurumi: I often say that I don't want to make games for adults. As people grow up, their tendency to reject things outside of their own interests gets stronger. Indeed, it's natural for one's childhood broad acceptance of things to get narrower the older one gets. But what if we regularly encounter various forms of expression? For example, when Japanese children are raised in the United States, don't they still like various styles of characters even when they become adults? Isn't someone working on such comparative research?

*Q: A contrary example is the proliferation of **Pokémon** throughout the United States. It was often mentioned five or six years ago that **Pokémon** was a huge hit in the States due to the prior advancement of anime there. And **Pokémon** was an animation for children. On the other hand, this has been done in the Japanese market by the works of Disney and Pixar.*

Tsurumi: In Japan, Pixar films are even popular for adults. I could go on forever about *The Incredibles.* For example, the director of that film, Brad Bird, also directed *The Iron Giant* (1999). When I observe his direction of *The Iron Giant* and the design of Mrs. Incredible and her children's faces, I can tell that they are all strongly influenced by manga and anime. Mrs. Incredible and the children are Caucasians, but the design of their faces is reminiscent of anime and manga characters. Of course, I think that heroes in American comics and other forms of media have been influenced in the same way. He probably also figured that if he put out a film with a strong influence from manga and anime in the primary Japanese movie market, he could expect quite a profit. That is what I have thought.

Hasegawa: On the other hand, just at about the time when I left Sega and moved to SCE, I was told by a Sega marketing woman that, "*Pokémon* will definitely not be a hit in the U.S. market." To be sure, even before *Pokémon,* anime was starting to gain popularity

all over the world, and in the U.S. market those works with the typical animation style were produced for their enthusiasts. That is why she thought that even *Pokémon* would not be a hit for the general audience there. She also had a lot of experience in the gaming industry. Actually, I was working with her at Sega. When we were working on the Genesis console,* she said that in the short clips shown throughout a game and in the scenes when the faces of the characters are shown close up, their faces are redrawn from their anime style into a two-dimensional American comic style. I think it was because she had experienced this before that she told me, "Anime-type representations of characters such as those in *Pokémon* will not be accepted by the American market."

But when *Pokémon* became a hit, the American market changed in a big way. Of course, even before *Pokémon,* anime like *Area 88, Nausicaa of the Valley of the Wind* (1986), *Akira* (1988), and the like had already come out in the States, and gradually what was once limited to a hard-core enthusiast market spread to the general market. And then when *Pokémon* came out, there was suddenly a huge anime boom.

Nausicaa of the Valley of the Wind
http://www.aic.gr.jp/anime/ghibli/1984n.shtml

Q: In the field of psychology they also talk about signification. There is research showing that as we become adults, we selectively choose behavioral patterns that are appropriate to particular cultures and start to distinguish those patterns from others. The ability to be receptive to some symbols but not others is innate to our thinking process.

Hasegawa: Is there research like that?

Tsurumi: I would like to hear more about that. It would be great if such research could reinforce the hypothesis I have considered all these years.

Q: They research things like this even at corporations like Bandai. They analyze the factors that determine how children perceive characters.

Hasegawa: Tsurumi often says that the character designs in works for children should be ones that children can draw easily. For example, if you just arrange three circles of different sizes together, it is pretty much recognizable as Mickey Mouse. Sometimes we get New Year's cards from children with portraits of Ratchet and Clank. When I look at those portraits, Ratchet's eyebrows are emphasized.

Tsurumi: Ratchet's ears and eyebrows are very special symbols in the Japanese market.

Hasegawa: And the striped pattern of his body, too. The eyebrows of the overseas version of Ratchet are much thinner than those of the Japanese version. The texture of Ratchet's eyebrows in the Japanese version is thick. There are several reasons for this. The first reason is that it emphasizes his character. When we were developing

*Genesis SEGA 16BIT videogame console.

advertisements for Shōgakukan's *Coro-Coro Comic* magazine, we were told by the editor that they wanted the character to have a more physical, visual quality. If we made it that way, then when children just glanced at the character they would be able to recognize his type. Also, Japanese characters that are easy to categorize based on such contours are more popular.

Shōgakukan Inc.
http://www.shogakukan.co.jp/

Coro-Coro Comic Magazine
http://www.corocoro.tv/

Hasegawa: Also, as I mentioned before, originally the part just below the eyebrows on the polygon model of Ratchet's face protruded quite a bit. But when it was made into a Japanese version, we changed the polygon model of the face by flattening the brow. Unfortunately, this became a problem when we rendered the CG clips in the game, so in the end we couldn't alter the polygon model of the face at all. But we could show the protruding brow by texturing them with thick growths of eyebrows.

So we were able to make a character that Japanese people would like by just applying a new texture to the face and not changing the polygon model of the face at all. As a result, we got New Year's cards from kids with emphasized eyebrows, and when the character was introduced by *Coro-Coro Comic,* there was a caption reading something like, "The hero with the bushy eyebrows." With that, the personality of Ratchet quickly caught on with the children. It was wonderful.

Tsurumi: This was about the time of the first *Ratchet & Clank* (SCE 2002), when the project was started by Insomniac Games, SCEA, and SCEJ. We were discussing several things then. At that time, not only did the Ratchet character not have eyebrows, he didn't even have that striped pattern on his body either.

Hasegawa: This is an alteration of the *Sly Cooper* (SCE 2003) character (GDC 2003, presentation data #33–35). Ratchet changed in a similar way.

Tsurumi: Initially, he was just a character holding a weapon and had these big pointy ears. To be honest, when I first saw him, I didn't understand what he was supposed to be. When I was looking at the work of the American game designers, I felt that they were thinking it was fine if the character didn't look human. But in Japan this didn't work. If you don't understand a character by its appearance, children can't draw a portrait of it, and you can't cognize the character in your mind. Such characters definitely won't be accepted in Japan. We have given this kind of advice to the character designers at Insomniac Games several times.

After they understood what we were telling them, we confirmed that Ratchet is a very vivacious character and then added the striped pattern to his body. It's not that Ratchet is some kind of animal; but if his body had stripes, even though he is not a tiger, people who saw him would appreciate his wild nature, ferocity, and strength. Plus, when we darkened his eyebrows, his appearance announced him as a richly expressive character. We talked about why it was necessary for us to change his

appearance in this way, and now Ratchet, even outside of Japan, has those eyebrows, even though they may not be as thick as the Japanese version. We added some other signature traits to the character, too.

Q: As you were adding these signature traits to the characters, were there any proposals or objections from Insomniac Games regarding character traits that they could not use?

Tsurumi: There were, regarding the degrees in which we wanted to change the character. But whether or not he had eyebrows changed the character completely. If Ratchet had eyebrows and a striped body from the beginning, we could just emphasize them for the Japanese version. Of course, if they didn't want to emphasize the eyebrows and stripes in the U.S. version, then that would have been fine. It is not a matter of the degree of signature qualities, but a problem of whether or not they are present.

When we exchange ideas about the rough design of the character in the very beginning, we usually make the character model so that we can change the color of the eyes, add details, and emphasize or eliminate elements of their outward appearance for different regions. So it's fine when the degrees of a character's qualities are not perfect for Japan.

Q: You mean that you design character models so that they are easy to modify for different regions?

Tsurumi: That's correct.

Q: When you were talking about making the alterations, I suppose the word "signature traits" came up quite a bit. Even in your GDC 2003 lecture, you mentioned that, in Japan, manga and anime characters are an assemblage of such traits. Tell me a little more about putting together such traits and bringing characters to life.

Tsurumi: If I start with the fundamentals of this, it all goes back to influence from manga and anime. First, there is not much of a definite manga style.

Hasegawa: There are a lot of reproductions.

Tsurumi: Yeah. I could explain 60 years of manga history here, but I will just summarize it.

Q: About all the post-Tezuka Osamu* variants, right?

Tsurumi: Yes. In the history of manga design there are many branches that follow in the footsteps of other writers of genius. The Japanese manga industry, like the Indian movie industry, is its greatest producer and place of consumption; fundamentally it begins and ends within the country. So the range of manga writers is very broad, and among them there are many standards that are important for each age. And, in turn,

*Tezuka Osamu (1928–1989)—the most famous cartoonist in Japan.
http://www.tezuka.co.jp/

those branches father branches of their own. For example, after the 1980s there were many descendents of Ōtomo Katsuhiro's style. Urasawa Naoki's *Yawara!,* Hōjō Tsukasa's *City Hunter,* etc. They all got their start imitating Otomo's style and gradually developed a style of their own.

Ōtomo Katsuhiro Akira (1988)
http://www.interq.or.jp/blue/junya/

Urasawa Naoki
http://www.5-ace.co.jp/yawara/

Hōjō Tsukasa
http://www.hojo-tsukasa.com/

Hasegawa: And there is also a branch of the Aoki Yūji (1945–2003) style. He wrote *The Way of the Market in Naniwa.*

Q: Like the illustrator of* Complaint Man, *Tōhū Takahiro, right?

Naniwa kinyūdō
http://www.naniwa-kinyu-dojyo.com/english/english.html

kabachitare
http://images-jp.amazon.com/images/P/4063286576.09.LZZZZZZZ.jpg

Tsurumi: Yes. That is the Aoki Yūji style.

Hasegawa: When I first saw Aoki's pictures, I had a strong aversion to them, but now I appreciate them as much as anyone else.

Tsurumi: Manga has a visual and dramatic appeal, and the story is very important. So compared to the world of illustrators, which is a competitive media market based solely on an illustrator's ability to draw, even if the images look a little similar they are not criticized much. The designs of Aoki Yūji's drawings were very suitable when he used his images to express the world of finance and the reality of the world that most adults didn't know about. Also, the target audience was thirty- to forty-year-olds, for whom such a theme was in demand. So the style of the images was recognized by the market even more than the work by itself. Although Aoki Yūji passed away, his style has been taken up by several other manga writers.

Before Aoki Yūji it probably would have been impossible for that image style to have even been accepted if it had been made into an anime. However, now it is totally possible for anime.

So, in the manga world there were more than 10 or so such geniuses. However, and I am excluding manga for young girls here, their branches produced a huge volume of manga in their styles.

Hasegawa: There was an amateur boom a while back too. Like Miura Jun.

Miura Jun
http://hotwired.goo.ne.jp/event/myboom/profile/

Tsurumi: The essence of manga has a visual element, too, but ultimately it is about the writing. First, it has a story, and the image styles that suit the story are chosen later. As for silent manga, there isn't much of a market for it in Japan. I mean, it is not a very important part of it.

In the end, when it comes to authorship and originality, I think if you exclude the work of the masters, there are still some original elements in the works of the several branches, and what makes them original are the signature traits of their character designs. There are only a few original expressions of character movements and layout designs. And in anime, even when they use just an ordinary character, they still move impressively. You can't do that with manga very well. But signature traits are even more important than the originality of the artwork. I think if you dismantle the expressive framework of manga, you will end up with an assemblage of character traits.

Hasegawa: When we were writing the manuscript for our GDC 2003 lecture, Tsurumi and I debated about this several times. And after our lecture we received email from a lot of people, and from that a new debate emerged. It seemed fresh at the time. For example, with manga and anime, there are scenes when the protagonist makes his appearance in an important scene, like when there is a real crisis or something. When this happens, there is usually a light shining behind the protagonist, and he makes his appearance as a silhouette. There is nothing unusual about this, but when this happens you must be able to tell that it is the protagonist only by his silhouette. So in anime it is fine to just show the character's movement, but in a game magazine, this can only be shown to the reader with a picture. That is why the character's silhouette is more important than character details.

For example, if there is a character whose headband is often streaming in the wind, you will know who it is by just the silhouette. Also, when a character strikes a special pose, you should be able to tell who it is by the pose alone. It's kind of like the poses they do in the kabuki theater. So style is also a character trait.

Q: So we can trace the production that gives a character his signature qualities by his poses and silhouette all the way back to the kabuki theater in the Edo period?

Hasegawa: That's right.

Q: Another example of a silhouette expressing a character's personality is the "justice scarf" in manga and anime. This word is a playful way of referring to those protagonists in manga and anime who wear a scarf all the time. And children understand that characters who wear a scarf are allies of justice. Also, their portraits are easy to draw. So a scarf is a symbol for justice.

Justice Scarf
Masked Rider (1971)
http://www.infosakyu.ne.jp/~yamaken/mymodel/rider_2/rider_2.html
Shinobi (2002 SEGA)
http://sega.jp/ps2/shinobi/

Hasegawa: Yeah. That's why I often mention fighting games as an example that is easy to understand. There are about 12–16 characters, and you need to be able to distinguish between them all. And we characterize them in an easily comprehensible way as either small agile characters, big assault characters, main characters, female characters, etc. So, for example, we make characters that punch with studded gloves, have spiked bracelets, carry a Buddhist rosary made with huge beads, or have a giant sword, and they are easily recognizable by just their silhouette. When listening to presentations given by overseas game designers, I often felt that, compared to Japan, the special qualities of their characters, like where they are from, personality, special skill, if they were a women, etc., were very weak.*

But lately, realism has become mainstream for games. For example, you can't make a very distinctive character silhouette for a game like *Metal Gear Solid 3* (Konami 2004). When we are dealing with something like that in Japan, we describe the character's profile in greater detail. So you might have this really powerful soldier who is afraid of mice, or a really beautiful, smart, first-rate female officer, but she is horrible at cooking. We help players empathize with the characters by adding things to their profile, even if it has nothing to do with the game's content. This seems to work.

In contrast to this, the setup of the character profiles in overseas games is just something like, "This is the main male character, and this is his supporting female character." We often say that it is easier for Japanese players to empathize with the characters when we add things to their profile and they do not just have images of the character to go by.

Tsurumi: Although the fighting game genre is no longer popular, this technique existed before they were all the rage. From about the time of *Street Fighter II*, fighting games started to have a catalogue of characters from which the player could choose. After that, the number of characters quickly increased, and the categorization of them became more detailed, but the characters became these things that were difficult to understand. Only people who were in the know understood them. Profiles, which added appeal to the characters, disappeared, and for a time it seemed like the variety of characters had been exhausted.

Hasegawa: Compared to the time of GDC 2003, the degree of acceptance for characters from overseas markets has started to change. The demand for images of the very typical Japanese anime style, in both Japan and abroad, has slackened, and also there is now a tendency to accept something closer to overseas styles. Games for children are an exception, but visually more stylish games are selling more to hard-core gamers. That is how the game trends in Japan are changing.

But there is something I realized when I spoke with various people about the depth of a character's personality. In Japan, the fact that characters are a complex of symbols has not changed. If you look at gaming magazines, especially at articles that introduce new games and in the columns with character profiles, their favorite foods are introduced, and the spiky hair of the characters is shown. Such a methodology is still practiced for Japanese games no matter what.

*Examples of easily distinguished characters from the fighting action/videogame genre include *Street Fighter II* (1991 CAPCOM), *Virtua Fighter* (1993 ~ SEGA), *TEKKEN* (1994 ~ NAMCO).

Tsurumi: Japanese people enjoy things that are loaded with symbols, and because they are accustomed to distinguishing the meaning of such symbols, they can recognize what type of person a character is by their unusual hairstyle alone. However, when I was working on *Jak II,* I made several comments to American designers about the character's hairstyle, and they said something like, "Just because he is the protagonist, it would be too stereotypical to make his hair spiky, so let's not go there." Also, even if they understand that there are several patterns of anime-type hairstyles, they cannot differentiate the subtle nuances of the variety of character hairstyles found in Japan. Anyone in Japan of a certain age can understand the diverse meanings of subtle differences of character hairstyles. Especially people who like *JoJo's Bizarre Adventure.*

JoJo's bizarre adventure
http://www.jojo-ova.com/

Hasegawa: In a story that I read during a Japanese lesson when I was in primary school, there was something that really left an impression on me. I remember it quite well even today. It mentioned how people, in their own cultural sphere, exhaustively recognize those things that are very important to them. For example, although we have one word for snow in Japan, an Inuit has a different word for freshly fallen snow, packed snow, and pressed snow used for making igloos. And nomadic desert tribes have different names for standing camels, sitting camels, a camel drinking water, and pregnant camels. But in Japan we call them all camels and just leave it at that. On the other hand, in Japan we call the same fish a different name based on how big it is, but in English there is only one word for them. It is the same when expressing the senses. If you go to France you will see that they have different ways of saying something based on its type of smell, like "the smell of a wet dog." In the same way, the level of sensitivity to the subtleties of a character based on their outward appearance is different for every country, but in Japan I feel that it is comparatively high.

We are also often surprised that American and European developers are viewing the same characters from a completely different aspect.

When the English version of the manga *Area 88* went on sale in the U.S., the eyes of the protagonist, Kazama Shin, were colored blue on the cover. Of course, this is a mistake, because the Kazama character is Japanese. But no matter how blue his eyes might be, if we are told he is Japanese we just ignore the color of his eyes and recognize him as such. However, several letters from American readers came asking, "If Kazama Shin is Japanese, then why are his eyes blue?" If Japanese people are told that Kazama Shin is Japanese, then they will not really care what color his eyes are. They understand that if his eyes are blue, this is just an expressive technique. But for American readers that was a major problem. That was really interesting.

Area 88 (Center male character on web image with blond hair is Kazama Shin)
http://avexmode.jp/animation/area88/

Q: Language is the ultimate symbolic system, but images also have a similar symbolic quality. From the standpoint of someone in the movie industry, such symbols are pervasive only in groups that have the same cultural background. So sometimes symbols

related to Japanese character design are difficult to convey properly outside of Japan. Conversely, in the U.S. market there exist many ethnic groups that have their own cultural backgrounds. If we can say that there is an expressive symbol that is common to them all, then it might be realistic expression, and that is why Hollywood CG has evolved to be more photo-realistic.

Tsurumi: I suppose that's right. That is why Hollywood movies are so prolific throughout the U.S. and the world, too. For example, in Japan, Leonardo DiCaprio was once called by the nickname Reo-sama. So if we take this into consideration, you are probably right.

Hasegawa: This may be the reason why, although there are many ardent fans of real Hollywood stars in Japan, they are generally not accepted when they appear as polygon characters in games.

Tsurumi: Do you think this would change if we made them more realistic?

Hasegawa: Only if it were more realistic. But I don't extend this criticism to the Jean Reno character of *Onimusha 3* (CAPCOM 2004) when I say this.

Tsurumi: That character is relatively popular In Japan.

Hasegawa: That is because there was already an image of the Jean Reno actor before the game.

Tsurumi: Of course. And for gamers, the character based on the real actor is the motivation for them to buy the game.

Hasegawa: If the polygon character is able to act very appealingly in the game, then the fictional foreign actor may be accepted.

Tsurumi: That we cannot expect appealing acting from the characters in the *Onimusha* series is evinced by the Kaneshiro Takeshi character in the first of that series. I'm joking, of course, but Jean Reno loves Japan, and he has many fans here, so there are a lot of characters that look like Jean Reno in manga and anime. Even if they hadn't used the Jean Reno character, his characteristic short hair, glasses, and beard, as they are in *Onimusha 3*, was already well known in Japan.

Q: That is a symbol too, right?

Tsurumi: Yeah. And there are a lot of Japanese who imitate his closely shaven head, glasses, and beard. You know that Jean Reno's influence has been so great because it is cool even for people in their thirties to imitate his style.

Q: The Arnold Schwarzenegger style of Terminator 2 (1991) *was also popular as a symbol. Like the combination of his sunglasses and muscular physique.*

Tsurumi: There are a lot of Hollywood stars who are accepted as a signifier to the extent that they are also imitated in manga. For example, can you envision Denzel Washington, now?

Hasegawa: I know what he looks like, of course. But like during the 2002 World Cup, there were a lot of Japanese boys who imitated David Beckham's hairstyle. But Denzel Washington's style is not one that everyone wants to imitate.

Tsurumi: Will Smith may be a better example because he has enjoyed popularity in Japan as a black actor and comedian.

Hasegawa: It used to be Eddie Murphy.

Tsurumi: Yeah. Of course, in the U.S. there are probably many types of black actors and comedians. But people like me, and middle-aged Japanese women who are fond of Yong-sama (Yong Joon Bae*), can't understand such fine categorizations at all.

Q: Yong has his character traits, too, like his glasses, scarf, and hairstyle.

Tsurumi: That's right. And that is why film devotees say he was great in every one of his movies. But since I am not the type who watches western films based on who appears in them, I don't understand the subtleties of actors and actresses. At most, I am familiar with Angelina Jolie's Lara Croft character.

Q: This is like the way a symbol adds meaning to a character in a game, like Ratchet's bushy eyebrows, for example. His eyebrows signify an animated personality to Japanese people.

Hasegawa: That's right.

Q: A character also gets its significance from things other than its design, such as its voice. What I think is really interesting is when Ratchet gets hurt in the game, he screams "Gabeen!"

Tsurumi: Not "gabeen," "gageen!"

Q: Sorry about that.

Hasegawa: Take a good look at the subtitle of the game. In the second game, the subtitle was "Ga-ga-ga, Ginga (Milky Way) Commandossu." But the subtitle for the English version was "Going commando."

Q: The subtitle of the English version is pretty ordinary.

Hasegawa: Yeah, it is. The Japanese version emphasized the native phonetic sounds "ga-gi-gu-ge-go," and used this in various places.

Tsurumi: The names "Ratchet" and "Clank" are pretty awkward, too.

*Bae, Yong Joon—the most popular Korean actor for Japanese.
http://www.yongjoon.jp/*

Q: Why do you suppose they were called Ratchet and Clank?

Hasegawa: Ratchet comes from ratchet wrench. When you turn a ratchet, it makes a "click, click, click" sound. That is the image from which his name comes. Clank comes from the sound of a robot or metal parts rolling around and is onomatopoeia for "ka-ching" and "clank."

Tsurumi: In the first game, when Ratchet and Clank meet in a spaceship for the first time, Ratchet asks Clank, "What is your name?" When Clank is about to reply, "Serial number—," their ship strikes something and Clank hits his body against something in the ship, which produces a "clank" sound. From then on he is nicknamed "Clank."

Hasegawa: But when we put that into the Japanese version, there were some places that we couldn't translate well.

Tsurumi: In the English version it is a nice play on words, but it is not funny at all in Japanese.

Hasegawa: Since in English when something hits something else it makes a "clank" sound. That is why he is named Clank.

Tsurumi: So it is strange that the name of the Japanese version is not *Ratchet & Gachan*, which would conform with the Japanese onomatopoeia for a metal object hitting something else.

Q: The shrill "gakin" sound is only in the Japanese version, right?

Tsurumi: Of course.

Q: I felt that really strengthened the image of the Ratchet character.

Hasegawa: That's where Tsurumi's talent really comes through. That is what he is best at.

Tsurumi: I want to backtrack a little and mention that because Ratchet and Clank were originally created as "Ratchet and Clank," I had no intention of changing their names or the title. There are many instances of when we changed the names of the protagonists and it was a failure, but we have changed the names of the supporting characters in Japanese versions.

Also, in Japan there is an idea that something can have a meaningless name but still be cool. For example, when Japanese people hear the name "Gundam," they think of something big, heavy, and strong.* But with just the names "Ratchet" and "Clank," something is missing. So I wanted to add some strong images using sound, especially ones that are easy to say.

Hasegawa: At first you made quite a fuss about the lack of voiced consonants.

*Gundam—the most popular anime series for Japanese "Otaku" people.
http://www.z-gundam.net/

77

Tsurumi: Yeah, yeah. So I intentionally changed the word "galactic" to "garakuchikku," which has a stronger impact and sounds a little silly. It is full of voiced consonants like "ga-gi-gu-ge-go." When we were working on *Ratchet & Clank 2,* we changed the English subtitle "Going Commando" to "Ga-ga-ga! Ginga no komandōssu." The subtitle of the third game, "Totsugeki! Garakuchikku renjāzu" (English version: Up Your Arsenal), doesn't have much of a speedy image to it, so in order to strengthen the image, we used a lot of sound effects like "gān," "gagaga," and "gakīn." So we have added a lot of onomatopoeia throughout the game story. Using a lot of onomatopoeia adds humor to the strength.

***Q: I feel that the Clank character is similar to Gonsuke in* 21-Emon.**

Tsurumi: It definitely is. Clank does resemble Gonsuke in *21-Emon,* but I identify him more with Korosuke from *Kiteretsu Daihyakka.* Korosuke is quite an arrogant character and is different from Clank, but I try to put Clank into the frame of a Korosuke-type character. I wanted an insolent politeness from Clank and so tried to make his lines more polite. Ultimately, halfway into the project we added the "ssu" to his lines, making them sound a little informal. I think that is absolutely suitable to Clank. Clank was set up to be such a character from the beginning. Although in the American version, the character is a little more polite.

21-Emon (Gonsuke:LEFT SIDE ROBOT)
http://www.dsnw.ne.jp/~comet/comic/21emon.html

Kiteretsu-Daihyakka
http://www.5-ace.co.jp/kiteretsu/

Korosuke (second character (Robot))
http://www.5-ace.co.jp/kiteretsu/jinbutsu.htm

Hasegawa: Clank's role in the game is pretty much equal to that of Ratchet. In an interview about the second *Ratchet & Clank,* someone from Insomniac Games said they made *Ratchet & Clank* like a "buddy movie." It's kind of like *48 Hours.* So when you play the English version, the roles of Ratchet and Clank are quite the same.

Tsurumi: But even if they are the same in many respects, Clank does not use contractions when he speaks, by convention, because he is a robot.

Hasegawa: So instead of "I don't" he says "I do not."

Tsurumi: We had Clank speak like a robot from the very beginning. He is on the same level as Ratchet, but in some ways Clank is like his butler. Since I had been thinking about such facets of his character, I ultimately decided to add the "ssu" to the end of his lines too. I have other special rules like that.

Of course, I think that the staff of Insomniac Games follows certain conventions regarding a character's speech as well, but since I grew up reading manga and watching anime, I pretty much follow Koike Kazuo's* methods of character design.

*Koike Kazuo—one of the most popular original Japanese writers for manga. *Road to Perdition* (2002) is based on his most important work, *Kodure-Ookami.*

Q: Is the relationship between Ratchet and Clank in the American and Japanese versions different?

Tsurumi: No, it's the same. But their relationship seems more dynamic in the Japanese version. When we were working on the first game, we were adjusting the translation at the end of the game so that children, who were its main players, would understand that sometimes Ratchet is the more dominant character, and sometimes it is Clank. Of course, the significance of the scenarios is the same as those in the U.S. version. When we were translating it into Japanese, we altered the nuance of the message a little.

In the beginning of the first game, Ratchet seems like he is going to just protect the Milky Way in a casual manner, and Clank adopts an unassuming attitude toward him but later incites him to carry out his role. Halfway through the game, Ratchet's feeling for justice is sparked, and Clank is left behind. But in the end, the two of them reconcile, and they are on equal footing. That is the structure of the narrative. We made it so that their tone of speech reflected this. Who is dominant in the relationship is always shifting. Although we say it is like a "buddy movie," since we translated it so that their relationship had such dynamics, they are quarrelling all through the game.

This is the part where it becomes difficult to explain this in detail. To do that we would have to explain each line, otherwise we could not do it justice. But this is how they make the dialogue structure of manga, and the same technique was used a lot for *Dragon Warrior** (Square-Enix 1987). They used this technique through the seventh game in that series, but *Dragon Warrior 8* (Square-Enix 2004) was like an anime version of the manga *Dragon Ball*. I don't find that to be very interesting.

Dragon Warrior 8
http://www.square-enix.co.jp/dragonquest/eight/

Hasegawa: Incidentally, what Tsurumi has explained thus far became more important as the game systems evolved. At the time of the first PlayStation, the mouths of characters moved with a fixed timing, but when PlayStation 2 came out, the character models were more refined, and when the characters spoke, their mouths were synchronized with the English dialogue. So with PlayStation all we had to do was translate the lines and adjust the timing. But with PlayStation 2, some complicated methods for this came about. For example, when a line in the English script ended with an "a" sound, the Japanese version had to as well. Tsurumi went through three or four processes when translating their dialogue. First there was the direct translation, then a version with some characters added, and finally it had to be made to match the movement of the model's lips. All throughout this process he immerses himself in the mind of the character, and starts mumbling to himself at about two o'clock in the morning while he is working on it.

Tsurumi: I don't mumble; I blab in a loud voice.

Hasegawa: And wanders all around the office.

Dragon Warrior series game designer and scenario writer Horii Yuuji wanted to become the original writer of manga, and had studied in Koike Kazuo's cram school (where a person goes after regular school hours to get really good at a subject) before starting to develop videogames.

79

Q: Isn't it a little discomforting for Japanese players when the Japanese script does not clearly correspond with the movement of the character's mouth?

Tsurumi: Since I am pretty good at that, I try to get it right no matter how hard it might prove to be. But in the case of Japanese production companies that do not have those skills, if they want to do it without cutting corners, the fastest way is to remake the character's facial animation.

Hasegawa: Of course, this is a time-consuming and labor-demanding process.

Tsurumi: In *Ratchet & Clank 3* there is a robot named Courtney Gears, which is a parody of Britney Spears, and there is a scene in the game where she sings a song. For that scene I wrote Japanese lyrics with pretty much the same meaning as the original and matched the movements of the model's mouth. I am rather proud of that.

Q: The facial expressions in Ratchet & Clank *are basically made to correspond with the English script, but it's translated so that it seems natural in the Japanese version.*

Hasegawa: It's like it's infused with a spirit that transcends the level of simple translation and localization. You should emphasize that point a little more.

Tsurumi: No, I would rather the fact that, even on a global scale, the level of the Japanese voice actors was quite high. Their technique is the best in the world. When they make animations in the U.S., they use the prerecording style by which they first have the voice actors perform the script, and then they make the animation to match the voice track. They usually do this for American game movies too. But in Japan the post-recording method is preferred, by which they make the film first and lay down the audio track to match the film second. So if you write a good script, they will bring the character properly to life. Actually, we only use talented voice actors; we don't choose them based on their popularity.

Hasegawa: While we're on the subject, I should mention that the localization of the English version of *Spirited Away* was very well done. Miyazaki was very careful about that. It was done extremely well. I was impressed.

Tsurumi: I watch both the subtitled and dubbed versions of overseas films, but English versions of Japanese films are something I never paid attention to before.

Hasegawa: They're worth seeing.

Tsurumi: A contrary example is the Japanese version of *Treasure Planet* (2002). That was well done too. But to be honest, it wasn't put together very well. In the Japanese version, however, the voice actors added some flavor to the standard characters, and the script and mouth movements matched perfectly. In *Shrek* (2001), for example, Yamadera Kō ichi's voice of Shrek was superb. He is a pro among pros.

Hasegawa: That is why his earnings are so high.

Tsurumi: What was also better than I expected was Kuroki Hitomi's voice of Mrs. Incredible.

80

Q: She is a famous Japanese actress and has little experience as a voice actress, but her performance was wonderful.

Hasegawa: Casting Kuroki Hitomi was well received because originally the main character of *The Incredibles* was really Mrs. Incredible.

Q: In games made for Japan it is normal practice to dub boy characters with voice actresses, right?

Hasegawa: Yep. And when we mention this to overseas developing teams, they understand.

Tsurumi: It is the same as the eyebrows we mentioned before, or some other part of a character we want to emphasize; we need to come to a consensus between the Japanese and American teams about the basics of what kind of character we want to make, meaning that in Japan the design of the character must be different in order for it to have the same significance.

Q: On the other hand, even if you look at characters with a similar design, Japanese and American players will experience something different.

Tsurumi: That's right.

Q: Please tell me briefly about the workflow of character design. If a new game project is initiated in the U.S. with the assumption that it will go on sale in Japan, what kind of steps do you take to make the character?

Tsurumi: First, we list the ideas of what kinds of characters we want to make and consider the plot of the game's story and any characters that may be necessary. These are the first two things that we do. Next, someone mentions any ideas they have about a character. Based on that, an artist begins to sketch a rough design of the character.

Q: Do you do this with both the Japanese and American developers present?

Hasegawa: There are a lot of production companies in the world, and what is fortunate about our position is that we can participate together on a project from the very beginning. Generally, the localization process begins when a Japanese company gives the OK to a beta version of a game that an overseas production company has made or to one of their games already on the market. However, in our case, we can participate in game development when a project only exists on paper. That is why, as Tsurumi said, we can also propose to U.S. developers those elements that we think are necessary for a character's personality and their role in a game. These days, Japanese, American, European, and recently Korean producers, too, all gather at the same table to discuss the development of a game. The fact that we are able to do that is testament, I think, to how fortunate we probably are among game developers throughout the world.

Tsurumi: I think that other companies are doing that, too, because Naughty Dog used the same methods when they made *Crash Bandicoot* seven or eight years ago after we mentioned it to them.

Hasegawa: But to what extent are other companies doing it?

Tsurumi: They are doing it to some degree.

Q: Nintendo may have done that when they made **Metroid Prime** *(2002).*

Tsurumi: Oh, that's right. The rookie studio that made *Metroid Prime,* Retro Studios, was a company composed of American developers who wanted to make a *Metroid* game.

Q: An example from some time ago is Donkey Kong Country (Nintendo 1994), which was developed by the English company Rare. But I don't know much about how they made it.

Tsurumi: Didn't Nintendo just supervise the character development for that project?

Q: That might be right.

Tsurumi: Going back to our previous topic, presentations on character design are given by development companies to producers at SCEJ, SCEA, SCEE, and SCEK*, and then the producers discuss the contents of the presentation. This is the relationship between production companies and publishers. People get together from different regions to evaluate ideas and discuss the necessary elements of a character's design for each region so that the game can be sold in Japan, the U.S., Europe, and Korea. The production company then puts together the contents of this review session and comes up with a second design proposal after adjusting the conflicting elements for each region. We do this again and again until we come up with the final design of the character. I think this process is very typical. So I think that the method itself is possible for any company.

But I don't know if the reason that there are only a few character designs originally produced in the U.S. that are accepted by the Japanese market is because they are not very good at doing this, or if it is because they are not experienced at it. But this is how we have been doing things for the past seven or eight years.

Q: So in the very beginning, an American designer draws a rough sketch based on the specifications of a character you write up.

Tsurumi: Yes. They draw page after page. That is why the initial proposal is so necessary. The character artist draws several pages based on our suggestions. His or her drawings are then digitized and passed around on the Internet.

*SCEJ: Sony Computer Entertainment Japan, SCEA: Sony Computer Entertainment America, SCEE: Sony Computer Entertainment Europe, SCEK: Sony Computer Entertainment Korea.

But this is what the production company has to pay attention to. If they incorporate the various suggestions from each region, and modify the rough sketches by a process of elimination, the character will be a little ordinary; or if they try to include everything, the character will be a disaster. Ultimately, the character artist listens to the requests of each region, and must understand the basic significance of their demands. That is why I send manga to them as reference materials, so they understand what we want. The Europeans are good at letting us know the types they prefer, too.

Q: So does the staff member who ultimately puts together the character design, like the character artist for Ratchet & Clank at Insomniac Games, have that kind of authority?

Tsurumi: No, SCEA has the authority to approve character designs.

Q: But the person who actually draws them by hand is the character artist at Insomniac Games, right? So it is necessary for that person to put together the requests for signature traits into a character's design for each region. For example, there are various ways to adjust Ratchet's eyebrows to make them thicker, so it is necessary to have a good understanding of that sense. There must be a lot of demand placed on the skill of a character artist.

Hasegawa: That is, without a doubt, true.

Tsurumi: If those sorts of signification elements have been included, we can still make different illustrations for the Japanese version. That is why we said that if the character had eyebrows, it would have been fine if they had been drawn to a minimum, or if they included stripes on his body we could have modified the details of the texture in Japan.

Hasegawa: This [*Ratchet & Clank 3* CG (Computer Graphics) manual] is essentially an overseas illustration, but only the eyebrows have been altered for the Japanese version. Conversely, the image on the packaging was independently created in Japan.

Q: Other than the heroine, the supporting characters are very American. Weren't there any other changes?

Tsurumi: Yeah. The supporting characters haven't been changed very much. To be honest, other than the protagonist, they were fine as they were. The supporting characters in the American version were just fine for Japan. There are some characters among them that seem a little weird for Japanese people. The Scrunch character in *Ratchet & Clank 3* is a case in point. But other than the protagonist, the other characters were fine. Of course the heroine was important too, but the Captain Sarsha character in *Ratchet & Clank 3* was not very appealing for a heroine.

To be sure, it is necessary to consider the age bracket of a game's main players. If *Ratchet & Clank* had been a game meant for teenagers, we would have had to have made the heroine more stimulating for them. In Japanese games for teenagers the heroines all have something erotic or sexy about them these days. Of course, we make it very subtle. But since *Ratchet & Clank* is not a game for teenagers in Japan, we didn't consider such alterations.

Q: Is the target age group the same in the other regions?

Tsurumi: They are slightly different. *Ratchet & Clank* has a different rating depending on the region. In Japan it's for all ages, but in the U.S. it was rated "teen."*

Q: Why was it rated "teen"?

Hasegawa: It must be because the hero carries a realistic gun. Also, the marketing approach of SCEA and SCEE is that if there is an E symbol on the packaging, it will be regarded as a game for children. And teenagers won't even touch those games. That is why in order for the game to have a cool image they wanted to give it a teen rating. The dialogue of the characters in the English version is also somewhat adult in nature. In the U.S., stores like Toys "R" Us and Wal-Mart would not accept advertisement material featuring Ratchet equipped with a gun. This was fundamentally out of the question for general circulation. Also, the game had to be displayed on the upper shelves because children might pick it up and look at it. But that is also why SCEA and SCEE went ahead and rated it "teen" for marketing reasons.

But because *Ratchet & Clank* is such a great game, anyone could enjoy it if they give it a try. Even little boys could enjoy it if it was their older brother who purchased the game. So we made the content and images so that even high-school students would be satisfied if they played the game.

On the other hand, since the people who play this type of game in Japan are at best younger players, we made the game for all ages. Fortunately, we are tolerant of images of guns in Japan. Also we translated the dialogue scenes so that even a child could understand them and feel safe playing the game. There was no bloodshed in the game from the beginning anyway.

When *Jak and Daxter* came out, the original design of the overseas version was very cool, but *Ratchet & Clank* worked better for us. Although in Japan *Jak and Daxter* was sold to primary-school students, when the second of that series came out, the content was too mature, and there were a number of differences from our marketing strategy for children. That is why we didn't sell many in Japan. We couldn't attract players from all age groups by just localizing the game.

Tsurumi: To go back to our original discussion, this is an example of why children are more receptive to character design. The number of children who could identify with the characters in the first *Jak and Daxter* was high, but they didn't really strike a chord with

*The rating system for the U.S. includes EC (early childhood, ages three and over), E (everyone, six and over), T (teen, 13 and over), M (mature, 17 and over), and AO (adults only, 19 and over). When a game is introduced before its release without a rating, it is labeled RP (rating pending). Ratings are assigned by the Entertainment Software Rating Board (ESRB).

In Japan, the rating systems for console and computer games are different. Console game ratings include "everyone," "12 and over," "15 and over," and "18 and over." Their ratings are assigned by the Computer Entertainment Rating Organization (CERO). For computer games there are two ratings, "18 and over" and "15 and over." The ratings are assigned by the Ethics Organization of Computer Software (EOCS).

players in their early teens and older. On the other hand, when the second game came out, even though we were not disregarding children, because the game content was a little more mature, we marketed it to players in their early teens and older, but our efforts did not bear much fruit.

Hasegawa: The content of *Jak and Daxter 2* received very favorable ratings. Some game enthusiasts bought it on a hunch and really enjoyed it. But even they said it would not sell well to most gamers. We got a lot of candid advice written on some Internet BBS (Bulletin board system) sites. It was a fine product, but SCEJ didn't market it properly.

Tsurumi: I have some ideas for *Jak and Daxter 2,* but ultimately there is nothing I can do. But if I had done some passable design work for the characters in *Jak and Daxter.* . . . Sorry, this is my own opinion, but for me all of the characters in Japanese RPGs (role-playing games) look so much alike now that I can't tell them apart. Maybe my thinking is just old fashioned, but I really don't get it. Even when I look at the images in *Radiata Stories* (Square-Enix 2005), it looks just like the other games. Because I read a lot of manga, I can differentiate the *Tales* series (Namco 1996) from the others, but [The character designer for the PS2 version of the *Tales* series is the illustrator Inomata Mutsumi.]

Radiata Stories
http://www.square-enix.co.jp/games/ps2/radiata/

Tales series
http://namco-ch.net/talesofrebirth/index.php

Conversely, even if we had hired a popular Japanese character designer and assigned him to *Jak and Daxter,* I probably wouldn't have been able to feel any affection for them. But it may have sold better. Also, if we had used photo-realistic characters like those in *Onimusha 3* for that system, it might have sold itself.

Hasegawa: On the other hand, when we enter the era of the PlayStation 3, our job is probably going to get a lot more difficult than it is now. If it were a character like *Crash Bandicoot* for the first PlayStation, even if we didn't alter the character in the game at all, and only changed the package illustration and text, there are some things we could leave to the player to imagine by themselves because the visual animation for the first PlayStation was limited. When it becomes possible to make even more photo-realistic animation, then we will have to express this with only an image. That is why when PlayStation 3 comes out, superficial changes like those we did for *Ratchet & Clank 3,* like just altering his eyebrows to make them a little thicker, will become impossible. We may have to make a different polygon model of just a character's head for the Japanese, American, European, and Korean markets.

Q: Do you mean to say that while the protagonist is important, the most important thing about him or her is their head?

Tsurumi: No, it's not just their head, but artistic style as a whole that is important.

Hasegawa: But when character visuals are run in game magazines, readers will wonder "What is this supposed to be," and they will hesitate to buy it.

Tsurumi: It is better for them to think that it is a passable design than wonder what the character is supposed to be. I'm only talking about artistic style. Even if the character has a passable design, there is a technique by which we have the character carry a weapon with an unconventional design, which makes the character distinguishable from others. I should mention Square-Enix as an example here. I couldn't believe my eyes when I saw *Final Fantasy X*. The character is realistic and beautiful, wears a very revealing costume, and carries a cane with an unusual design. It is an amazing character design. It was marketed wonderfully and is technically superb. I have no complaints about it. But I am still a little puzzled. Fortunately, however, it includes everything necessary for the Japanese market and those overseas. Everything harmonizes very well.

Q: I have always thought that for the character designs of the Final Fantasy *series, the protagonists have all had a Japanese pop idol motif, and the heroines have been based on female celebrities popular at the time. In short, I have thought that the design of the* Final Fantasy *characters was purely for the Japanese market, but actually a lot of elements were used that made them popular overseas, too.*

Tsurumi: That's right. They have a lot of different things to them.

Hasegawa: That's not a very typical anime style, so if an American player sees the characters, they are able to appreciate them fully.

Tsurumi: Japanese female faces are well received in the U.S. It's a realistic CG character, but she wears somewhat oriental, skimpy clothing. The sexy elements of the character are quite understated, but they are there. That was done in great taste.

Q: Going back to our discussion on gamer demographics, whether the character design of a game is culturally acceptable is closely related to the game's marketability. So in the U.S., they rate games higher than they do in Japan, and in Japan you make games for primary school students that easily become popular among older and younger generations, like for middle- and high-school students?

Hasegawa: I don't know about the older generations, but they do pick up a following easily among the younger players. Like I said before, we can think about this being like a little boy trying to raise himself up to the adult world. American gamers in their 20s and 30s probably gather information themselves more than they do in Japan and have a tendency to judge a game's marketability by this information. They might think, "I want to play a fighting game, so what is the best fighter on the market now?" I have the impression that they buy games after investigating them thoroughly in game magazines and on the Internet. Compared to that, in the Japanese market at present, the public image has a very strong influence on game sales. There are many gamers who comment on the contents of a game without ever having played them.

Tsurumi: There are people like that in America too.

Hasegawa: Of course there are, but no matter how I look at it, I feel that their gut feeling for choosing a game comes from having evaluated games after playing them themselves

or from their own personal tastes. Japanese gamers these days are not very judgmental, I think. A lot of them buy games based on their impressions from a game's television commercial. Of course they also pay attention to reviews on the Internet, but in spite of what they say, I think there are a lot of examples of people who make comments without ever having played a game. There are a lot of users who play games with just a superficial knowledge of its content.

So I think the range of gamers who actually play a game are probably primary and middle-school students.

Q: A minute ago we talked about how gamers in different countries get a different impression even if they see the same thing, so in order to give the same impression to the users it is necessary to use different forms of expression. You may be able to say the same thing about color. That is what I feel about the color of Nintendo's logo. In Japan, the Nintendo logo is written with red letters on a white background, but in the U.S. it is written with red letters on a black background. I felt that the difference between the combination of red and white compared to the black and red indicated something about the differences between the target groups in both countries.

Hasegawa: I see.

Tsurumi: Compared to *Ratchet & Clank,* the color usage for *Monkey Mania* (SCE 2000) has a lot of primary colors. But in order to make the explosion effects realistic in *Ratchet & Clank,* the background is made to look more realistic and has darker, toned-down images. Unlike Japanese designers, their level designers seem to want to make levels with toned-down color schemes, but in Japan we get requests from various offices asking us to please make the background more colorful. That is pretty much what happens. But if we do that, we will be concerned that players might not be able to appreciate the explosion effects. The result is that we can't alter it at all because we have this apprehension that the overall enjoyment they will get from playing the game will be weaker, even when we localize the game. The significance of color usage in the U.S. and Japan is that different.

Q: The use of colors for characters in American games is distinctive. They have a tendency to tone down the colors more than what you see in Japanese games.

Hasegawa: In Japan we have a tendency to use a lot of primary and pastel colors, but they don't use a lot of them for their characters.

Tsurumi: Also, American production companies use a different approach when they create images, like making Ratchet's body hair realistic. So for the Japanese version of the character, we toned down his realistic hair a little when we localized the game. But we can't alter the color at all for Japan because it is possible that it will change the game's marketability.

Another example of how an alteration may change a game's marketability is adjusting its difficulty level. (When a game is localized for Japan, it is normal to lower the difficulty level by making the game easier.) Like with the first *Tomb Raider* game (Eidos 1996), the difficulty adjustments were not very good. In a certain stage, the map mechanism was changed too much, and the original feeling of a challenge was weakened. And

mechanisms that were too difficult on other levels weren't changed. When we make changes like this, we use test players to see how the game will do with our intended users because it is necessary to find out whether or not our alterations of the difficulty levels are reasonable. Even for levels that seem difficult at a glance, we consider whether or not we can handle changing the way hints are provided in the game or if we need to alter the system. For example, with *Ratchet & Clank* we can think about how, when a character collects bolts, it gains experience points and his ability level increases. So we determine what modifications will work based on the results of our focus tests. Only after we make sure that our alterations won't harm the best possible marketability of a game that was made by an American production company can we move on to the next step, which is changing the difficulty level for Japan.

But we don't have any way of determining whether or not a game's marketability will definitely change if we alter the visuals.

Hasegawa: We just wait for reactions from gamers after a game goes on sale.

Q: So while you are able to conduct a focus test to try out a character, it is difficult to test the overall visual design and coloration.

Tsurumi: That's right. Even if we considered changing the overall color scheme and contrasts to make the images more attractive, it's pointless if the visual appeal of the explosion effects is reduced as a result.

Q: So it's difficult to analyze in detail the reaction of gamers.

Tsurumi: Yes. So we give American production companies some suggestions, but ultimately we leave the decision to them. To be sure, we are still told by the SCEJ marketing department how they think the game could be better.

Actually it is difficult to make the explosion effects realistic if we use a lot of primary colors for a game's background. It is also a matter of whether or not we want the explosion effects to be like a cartoon or more realistic. I think that even when looking at other games.

Q: We talked about how when the performance and resolution of game systems gets better, game localization will become more difficult. Does that mean that it was easier before?

Tsurumi: It was because explosion effects were drawn as just 2D pixel images. But that doesn't mean that every game will be realistic when PlayStation 3 comes out. Explosion effects are just one type of artistic style. When we choose to make the way we depict things like explosions and structural damage realistic, the overall color scheme of the game environment will be decided. Actually, the *Ratchet & Clank* for the PlayStation 2 was a case like this.

Of course, I suppose when PlayStation 3 comes out, the overall color scheme for games that we choose to use realistic explosions will be difficult. But if we choose to use a cartoon style to depict explosions, it probably won't matter much.

Hasegawa: When PlayStation 3 goes on sale, the physics engine that is used in *Half-Life 2* (Valve 2004) will probably be programmed into a lot of other games. For example, suppose there is a scene in the game with a wall made of bricks, and each brick has been programmed for a collision. Every time the wall is broken, the way they come apart will be different. This technique is representative of that. Overseas programmers will probably love using a physics engine to calculate the physics for such things. But it doesn't really matter to me. If they you are going to take that much time on how bricks react to a collision, I would rather they look after some of the other places. That sort of thing is going to start coming up more and more.

Q: It's a question of priorities.

Tsurumi: The choice of what you will focus on for a game design becomes more important as the potential of game systems increases. While the production company itself gets advice from various offices about projects, they need to have a certain taste and sense of balance so that they can claim what is important, like what they need to express; otherwise the game won't have an identity.

Hasegawa: Seven or eight years ago, the technical term "Ik" got a lot of attention. This technology programmed a character's ankles to adjust automatically to the slope of the ground and positioned their feet accordingly. At the time I didn't understand what was so great about that technology at all. To be sure, I thought that technologically it was great, but if they were going to be so particular about that, I would have preferred that they pay attention to some other things. Originally there were a lot of anime with characters walking like they were sliding across the floor. That was the case, for example, for what is said to be an anime popular all over Japan, *Sazae-san* (1969). Once we were told that when a character looks like it is sliding over the floor, or may be floating in the air, it means that the character is walking in that animation, we would recognize it as such. Without being aware of it, we try not to notice it by not acknowledging it.

Sazae-san
http://www.fujitv.co.jp/b_hp/sazaesan/

I couldn't believe it when it became popular in the Japanese game industry to insist that it was important for the soles of the feet to adjust to changes of the ground's slope in a game. However, they were saying that there was no other technique for the programmers to really show their skill.

To mention a similar example, in a scene where several stones come rolling down a hill, when the stones hit each other, they will have been programmed using physics to collide differently every time. I understand why programmers love to use that sort of technique. But when I saw it, I wasn't that impressed.

Tsurumi: There are some differing opinions about that. When I was making 2D side-scroll action games about twenty years ago, I had thought that if we didn't do something about a character's feet looking like they were sliding over the floor, the expressive techniques of the whole game industry wouldn't improve. Maybe at that time production

companies all over the world were making detailed alterations to the scrolling map one pixel at a time, which also contributed to the advance of the industry.

Hasegawa: It's not like I was saying that sort of challenge wasn't necessary.

Tsurumi: Yeah. It's a matter of focus.

Hasegawa: Since the level of a game console's expression was so limited a while back, we just focused on a few parts of the game. But when PlayStation 3 comes out, since the range of what we will be able to do will go up even more, we will have to pour a lot more energy into everything than we do now. That is why we will need to focus all the more. To give an extreme example, even if the puppeteers and stagehands who wear all-black garb for the Japanese stage and puppet theaters are seen by the audience, the viewers know that they are supposed to ignore them. In the same way, even if the feet look like they are sliding, it's best to just think of it as walking.

Tsurumi: A long time ago, Sega made a game called *Michael Jackson's Moonwalker* (Sega 1990). In order to emphasize Michael's moonwalk, we were told by the designer that his feet couldn't slide when he is walking normally. That's for sure. The designer said the same thing to the programmer. And the programmer consented.

Hasegawa: That's right.

Tsurumi: It's a question of what you focus on when your resources are so limited. When I am playing a game like *Dragon Warrior 8,* I don't pay attention to whether or not the character's feet are sliding anymore. But I used to.

Q: So, in the days of 8-bit games, the fact that the characters in **Super Mario Bros.** *and the blocks in* **Tetris,** *though I don't know if I can call a block a character, were accepted by the world market was because it was an abstract form of expression.*

Tsurumi: That's right.

Q: And with PlayStation and PlayStation 2, the expressive potential of game consoles improved, and when the third console comes out, it will be difficult to design a game character that will be accepted all over the world, because characters will be more realistic?

Hasegawa and **Tsurumi:** Exactly.

Tsurumi: I would be happy if there were some sort of definitive methodology, but compared to the days of 8-bit games, the business of being able to establish a character franchise is going to be more and more profitable.

Hasegawa: I think that we will breathe new life into the appeal of today's game characters for the next-generation systems when they first come out, but there may be characters that absolutely cannot be created with today's 2D anime-like techniques.

Tsurumi: Characters that can't be made with 2D anime techniques?

Hasegawa: Characters whose appeal will be represented by high-resolution 3D techniques for the first time.

Tsurumi: Like Mrs. Incredible?

Hasegawa: Well, something like that.

Personally, like I said before, I think the more photo-realistic game characters become, the more difficult the task of localizing a game will be.

Q: Incidentally, there are a lot of game characters that are created in Japan but are popular all over the world. Are there any characters that were created overseas and are popular in Japan as well?

Hasegawa: Just *Crash Bandicoot*. That character is the only one made by an overseas production company to sell more than a million titles in Japan.

Tsurumi: There wasn't another one?

Hasegawa: No. *Crash Bandicoot* is the only one that was popular in Japan. *Ratchet & Clank* is doing pretty well, but its peak sales have only reached about five hundred thousand titles.

Q: The **Crash Bandicoot** *series is still being made by a different publisher, but what is the demand for that series?*

Tsurumi: I only know about the title when the publisher was SCE. Roughly speaking, the sales figures for that game in Japan are *Crash Bandicoot,* 1 million; *Crash Bandicoot 2,* 1.5 million, *Crash Bandicoot 3: Warped,* 1.5 million; *Crash Team Racing* five hundred thousand; and *Crash Bash,* three hundred thousand.

Q: When the first **Crash Bandicoot** *went on sale, a lot of Japanese gamers, including myself, mistook it for a Japanese game.*

Tsurumi: That's because we made it so that you would think that [*laughs*].

Hasegawa: Naughty Dog, which made *Crash Bandicoot,* really respected Japanese game development and was eagerly researching our game designs. Their efforts paid off.

Tsurumi: And Mark Cerny was first rate.

Q: It has often been said lately that if you sell the same game, images in the game, including the characters, designed with the target market in mind sell better. That is one reason why Japanese games are no longer selling very well in the U.S. The game itself is interesting, but for them the images aren't "cool" enough. So when you discuss this problem, I imagine that you talk about what is "cool" for an American audience.

Tsurumi: Like *Viewtiful Joe* (Capcom 2003)?

***Q: Indeed** [laughs].*

Tsurumi: *Viewtiful Joe 1* was well received in the U.S., but I haven't heard much about the second, in the U.S. or Japan [*laughs*].

Q: What did Naughty Dog respect about Japanese games? Was it character design, game design, or both?

Hasegawa: I think that was different for each game.

Q: What about the first* Crash Bandicoot*? When they were making the first game, what kind of things were they trying to learn from Japanese games?

Tsurumi: They put great importance on the opinions of the Japanese team when they were at the development stage, and when they developed the game, Naughty Dog and Mark Cerny were researching the enjoyment of a game for its particular console and how to make such games on their own. They learned a lot while they were doing this. So what they respected about Japanese games was their game design.

Hasegawa: For example, the settings for a game's learning curve or how you teach a player how to control a character and what it can do in a game.

Tsurumi: Actually, since the first *Crash Bandicoot* still had some shortcomings, we made the second one perfect.

Q: Were there any reflections of suggestions you received from producers in different countries regarding character design?

Tsurumi: With the first game we didn't have that kind of system yet. The system for making such character designs was refined as we worked on the series. When we were working on the first game, the graphics of the first PlayStation were a little cheap, so we endeavored to have players supplement the image of the character other than what appeared on the screen. For example, for promotional uses we made a Crash Bandicoot costume, and when we illustrated the packaging, we added some "Japanese" elements to the character design. So it's possible that there may have been some difference between the Crash Bandicoot character in the game and the one we presented to the Japanese public.

But when the second game was in development, Naughty Dog adopted elements of character design popular in the Japanese market and tried to incorporate them into the game from the very beginning. For example, having Crash Bandicoot dance, having Coco Bandicoot, Crash's little sister, appear in the game for the first time, stuff like that. Of course, elements acceptable to markets other than Japan were adopted for the second game as well. So the development process matured as we worked on the series.

Hasegawa: I think that is probably because our localization process itself has come a long way since the *Crash Bandicoot* series.

Tsurumi: A while ago I mentioned that from the early stages of developing the characters for *Ratchet & Clank,* producers from different regions assembled to discuss character

design issues. This, too, was done as we worked on the *Crash Bandicoot* series. Because the producers who assemble together from SCEJ, SCEA, and SCEE haven't changed much since then, they have been cooperating and sharing knowledge as a matter of course. And it was through such a process that we developed *Ratchet & Clank*.

When I think about it now, *Crash Bandicoot* involved a lot of trial and error. I often made international calls to the U.S. in the middle of the night.

Q: So when the first game in that series came out, the hardware was not as good as it is now, but you had the option to expand things other than the visuals in the game.

Tsurumi: There was that, and also from the very beginning the Crash Bandicoot character was one that had stimulated interest, and it was already a suitable subject for the Japanese market. So I guess both worked well for us.

Q: In your presentation data for your lecture at GDC 2003, you had some materials about the changes made to the character designs in Sly 2: Band of Thieves.

Hasegawa: That's right.

Q: First you get a proposal of rough designs from the American team, then a design is proposed by the Japanese team, and finally a decision is made.

Hasegawa: That's right.

Q: What is the process after a character design has been decided?

Hasegawa: Once a character design is finalized, we move on to making the actual polygon model. Actually, both are done at the same time. If alterations are added to the character design, we make them to the polygon model as well.

Q: Do you alter the polygon model itself to suit each market?

Hasegawa: Not for *Sly 2*. For the Japanese version of *Ratchet & Clank* we made detailed alterations like changing the character's eye color and texture. But, we didn't modify the original polygon model of the character.

Tsurumi: When you change the polygon model of a character, it affects the way the character appears in the movie sections of the game in various ways. Due to production deadlines, we don't take it that far.

Q: But since you were changing the textures of the character in Ratchet & Clank, the Ratchet who appears in the movie parts is different in the U.S. and Japan. That means different movie files had to be made for Japan and the U.S.

Tsurumi: That's right. In other words, if we make a different movie file, change the texture of the CG image for advertisements, and have other visual materials, we can assume that Japanese users will put all of these elements together and envision their own Ratchet

character. So changing only the texture will suffice, even if we don't alter the polygon model.

So for now, if we can't adjust a character's image for Japan by just changing the texture, it's more efficient to just rethink the character design itself.

Q: So, we mentioned this before, but do you think it will be possible to make region-specific character polygon models for the next generation game consoles from the get-go?

Tsurumi: That's possible. But it will actually depend on production costs and time. And it will also be necessary to think about the additional processes that make it possible to modify the character model for each region whenever we are working on the movie data.

Q: So, to go back to the beginning, when you are thinking about making a character that will be accepted all over the world, you all have to work hard at it from the very start.

Hasegawa and **Tsurumi:** That's right.

Hasegawa: I think that principle will never change.

Tsurumi: Other than that, what is important is if a production company can make a character with an appealing identity, while taking the initiative to design that character by incorporating the requests of each region. And the publishers from different regions can verify if the resulting character will be appealing in their respective countries.

Ultimately it's the production company that designs a character. And it's also a matter of how the publishers verify the potential of a character design for their own countries. If they find a problem, it should be solved. To be more specific, I think it will become a pretty ordinary task to debate with people who propose character design problems. But when it comes to problems regarding character design as a field of art, since there are a lot of elements that depend on personal taste, it is truly difficult to design a character objectively. So for now it is still difficult to work out these problems. I hope this interview can help this matter in some way.

Q: Understanding and creating are two different things. The most important thing for a production company is a good sense of a character designer's creativity.

Tsurumi: That's right. And to go back to our original discussion, that is why we always send a large quantity of manga and anime for reference purposes. So we tell them, for example, "This is a great manga, so take a look at it." And we might also attach a memo that says something like, "The artwork in this manga is good for such-and-such a reason." We even regularly send stuff that has no direct relationship with the project we are currently working on.

Hasegawa: When we were working on *Sly 2*, we showed a DVD of *The Castle of Cagliostro* (1979) to the whole staff of the American production company so that they would understand the details of a certain taste we were hoping to capture.

The Castle of Cagliostro
http://anime.goo.ne.jp/dvd/detail/D110488116.html

Tsurumi: The head of the art design team for *Sly 2* loved that sort of manga and anime.

Hasegawa: That guy was originally not from the gaming industry but worked on *Spider-Man* for Marvel Comics. It was easy to talk with him about matters of creativity since he himself was a comic-book artist. He was an amazing artist.

Q: The directors of **The Matrix** *(1999), the Wachowski brothers, are big fans of anime. And in Japan, among people who are sensitive to trends, fans of the artwork in American comics, like Marvel and DC, are increasing. Compared to five or six years ago is, has there been any progress regarding a mutual understanding of creativity between Japanese and American creators?*

Tsurumi: It is difficult to come up with a consensus about that because it's different for each creator.

Hasegawa: Other than the creator, the range of market acceptance among consumers in the U.S. and Japan will, for example, suddenly increase simultaneously with the release of some outstanding product. The way it increases is not in a straight line but escalating.

For example, the 2 Channel* BBS (bulletin board system) and its jargon was liked by only a portion of its users for a long time in Japan, but now that sort of slang is sometimes being used for the titles of articles in fashion magazines for young girls and the like. This happened when *Train Man,* which began as an entry on 2 Channel, got attention from the general public and became a bestseller. When that happened, the degree of acceptance for 2 Channel among the general public increased.

Didn't the range of acceptance in the Japanese market for overseas character designs increase around the time of *Crash Bandicoot*? If a strong title or something comes out some time later, the range of a Japanese player's degree of acceptance will probably go up.

Tsurumi: If only the X-Box had sold more in Japan, the design of the protagonist in *Halo* (Microsoft 2000), Master Chief, would have been more popular!

Q: What about **Grand Theft Auto 3** *(Rockstar 2003)?*

Tsurumi: The Japanese version sold about three to four hundred thousand copies. About the same as *Grand Theft Auto: Vice City.* There are still some limitations.

Hasegawa: Other than the game, they also sell a soundtrack of *Vice City.* The soundtrack is perfect for people like us, who grew up in the generation that watched *Best Hit USA.* (*Best Hit USA* was a popular television program in Japan in the late 80s, which introduced the trendiest pop music in the U.S.)

*2 Channel—The biggest Japanese underground BBS.
http://www2.2ch.net/2ch.html

Tsurumi: Since I am a generation above them, I still don't think I want to play the newest *Grand Theft Auto* game, *GTA 3: San Andreas,* even when I hear good reviews of the game.

Hasegawa: But *GTA 3* has some violent scenes, so in Japan it never became a mainstream game. It's a game for hard-core gamers, and normally fathers with children won't buy it.

Q: There is a character named Snoopy, for example. Snoopy is a character in the **Peanuts** *cartoon, but, interestingly, not much is known about* **Peanuts** *in Japan. Snoopy is loved by a lot of people in Japan because the design of the character is cute. Are there no such cases of this phenomenon with games? Not overseas games, but just their characters?*

Tsurumi: That makes me think of Toro* [*laughs*]!

Hasegawa: Let me give you a different example. In *Space Channel 5* (Sega 1999) there is a character named Ulala. The character designer who came up with Ulala also designed characters for feminine products in Japan. This is an example of a design being more popular than the character itself.

Tsurumi: So Toro is an example of how a character is recognized more than how well a game sells. Don't avert your eyes [*laughs*].

But that was actually a marketing problem. The *Toro* game only sold when it first came out, and it didn't sell well after that, but selling products featuring the Toro character made it profitable for the company. So the series is still being made even today. Without such exposure and marketing of a fixed character, it won't last in the market. It is difficult to make known only the character if the company doesn't engage in some foundational economic activity. So in order for a game character to be widely recognized, it is necessary to sell character products and establish a link between that character and the continuing production of its game.

Q: However, it was a major turning point when **Toro** *first appeared in the* **Dokodemo Issho** *game itself. It picked up a big following with people other than gamers. If the game as a nucleus is boring, then there is no way for the character itself to be recognized.*

Hasegawa: What about Lara Croft from *Tomb Raider* (Eidos 1997–2005)?

Tsurumi: That's because that character was recognized in Japan more as a character in a movie than in a game.

Hasegawa: Even before that, there are instances such as the Sonic character in *Sonic the Hedgehog* (Sega 1991) becoming known as an apparel character more than a game character.

Toro—cat character on Dokodemo-issyo (SCEJ 1999).
http://ascii24.com/news/i/topi/article/2001/10/12/thumbnail/
thumb320x240-images665053.jpg
http://www.dokodemoissyo.com/

Tsurumi: Sonic was first popular in the United Kingdom, and is an example of a reverse import to Japan, so it's a little different. I even had five or six *Sonic* T-shirts.

Q: Sonic was a popular game in Japan as well.

Hasegawa: Even though that game was made in Japan, it was a big hit first in the U.S. and then Europe, and ultimately its popularity spread back to Japan.

Tsurumi: The *Sonic* game series is still being made, but it's an example of a character whose market potential has stalled, perhaps due to poor marketing.

In short, for a game character to be widely recognized, it is necessary to market it well and add some appeal to the game itself. The publisher of *Crash Bandicoot* switched from SCE to Vivendi Universal Games in the U.S. and Konami in Japan, but because their marketing was not as good as SCE, in both the U.S. and Japan the degree of recognition decreased.

Hasegawa: The *Crash Bandicoot* character is no longer popular in Japan.

Tsurumi: What I often said about *Ratchet & Clank* was that even if we continued to produce the game for a few years for the children's market, when the older children stopped playing it, the younger generation would fill in the gap. Since the population of children is quickly diminishing, the Japanese market for children is affected by lower birthrates, but I think it's possible to maintain a character's brand value by marketing them well.

Hasegawa: What was fortunate about *Ratchet & Clank* in Japan was that hardcore gamers recognized it as a high quality game, so we were able to reduce the number of people who might normally stop playing it earlier.

Tsurumi: And we market games for parents, too. So I guess we can maintain a character brand if we market it for the whole family. Of course, we could have done that for *Crash Bandicoot* in Japan by marketing it for the family and establishing it as a good quality action game that could be played during the holiday season. If we could have done this for five or ten years, it would have been a big hit. That is true for the Nintendo character franchise. It would be a powerful weapon if you had a character franchise and could continue to market and serialize it.

Q: In the very beginning, we talked about portraits of Ratchet. In Japan, importance has been placed on the design of a character's silhouette so that children could readily draw their portrait from the days of Ultraman (1969). Do they do this in the U.S., too?

Ultraman
http://www.m-78.com/

Tsurumi: When American comic heroes like Superman, Batman, and the X-Men spread all over the world in the 1960s and 1970s, I heard that editors asked color illustrators to paint characters simply and use a color scheme that made it easy to understand the

characteristics of a character, and that the editors also asked their artists to make the silhouettes of the characters easily identifiable. But 10 years later, that sort of technique was ridiculed as being somewhat childish.

Q: Long ago, I heard that when Yokoi Gunpei (1941–1997), who is famous for developing gaming machines, was producing Game & Watch *(1980),* Donkey Kong *(1981), and* Super Mario Brothers *(1982), he incorporated the American cartoon style into character and game designs because he loved Hanna-Barbera cartoons like* Popeye *and* Tom and Jerry. *The cornerstone of Japanese game character design is functionality, but we can say that what influenced that functionality is American cartoons. Of course, after that, anime and manga style was quickly incorporated as well.*

Hasegawa: That's right.

Q: On the other hand, as game systems evolve, the design of American game characters hasn't incorporated the American comic and cartoon style.

Tsurumi: The character design of *Crash Bandicoot* seems to have been influenced by American cartoons.

Q: That's true, but from the era of the Atari to Crash Bandicoot, *I feel that there is a greater distance between American games and cartoons than that in Japan.*

Tsurumi: One of the reasons for that is that there was an idea to use Hollywood animators to develop games, but that might not have been very typical until the latter half of the 1990s. But this became customary at about the time when *Crash Bandicoot* came out.

Hasegawa: Long ago, there was a game for the Sega Genesis called *Aladdin* (1993). From what I know, that was the first time that an American production company used a Disney animator to develop a game. Before then, when we animated a 2D character swinging a sword, we were drawing several pages of the animated motion of the arm at equal intervals throughout the whole movement. But with *Aladdin,* they used the same devices as Disney animation to make the arm movements look good, so they shortened the animated sections when an arm starts to move, and lengthened them for when an arm is extended. This is the same technique as those used to make real animated cartoons in the studio. This was shocking for a lot of the Sega creators. At the time, I was in charge of localizing *Aladdin,* and a lot of designers from the arcade-game machine development team were coming to study these animation patterns. That was a time when 3D CG was being used for arcade games, and 3D fighting-games projects like *Virtual Fighter* (1993) were being developed.

Tsurumi: The early 1990s was a time when ordering character animation from external production companies was starting to increase, even for game development studios. It was at about that time when what kind of action a character does, and a character's personality reflected in that action, came to be regarded as important.

Q: There was also a Super NES version of that Aladdin **game, which Capcom sold in Japan.**

Tsurumi: That's a different game, and it wasn't made very well. The Sega Genesis version of *Aladdin* was sold as a Disney product in the U.S., and Virgin Interactive was the publisher. So it was made very well.

Q: Speaking of Disney games for the Sega Genesis, there was one called Mickey Mouse: Castle of Illusion *(Sega 1990)* **at that time. For me the way Mickey moved was a real turning point. But I didn't pay attention to** Aladdin.

Hasegawa: *Mickey Mouse* was a great game, too, but *Aladdin* was better. That is why *Aladdin* is still held in high regard as a great game.

Q: Just to backtrack a little, creators in Japan who wanted to work on image development in the industrial establishment could only work on anime before the 1980s and, for the gaming industry, beginning from the late 1980s. I guess in the U.S., since such artists just went straight to Hollywood, they started to have a relationship with the gaming industry from the early 1990s.

Tsurumi: Since *Aladdin* came out in 1993, I suppose that was the beginning of it all. And it probably became the norm around 1993 to 1994. From that time the memory capacity of the ROM cartridge got larger. Soon after that, the CD-ROM started to be used as game media, and the data capacity went way up. Until then, due to the limits of the ROM cartridge's memory capacity, we couldn't include a lot of animation patterns.

Q: Right after the 3DO came out, we entered the era of PlayStation and Sega Saturn. It was also at about that time when companies like Lucas Arts started to excel at making games based on films.

Tsurumi: The evolution of game technology is part and parcel of the exchange of human resources between the movie and game industries. And that continues to be true even today.

Hasegawa: That was a time when the whole industry was making games while struggling to come up with new methods of game expression. We can talk like experts about this now, but we were unaware of it when we were absorbed in our work on *Crash Bandicoot*.

Tsurumi: We bickered with Mark Cerny a lot when we were working on that project.

Q: Games and animation are both enjoyed on a television screen. We can say that the difference between the two is a matter of whether or not you can manipulate the images. So as we looked back at the history of game character design, we arrived at the world of the American animated film, so I think I understand that

there is a relationship between the animation and gaming industries in both Japan and the U.S.

Tsurumi: In Japan, it's *Gundam,* in the U.S., it's the American comic. It would be nice if someone made a chart featuring the history of the relationship between manga, anime, and games.

Q: I would like to see that. Thank you very much.

3.5 Interview: W. Lewis Johnson

W. Lewis Johnson has been a pioneer in the research and development of computer characters for learning applications (referred to in the research community as *pedagogical agents*). Johnson and his team of researchers created one of the first virtual tutors to make use of gestures as well as language within an immersive environment. Currently, he is leading a project at the University of Southern California (USC) that aims to teach Arabic to students through coaching by and immersive interaction with characters. The team used the 2003 Unreal Tournament Engine as one technical component of the learning environment. Learners were coached not just in words themselves but also in fine-tuning pronunciation and in using culturally appropriate gestures when communicating. The tutoring modules are game-like, with objectives that build upon one another, motivating the learner to move through the lessons themselves. See Clip 3.1 on the DVD for a sample of the Tactical Language system in action.

Q: In the Tactical Language Project, the approach to language learning includes not just vocabulary and grammar but also tutoring in nonverbal communication and social skills. What made you decide to take this approach?

We focus on rapid acquisition of conversational skills. We want to teach people enough language and culture so that they can engage effectively in face-to-face communication.

FIGURE
3.17

W. Lewis Johnson, Director of the Center for Advanced Research in Technology for Education at the University of Southern California.

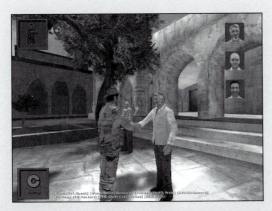

FIGURE
3.18

The Tactical Language Project uses embodied conversational agents to train people in both language and culturally appropriate nonverbal skills (see Clip 3.1).

For many people using our training software, that is main thing that they want to learn—they are planning to travel to a foreign country, and they want to be able to communicate effectively with the people there. And if you can converse well in a language, it is going to be easier to understand, read, and write the language. So many language courses do just the opposite—they focus on reading and writing first, and conversation skills don't really come until later. We think our approach is closer to the way people learn language naturally when they live in a language community.

So, given the focus on conversation, we asked ourselves: how can we help people acquire conversational skills as quickly as possible? We decided to focus on particular conversational tasks in common social situations. Tasks include introducing yourself, describing your job or mission, asking for directions, arranging meetings with officials, and so on. By narrowing the focus we can give learners experience in engaging in conversations early on, while their knowledge of vocabulary and grammar is still limited. This helps build confidence, and encourages learners to continue to develop their skills.

Then, because we put the emphasis on communication skills in social situations, we must consider broadly what learners will need to know to communicate most effectively in social situations. This includes an understanding of the cultural rules and norms relating to those social situations. Learners need to become sensitive to the differences in norms of behavior among societies. This will help to avoid misunderstandings. And they need to understand cultural differences in nonverbal communication. Nonverbal communication skills can compensate for deficiencies in verbal communication skills. Plus, they signal cultural sensitivity and help to build rapport.

Q: How did you go about crafting the gestures and situations in the project? Did you motion-capture native speakers? Work from film footage? How did you know which gestures were important and why?

We start by drawing from books on the target culture. These are helpful but are often very general and do not show the gestures in use in specific situations. We then

construct scripts for dialogs in particular situations. Writing these scripts involves collaboration between English-speaking script writers and specialists who are either from the target culture or have extensive experience in the target culture. Placing the dialogue in specific situations helps to uncover cultural details that are not apparent when one discusses communicative skills in the abstract. We then videotape people from the target culture role-playing the scripts in order to uncover further details.

It is important to have multiple people look at the materials as we develop them. Cultures are not homogeneous things, and different people have different views about what is appropriate in a given situation. This is particularly important for our work because we emphasize colloquial dialects. There is often little agreement as to what is proper or appropriate in a given dialect.

Q: What were the most striking differences in American and Arabic gestures and social behaviors that you and your team uncovered in the process?

Arabs are very relationship-oriented. Whereas Americans tend to be rather matter-of-fact and get down to business quickly, Arabs typically want to first understand the social position and trustworthiness of the person they are dealing with. So we put emphasis in our training in techniques for showing and garnering respect. Gestures play an important role here; for example, bowing slightly with your right hand over your heart indicates respect and sincerity.

Q: You've conducted early evaluations of the system. What sort of feedback did you get from learners about the nonverbal component of the lessons?

The nonverbal component helps convey a degree of responsiveness and interactivity that language alone does not. We have found it most effective to encourage learners to enter our game world as early as possible and just try walking up to one of the nonplayer-characters and say hello. Our user interface allows the user to select a gesture for their character, while they speak on behalf of their character into a microphone. When the characters in the game respond with speech and gesture, many learners find the simulation of interactive dialogue very compelling.

Our software includes a combination of game-like experiences and practice exercises in which learners develop the skills they need to play the game effectively. Our evaluations show that these learning materials support each other. The game experiences help learners to understand clearly how what they are learning will apply to realistic conversational situations. Learners are motivated to work on the practice exercises so that they can play the game more effectively.

Q: You used the Unreal Engine as a part of the technical structure of the project and for a game-like approach to learning. Could you speak to the reasons for these choices and any evaluation results to support the choice to create a more game-like situation?

The Unreal Engine provides extensive capabilities for animating characters. This was essential for emulating face-to-face dialogue in the Tactical Language Project. Some

researchers have experimented with 3D virtual worlds as vehicles for language learning, but they do not support animated characters, so learners don't get any experience with face-to-face conversation. Some play video clips to simulate dialogue turns, but video clips do not convey the same degree of responsiveness, not without a huge library of clips.

In addition, building on top of game technology helps us to understand how games can contribute to learning. There is a lot of interest these days in using game technology to make learning fun and engaging. There is certainly a lot to learn from game developers in how to structure user experiences to be make them fun and engaging. These include giving learners a clear goal and objective and managing the level of difficulty of the experience in order to achieve the objective. But we also find that making the experience more game-like is only part of the story. Games achieve engagement through action and interactivity, but reflection is important too. Learners want to understand what mistakes they made in playing the game and improve their skills so that they can play the game better next time. For many games this reflective aspect is not explicitly supported, so games create blogs and discussion groups where they can share their insights. We, on the other hand, consider reflection and practice to be essential parts of the learning experience and provide a mixture of action-oriented and reflection-oriented experiences.

Q: Anything else you'd like to add about the project? About the challenges of crafting an authentic cross-cultural experience for learners?

Cross-disciplinary and cross-cultural collaboration are essential for a project such as this. It has become a central theme of our work. Most multimedia authoring tools, including language-learning authoring tools, are designed to support individual content authors. We have had to develop a whole new suite of tools enabling people with different technical and even cultural backgrounds to work together collaboratively. It also requires that team members learn to respect the contributions of the other team members.

It is also interesting to note the extent to which we have had to develop connections with different cultural communities in order to carry out this project. People familiar with the culture participate in the design of the materials; native speakers of the language record samples of the language and lines of dialogue for the game characters. We have to work with people we can find to work with, even in a big city like Los Angeles, which contains many ethnic groups. In fact, we found ourselves applying our own cultural lessons, as we developed relationships with the local Arab-American community in Los Angeles. These skills and cultural sensitivities will come in handy as we proceed to develop training materials for other languages and cultures.

3.6 Summary and What Is Next

This chapter introduced some of the complexities of culture as it applies to the appeal of characters in games. Issues addressed included cultural differences in social expression and appearance norms, variations in social roles, and the impact

of media contexts on how characters are "read." Although there are no easy answers for designing characters that successfully span cultures in their appeal, some suggestions were made for improving a designer's chances of achieving this goal. Chapter 4 continues discussion of player characteristics with an examination of gender and its impact on character preferences.

3.7 Exercises

3.7.1 Beyond Cultural Stereotypes

Choose two or three national cultures, including your own (e.g., United States, Japan, and Germany). Break into two teams for each country—one group should collect stereotypical images of people from that culture (these can be found in movies, comic books, and other media), and the other should collect present-day, news-related imagery of people from this culture that were produced within that culture. Create slideshows and compare the two sets of images for each country, noticing areas where the two sets of imagery radically differ. It may also be interesting to compare historical stereotypical images with more recent ones, to see how they shift over time.

3.7.2 Street Cred Check

What cultural and subcultural groups do you belong to? Have each person make a list of their memberships. These can include pop subcultural groups such as musical tastes (punk, metal, etc.), hobbies, and the like, as well as broader cultural groups such as nationality and ethnicity. When your group gets to a stage where you are generating game and character ideas, pull these lists back out and consider whether you have the "street cred" to give the right cultural depth and authenticity to what you have dreamed up. You can also use these lists to help generate ideas that will be well grounded in what your team knows well.

3.8 Further Reading

Andersen, P. A., M. L. Hecht, G. D. Hoobler, and M. Smallwood. 2002. Nonverbal communication across cultures. In *Handbook of International and Intercultural Communication* (2nd edition), eds. W. B. Gudykunst and B. Mody, 89–106. Thousand Oaks, CA: Sage Publications.

De Mente, B. L. 1997. *The Japanese Have a Word for It: The Complete Guide to Japanese Thought and Culture.* Lincolnwood (Chicago), IL: Passport Books.

Ekman, P. 1973. *Darwin and Facial Expression.* New York: Academic Press.

Hall, E. 1976. *Beyond Culture.* New York: Doubleday.

Hofstede, G. 1980. *Culture's Consequences: International Differences in Work-Related Values.* Beverly Hills, CA: Sage Publications.

Hofstede, G. 1983. Dimensions of national cultures in fifty countries and three regions. In *Expiscations in Cross-Cultural Psychology,* eds. J. Deregowski, S. Dziurawiec, and R. Annis. Lisse, the Netherlands: Swets and Zeitlinger.

Jenkins, H. 2003. Lessons from Littleton: What congress doesn't want to hear about youth and media. In *Gender, Race and Class in Media: A Text Reader,* eds. G. Dines and J. M. Humez, 385–395. Thousand Oaks, CA: Sage Publications.

Kellner, D. 2003. Cultural Studies, Multiculturalism, and Media Culture. In *Gender, Race and Class in Media: A Text Reader,* eds. G. Dines and J. M. Humez, 9–20. Thousand Oaks, CA: Sage Publications.

Ko, D., J. K. Haboush, and J. Piggott (eds.) 2003. *Women and Confucian Cultures in Premodern China, Korea, and Japan.* Berkeley, CA: University of California Press.

Leathers, D. G. 1986. *Successful Nonverbal Communication: Principles and Applications.* New York: MacMillan Publishing Company.

Matsumoto, D., B. Franklin, J.-W. Choi, D. Rogers, and H. Tatani. 2002. Cultural influences on the expression and perception of emotion. In *Handbook of International and Intercultural Communication* (2nd edition), eds. W. B. Gudykunst and B. Mody, 107–125. Thousand Oaks, CA: Sage Publications.

Nass, C., K. Isbister, and E.-J. Lee. 2000. Truth is Beauty: Researching Embodied Conversational Agents. In *Embodied Conversational Agents,* eds. J. Cassell, J. Sullivan, S. Prevost, and E. Churchill. Cambridge, MA: MIT Press.

Rosman, A., and P. G. Rubel. 1989. *The Tapestry of Culture: An Introduction to Cultural Anthropology.* New York: Random House.

Smith, P. B., and M. H. Bond. 1999. *Social Psychology across Cultures.* Boston: Allyn and Bacon.

Stephan, C. W., and W. G. Stephan. 2002. Cognition and affect in cross-cultural relations. In *Handbook of International and Intercultural Communication* (2nd edition), eds. W. B. Gudykunst and B. Mody, 127–142. Thousand Oaks, CA: Sage Publications.

Ting-Toomey, S., and J. G. Oetzel. 2002. Cross-cultural face concerns and conflict styles: Current status and future directions. In *Handbook of International and Intercultural Communication* (2nd edition), eds. W. B. Gudykunst and B. Mody, 143–163. Thousand Oaks, CA: Sage Publications.

Yamada, H. 1997. *Different Games Different Rules: Why Americans and Japanese Misunderstand Each Other.* New York: Oxford University Press.

CHAPTER Four

Gender

4.1 What Is Covered and Why

This chapter provides an introduction to how a player's gender can have an impact on reactions to game characters, and it describes ways to shift design practices to create specific gender or cross-gender appeal in characters. Gender is a controversial topic in the social sciences (and in general), so this chapter also takes some time to define gender, insofar as it relates to creating game characters, using a social psychological approach.

There are many important major demographic variables, such as race, age, and socioeconomic status. Why focus on gender? Short of culture, gender is probably one of the most discussed demographic factors in game design today. Much has been written in the popular press about the predominance of males as game consumers. Concerns about this imbalance span the commercial and the critical spectrum: game publishers would like to sell games to a broader audience, and social critics want to see girls participating equally in computer literacy through games. (See [Brunner et al. 1998] for an excellent overview of the concerns and hopes for female-oriented games during the mid-1990s.)

There is some evidence that the gamer gender gap is slowly narrowing: a 2004 survey by the Entertainment Software Association (ESA) reported that 39% of computer and video game players were female, up from 38% in a 2001 survey (ESA 2001, 2004). These numbers, though, do not highlight the fact that far more hardcore, frequent gamers are male.

There are many factors that influence whether a game is female friendly. This chapter focuses on the influence of character design in attracting female players. We will look at research about gender and preferences in games, toward an understanding of how the design of characters in a game affects whether females want to play it. We'll look at some games whose characters have many of the features girls seem to prefer, which have done well with female gamers, and then will cover guidelines to help in making design decisions about characters that will be more likely to support female players.

4.2 The Psychological Principles

4.2.1 *Gender: Getting Clear on the Concept*

Researchers generally make a conceptual distinction between gender and sex. Sex is the biological aspect of being male or female, and gender is the part that gets learned and adopted after birth, from other people and from the cultural environment. Though there is evidence that a few biologically based differences between men and women could contribute to overall game preferences, this evidence does not have a major impact on character design choices. I will touch on these topics, but most of the research in this chapter focuses on observed gender differences, not on biologically-linked sex differences—things that are *learned* not *inherited*.

Gender patterns that get learned as a person grows up in a given culture and time do not follow a simple binary pattern—each person does not simply learn all the "proper" male or female behaviors and reactions. Rather, we follow a unique trajectory through this learning space. Any given individual may be typically "feminine" in some regards and "masculine" in others; for example in dress—see Figures 4.1

FIGURE
4.1

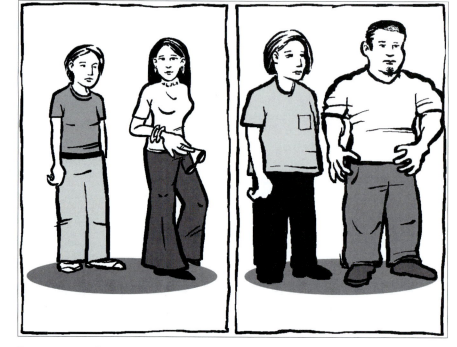

Two women and two men with the more gendered dresser of each pair on the right.

FIGURE
4.2

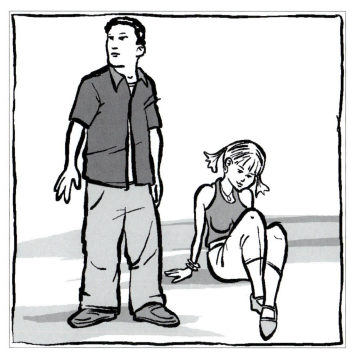

Two adolescents dressed and posed in gendered ways.

and 4.2. So it is with the ways that any given female will approach gaming. Some will very much enjoy masculine play patterns and personas in games. This chapter highlights findings that point out where gender roles tend to differ. These findings, when applied, may also end up opening up a game's characters to a broader swath of the male audience, not all of whom enjoy highly masculine gaming and characters.

Some aspects of gender are more culturally open for exploration than others, and this varies among and even within cultures. For example, wearing pants is acceptable for women in the U.S., but wearing skirts is not okay for men in most U.S. regions (although there are male, nontransvestite wearers of "utili-kilts").

Gender roles and qualities can also shift dramatically over time: what may have been considered masculine 100 years ago (or even 10) may now be considered feminine. The name "Leslie," for example, used to be considered a male name. Gendered behavior can also shift within a person's lifetime—for example, adolescents are much more concerned with whether they are behaving in gender-appropriate ways than adults.

What does all this mean for game character design?

- *The terrain of gender and games is always shifting.* As the ESA studies show, girls are increasingly playing games. Over time, this alters the male "genderedness" of playing games. It also means that it may become increasingly important for games expected to be mainstream blockbusters to support female gamers by designing characters with them in mind.

- *All female gamers are not alike.* The audience of female gamers is composed of different clusters of gender behavior. Some female gamers are interested in exploring and engaging in male-gendered activities and styles of games. Most discussion in this chapter will focus on gender-related habits and interests girls have that are not well-expressed in many current games.

- *Feminine game-character qualities could also appeal to males.* Some argue that games with a range of character choices (such as massively multiplayer online role-playing games (MMORPGs)) provide an opportunity to try on different gender roles for both sexes. Broadening a game's characters and modes of engaging with players could have the side effect of drawing a wider male audience, including men who have (or wish to explore) a more feminine side.

4.2.2 *Biology: Research Findings and Characters*

There are two biologically based differences between males and females that bear mentioning in relation to character design. The first is a slight trend toward better spatial abilities in the average male, including mental rotation of objects as well as spatial navigation. Women rely more on landmarks for navigation, orienting themselves based on the terrain in relation to their own physical position. This difference has been detected across cultures (Boon and Lu 2000, Schmitz 1999).

This means that a larger number of female gamers may find game play more accessible if they can wayfind using landmarks to orient themselves physically within the game world. At present, I am conducting research with a graduate student at Stanford to determine whether female gamers have an easier time wayfinding in a third-person view, when they can see their own character's body, than in a first-person view (see Figure 4.3). It may be the case that this contributes to the bias in first-person shooter audience toward male gamers.

The second relevant biological difference is the presence (to varying degrees) of the hormone testosterone. Testosterone level in men has been associated with increased tendency toward aggressive behavior, and there seems to be a correlation between the amount of free testosterone and other related hormones a woman has in her system and her physically and verbally aggressive behavior (von der Pahlen et al 2002, Cashdan 2003). This research supports the observed differences in game-play preferences between the average male and female—males tend to enjoy violent play more and have less of a problem with engaging in violence that is not heavily

FIGURE
4.3

It is possible that women may navigate better in an online 3D world when they can see their own character. *There.com* provides both options for players. ©2005 There.com. All rights reserved.

motivated by a game's backstory (see Figure 4.4). This means that games that have characters that do not engage in heavy, unmotivated aggression are more likely to appeal to most female gamers.

4.2.3 *Gender: Research Findings and Characters*

The full range of differences in gender behavior and acculturation could and does fill many volumes. My aim is to share a few concepts directly related to how females, in particular girls upon whom most research to date focuses, typically react to characters in games. These can be broken down into three broad areas:

1. play styles
2. roles that girls are comfortable taking on and fantasizing about
3. ways that others will likely behave toward a girl versus a boy

Play Styles
What Girls Like to Do in Games
Studies investigating girls' play tendencies reveal some interesting divergences from the majority of games on the market and help to explain the popularity of games

FIGURE
4.4

The *Mortal Kombat* series' graphic violence may make it less interesting to female gamers (*Mortal Kombat: Deception* is shown here). ©Midway Amusement Games, LLC. All rights reserved. *Mortal Kombat,* the dragon logo, Midway, and the Midway logo are registered trademarks of Midway Amusement Games, LLC.

such as *The Sims*™ and *Animal Crossing*. Please note that these are tendencies, not absolutes, and depend upon the individual's own personality, preferences, and acculturation. The results cited in this chapter are drawn from four research efforts, with different approaches and agendas, ranging from a broad survey of play patterns conducted at a research think tank to a design exercise in which boys and girls were asked to create their own games. For more details on any one of these studies, please see *Further Reading* at the end of this chapter. I have indicated which studies support which play patterns here:

- Girls tend to enjoy games that allow for open-ended play and exploration that does not necessarily require completion of one goal or level to get to the next (Gorriz and Medina 2000, Kafai 1996).

- Girls prefer games with puzzles or mysteries over games that involve physical accuracy and acuity (Children Now 2001, Gorriz and Medina 2000).

- Girls would rather spend their time creating things instead of destroying things (Gorriz and Medina 2000, Bruner, Bennet, and Honey 1998).

- Girls enjoy everyday life activities and metaphors just as much if not more than fantasy adventures (Subrahmanyam and Greenfield 1998).

FIGURE
4.5

A typical suburban morning in *The Sims*™, a game which includes many play patterns research has proved to be female friendly. See Clip 4.1 for a brief snippet of game play. *The Sims*™ *Unleashed* image ©2005 Electronic Arts Inc. *The Sims* is a registered trademark of Electronic Arts Inc. in the U.S. and other countries. All rights reserved.

- Girls may be less comfortable than boys about just jumping in and exploring a game to learn how to do things; they may do better with more explicit mentoring and instruction at the beginning of a game (Subrahmanyam and Greenfield 1998).

The Sims™, a game that has been popular with female gamers, fits many of these play patterns (see Figure 4.5). It is not a highly goal-directed game—players can determine their own subgoals and can move from one to another freely. A player can devote time to building her Sims characters' careers, their social lives, or their houses, in any order, at any time. Destruction and violence are not primary game activities. *The Sims*™ metaphor—families with careers and children—is quite close to everyday suburban life (with some entertaining twists, of course).

Animal Crossing is another game that supports open-ended play. The village metaphor is not far from everyday life, and the player spends time collecting items, furnishing the house, and going on quests on behalf of other characters, rather than going on major campaigns of destruction. The game begins with a friendly introduction for how to get around town and what to do, by the village shop owner, Tom Nook (see Figure 4.6). All of these qualities of game play probably contribute to this game's success with a female audience.

How do these qualities relate to character design? They help to determine the visceral and cognitive aspects of a game's player-character (which I will discuss further in Part IV). Briefly, the player-character is an extension of the person playing the game, on several psychological levels: the basic visceral level (physical and emotional); the cognitive strategy level (problem solving); the social level (how I relate to others); and the fantasy level (getting into the history and motivations of the character). Play style drives the design of the first two levels: how the game feels as the

113

FIGURE
4.6

In *Animal Crossing,* the game play includes shopping and collecting. See Clip 4.2 for a brief snippet of shopping game play. Image courtesy of Nintendo.

player physically navigates in the world and what sorts of problem-solving strategies she will use in playing the game. Supporting female play styles means that a larger number of women will be able to easily jump into the player-character's "skin" and feel comfortable and engaged. It also means that the female player's strategies for decision making will work for her instead of fighting the core game-play style.

How Girls Play with Others in Games

Another factor about female play styles that affects character design is how the player relates to others during game play. This influences design of the social aspects of the player-character. Here are some trends reported from the studies I mentioned in the previous section:

- Girls prefer collaboration to violence against others in games (Gorriz and Medina 2000, Subrahmanyam and Greenfield 1998).

- Girls tend to prefer working in smaller teams than boys do (Subrahmanyam and Greenfield 1998).

- Girls enjoy forging relationships—visiting other characters, writing letters, learning about how other characters feel about what is going on (Subrahmanyam and Greenfield, Bruner, Bennet, and Honey 1998).

- Girls are interested in the story behind the story—motivations and interrelationships among characters (Gorriz and Medina 2000).

- Girls enjoy communication with other girls, and games that encourage or incorporate chat and social activity in conjunction with the game can support this (Gorriz and Medina 2000).

114

FIGURE
4.7

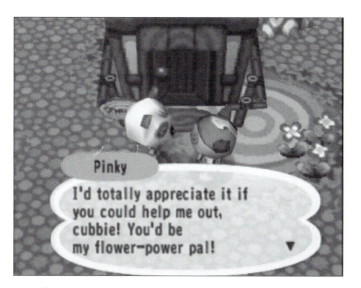

Part of game play in *Animal Crossing* is communicating with neighbors and helping them with everyday tasks, such as flower planting. See Clip 4.3 to watch the player go on a social errand. Image courtesy of Nintendo.

Animal Crossing includes many of these features. The player's character moves to a new town and sets up house. She visits with other residents and can have short exchanges with them and send and receive letters (see *Figure 4.7*). Over time, she learns more about the history and interrelationship and moods of the various townspeople. If she likes, the player can also asynchronously send letters or items to friends who also play *Animal Crossing*, and can visit another person's town using their memory card.

The Sims™ also supports collaboration and conversation—social situations are not typically resolved with violence (see Figure 4.8). Much of the game's appeal is that you can manage and rearrange the social relationships among your characters and watch and interpret their actions toward one another, building elaborate back stories. Fans have used *The Sims*™ to create short stories, supported by screenshots, with complex plots and interrelationships. (See Maxis' fan Web site for examples: (*http://thesims.ea.com/us/index.html?menu-community&content-/us/chat/*)). Neither game involves large teams.

Roles for Girls: Fantasy Personas Girls Can Relate To

Another way to make a game's player-character girl friendly is by providing a fantasy persona that a girl would like to step into. Girls have a different spectrum of interests in and needs for exploring social roles and possibilities than boys do. Young girls are trying on possible personas and learning gender norms, women players may be expressing aspects of themselves within the cultural framework for being "feminine",

FIGURE
4.8

Changing conversational topics in *The Sims™*. *The Sims™ Unleashed* image ©2005 Electronic Arts Inc. *The Sims* is a registered trademark of Electronic Arts Inc. in the U.S. and other countries. All rights reserved.

as they take part in a game. Female roles shift over time in any given culture, and games and other media are part of the terrain where they are contested and evolve. A girl may enjoy trying on a male persona as well, but including female-friendly fantasy personas will enlarge a game's chance of appealing broadly to female players.

A look at popular culture reveals a range of female archetypes that have been created for girls and have met with some popular success: Nancy Drew, *Buffy the Vampire Slayer*, Hermione of *Harry Potter*, Barbie. These transmedia personalities do get incorporated directly into games—for example, *Buffy the Vampire Slayer*, who stars in a game by the same name.

Offering players a chance to choose their gender and to control some physical aspects of the player-character can help to address desires to create a feminine or masculine fantasy persona in a game. *The Sims*™ offers extensive choices to players so that a girl can set up the look she likes (see Figure 4.9).

Other games provide a mix of characters that includes engaging female fantasy personas. The core party in *Final Fantasy X*, for example, includes female characters in the fighting group with different personal qualities (see Figure 4.10). Lulu

FIGURE
4.9

The Sims™ offers extensive customization capabilities for players. *The Sims*™ *Unleashed* image ©2005 Electronic Arts Inc. *The Sims* is a registered trademark of Electronic Arts Inc. in the U. S. and other countries. All rights reserved.

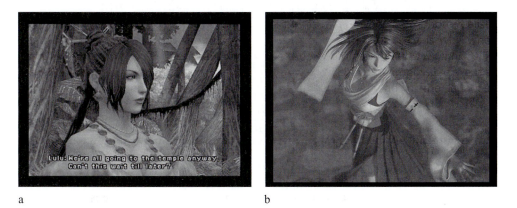

FIGURE
4.10

a b

(a) Lulu and (b) Yuna (from *Final Fantasy X*) offer female players interesting fantasy personas to inhabit. ©2001 Square Enix Co., Ltd. Character design: Tetsuya Nomura.

is a sensual, materialistic, hyperfeminine character, whereas Yuna is androgenous, understated, and more focused on the spiritual. Both blend strong fighting skills with more traditionally feminine qualities.

Industry watchdog research suggests that female player-characters that are appealing to female players are still underrepresented in current games, helping to contribute to why girls play less. Even when player characters are biologically female, they are still "aggressive and have the physical attributes of a male-defined sex symbol" (Subrahmanyam and Greenfield 1998, 59). Also, see (Children Now 2001) for an analysis of player-characters in top-selling games. A character that a male enjoys watching may or may not be one that a female enjoys inhabiting. It depends upon her own ability to project herself into the role of that character and to feel excited and empowered by her abilities in game play.

Reactions to Girls

Another way to engage female gamers is to acknowledge gender in the ways that nonplayer-characters (NPCs) relate to the player. Gender has a big social impact in real life—males and females are treated differently in both subtle and not-so-subtle ways, in every culture. If NPCs do not acknowledge a player's gender when this would happen in real life, or worse, react as if the player is of the wrong gender when the player is not interested in gender play, this can throw the player right out of her willing suspension of disbelief. Conversely, the appeal of an NPC to the player may depend on his or her gender.

The Impact of Gender-Based Attraction

One motivation for social interaction is sexual interest, for both men and women. It is important, when designing NPC reactions to the player-character, to consider how well the player's own desires map onto the design. For example, (heterosexual) female players may not respond as strongly and positively to characters like Cortana of *Halo*, or Princess Yorda in *ICO*, who draw part of their appeal from being attractive women that the male player is drawn to visually. By contrast, an NPC such as Auron from *Final Fantasy X* has a strong appeal to (heterosexual) female gamers as both a romantic figure and a mentor (see Figure 4.11).

Games with cartoonish, nonhuman characters avoid this issue entirely by removing physical attraction from the palette of the designer, which may help to explain their broader cross-gender appeal (see Figure 4.12).

Gender and Assumptions about the Player-Character

Acknowledging gender in a game and building gendered behavior into reactions to the player-character may make the game more immersive and interesting both for girls who want to play female characters and for boys who want to try out what it

FIGURE
4.11

a b

(a) Cortana, the computer guide (from *Halo*), has visual appeal for male gamers, (b) Auron, (from *Final Fantasy X*) may be a more attractive mentor for female gamers. (a) Screenshot from *Halo®: Combat Evolved.* ©2005 Microsoft Corporation. All rights reserved. (b) ©2001 Square Enix Co., Ltd. Character Design: Tetsuya Nomura.

FIGURE
4.12

The cartoonish and nonhuman appearance of characters in *Animal Crossing* tends to minimize the impact of sex appeal on a player's reactions. Image courtesy of Nintendo.

is like to use female social strategies and deal with gendered assumptions. The trick is to avoid simply replicating annoying gender-based behaviors (such as those that sometimes occur in games like *Star Wars: Knights of the Old Republic*; see Figure 4.13). Gender-based behavior in the game should ideally add value to the player's experience not just low-grade, real-world sexism.

FIGURE
4.13

Star Wars: Knights of the Old Republic varies NPC reactions based on player-character gender, but the interactions do not necessarily always add to a female player's gaming experience. This NPC flirts with a female player character, which he will not do with male player characters. ©2003 Lucasfilm Entertainment Company Ltd. All rights reserved.

4.3 Design Pointers

Knowing about these gender variations in game and character preferences, how do you design a game with characters that will be a success with female gamers? Based on the findings discussed in this chapter, there are a few things I would recommend.

First, decide whether the aim is to design a game that appeals to *both* genders or one that is targeted toward female gamers specifically. If the answer is a game with broad cross-gender appeal, here are a few pointers:

- Don't accidentally leave out female gamers.
- NPCs should be appealing to both genders and should react in gender-realistic ways, especially if the game has a more photorealistic and mature (as opposed to cartoon) style.
- Core game play should offer a broad enough range of actions and goals to support both female and male play preferences and strengths. This means it is ideal to avoid extremely goal-driven play, purely spatial navigation without good landmarks, and unmotivated aggression. It also means you may gain audience members by including some form of communication and social play qualities and by including some nonviolent ways to participate (such as collecting, collaborating, or building).
- Offer flexible character choices so players can choose not only which gender but how extremely gendered they want to be.

If you want to specifically target female gamers:

- Design female player characters that are relevant archetypes or that offer customization.
- Make sure NPCs react in ways that enhance the player's experience of her character. Consider whether NPCs are attractive and engaging to the female eye.
- Consider developing deeper backstory and connections between characters.
- Think about moving beyond traditional genres, as *The Sims*™ and *Animal Crossing* did, to embed female-friendly play styles (collaboration, communication, building, and everyday life metaphors) more deeply into the core play mechanics of the game.

In either case, I would also recommend two tweaks to the design process that will increase the odds of success: early and frequent play-testing by females in the target audience group and the inclusion of women in the game development team. The latter helps ensure that early brainstorming sessions, design documents, and prototypes will be shaped in a way that supports female game play. With the inevitable fast and furious design-and-build time frame, this is the safest way to ensure that a game will truly appeal to female gamers.

4.4 Interviews with Gamers—Personal Perspectives

Gathering data from real people who play is the best way to ensure that a game's character designs truly work. To help show the value and richness of individual perspectives (versus relying on generalizations about broad patterns), I have included two interviews with female gamers and one with a male gamer about their gaming histories and preferences. I hope these will serve as inspiration for incorporating—early and often—both men and women who fall into target audience segments into design teams and test groups as a game is designed.

4.4.1 *Interview: Sarah Walter*

Sarah Walter grew up with computer games in the house, thanks to her father encouraging a computing hobby. She received a BS from UCLA in cognitive

science, specializing in computing. For the next two years, she worked as an interaction designer for mainstream Web sites and applications, straddling the line between users and implementation. Currently living in San Francisco, Sarah is pursuing a PhD in learning sciences and technology design at Stanford University, focusing her research on informal learning with games and gender differences in gaming. She recently interned in the video game industry in a production role.

Q: First off, what games do you like to play? List a few favorites and why you love them. Also, tell me a bit about the kinds of genres you like and why.

This is a tough question; I normally respond with my current addictions, though a few games stand out in my history of gaming Adventure games, text-based and otherwise, have been a favorite, for their problem-solving game play and story lines. Old addictions include the *King's Quest* series, *Maniac Mansion* and *Day of the Tentacle*, and the *Laura Bow* and *Monkey Island* series. *Below the Root* for the Apple IIc was based on a series by one of my favorite authors at the time, which pretty much blew me away. The game was an early favorite. I loved that the designer of several 1980s to 1990s Sierra adventure games was a woman, Roberta Williams; this fact most definitely contributed to my early desire to design games.

Freely exploring another world totally draws me in, as in *GTA 3* and up. There's nothing like plowing down innocent pedestrians in a stolen car while listening to old school Michael Jackson. *The Legend of Zelda: The Windwaker* is phenomenal. I love Nintendo's colorful style, and the vast world offers plenty of exploration.

In my next life I'd like to be an architect, but for this life, I'll keep playing the *SimCity*™ and *Sims*™ series to satisfy this building urge. Earlier, I played *Rocky's Boots* and *The Incredible Machine* for the same reason. I also love any game that makes me tap into logic skills, like these latter two games, as well as *Advance Wars* and any game requiring stealth.

FIGURE
4.14

Sarah Walter

Q: How did you get into gaming?

My dad drew me in to his computing hobby when I was in grade school. We had games for our Apple IIc, Atari, and later the x86 machines. He subscribed to a service which mailed out 5.25-inch floppies full of small applications every month or so. I searched for the games in each of these disks. I also played *Carmen San Diego* with grade-school friends; we each had a certain task for the game, such as fact-checker, note-taker, and driver. We played this single-person game as a team. Playing video games with girl friends fell off as we grew up, unfortunately, although by age 14, I knew I wanted to design games that encourage thinking and learning.

Q: What are your play patterns? (When do you play and for how long? For what reasons? Alone or with others?)

I was a closet gamer during high school and college. Now I try to recruit friends to play games with me, like *Halo*, in cooperative mode. I play competitively too, but as neither my boyfriend nor I like to lose, it is probably best we play together against the machine.

I play games by myself to escape, or decompress, at the day's end. One of my favorites now is the *Advance Wars* series on the GBA (Game Boy Advance); it is a great way to get in 15 minutes of one complete game, enough to tide me over for a bit, or while waiting in airports, etc. Although, it is easy for me to sink an entire day engrossed in a game, even if I tell myself I'm just decompressing. Other times, I will turn to a game for the same reasons I turn to a good novel, to immerse myself in this other world.

I'd love to play more games with friends, but the selection of great multiplayer games seems slim right now, at least for my preferences. I don't enjoy realistic sports games, and most of the rich story lines and environments seem to exist in single-player games at the present. I would love to see the industry work to make more types of games to play with people in the same room, as opposed to over a network.

Q: Did you or do you take any guff from folks for being a female who likes playing games? How do you feel about it?

I've gotten slack for being a gamer in general, not for being a female gamer specifically. I definitely have felt out of place at GDC (Game Developers Conference), E3 (Electronic Entertainment Expo), or in the games aisle at the store, but this is more a product of my mind than a result of others' actions towards me.

Q: How do the men in your life feel about your gaming habits? Do you play games with other gals? With other guys?

I've turned my boyfriend, Brent, into a *Halo* addict. He says he is not a gamer, but I have introduced him to a game or two, only to find him in the same position hours later, trying to complete a level. Another of my close male friends now comes over

123

to challenge Brent at *NCAA Football*. It is hilarious how worked up they get. I'll play other games with them, like *SSX*™, shooting or racing games, but not the realistic sports games.

Brent just reminded me to include how annoying my current addiction to *Advance Wars* is. Apparently, I turn into a "zombie" for a couple hours while playing a few levels of this game. I think that he does not want to play, fearing he will become addicted as well. I seldom play games with my girl friends. While interning at EA over the summer, a few interns and employees started a girls' gaming night. These evenings are a lot of fun since I have not had a videogame-playing group of girl friends since grade school. We play whatever strikes us at the moment, from *Mario Party* to *SSX*™ *3* to *Katamari Damaci* on a Japanese PS2. My guess would be that we feel comfortable exploring a new game or genre in this setting, as our experiences with games range quite a bit. Learning with an advanced group, male or female, can be intimidating, just as it would be for any domain.

Q: Do you think your own gaming interests are "typical" of female gamers? Why or why not?

Yup, when I mentioned *Halo* in "cooperative" mode, that was a big female flag; however, I'm still killing aliens, which many people think is not a "girl" thing. A female gamer friend and I recently had several of our female grad student friends get together to play some console games. We were both pleasantly surprised when they wanted to stop playing *Mario Party* so they could "kill stuff." As with any generalization, typical female game-play patterns sometimes don't apply.

Q: What advice would you give to designers hoping to craft games to appeal to you as a female gamer?

The problem of attracting females to video games is the same as attracting any new user to the game. Involve a wide range of gamers, including females, in the design. Test concepts and game play with females as well as males, early and often throughout the design process. It is not that girls don't want to play; find a hook to draw the women into the game; think about women who might be in the room while the men in their lives are playing. Talk to them. From what I have seen, game designers have been designing mostly for the people in their own buildings. This has been successful for part of the population so far, but as the generations infused with technology grow up and game design advances, games will no doubt start to appeal to a wider audience.

Q: Have you or do you have any interest in being a part of the game-design business? In what ways?

I interned at EA/Maxis during the summer of 2004, on the final stages of *The Sims*™ *2.0* production. I was involved from alpha to release, helping to run short- and long-term

play tests, and working with the production team to get the product finished It was a blast. I hope to return to the industry after I finish my doctorate.

4.4.2 Interview: Stephanie Bergman

Stephanie Bergman is an avid gamer who spoke out about her non-"girlie" preferences in games as part of a chapter highlighting Game Grrlz voices in *From Barbie to Mortal Kombat* (Cassell and Jenkins 1998). I caught up with Bergman in 2004 to get further insight into her experiences as a girl gamer.

Q: First off, what games do you like to play? List a few favorites and why you love them. Also, tell me a bit about the kinds of genres you like and why.

My all-time favorite game would have to be the multi-user *Dungem* (*MUD)* I was fairly addicted to in college. Role-playing games (RPGs) are definitely my absolute favorite genre overall—I love creating a character and burying myself in a story line. I'm also very, very prone to becoming solidly addicted to online games. I was an early beta tester for three different online RPGs (what you could sort of consider graphical evolutions of my old MUD). *EverQuest* and *Asheron's Call* are still around of the two, and as soon as they launched in the retail version, I stopped playing out of necessity. I just knew that if I kept playing I would never stop. I remember far too many nights where I would be online at 4 a.m. with a bunch of people trying to solve one more quest or trying to get myself up one more level.

I concentrate these days on playing single-player role-playing games instead. They have a shorter life span, in that I finish them and they're done—they don't really have very much replay value—so at least they only suck my life away for a few weeks instead of multiple months. I love the *Final Fantasy* series of games and am nearly finished with *Kingdom Hearts*, which is a very cute combination of two of my favorite things—*Final Fantasy* and Disney.

On the flip side of my gaming interests, I also love first-person shooters, which are rather violent, agressive games. Unlike RPGs, I can jump into a first-person shooter, play for 20 minutes, and feel completely satisfied. It's a wonderful way to get out a great deal of stress, and a lot of fun. My favorite is still *Quake 3*, which is now considered fairly old, I suppose, but it's great to me. I should say, I have been known to be online until 4 a.m. playing *Quake 3* as well, but that was generally due to the people I was playing with—I was part of a *Quake* clan and would hang out with my friends and have matches at all hours of the night. *Quake* also has a team-based variant called *Capture the Flag*, which is a favorite of mine; nothing could possibly compare to the feeling of a group of us working together as a team to win a hard-fought match.

I've also had a blast with the whole *Grand Theft Auto* series; it's a lot of really silly, reckless fun.

I also play more silly games, which I don't really consider games in my silly gamer way of thinking—just the little ones I download onto my handheld—things

like *Hearts*, *Solitaire*, *Bejeweled*—games I play when I am waiting at the airport or something.

Q: How did you get into gaming?

I begged my parents to buy an Atari, and they did. After that, I kept trying out different systems—I played games on our Apple IIc, on various consoles, on handhelds (Game Gear, etc.), until I ended up here.

Online gaming—my brother and I had heard that we could get two computers to play *Doom* against each other if one called the other using a modem. We kept trying, and trying, until suddenly it worked. The second I saw him run across my computer screen I was totally hooked. It was the neatest thing I think I'd ever seen.

Q: What are your play patterns? (When do you play and for how long? For what reasons? Alone or with others?)

It depends on the game I'm playing. RPGs, I think I definitely need a chunk of time to play. They're not fast and quick games, so I reserve them for the weekend.

Shooters I don't play at all anymore, since my computer died (I need to buy a new one). I used to play those at night during the week to let off steam; they were perfect for that. In fact, at my old job, my entire office used to get online every night to play *Quake*. I tell you, there is NOTHING like being able to shoot your boss in the head when you're mad at him. It is a wonderful feeling, and much more productive for the workplace. You can even shout smack talk at him, and it's all considered totally appropriate.

When I was part of a *Quake* clan, I would always play with them—they were a wonderful group of women who I proudly called my sisters. We played in tournaments, had practices, just like any other team—it was just a very different "sport."

Q: Did you or do you take any guff from folks for being a female who likes playing games? How do you feel about it?

Oh, of course. It's gotten better now, but it was terrible when I first got online. In fact, when I first started playing online, I was afraid to use my real name, so I picked the most masculine, manly name I possibly could—I was John Clark (from the Tom Clancy novels).

About six months after I was playing online, there was an all-female *Quake* tournament happening, and I really wanted to play, but in order to do that, I had to "come out," so to speak. So I changed my name. The first time I joined a server as a girl, I was first asked why I had such a gay name for a guy (my nickname was/is Bobbi). I said I was a girl. The guy wrote back that I wasn't—I insisted I was. He said that I must be a lesbian—I told him I'd tell my boyfriend that. He then said that my boyfriend was gay.

That's actually a much tamer story than most. I've been called every name in the book, but the lesbian one comes up most often, that women who play games are butch, aren't real women, what are we thinking, how can we be interested in this.

We'd also be told how if we were women, well, then, we must be terrible, because women couldn't be any good at games. Then, if we beat them, we'd never hear the end of it—that would be when the insults would come out. That would always be a lot of fun, though.

We made a joke out of all of the insults with our clan name, which was Clan PMS (there's even a PMS model in *Quake 3* that you can get!)—PMS stands for Psycho Men Slayers. All very tongue in cheek, but also very appropriate; after all, 99% of the people we would be playing against would be men.

Q: How do the men in your life feel about your gaming habits? Do you play games with other gals? With other guys?

My male friends actually love it and joke that they wish they had a girlfriend who would understand their love for their computer, or their PS2. We have "gaming nights," and have brought games into work on occasion and hung out there playing *Mario Kart*; it's a lot of fun.

The majority of my gaming is done on my PS2 these days, though I just don't have the time to commit to multiplayer games anymore. Single-player games are much more manageable, time-wise.

Q: Do you think your own gaming interests are "typical" of female gamers? Why or why not?

Based on what the statistics show, anyway, they aren't. From what I understand the stats to show, most women these days are playing games like *The Sims*™, or Web-based games like those on the Zone or Pogo. I find those to be boring, more of the fluffier-type games that I was referring to earlier. I like more in-depth, immersive games where there's either a great story and some sort of progression, or some kind of winner and loser.

Q: What advice would you give to designers hoping to craft games to appeal to you as a female gamer?

Don't make games for women.

Back when I got my Atari, there was Pong, and I loved it. It was just Pong, though; it wasn't made for women or men. And it was perfect.

These days, there are companies making games specifically for girls, and nearly 100% across the board, I find them to be horrible. They're dumbing down the concept of games, thinking that THAT is what women are looking for. If they actually look at where women are—*The Sims*™, *Pogo*—those are asexual games. All game developers need to do is make good games. Women will follow.

A few years ago I saw some boys teasing a girl on a subway in NYC because she wanted to talk about the racing game they'd been talking about; they were teasing her that she should have been more interested in *Lara Croft* because "that's a girl's game." The look on that little girl's face as the boys teased her is not something I am about to

forget. THAT's what making girl games is starting to do to the gaming industry; it's forcing people to classify games as male and female, and it's already affecting little kids. It's a very, very dangerous path to go down.

People have fought for years to have workplaces and schools not be classified by gender—why are we doing it to games? It's taking a huge step back.

Q: Have you or do you have any interest in being a part of the game-design business? In what ways?

I used to write for a few different online publications about the gaming industry (the main one is still up and archived at *http://www.loonygames.com)*, and I also coproduced and cohosted an internet television show specifically targeted towards women. (My day job at the time was cohosting and producing another daily show about gaming—but my baby was my show about women and games.)

I loved doing that—it was great being head-deep in an industry that I loved, and I especially adored being able to be in a situation where we could do something specifically for women. We targeted our show towards women who were first getting online and might not know as much about games, and we did a lot of segments teaching more basic things than our other programming would have covered—how to set up networking for games, how to install mouse drivers—things that may seem simple to a lot of people, so simple that nobody ever explains it anywhere.

We were also able to do our own female *Quake* tournament—the same type that had gotten me to "come out of the closet" years before, but on a much larger scale. We flew the finalists in our tournament from all around the country (one came from Alaska!) to NY for the finals, gave them a real New York City experience that only a woman could enjoy—a spa day at Elizabeth Arden—and had the main event at a large *Quake* tournament held right in downtown NYC. The women were even taken out to dinner by John Romero and Stevie "Killcreek" Case. John Romero's one of the original creators of *Doom* and *Quake*, and Stevie's probably one of the best-known women in the gaming industry.

Now I definitely would love to get back into the industry someday. I love the people, and obviously I love the games and the technology. But I'm not a programmer, so my ability to actually be involved is somewhat limited. I also am very happy in my current position, so I'm staying where I am for now.

4.4.3 Interview: Daniel Condaxis

Daniel Condaxis is an undergraduate student at Rensselaer Polytechnic Institute, with an interest in game design and development.

Q: First off, what games do you like to play? List a few favorites and why you love them. Also, tell me a bit about the kinds of genres you like and why.

I'm a huge fan of the *Final Fantasy* series, and similar RPGs in general (*The Legend of Dragoon, Xenogears,* etc). I also like adventure games in the style of *The Legend of*

FIGURE
4.15

Daniel Condaxis

Zelda and *Kingdom Hearts*. Action games like *Devil May Cry* and *Zone of the Enders* are nice, but I find them to be a bit short. It's the story and the characters of a game that drive me to play them. Game play is essential, of course, but I'd rather have a massive plot with twists and turns, character growth, and emotional cinematics than any amount of high-resolution graphics (though I won't complain if a game has both).

Q: How did you get into gaming?

I only played a few games at first. Things like the original *Castle Wolfenstein* and *Star Trek 25th Anniversary* were my first exposure to games. I also got into *Half-Life* when it first came out. However, it wasn't until I began playing *The Legend of Zelda: The Ocarina of Time* and *Final Fantasy VII* that I really started to consider myself a "serious" gamer. Afterwards, I followed the *Final Fantasy* series and became increasingly interested in Japanese-style RPGs and adventure games.

Q: What are your play patterns? (When do you play and for how long? For what reasons? Alone or with others?)

How and when I play depends on the kind of game I'm playing. I typically play in the evenings or on weekends, when I have a good chunk of free time and nothing scheduled. I'll also play between other important tasks to clear my head. If I'm playing an RPG, I'll sit down for anywhere from half an hour to two hours or so, trying to get as far as I can into the story before other things pull me away. If I'm playing an action game, it's typically a much shorter session, usually no more than an hour, or until I complete a level or three. Adventure games are much more varied. Typically, I'll play until I reach a point where there aren't any pressing quests or important questions to be answered. Sometimes, I'll play quick little games like *Warning Forever* or *Squares* when I don't want to start my work

immediately, or I just need a break. These games only last for 10 minutes or so, so they don't take too long to go through, and provide a quick distraction.

Q: Do you think your own gaming interests and patterns are "typical" of male gamers? Why or why not?

It really depends, I suppose. I know some guys who play just like I do and many more who are completely different. However, I'd have to say that I'm not altogether the most common type of male gamer. While I enjoy action games and first-person shooters for a quick distraction or an outlet after a frustrating day, I prefer much deeper and more complex games. I don't like being stuck in the role of a faceless, nameless grunt mowing down alien horrors for no good reason, unless I'm allowed to explore to my heart's content. I tend to enjoy putting myself in the place of a much more driven and intricate character. That's probably why I enjoy RPGs so much, especially Japanese titles. They tend to have incredibly intricate plots and characters with multiple driving forces behind their actions. For example, you can compare Zidane, the lead character of *Final Fantasy IX*, to the faceless "hero" of *Diablo II*. Zidane's character is exposed throughout the game, showing him as a wise-cracking, flirtatious rogue who actually cares about people and will do almost anything to help others but still thinks about his actions first. On the other hand, the player-character of *Diablo II* is defined solely by his or her class. They have no backstory, no personality, and no real identifying characteristics. In that game, all you are is the armor you wear and the attacks you choose. You're a schmuck who just happens to be the only one who can save the world. I'm not a fan of those kinds of characters.

Q: Did you or do you take any guff from folks for being a guy who likes playing games that usually appeal to females? How do you feel about it?

Not really. I do tend to get defensive when people make fun of games I like, especially the *Final Fantasy* series. Some people complain that they're boring, or constantly whine about the turn-based combat and the angst-filled characters. But that's more of a general thing. It's just a personal preference of mine, and I really don't care what other people expect. I just find it sad how slanted the advertising and business of games seem to be. For example, in its first day of release, *Halo 2* sold over two million copies. While I haven't played the game, it looks to me to be just another formulaic shooter with really flashy graphics and weapons that make pretty explosions. On the other hand, almost no one outside the fan-base even knows when a *Final Fantasy* game comes out. It's fairly annoying to see so many gamers (primarily male) swooning over that kind of game, whereas a deep and emotional game that takes 40 hours to complete and doesn't involve guns and rockets in every situation is overlooked by a vast majority of gamers.

Q: Do you play games with other guys? With female friends? Does this differ in terms of type of game and style of play?

It always depends on the kind of game. If I'm playing a single-player game or RPG, I'll typically ask if anyone wants to watch, or watch someone else play. If it's an adventure

or action game, I'll sometimes switch off with another person (male or female, it really doesn't matter) so we both get to experience it and help each other out. I also enjoy playing fighting games in multiplayer mode. There's nothing quite as fun as trying to one-up one another without resorting to actual physical conflict.

Q: What advice would you give to designers hoping to craft games to appeal to you as a gamer?

Story, story, story, character, character, character. Every character in a game, no matter how long they stay on screen, has some impact on the story and the player. Don't just send a player and his or her avatar* into a situation for no clear reason. There's really no difference between someone fighting for a good cause and someone who just kills anyone and anything that gets in his way if the good cause is not there. There has to be a REASON for as much of the game play and story as possible. Without justifications for their actions, there's really no reason for players or their avatars to be involved in the game at all.

Q: Have you or do you have any interest in being a part of the game design business? In what ways?

I'm hoping to become a game designer in the future. My primary interest lies in scripting, story, and character design. I couldn't program my way out of a paper bag, but I'm always interested in the basic systems behind games. I want to be able to work with programmers, writers, and other artists to create games that are artistic and deep but still just plain fun. That is really my only goal: to create things that I enjoy making and that others will enjoy playing.

*Avatar: the player's physical representation in a game—a character that is controlled through player actions.

4.5 Summary and What Is Next

This chapter presented research findings on biological and encultured differences between men and women that have an impact on game and character appeal. Two games that succeeded with both genders—*The Sims*™ and *Animal Crossing*—were discussed in light of these findings. The chapter ended with some recommendations for taking gender-based preferences into account in the design process. Though there are certainly other demographic variables to consider when designing characters, this marks the end of the section on player qualities and character design. Part III focuses on the social equipment that a character possesses—face, body, voice—and how to make the most of these from a psychological point of view.

4.6 Exercises

4.6.1 Interviews

Do the people in your design group display typical gender patterns in their play preferences? Conduct interviews of male and female gamers in your group and compare play preferences: genres, favorite games and styles of play, most- and least-liked characters, and specific turn-offs about game play. Compare notes: How many people fell into highly gendered play patterns? How many had counter-gender patterns? What about blended preferences?

4.6.2 Androgynous Game Sketches

Based on the overlap between the male and female preferences you gathered in your interviews, work in teams to design game concepts that will appeal to both genders. As you brainstorm, consider games that have demonstrated cross-gender appeal, such as *The Sims*™ and *Animal Crossing* (discussed in this chapter), and party games such as *Dance Dance Revolution*. What aspects of these games work well to support cross-gender appeal? Incorporate some of these elements into your own design sketches.

4.7 Further Reading

Boone, K. B., and P. Lu. 2000. Gender effects in neurospsychological assessment. In *Handbook of Cross-Cultural Neuropsychology*, eds. Fletcher-Janze, Strickland, and Reynolds, 73–85. New York: Kluwer Academic/Plenum Publishers.

Brunner, C., D. Bennett, and M. Honey. 1998. Girl games and technological desire. In *From Barbie to Mortal Kombat: Gender and Computer Games*, eds. J. Cassell and H. Jenkins, 72–87. Cambridge, MA: The MIT Press.

Cashdan, E. 2003. Hormones and competitive aggression in women. *Aggressive Behavior 29*: 107–115.

Cassell, J., and H. Jenkins, (Eds.) 1998. *From Barbie to Mortal Kombat: Gender and Computer Games*. Cambridge, MA: The MIT Press.

Children Now. 2001. *Fair Play: Violence, Gender and Race in Video Games*. *http://www.childrennow.org/media/video-games/2001/*.

Entertainment Software Association 2002, 2005. Essential Facts About the Computer and Video Game Industry (*http://www.theesa.com/facts/index.php*)

Gorriz, C. M., and C. Medina. 2000. Engaging girls with computers through software games, *Communications of the ACM 43*(1): 42–29.

Kafai, Y. B. 1996 Gender differences in children's construction of video games. In *Interacting with Video*, eds. P. M. Greenfield and R. R. Cocking, 39–66. Norwood, NJ: Ablex Publishing.

Lippa, R. A. 2002. *Gender, Nature, and Nurture*. Mahwah, NJ: Lawrence Erlbaum Associates.

Schmitz, S. 1999. Gender differences in acquisition of environmental knowledge relating to wayfinding behavior, spatial anxiety and self-estimated environmental competencies, *Sex Roles 41*(1/2): 71–93.

Subrahmanyam, K., and P. Greenfield. 1998 Computer games for girls: What makes them play? In *From Barbie to Mortal Kombat: Gender and Computer Games*, eds. J. Cassell and H. Jenkins, 46–67. Cambridge, MA: The MIT Press.

Von der Pahlen, B., R. Lindman, T. Sarkola, H. Mäkisalo, and C. J. P. Eriksson. 2002. An exploratory study on self-evaluated aggression and androgens in women, *Aggressive Behavior* 28: 273–280.

4.8 Acknowledgments

Special thanks to Sarah Walter, Nina Neulight, and Kelli Millwood for research contributions to this chapter.

PARTThree

Using a Character's Social Equipment

What is Covered and Why

Part III turns back toward what is on the screen, diving into the details of social impressions and how they emerge through cues from character faces, bodies, and voices. Chapters 5–7 include examples from games that take maximum advantage of these cues, and each offers specific pointers for incorporating insights into designs. Design tips include areas of social-cue research that are not really being taken advantage of with current character designs and that could give a design a unique edge.

The psychological principles in this section deal with ways that each component of the person—face, body, and voice—contributes to an interaction partner's social and emotional experience. Although face, body, and voice are discussed separately; of course, these modes of expression work together to create overall impressions. When interpreting the behavior of others, people sift through these signals to resolve (or revel in) ambiguities and to sniff out falsehoods. If one aspect of a person's social signals is hard to read or unavailable (for example, in a phone conversation), the observer will lean more heavily on the cues that remain. This means that designers who know that one area of social cues will be weak in a game's characters due to technical or other limitations (such as small screen size or limited memory) can at least partially compensate with higher-quality cues in other modalities.

It is important to keep in mind that the basic behaviors and reactions discussed in Part III are modulated through different cultural influences and training. For example, human beings tend to raise their eyebrows briefly when greeting someone they know already, but in Japan, this impulse is suppressed because it is considered impolite. Use of social signals for audiences beyond the development team should be undertaken with the caveats in Chapter 3—to include members from the target audience on the design team and to make sure to test early and often.

I hope that reading these chapters will give designers valuable insights for directing character development efforts, not only at the animation or sound-design level, but also in terms of integrating the subtle impressions that faces, bodies, and voices make as a whole upon the player. Using these basic building blocks with an eye

toward sculpting the overall social interaction can lead to much more powerful emotional responses and resonance with characters.

Who Will Find Part III Most Useful

This section will be of value to anyone who works on character design (not just artists, animators, and audio specialists). Social cues are conveyed within the context of game action, so adept application of the principles requires the understanding and engagement of programmers and game designers as well as media artists.

Overview of Key Concepts

Faces

Chapter 5 introduces the psychological foundations for the ways that faces work to communicate and encourage emotion, to teach others, to sync people up, and to reflect and forge social relationships.

Reading Faces

The chapter begins with analysis from psychologists who have broken down the components of facial expressions.

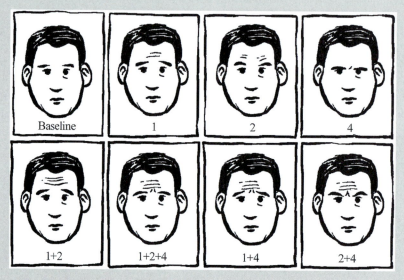

"Action units" for the brow and forehead, mapped out by Ekman and colleagues to better understand emotional expressions. (Based on Knapp and Hall 2002).

Social Learning from Faces

Next, the concept of social learning is discussed—how human beings increase the pace of learning by watching others.

Link (from *Zelda: Windwaker*) has large eyes that make tracking his gaze easy. Image courtesy of Nintendo.

Social Synching—Empathy

This chapter includes a discussion of how emotions that people read in others can be "contagious" and how this applies to crafting player-character faces.

The player-character in *Super Monkey Ball 2* smiles after a successful run. ©Sega Corporation. All rights reserved. Printed with permission.

Social Relationships and the Face

Chapter 5 concludes with a discussion of how people convey their social feelings toward one another, and reinforce social roles, through facial expressions, with a look at excellent character design from *The Legend of Zelda: The Windwaker*.

The nonplayer-characters in *The Legend of Zelda: The Windwaker* show their social relationships to the player-character with their facial expressions. Images courtesy of Nintendo.

Bodies

Chapter 6 shows that bodies are vital in everyday social communication. How, when, and where people move reveals relationships and ongoing shifts in feelings toward others and expresses personalities, moods, and attitudes.

Interpersonal Distance and Touch

This chapter begins with a discussion of interpersonal distance and touch—two simple yet powerful ways people communicate connections with others and perceive them between those they observe.

ICO makes masterful use of interpersonal distance and touch. *ICO* is a trademark of Sony Computer Entertainment America Inc. ©2001 Sony Computer Entertainment America Inc.

138

Imitation

The chapter goes on to address the tendency people have to unconsciously imitate others' postures and what this may indicate about their relationships. This powerful social effect is not currently used in games and is a great opportunity for adding unique social power to a game's characters.

Gesture imitation happens in many everyday social contexts; becoming aware of it can help reveal underlying social structures.

Social Grouping

Chapter 6 also includes a discussion of how people adjust their posture to welcome or stall conversation partners who want to participate in a group conversation. The chapter includes an interview with Chuck Clanton, one of *There's* designers, who worked on the innovative social body language *There* avatars use.

There avatars automatically adjust their posture toward one another as conversations take place.

Bodies and Identity

Chapter 6 concludes with a discussion of ways that psychologists and movement experts have worked to analyze and identify signature movement qualities and parameters that convey meaning about a person's current emotional and physical state and general personality. Making studied use of these parameters in character planning and design could help achieve the kinds of powerful effects that can be seen when contrasting the casual grace of characters in sports games with the endearing awkwardness of the characters in *ICO*.

a b

The movement of athletes in games such as (a) *SSX™ 3* conveys very different personal style and evokes different player emotions than the movement of the more vulnerable, awkward characters in (b) *ICO*. (a) *SSX™ 3* image ©2005 Electronic Arts Inc. *SSX* is a registered trademark of Electronic Arts Inc. in the U. S. and other countries. All rights reserved. (b) *ICO* is a trademark of Sony Computer Entertainment America Inc. ©2001 Sony Computer Entertainment America Inc.

Voices

Emotion in Voice

Chapter 7 begins with a discussion of cues of emotion. The voice can convey a person's unfolding emotions in reaction to what others do and say. These cues can be "read" even when a person does not speak the other's language.

In *The Sims™*, characters speak an incomprehensible language that consists primarily of emotional tones, which manage to give the player a clear picture of what is going on emotionally with and between the Sim characters.

The Sims™ uses emotional tone of voice to reveal what is happening between characters. *The Sims™ Unleashed* image ©2005 Electronic Arts Inc. *The Sims* is a registered trademark of Electronic Arts Inc. in the U. S. and other countries. All rights reserved.

Social Context and Identity

Chapter 7 also discusses the ways that a person's voice conveys information about social status and relationship to the listener. In *Warcraft III: Reign of Chaos*, peons respond in a more submissive tone of voice than other higher-ranking characters when given orders.

NPCs in *Warcraft III* respond to the player in very different tones of voice, depending upon their social status in the game world. *Warcraft III: Reign of Chaos* provided courtesy of Blizzard Entertainment, Inc.

Social Interaction Logistics

Chapter 7 concludes with a discussion of the ways that vocal cues help manage social interaction—as when sounds like "mmmhmmm" are used in everyday conversation to indicate that the other person is listening and to help modulate turn-taking. As games evolve to include voice interfaces among players, these sorts of cues will become increasingly important for crafting believable and engaging character interactions during game play.

Take-Aways from Part III

Part III will give the reader a better understanding of how character faces, bodies, and voices contribute to the quality of social interactions with players. After reading these chapters, a designer will be able to analyze characters she or he has already made, isolating which aspects of a character's social signals are effective and which are not. These chapters will give design teams criteria for directing and improving character design at this level of detail and may help to uncover where problems lie with characters that are somehow not socially engaging and lifelike. These ideas also serve as a foundation for making use of the more general pointers about player-character and nonplayer-character design in Part IV.

CHAPTER Five

The Face

5.1 What Is Covered and Why

Character faces are becoming increasingly important as game graphics capabilities and processing power allow for more visibility of and subtlety in facial expression. What was not possible 20 years ago (when conveying a smile or frown in a sprite (a player character image on-screen during gameplay) was an achievement), is now limited only by the designer's imagination and abilities. Subtle mingling of fear and excitement upon an enemy's face, unmistakable delight of an ally at seeing the player-character—these emotions and more are now possible. This is wonderful insofar as the social power of games is concerned. The face is one of the most important human communication channels.

This chapter introduces some of the social cues people are looking for in one another's faces and offers ways to incorporate them intelligently and appropriately into the design of characters. Game examples are drawn from *The Legend of Zelda: The Windwaker* and *Super Monkey Ball 2*.

5.2 The Psychological Principles

Reading faces is a fundamental aspect of social interaction. There is evidence that there are specific areas of human (and primate) brains devoted to the processing of faces (see Figure 5.1).

5.2.1 *What We Look for in Faces and Why*

Expressions

When interacting, people watch the play of expressions upon the other person's face—the raising or lowering of an eyebrow, crinkles forming around the eyes, or a subtle droop at the corners of the mouth. Researchers who study the movement

FIGURE
5.1

Responses of a neuron in a monkey's area IT to various stimuli. This neuron responds best to a full face, as shown by its response to monkey and human faces in the top two records. Removing the eyes or presenting a caricature of a face reduces the response. This neuron does not respond to a random arrangement of lines. *(From Bruce, Desimone, and Gross 1981.)*

of these muscles have isolated 46 *action units* involved in forming expressions (Ekman, Friesen, and Hagen 2002). Figure 5.2 shows the action units identified for the brows and forehead. Specific combinations of these action units lead people to say that a particular emotion is being expressed. For example, the combination of action units 1 and 2 leads to a label of "surprise." Ekman and his colleagues painstakingly catalogued the individual facial muscles and their combinations and studied how they are used to convey basic emotions such as fear, anger, happiness, and sadness. They then investigated whether people from different cultures identify the same emotions from their database—is a sad face recognized as sad across the globe? The answer seems to be yes.

Why is this the case? Darwin's ground-breaking work on facial expression suggested that human emotional expressions evolved out of involuntary physical reactions that can also be observed in other animals. Today psychologists know that there are some cultural differences in emotion display patterns, but most

FIGURE
5.2

Action units *for the brow and forehead.*

researchers agree on the universality of at least four basic emotions (see Figure 5.3 for illustrations of some forms of these expressions):

- anger (assertion),
- fear (aversion),
- happiness (satisfaction), and
- sadness (disappointment).

Beyond expressing emotions, the movement of the muscles of the face also contributes meaning to conversation. For example, raised eyebrows can be used to emphasize words or phrases in conversation, or to indicate that one is paying attention as another speaks (see Figure 5.4).

Gaze

When watching a person's face, people are also paying close attention to gaze. Where the other looks and whether and for how long they make eye contact, provide important social information. Timing and direction of gaze can indicate

- dominance or submissiveness (patterns of holding or avoiding direct eye contact),
- where a person's attention is at the moment,
- flirtation,
- interest in beginning a conversation (or desire to avoid one),

FIGURE
5.3

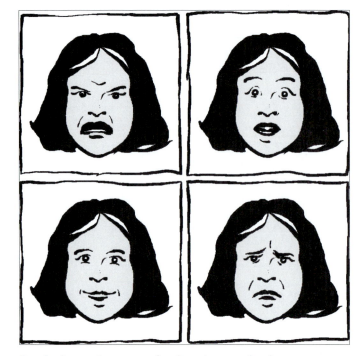

Four basic emotions: anger, fear, happiness, and sadness.

- an invitation for one's conversation partner to take a turn in the dialogue,
- active listening, and
- pondering of a point.

As with expression, patterns of gaze can vary depending upon culture or subculture. For example, lack of sustained mutual gaze might be interpreted as indifference or rudeness by an American person and as politeness by a Japanese person.

5.2.2 *Social Uses of Reading Expression and Gaze*

Social Learning

If you needed to repair something complex for the very first time, would you prefer to do it alone, learning through a combination of manuals and trial and error? Or, would you want to work with another person who was already a repair expert, watching and learning from what they did?

Most likely you would want to do the latter. It is much easier to learn how to do something new with another person who is an expert to watch (see Figure 5.5).

FIGURE
5.4

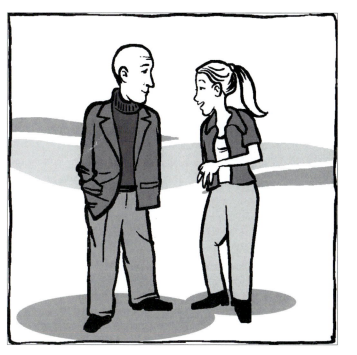

Raised eyebrows can be used in conversation to emphasize a point, or to show that one is listening attentively.

FIGURE
5.5

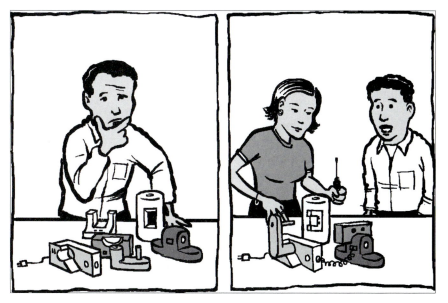

Learning a new task is often much easier when we can watch someone else do it first.

Psychologists have demonstrated that this is a powerful part of being human—a person could never learn all he or she needs to know about life through sheer trial and error. Instead, people learn rapidly and efficiently by watching one another and learning from each others' mistakes and successes. (See [Bandura 1977] for an overview of social learning theory.) The face is one place people look to learn.

What do you think the person in Figure 5.6 sees? What might you do if you were in the same room with this person? You would probably brace yourself for something bad and would look up to see the potential threat.

When people watch another's face to learn about what is happening, they are drawing conclusions about

- where attention is, by following the other's gaze, and
- what the other's emotional reaction is, by reading facial expression.

People put these clues together to help guide quick decisions about what to do to be ready for what may be coming next. Social learning is the ongoing process of watching other peoples' attention shifts, actions, and reactions. The face plays an important role in this process.

FIGURE
5.6

What is this boy so horrified by? If you saw him looking above you with this expression, you would probably look for yourself to see what was so scary.

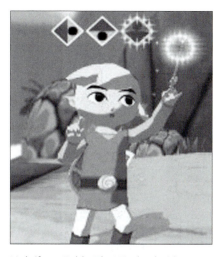

FIGURE
5.7

Link (from *Zelda: The Windwaker*) has an expressive face with large eyes that make gaze tracking easy. Image courtesy of Nintendo.

Players can engage in social learning from well-designed characters just as they do with people. In *The Legend of Zelda: The Windwaker*, the player's character gives hints about what to do and where to go with his large and expressive eyes (see Figure 5.7). For example, in Clip 5.1 on the DVD, Link's gaze is tracking on the lantern that the player must swing from to get across the room. Such subtle cues help guide beginners, or players struggling with the next insight, into the right actions intuitively, avoiding the need for overt hints from guide characters or from the interface itself.

Empathy and Emotional Feedback with Faces

As people scan others' faces for emotional expressions, their own faces involuntarily respond. Mirroring the expression on another's face with your own helps establish connection and demonstrates empathy. During a conversation with someone retelling a sad event, for example, you may mirror the grief in the face of the teller. Listening to a funny story, you may put on a happy expression at the moment when the teller describes a happy surprise, showing that you are emotionally on board for the tale (see Figure 5.8).

Curiously, this mirroring can have an impact on our own emotions (see Figure 5.9). Making a face seems to trigger the emotion that is "faked." The *facial feedback hypothesis*, first proposed by Darwin, has been tested in modern times with a rather ingenious study. Researchers had participants hold a penlike object in their mouth, either with their lips wrapped fully around it or just clenched in the teeth with the mouth open, which triggered use of the muscles that form a smile (see Figure 5.10). The participants were told they were testing ways for disabled people to hold writing utensils. Both sets of people rated how funny the same

149

FIGURE
5.8

Learning social emotion display is a part of childhood development. Some of these children are mirroring the emotions described in the story the teacher is reading.

FIGURE
5.9

Try imitating each of these faces. Did you notice a shift in your own mood in either case? If so, you experienced the *facial feedback hypothesis*.

FIGURE
5.10

Participants in a study who held a penlike object in their mouth in a way that forced them to use their smile muscles rated cartoons as funnier than those who held the object with pursed lips.

cartoons were—those who had a "smile" on their faces rated the cartoons as funnier (Strack, Martin, and Stepper)!

Given the fact that people unconsciously mimic facial expressions when they are sympathetic, and that this can cause an emotional feedback loop, the player-character's face becomes an important tool in a designer's arsenal for crafting the right flow of emotion for players.

Good character designers direct player emotions by using player-characters to underscore desirable feelings (such as triumph or suspense) and to minimize undesirable ones (such as fear or frustration). For example, in *Super Monkey Ball 2*, the player-characters show intense joy when they succeed, and have ongoing cheer and energy-level which make this party game even more fun (see Figure 5.11). In Clip 5.2, the player-character dances while the player selects which obstacle course to tackle next. In Clip 5.3, the player-character celebrates after a win (the cues are especially noticeable in the instant replay at the end of the clip).

In *The Legend of Zelda: The Windwaker*, the designers also help guide and shape the player's emotions through Link's reactions to what is happening. In Clip 5.4 Link is shot out of a cannon by the pirate (see Figure 5.12). His expressions shift from fear to determination as the countdown takes place. During game play, Link's expression is one of resolve and courage, regardless of the obstacles that he faces.

Social Relationships and the Face

The expressions on human faces are not simply automatic reflections of internal feelings nor unconscious imitations of others—they are also consciously controlled social signals that help people connect. Researchers have demonstrated that

FIGURE
5.11

The player-characters in *Super Monkey Ball 2* have clear and engaging emotional reactions to what is happening in game play. ©Sega Corporation. All rights reserved. Reprinted with permission.

FIGURE
5.12

Link prepares to be shot from the cannon. See Clip 5.4 to watch the sequence. Image courtesy of Nintendo.

humans use emotional expressions much more when in the presence of other people (see Figure 5.13). For example, a study of the expressions on the faces of Olympic winners at the moment of victory showed that they generally wore a smile only when they knew others were watching their expressions. The smiles that they put on for others were genuine (not "fake" smiles) but were nonetheless replaced with other expressions in less public moments. Intentionally displayed facial expressions help convey intentions and relationships to others and fulfill social obligations to have certain feelings at certain times (for example, the persistent smile of the flight attendant—see Hochschild, 2003).

FIGURE
5.13

Researchers have demonstrated that people use facial expressions more when others are present.

Some facial expressions that are used to communicate social intent include

- friendly or suspicious expressions (an important first impression factor, as discussed in Chapter 1),
- dominant or submissive facial reactions (also mentioned in Chapter 1), and
- ongoing facial reactions to shared experiences and stories (see Figure 5.14). The degree and manner of empathetic emotions in a person's face helps tell another that he or she is connected and on the storyteller's team. (The ways that social roles shape the use of emotional expressions will be discussed in greater detail in Part IV.)

FIGURE
5.14

The designers of *The Legend of Zelda: The Windwaker* use faces to forge strong connections between characters. Image courtesy of Nintendo.

Great character designers make use of NPC (nonplayer-character) reactions to the player's character to help build connection to game goals and to show the player her social role in the gameworld. In *The Legend of Zelda: The Windwaker*, Link's initial social relationships to three women—his sister (Figure 5.15), his grandmother (Figure 5.16), and a pirate girl (Figure 5.17)—help to quickly and intuitively set up the player's game goals and play style.

Link's little sister is dear to his heart and relies on him entirely. Her face is adoring and trusting (see Figure 5.15). In Clip 5.5, she is stolen from him by an evil bird. The player's motivation to save her is enhanced by the emotional bonds created through the use of facial expressions.

Link's grandmother is very proud of him, and she acts as a slightly smothering mother figure (see Figure 5.16). In Clip 5.6 she gives him the clothes that mark his coming of age, and his reluctance and irritation is classic adolescent behavior.

Petra the Pirate is a bit patronizing to Link, but helps him along (see Figure 5.17). In Clip 5.7, she treats him as a bossy older sister might.

The use of facial expressions as a rich source of information about the NPC's relationship to the player-character is apparent in each clip. These social expressions are a subtle and intuitive way to help guide the player's motivations and intentions.

FIGURE
5.15

Link's little sister gives him her favorite toy as a birthday gift. Image courtesy of Nintendo.

FIGURE
5.16

Link's grandmother is supportive and kind.

FIGURE
5.17

Petra the Pirate makes fun of Link for saying goodbye to his grandmother. Images courtesy of Nintendo.

5.3 Design Pointers

Here are some recommendations for taking game characters further with face-work:

5.3.1 *Give the Character's Face the Right Mobility*

Visual design and animation style should take into account the social messages a designer wants to communicate. If you want to use gaze to teach the player, consider making a character's eyes larger, with high contrast between pupils and whites of eyes, so that gaze direction is easy to determine (like Petra in Figure 5.18). If you want the player to connect emotionally to a character's

FIGURE
5.18

The faces of characters in *The Legend of Zelda: The Windwaker* have simple, exaggerated features that successfully convey subtle emotions. Here, Petra has decided to send Link over to the island with her cannon, but she hasn't let him in on the joke. Image courtesy of Nintendo.

face, make sure that the key expressions—surprise, anger, happiness, and sadness—are quite legible for the player. Your facial modelers and animators may want to take a look at Ekman and Friesen's *Facial Action Coding System* (2002) to make sure you have the right range of motion for the emotions you want to convey. You will also probably want to test how readable expressions are in game-play conditions when the player is focusing on many things at once.

5.3.2 Use the Face to Telegraph Intention
To help guide the player, consider using the technique from *The Legend of Zelda: The Windwaker* presented earlier on page 149 (also used by *Max Payne* and a handful of other games): give the player clues about what is active in the environment through gaze (see Figure 5.19).

5.3.3 Use the Player-Character's Face to Inspire and Control Player Emotions
You can influence the player's emotions by giving the player-character strong positive reactions to happy events and calm and determined reactions to adversity. Think about the emotions you want to enhance or minimize for players when crafting the player-character's emotional reponses (for example, the look of grim determination on the monkey's face in Figure 5.20).

5.3.4 Use NPC Faces to Enhance Social Relationships with the Player
Armed with a plan for the relationships the player-character has with each NPC in your game (for example, by creating a relationship diagram as

FIGURE
5.19

Consider using the player-character's gaze to show the player where to focus. Image courtesy of Nintendo.

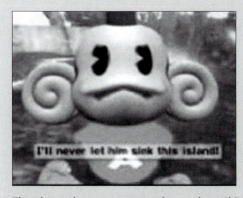

FIGURE
5.20

The player-character vows to thwart the evil Dr. Badboon (*Super Monkey Ball 2*). ©Sega Corporation. All rights reserved. Reprinted with permission.

discussed in Chapter 2), you can map out what sorts of feelings each NPC would have toward the player, at any given moment in the game. Then you can craft the NPCs' facial expressions to show how they feel, evoking reactions from the player to help drive and motivate game play (see Figure 5.21). These emotions might be positive (e.g., nurturing a sister) or negative (e.g., being goaded by a bossy pirate)—both types of emotion can support a player's motivation through relationship-based reactions.

FIGURE
5.21

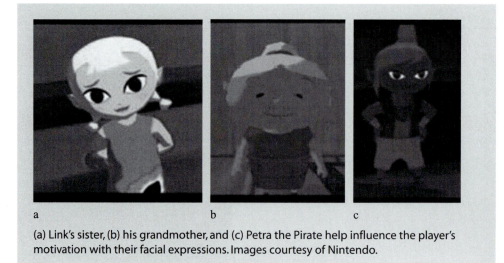

a b c

(a) Link's sister, (b) his grandmother, and (c) Petra the Pirate help influence the player's motivation with their facial expressions. Images courtesy of Nintendo.

5.4 Summary and What Is Next

This chapter highlighted the importance of the face in social interaction, introducing psychological research about how the face is used in social learning, in fostering empathy, and as a communication tool in relationship building. Examples from *The Legend of Zelda: The Windwaker* and *Super Monkey Ball 2* illustrated ways designers can make use of these effects in character designs. Chapter 6 continues this overview of characters' social equipment, turning to bodies and the role they play in social interaction.

5.5 Exercise: Contagious Emotions

Can a character's face really affect your emotions as you play? Test the power of this effect in one of these ways:

1. Using Web cameras, try playing an online turn-taking game (like *tic-tac-toe*, *checkers*, *chess*, or *go*), either with or without being able to see your opponent's face on video as you play. How did seeing his or her face affect the game play experience?

2. Create two versions of a simple flash-based turn-taking game (like *tic-tac-toe*): one version with no faces, and another version that includes an on-screen face for each player that reacts to moves in appropriate ways. Take care in designing the emotional reactions of the characters, and make them fun to watch. Does playing the game with the faces add to (or subtract from) the emotional feel of playing? How so?

5.6 Further Reading

On Social Learning and Decoding Facial Expression

Bandura, A. 1977. *Social Learning Theory*. Englewood Cliffs, NJ: Prentice Hall.

Bruce, C., R. Desimone, and C. Gross. 1981. Visual properties of neurons in a polysensory area in the superior temporal sulcus of the macaque, *J. Neurophys* 46: 369–384.

Ekman, P., and W. V. Friesen. 1978. *The Facial Action Coding System: A Technique for the Measurement of Facial Movement*. Palo Alto: Consulting Psychologists Press. Updated version (2002) with CD-ROM, *http://face-and-emotion.com/dataface/facs/new_version.jsp*.

On Facial Expression, Empathy, and Social Signals

Darwin, C. 1965. *The Expression of the Emotions in Man and Animals*. Chicago: University of Chicago Press.

Ekman, P., W. V. Friesen, and J. C. Hager. 2002. *Facial Action Coding System: The Manual*. On CD-ROM. Salt Lake City, UT: A Human Face. *http://face-and-emotion.com/dataface/facs/new_version.jsp*.

Hochschild, A. R. 2003. The Managed Heart: Commercialization of Human Feeling, Twentieth Anniversary Edition. Berkeley CA: University of Cambridge Press.

Knapp, M. L., and J. A. Hall. 2002. *Nonverbal Communication in Human Interaction*. Australia: Wadsworth Thomson Learning.

Russell, J. A., and J. M. Fernández-Dols. 1987. *The Psychology of Facial Expression*. Cambridge: Cambridge University Press.

Strack, F., L. L. Martin, and S. Stepper. 1988. Inhibiting and facilitating conditions of the human smile: A nonobtrusive test of the facial feedback hypothesis. Journal of Personality and Social Psychology 54, 768–777.

Turner, J. H. 2002. *Face to Face: Toward a Sociological Theory of Interpersonal Behavior*. Stanford, CA: Stanford University Press.

CHAPTER Six

The Body

6.1 What Is Covered and Why

Bodies reveal a wealth of information about people and their relationships. Designers have far more options for range and subtlety in character movement today with better animation tools and more powerful platforms. Although character animators do focus a great deal of attention on the body language of individual characters, there is still little consideration of how characters move in relation to one another. This chapter examines some of the social messages bodies convey, with examples from games that make use of these cues in characters—*ICO, SSX™ 3*, and *There*. The chapter concludes with tips for taking advantage of body language in character design. The chapter also includes an interview with one of the designers of *There* about the forward-thinking choices made in designing the player avatars for this highly social environment.

6.2 The Psychological Principles

Studying human movement and its place in social relations is not an easy task. Until recently, there were no adequate technologies for recording and systematically analyzing motion. Even with these tools in hand, it is difficult to translate insights about holistic impressions of personality or social connection into quantifiable and testable predictions. This predicament is not improved by the fact that most people are dimly, if at all, aware of the incredible impact of bodies in social interaction. Ask the average person if they think body language plays a big part in their assessment of others, and they are likely to say no, even when research results show that they are sensing and making decisions based upon body cues (Nass, Isbister, and Lee 2000).

Body cues have a pervasive influence on social relationships and are therefore an important part of crafting truly engaging game characters that feel lifelike and that evoke social reactions from players. This chapter will present some of what has been unearthed in this still-evolving area of social psychology.

6.2.1 *Bodies Show Relationship*

Interpersonal Distance and Touch

One way to begin considering how bodies work in social interaction is to consider what *proximity* (how close people are together when they interact) says about relationship. Consider Figures 6.1, 6.2, and 6.3 for a moment. Most people guess that the first pair are colleagues or new acquaintances. The second pair tends to look like more familiar friends, and the third pair like a couple. Something as simple as how close people stand together has a profound affect on what they are communicating about their relationship. Edward Hall, a well-known anthropologist, made observations of four zones of interpersonal space in U.S. social contexts:

- *Public distance.* Standing more than 12 feet apart. At this distance, it is easy to see everyone's full body. Typically, people will slightly exaggerate their expressions and movements so that they are easy to interpret.

- *Social distance.* Standing 4 to 12 feet apart. This is the zone that most people hover within at parties—the closer they stand within this range, the better they probably know one another.

FIGURE
6.1

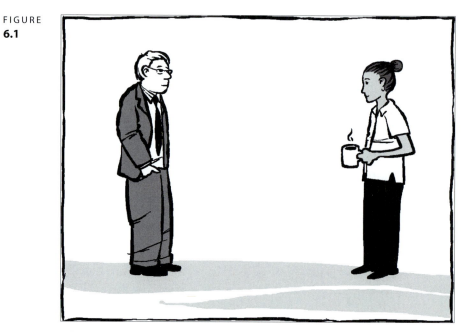

What would you guess the relationship is between these two people?

FIGURE
6.2

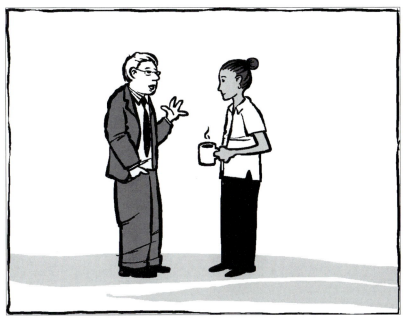

How about the relationship between these two?

FIGURE
6.3

How about these people?

- *Personal distance.* Standing 18 inches to 4 feet apart. At this distance, it is easy to read subtle facial expressions. This is the distance that people use for more private conversations.

- *Intimate distance.* Less than 18 inches apart. This allows the people to easily touch and even to smell one another.

As was mentioned in Chapter 3, social distances vary depending upon culture and subculture, but the principle holds true: people can tell very quickly by the distance between people how likely it is that they are already in a close relationship. Types of touch also contributes to how people perceive relationships (see Figure 6.4). Some key purposes of touch include:

- *Function.* Touch as part of a task, such as a doctor's examination or a coach clarifying a movement.

- *Social ritual.* Rituals such as handshakes or cheek kisses.

- *Friendship building.* Touches that show care and liking for another, such as a pat on the shoulder or a hug.

- *Intimacy.* Touch that expresses sexual interest and/or emotional connection.

FIGURE
6.4

Touch communicates social connection.

164

In *ICO*, the player-character (the young boy carrying the stick) finds a trapped princess very early on in game play. From this moment forward, the player takes care of her. The princess (Yorda), is not really able to defend herself and is not as agile as the player-character. She must be led by the hand to ensure that she tags along, and she needs help over obstacles. When the player battles the shadows that threaten her, she will stay close by (within social distance). (See Figure 6.5 and Clip 6.1 to observe some of their interaction in game play.)

Many players of this game have remarked upon the emotions created by Yorda's dependence upon them. This dependence is expressed almost entirely through body language. By keeping the two characters close, and by using touch as part of game play, the designers build a powerful connection between the player and Yorda.

Imitation

Another way people display relationship through bodies is imitation. Without realizing it, people often unconsciously mimic the postures and movements of those around them (Figure 6.6). Certain circumstances evoke this behavior:

- *When the other person is more dominant.* People tend to imitate those who have more social influence than they do.

- *If seeking assistance.* If a person needs something from another, she or he will begin to adapt the other's poses when making a request.

FIGURE
6.5

ICO makes masterful use of interpersonal distance and touch (see Clip 6.1 to view a bit of in-game interaction). *ICO* is a trademark of Sony Computer Entertainment America Inc.©2001 Sony Computer Entertainment America Inc.

FIGURE
6.6

Gesture imitation happens in many everyday social contexts; becoming aware of it can help reveal underlying social structures.

- *When absorbed in conversation with someone.* Researchers have noticed that gesture synchrony happens more when people are highly engaged with an inter-action.

People tend to avoid imitating someone's postures and gestures if in competition with them (see Figure 6.7).

One way to explore the power of imitation is to do some observation in everyday life. For example, in a meeting at work, it is possible to observe body dynamics: who around the table is already holding similar postures? Are they people who share the same views? If you introduce a new pose (such as clasping your hands on your head), do people take the same pose? To directly observe the unconscious nature of these effects, you might ask them if they were aware that they copied your pose. Most likely, they will say no. Your colleagues can probably tell you who got along with whom in the meeting but may not be able to articulate exactly how body language affected their perceptions.

Social Grouping

People also communicate relationship in the ways they orient themselves toward others during the ebb and flow of group interaction. From a young age, humans learn which groups are open to our approach and which are not by observing whether group members seem to "open up" space as we approach. Turning to acknowledge

FIGURE
6.7

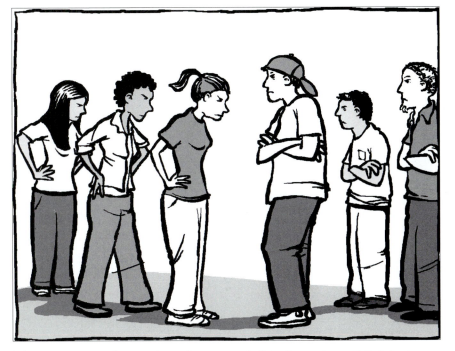

It is not uncommon for members of a group to imitate the postures of their leader.

new arrivals, and including them in the sweep of one's gaze shows acceptance. "Turning a cold shoulder" is likely to cause the new person to hesitate, and if the situation does not change, to move on to some other group (see Figure 6.8).

There are many online 3D social environments and games but few with as natural and inviting a use of body language as *There*. Figure 6.9 and Clip 6.2 show how *There* avatars glance toward the speaker who is taking the current turn and realign themselves as a group to allow newcomers to enter and exit. These subtle automated touches help to tip the balance toward friendly interaction among players. For an in-depth discussion of the design choices made in creating *There*, see Section 6.4 for the interview with Chuck Clanton.

6.2.2 Bodies Communicate Identity

Posture and movement also communicate who people are as social individuals— what they will be like to interact with and what to expect from them.

Each of the people in Figure 6.10 is sending social signals through posture and movement—clues about how they are feeling and about their general persona.

FIGURE
6.8

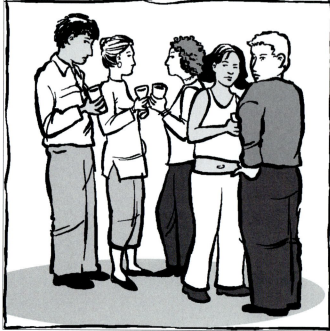

Which group seems more approachable?

FIGURE
6.9

There avatars automatically adjust their posture toward one another as conversations take place. ©2005 There.com. All rights reserved.

FIGURE
6.10

a

Posture and movement can reveal both momentary and more persistent social qualities of a person. For example, (b) and (c) show far more animation than (a), and (b) has a much more expansive gait than (a).

FIGURE
6.10
(Cont'd)

b

c

Putting a name on the kinds of qualities one can observe in these examples, and understanding their underlying dimensions, has been an ongoing challenge for psychologists. Some nonverbal qualities easily map to broader traits, such as friendliness or dominance (which were discussed in Chapter 2). Others seem specific to movement itself. One researcher analyzed nonverbal style by systematically collecting words for movement qualities and asking people to rate friends' movement styles using these words (Gallaher 1992). Based on the results, she came up with a few key factors:

- *Expressiveness*. Using a lot of variety and energy in expressions and gestures when talking with others.
- *Animation*. Showing a lot of energy in general movement—a bouncy walk, quick reactions, and so on.
- *Expansiveness*. Taking up more space with one's body in movement.
- *Coordination*. Moving smoothly and with grace.

She found statistical connections between these movement qualities and personal qualities. For example, someone who was habitually fearful would typically show less expansive movement and less animation.

She also found a gender-related pattern: women tended to score higher on the expressiveness scale, while men scored higher on the expansiveness scale. And she found trends of connection between a person's body type and their movement style: heavier people were rated as less animated and more expansive; taller people were rated as more expansive, and people with more muscle were rated as more animated and coordinated.

Gallaher's findings mesh well with the movement analysis dimensions developed by a famous early-twentieth-century dance researcher, Rudolf Laban (Laban 1974). He created a system of movement analysis in which he coded the following dimensions:

- *Space*. Whether movement is indirect and wandering or to the point (shooing flies versus threading a needle).
- *Weight*. A light movement seems weightless and easy; a strong movement shows much force behind it (brushing your fingers across a flower's petals versus wringing a towel).
- *Time*. Sustained actions seem to take their time; sudden actions are rapid and over quickly (petting a cat versus grabbing the cat as it is about to escape from the house).
- *Flow*. Free movement looks loose and uncontrolled; bound movement looks quite controlled and perhaps even rigid (a dog shaking water off itself versus balancing a biscuit on its nose).

Laban crafted a system of movement notation to diagram the qualities of any given action. In Figure 6.11a Laban's parameters for movement are arranged in a notational space, and in Figure 6.11b, the effort diagram of someone screwing a lighbulb into place shows how the notation gets used for a particular motion.

There has been recent work examining the Laban signatures of emotionally-driven movement, clustering emotional movements into different effort signatures (Fagerberg, Ståhl, and Höök 2004). These researchers found some interesting clusters of emotions (see Figure 6.12):

- Excitement, anger, and surprised–afraid (all flexible, fluent, and quick motions)

- Sulkiness, surprised–interested, pride, satisfaction (all direct, light, bound, and sustained motions)

- Sadness, being in love (sustained, fluent, light, and direct motions)

FIGURE
6.11

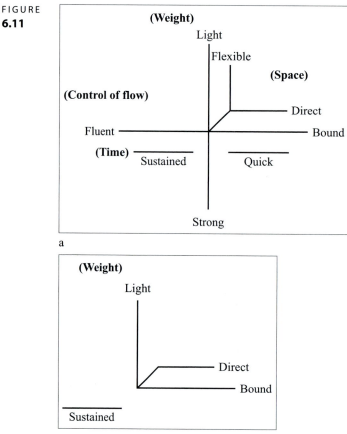

a

b

A Laban effort graph of putting in a lightbulb (based on [Fagerberg, Ståhl, and Höök 2003]).

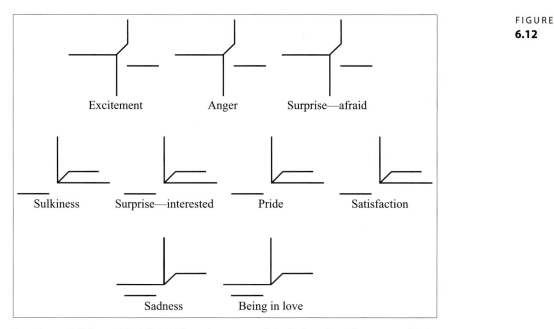

FIGURE
6.12

Fagerberg, Ståhl, and Höök (2003) found patterns of similarity when they created Laban diagrams of an actor's portrayals of emotions (based on [Fagerberg, Ståhl, and Höök 2003]).

There is no definitive empirical strategy for analyzing motion as it expresses emotion, mood, or more enduring personality traits. However, working from Gallaher's and Laban's dimensions, it is possible to create a profile of a character's style of movement that can be useful for a design team in guiding choices about animation details. Thinking about a character's likely emotions in a social encounter, and about the character's overall personality and build and how these will impact motion, will help take full advantage of the character's body as a social instrument.

Designers of professional sports games invest considerable design time in recreating the signature moves and general style of athletes from real-world teams. Even games such as *SSX™ 3* that do not explicitly recreate famous athletes, exaggerate the qualities that everyday people envy in athletes: their high level of coordination and the magical way they have of making difficult movements seem light, weightless, flowing, and with a sense that they have all the time in the world at their disposal (see Figure 6.13). Watching Clip 6.3 while keeping Laban's dimensions of effort—space, weight, time, and flow—in mind, it becomes apparent that these characters lift the player out of the everyday by heightening these qualities.

In contrast, consider again the movements of the player-character and Yorda in *ICO* (see Figure 6.14 and Clip 6.1). Neither has nearly the coordination and

FIGURE
6.13

Sports games such as *SSX™ 3* showcase the signature moves and general grace of athletes. *SSX™ 3* image ©2005 Electronic Arts Inc. *SSX* is a registered trademark of Electronic Arts Inc. in the U.S. and other countries. All rights reserved.

FIGURE
6.14

ICO's player-character and his companion, Yorda, move very differently than sports characters. *ICO* is a trademark of Sony Computer Entertainment America Inc. ©2001 Sony Computer Entertainment America Inc.

smooth grace of the athletes. The player-character uses rapid, sometimes clumsy movements. Yorda is more flowing but also clumsy. Both characters create a sense of vulnerability and dependence through their movements, heightening the tension for the player and perhaps increasing the urge toward teamwork for survival. By manipulating body movements, the designers have subtly pressured the player's game-play strategy and emotions.

6.3 Design Pointers

6.3.1 Think between Characters

When coming up with initial character concepts and sketches, think not just about how each character behaves in isolation but also about the relationships between characters. How does this character feel about that one? How does he express this in how he moves? Does he keep a greater distance from the other? Are his movements more closed and tense around the other? It is possible to provide a much richer and more socially realistic experience for the player if designs are grounded within the larger social framework of the interactions *between* bodies.

6.3.2 Use Touch and Interpersonal Distance

Consider using touch and interpersonal distance to help players understand character relationships and to enhance emotional reactions to what is going on. If a player is being mentored by a character, why not have that character give the player's character a friendly pat on the shoulder? If a player is closer to one character and not friendly with another, show this in how close they stand when they talk and how their bodies orient toward one another. You can even incorporate social touch into core game-play dynamics, as in *ICO*, expanding the notion of physical contact in games beyond trading blows.

6.3.3 Imitation: A Missed Opportunity

The principle of imitation was included in this chapter, although I could not find a good current game example, leading me to believe that this is a powerful, missed design opportunity. Consider how the subtle imitation of a powerful character's movements by more submissive characters could enhance their apparent authority and charisma. Imagine showing shifting alliances in a complex RPG through imitation by characters. Envision showing friendship networks and hierarchies in a social online game through automated imitation by player-characters. Think creatively about making use of imitation.

6.3.4 Group Dynamics

The designers at *There* have demonstrated the value of incorporating group dynamics into 3D chat. When creating a multiplayer environment, consider building and extending from their work to help make the game more socially realistic and engaging.

6.3.5 *Extend a Game's Character-Style Palette*

When planning how characters will move, consider the signature dimensions of body movement that were discussed earlier and choose a palette of physical qualities that evokes the experience you want the player to have. Not all characters should possess the exaggerated grace and flow of professional athletes. ICO is a splendid example of using some awkward movement traits to create a different sort of engaging player experience.

Consider taking time during the design phase to give each character a rating along Gallaher's dimensions: expressiveness, animation, expansiveness, and coordination. When crafting specific animations, Laban's effort dimenions—space, weight, time, and flow—may be useful for helping to capture the personality and mood of a character performing that motion.

6.4 Interview: Chuck Clanton

Chuck Clanton wore many hats during the creation of *There*, including director of user experience, principal designer, and executive producer of social interaction. Clanton was codesigner of this avatar-centric communication project (described in Section 6.2.1 under Social Grouping and discussed in this interview). Prior to joining the *There* team, Clanton was at Bullfrog and Electronic Arts U.K. Studio.

FIGURE
6.15

Chuck Clanton of *There*.

FIGURE
6.16

There is an online social "get-away" environment. ©2005 There.com. All rights reserved.

Q: First of all, a little about There itself: some folks might not consider this a game. What about you? Do you think that There falls within the "game" context? Why or why not? What is or are the primary driver(s) for participation in There for players?

Based on strict definitions, *There* is certainly not a game. It has a physics, which could be considered rules, but there is no way to win or lose. In the entertainment sense, it is a toy, something you use for play. Psychologically, it is an immersive environment, a world, and a place where you can live part of your life.

We thought and talked about *There* as being a virtual world, a place where games could be invented and played. Like the real world, much of the fun surrounds rather than inhabits games. You anticipate a game, you prepare to play or to watch your team, you talk about what happened afterward and are elated or depressed at the results, sharing those feelings with others. Like the real world, games result in social fun outside the game itself.

So, activities in *There* are certainly games. I ran one of the first Buffy Trivia Contests in *There*. It was great fun and definitely a game. One woman knew the answer to every question and was fast on the buzzer. The contest was so one-sided that we all got quite silly and giggly, spending more time talking and razzing each other than actually playing. I talked with contestants and even others who had heard about it for days afterward.

(The winner ended up running most of the Buffy Trivia Contests later because no one wanted to play against her!)

Most people are attracted to *There* because of the opportunity to do fun activities with other people, and they stay in *There* because they form friendships. Fun activities include those available in real life, like shopping for the right outfit, and those that are purely fantasies, like "surfing" the boneyard in Tyr under the full moon on a hoverboard. For some, their avatar is an extension of themselves so they are living in this virtual world.

177

For others, their avatar is a fantasy of some part of themselves they would like to experience and cannot in any other way. An example of this is selecting an avatar of the opposite gender. It is quite thought provoking as a guy to have a female avatar and see all the ways other guys relate to me. (And I enjoy all of the possibilities for clothing that are not available to male avatars. In Elizabethan times, men got to wear all sorts of fancy clothing, but today most finery is reserved for women. In the animal kingdom, adornment of the male is commonplace, often more than of the female. Too bad for modern men, but in a virtual world, you can choose to have a female avatar and take advantage of all of the wonderful clothing that exists in *There*.)

Q: There *seems to be primarily a social activity space. Did this focus of play affect how you developed player-character styling, animation, and actions? How so?*

Yes, very much so. Very early in the development of *There*, we initiated a project called "avatar-centric communication." The team working on this was Jeffrey Ventrella, who codesigned most of this with me; Fernando Paiz, who was our lead engineer and a very creative contributor; and Ko Patel, another very creative engineer who contributed many ideas as well. Tom Melcher, the president at that time, was really our executive producer and a creative contributor as well. We believed very strongly that *There* would be primarily a social place. So talking with others would be extraordinarily important. In real life, talking in person has great value compared to a disembodied voice, like the telephone, or even this email conversation. We knew we needed to express that value in *There* to realize the benefit of having an avatar. Otherwise, you might as well use email and IM. There are several reasons why having a conversation in a body in a place is important. The place itself adds context. Talking while looking out at an incredible vista from the top of a volcano is very different from meeting someone in a small dark tomb whose hidden entrance you just discovered. A crowded bar adds a different flavor than the seashore. The greatest value comes from the body of your avatars, body language.

Body language appears in two ways . . . autonomic and intentional. The autonomic nervous system is what keeps you alive, it runs your heartbeat and breathing. Avatars breath and move around slightly all of the time, just like humans. This makes them seem alive. Intentional expressions are driven by the intentions of the user. You can use the smiley language to smile or laugh or cry. In addition, if you use certain words like "yes" and "no" in your chat balloons, your avatar nods or shakes its head. In fact, we keep track of the emotional state of the body language you use and the level of attention based on how much you are chatting, and change the poses of the avatar continuously to make the ongoing body language of your avatar consistent with the conversation. And finally, there are many elements to body language that create social context. For example, when someone joins a conversation group, everyone looks at them briefly. This makes you feel acknowledged and welcome but is much too small a behavior to require that the user control it. So our avatars do these nearly subconscious social acts as part of their autonomic behavior, and it makes conversations feel much more natural.

The styling of the avatars went through several iterations. Our first avatars were very simple and cartoonlike and incredibly expressive. Cartoon faces can do things that real faces cannot. But they were so cartoonlike that it was hard to "inhabit" the avatar as yourself. We then made avatars that were much more realistic. This caused expressivity of the faces to suffer. So the final version you see today is somewhat less realistic and more expressive.

And just as the avatars are somewhat less realistic in order to be more expressive, we also added emotional expressions that are familiar but not realistic . . . what we call *moodicons*. I can send a big red heart from my chest to yours with the smiley language or cause yellow question marks to rise out of my head. We are all familiar with this language from cartoons, and it has a lot of emotional power that mere expressions do not.

Q: I notice that the There avatars move on their own during chat. Why is this? What did you have in mind when designing these animations? Have you done any play testing of player reactions to this low-level autonomy of their avatars? If so, how did they feel?

I did dozens of play tests as we progressed through the avatar-centric communication project. Of course, we tried many variants and found many dead ends as well as fortuitous discoveries. Social autonomic behaviors have a very significant impact on improving the sense of presence and welcome and involvement in the group. For example, if others look at you when you speak, you feel their presence and you are more likely to talk and feel involved.

Another element that bears mentioning is the camera. In most virtual worlds, there is a single, fixed third-person camera that trails your avatar and creates the experience of having a body in the world. However, in films, the camera is used much more expressively. Studies on the psychology of TV and film show that the bigger an image is on your retina, the greater its emotional impact. That's why the close-up shot in film is used to create emotionally powerful scenes. In *There*, we wanted social interactions to have similar power. So we created a cinematic camera for conversational groups. When someone uses a strong emotional expression like laughing, the camera cuts to their face briefly to give power to that expression. Play testing did prove that this was very powerful, but it could also be annoying. In large conversational groups, the camera cuts felt distracting, and we also noticed that most members used fewer emotions and focused more on chat in that setting. So, over time, we carefully tuned the context where camera cuts would be used.

We also gave users control over the camera so they could accept the default view on joining a conversational group, which shows everyone but is quite distant, or they could rotate and zoom the camera in to better see what they are interested in. So, for example, when seated in the audience at a stage, you can choose to have a close-up camera view of the people on the stage or of the audience or of yourself and your nearest neighbors. In some games, audience members may need to talk among themselves, which is best done with one camera, and then call out answers to someone on a stage, which is best viewed with a different camera.

The camera is one of the most powerful tools in *There* for creating social spaces and increasing the expressive power of body language.

Q: How did the design process unfold? Any anecdotes you are willing to share with readers about choices you made in developing the player-characters for There (body language or any other factors)?

The avatar-centric communication project went through three major phases that reveal the power of iterative design. We created an initial prototype for two avatars where conversations could occur any time the two approached one another face to face. Most of the social and body language features were invented in this phase. Our intelligent cinematic camera worked very well, and we were all sold by this prototype on the success of our approach. Then we added more avatars, and the camera could not be made to work. It is a very hard problem finding good camera angles to view everyone in a conversation when they are allowed to stand in arbitrary positions relative to one another in the world, and without a good camera, most of the emotional power disappears. We needed avatars to be in specific positions to engage in conversation. We invented the *chatprop*, and our first chatprop was the loveseat. The loveseat was a two-person bench where we imagined a couple sitting, talking, flirting, arguing . . . and we made the camera change its position as the avatars changed their poses. If you sat facing your partner, the camera shot would emphasize togetherness. If you turned away, it would emphasize separation. This chatprop was great, but unfortunately it was a dead end. In almost every other chatprop, emotional expression of pose and camera view needed to be separately controlled. Another iteration in our design lead to many chatprops, like a living room with a sofa and two chairs, a stage with audience seats, where camera view is directly controlled. All during this phase, conversational groups could only form when seated, never when standing around in the world because we did not know how to solve the camera problem with free-form groups. We knew what we wanted, but it was very difficult to program. We wanted avatars to be nudged into fixed positions relative to one another when they started talking. And we finally figured out how to do it. So, today if you walk up and talk to another avatar, you are both nudged into a specific position relative to one another, and the camera works correctly to show the conversation and cut to your facial expressions. Others can come up and join the conversation, and everyone moves sideways slightly to let them in.

We began with a simple prototype that allowed conversations in the world to work well, it didn't scale, we had to solve many problems along the way, and finally we came full circle to solving our original problem. Of course, there were many design areas like this. For example, chat balloons rise from each avatar and their order tells you about the conversational order. If they rise too fast, it is impossible to follow the conversation. So we designed a fairly complex scheme to make conversations as legible as possible by keeping the chat balloon ascent as slow as possible during heavy chat.

Q: Do you think your players are conscious of all the body language you've put into the avatars?

I know they are not conscious of it from play-testing results, but it has its intended effect without calling attention to itself.

6.5 Summary and What Is Next

This chapter discussed some of the social cues bodies convey about a person's relationships and identity, using examples from games that make use of these principles. Design suggestions were made for incorporating body cues into character designs, including the missed opportunity of imitation. Chapter 7 will complete this section on using characters' social equipment with a discussion of the power of the voice.

6.6 Exercise: Social Bodies

Watch a movie together, with the sound turned off. Look for the social uses of the body that were discussed in this chapter: interpersonal distance, touch, identity, social grouping, and attitude. As you watch, pause and rewind the movie whenever necessary to get a better look at particular examples. Have one person jot down notes about where and how body dynamics are being used in the film that you can use later as reference. Working in teams, design and begin to animate a party of characters for an RPG that use some of the behaviors you saw, focusing on how the space and actions *between* characters work.

6.7 Further Reading

DePaulo, B. M., and H. S. Friedman. 1998. Nonverbal communication. In *The Handbook of Social Psychology*, eds. D. T. Gilbert, S. T. Fiske, and G. Lindzey. Boston, MA: The McGraw-Hill Companies, Inc.

Fagerberg, P., A. Ståhl, K. Höök. 2003. *Designing Gestures for Affective Input: An Analysis of Effort, Shape, and Valence*. In Proceedings of Mobile Ubiquitous and Multimedia, MUM 2003, Norrköping, Sweden.

Hall, E. T. 1966. *The Hidden Dimension*. New York: Anchor Books, Doubleday.

Gallaher, P. E. 1992. Individual differences in nonverbal behavior: Dimensions of style. *Journal of Personality and Social Psychology 63*(1): 133–145.

Knapp, M. L., and J. A. Hall. 2002. *Nonverbal Communication in Human Interaction*. Australia: Wadsworth Thomson Learning.

Laban, R., and F. C. Lawrence. 1974. *Effort: Economy in Body Movement*. Boston, MA: Plays, Inc.

Nass, C., K. Isbister and E.-J. Lee. 2000. Truth is beauty: Researching embodied conversational agents. In *Embodied Conversational Agents*, eds. J. Cassell, S. Prevost, J. Sullivan, and E. Churchill. Boston, MA: MIT Press.

The Voice

7.1 What Is Covered and Why

Chapters 5 and 6 were about social cues that engage the eyes. This chapter is devoted to the ear. Chapter 7 completes the discussion of characters' basic social equipment with discussion of the voice—the rich messages that people convey through *how* they say things.[1] The chapter includes an overview of the kinds of social cues that the voice conveys, with many listenable examples from games (including *Warcraft III: Reign of Chaos, Final Fantasy X, The Sims™, Grim Fandango*, and *Curse of Monkey Island*), and offers design tips for considering the aural side of social signals when crafting character voices. Chapter 7 also includes discussion of some future-facing voice technology and an interview with two pioneers in using emotion detection from voice cues to adjust interfaces.

7.2 The Psychological Principles

Before reading this section, take a moment to listen to the first two voice samples on the DVD (Clips 7.1 and 7.2). While listening to each person, try to form a mental picture: How old are they? What gender? Is this person of high or low status? Are they in a good or bad mood? Then see Section 7.9 for photos of the speakers. Most likely you correctly identified the majority of these visible traits from voice alone.

Listening to a person's voice on the telephone, you can often make a good guess about age, gender, social status, mood, and other characteristics without any visual cues to help. Even if the person is speaking another language and you cannot understand the meaning of the speech, you can still get pretty far in assessing these qualities. How is this possible?

Researchers point to the evolutionary roots of speech in the grunts and calls of our primate ancestors. There are striking similarities in the vocal characteristics of fright, anger, and dominance, among other social cues, when one compares primate

[1]Analyzing the social meaning of *what* characters say moves into the territory of linguistics, which would require a book in and of itself. For further reading on this topic, see (Clark 1996).

and human voices. Researchers who asked participants in a study to listen to male macaque monkeys found that more than 80% of the listeners could accurately identify what the dominance calls meant (Tusing and Dillard 2000, 149).

Social scientists refer to the information that is not conveyed by the words in speech as *paralinguistic cues*. A large proportion of the meaning in everyday conversation emerges through paralinguistic cues—shifts in voice quality while speaking, pauses, grunts, and other nonlinguistic utterances. Paralinguistic cues play an even bigger role in communication between people who already know each other well—a well-placed sigh or lack of a heartfelt tone conveys volumes. To make characters seem richly human in their communication, then, a designer should have a solid understanding of what they are conveying with *how* they say things.

7.2.1 *The Mechanics of Speech*

To speak, a person pushes air from the lungs through the larynx, mouth, and nose. The pitch and the qualities of sounds are affected in two different ways: phonation and articulation. *Phonation* is the way a person moves the larynx itself to make the initial sound. When the shape of the muscle folds in the larynx (which used to be called the *vocal cords*) is altered, it produces different sound pitches (called *fundamental frequencies*) and also different sound qualities, such as breathiness or harshness. These qualities can shift due to a person's emotional state—tenseness, tiredness, depression, and excitement all can have effects on phonation. *Articulation* is when a person uses the natural resonance of the mouth, nose, and even of the chest cavity, as well as moving the tongue and lips and palate, to alter the sound as it comes out. People are very sensitive to shifts in articulation—for example, a person can "hear" a smile in another's voice, in part because the shift in lip shape when speaking affects the articulation of the sound (see Figure 7.1). Listen to audio Clips 7.3 and 7.4 on the DVD. Can you tell which recording was made while smiling? See Section 7.9 for the answer.

As with facial expression and gesture, some of what people hear in others' voices comes from their physical qualities and their body's involuntary reactions to circumstances. Some comes from learned strategies and responses to social circumstances. For example, gender and age come across in voice because of physical qualities of the person's vocal equipment itself (which can be a problem for people whose voices fall outside the usual range for their gender or age group). Mood and emotion are signalled involuntarily (at least in part) because of changes in vocal production as the person's nervous system reacts—for example, the dry mouth and speedier heart rate of anxiety also have effects on the muscles in the larynx and on breathing itself. However, a person can also mold the tone of his or her voice in some ways, adopting a pacifying, pleading, arrogant, or neutral tone of voice using intonation and rhythm (referred to as *prosody* by researchers). Failing to adopt the proper social tone of voice is a communication in and of itself.

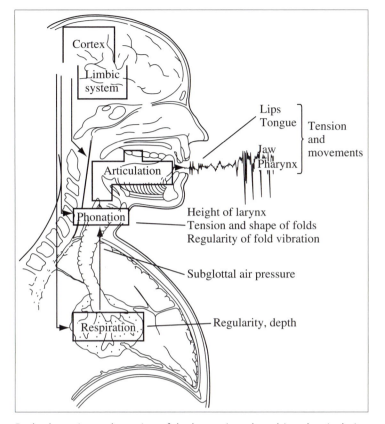

FIGURE
7.1

Both *phonation*— the action of the larynx (vocal cords) and *articulation*— the shaping of the mouth, tongue, and lips—create the subtle alterations in tone that carry social and emotional information (based on Kappas, Hess, and Scherer 1991).

7.2.2 *The Social Signals in Voice*

Emotion in Voice

Emotions underpin decision-making, including social action and reaction (see [Damasio 1994] for a fascinating account of the role of emotions in thinking). Knowing that another person is angry is crucial to understanding how they are interpreting social actions and the world at large, thus helping to predict what they might do next. Failure to recognize emotional expression is a serious liability in human interaction—it is in fact a symptom of some disorders in the autism spectrum.

Chapter 5 touched upon Ekman and colleagues' work on recognizing facial expressions of emotion. There has also been extensive work on the expression of emotion in the voice. Voice researchers have found, when they look for consistent signatures of emotions, that there are clear patterns (see [Kappas, Hess, and

Scherer 1991; Cahn 1990; and Burkhardt and Sendlmeier 2000] for more detail on the taxonomy that follows):

- *Anger (hot)*. Tense voice, faster speech rate, higher pitch, broader pitch range
- *Anger (cold)*. Tense voice, faster speech rate, higher fundamental frequency and intensity, tendency toward downward-directed intonation contours
- *Joy*. Faster speech rate, raised pitch, broader pitch range, rising pitch pattern
- *Fear*. Raised pitch, faster speech rate, broadened range, high-frequency energy
- *Boredom*. Slower speech rate, additional lengthening of stressed syllables, lowered pitch, reduced pitch range and variability
- *Sadness (crying despair)*. Slower speech rate, raised pitch, narrowed pitch range, narrowed variability
- *Sadness (quiet sorrow)*. Slower speech rate, lowered pitch, narrower pitch range, narrower variability, downward-directed contours, lower mean intensity, less precision of articulation
- *Depression*. Lower intensity and dynamic range, downward contours

Notice the similarities among emotions—fear, anger, and joy all seem to be signalled by faster speech, higher pitch, and more range. In contrast, quiet sadness, depression, and boredom share slowing of pace, lower pitch, and less variability. These effects can be traced back to what is going on in the person's nervous system. The arousal of a person's sympathetic nervous system, which causes things like increased heart rate and sweating, also causes these changes in the voice. When a person's parasympathetic system, which decreases blood pressure and slows heartrate, moves into action, it also shifts what happens in the voice itself. A glance back at the Laban movement graphs in Chapter 6 (Figures 6.12 and 6.13) shows that body movement style also seems to be modulated in this way.

So how do people learn to tell apart the high-energy or low-energy emotions in the voice? Certainly they use context contributed by the words themselves, but people are also able to tell what position the mouth is in, based upon sound. As mentioned above, a person can "hear" a smile. Voice researchers have detected different patterns of intonation as well—such as the characteristic rising pitch pattern of joy. It is also the case that people acclimate to one another's vocal patterns—knowing someone well includes knowing how they, in particular, signal sadness or joy with their voice.

One game that takes full advantage of the power of paralinguistic cues in conveying emotion is *The Sims*™. Sim characters speak to one another, but their words are entirely incomprehensible. Simlish may be gibberish, but it is laden with emotional signals, and it allows the player to draw conclusions about how his or her Sim is feeling in general, and in relation to other Sim characters (see Figure 7.2). For example, listen to Clip 7.5. As the Sim characters move from joy to jealousy, it is easy to follow along despite the lack of words.

FIGURE
7.2

The Sim language—"Simlish"—uses paralinguistic cues of emotion (listen to Clip 7.5). *The Sims™ Unleashed* image ©2005 Electronic Arts Inc. *The Sims* is a registered trademark of Electronic Arts Inc. in the U.S. and other countries. All rights reserved.

Interestingly, researchers have found connections between the expression of emotion in the human voice and strategies for evoking emotion through music. Two researchers performed a meta-analysis of research that had been done on evoking specific emotions with music, with work on emotions in speech. Data "strongly suggest . . . that there are emotion-specific patterns of acoustic cues that can be used to communicate discrete emotions in both vocal and musical expressions of emotion" (Juslin and Laukka 2003, 799). This makes sense if one considers that the playing of musical instruments tends to reflect the muscular tension and general arousal state of the performer—creating a bridge to the listener into a particular emotional state.

Some games, for example, *Grim Fandango*, make use of this connection between music and emotion to heighten the player's experience of a character's emotional reactions. See Figure 7.3 and Clip 7.6, in which Manny's boss berates him for a

FIGURE
7.3

Grim Fandago uses music to heighten the player's reaction to an NPC's tirade (listen to Clip 7.6). ©1998 Lucasfilm Entertainment Company Ltd. All rights reserved.

mistake. Notice the music in the background, which displays some of the same aural qualities as the boss's tirade.

Social Context and Identity

As researchers begin to assemble a more detailed picture of how the voice contributes to social interaction, one thing they are realizing is that emotion is not necessarily the predominant message communicated. Researchers in Japan who gathered a large body of recorded speech by asking people to wear headsets around in everyday life, found few examples of strong emotion in voices. Day to day, people tended to keep their emotional reactions mostly to themselves. What did show up were big differences in patterns of voice depending upon who the person was speaking to—adjustment based on social roles and relationships (Campbell 2004) and, of course, individual differences in vocal style that emerged from each person's own personality and physical qualities.

Some traces of social roles and relationships in voices can be broken down along the dimensions first discussed in Chapter 2: cues of dominance and of friendliness. People demonstrating dominance tend to lower their voice somewhat and to construct shorter utterances in general. They may sometimes speak more loudly, depending upon the situation. Showing submission with voice involves using a softer, more highly pitched voice, and subordinates tend to say more. As was mentioned earlier in this chapter, these general vocal contours of dominance are true of other primates as well as people. Clips 7.7 and 7.8 demonstrate the difference between dominant and submissive voices. Although the butler (Raoul) is initially very dominant, he moves to submissive obsequiousness in the second clip once Manny has a pass to the VIP lounge (see Figure 7.4). In general, *Grim Fandango*

FIGURE
7.5

The Curse of Monkey Island also makes use of dominance cues to heighten comic effect (listen to Clip 7.9) ©1997 Lucasfilm Entertainment Company Ltd. All rights reserved.

FIGURE
7.6

The peons in *Warcraft III* are charmingly submissive in their voices and responses to player commands (listen to Clip 7.10). *Warcraft III: Reign of chaos* provided courtesy of Blizzard Entertainment, Inc.

makes brilliant use of vocal dominance cues to heighten comic effect. Other examples of games that use dominance cues in similar ways are *The Curse of Monkey Island* (Figure 7.5, Clip 7.9) and *Warcraft III* (Figure 7.6, Clip 7.10).

Friendliness is shown in various ways. Meeting with a friend usually leads to warmth and energy in the voice, the signals of joy. Conversation among close friends includes more range of emotion than between more distant acquaintances—more revelation of personal emotional state and empathizing with the other's state

FIGURE
7.7

The hat-check girl in *Grim Fandango* has a distinctive way of speaking (listen to Clip 7.12).
©1998 Lucasfilm Entertainment Company Ltd. All rights reserved.

through modulation of your own voice. Intimacy with someone is often reflected with a more breathy quality in the voice. For an example of the breathiness of intimacy, contrast the clips from *Grim Fandango* above, with Clip 7.11—a conversation between Manny and his love interest, Meche. Both Manny and Meche have a great deal of breathiness in their voices.

Individual personality can come through in the voice as characteristic patterns of emotion and energy. For example, in *Grim Fandango*, the hat-check girl is a high-energy character who makes rapid turns from enthusiasm to anger (see Figure 7.7, Clip 7.12).

Social Interaction Logistics

Vocal modulations during an interaction show that a person is listening and comprehending and also help to orchestrate turn-taking in conversation. "Back-channel" responses such as "uh hunh" make the speaker feel the listener is engaged with what is happening. People also use such noises to indicate that they are still thinking or to express a range of emotions in response to a statement before they can put them into words.

Games with elaborate and extensive cut scenes, such as *Final Fantasy X*, make artful use of these sorts of cues to reveal the nuances of relationships among characters (see Figure 7.8).

Back-channel responses may be one reason that people enjoy using voice-enabled multiplayer online games as well—players can hear the triumph or despair in one another's voices as they play, heightening the experience itself, and can use vocal cues (e.g., "whoa!" or "uhhhh . . .") to help guide one another's actions.

FIGURE
7.8

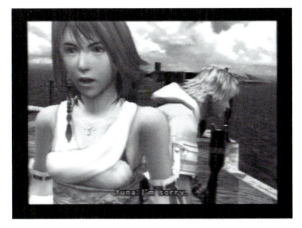

The cut-scenes in *Final Fantasy X* use vocal cues to heighten the player's experience of the NPCs' emotions and unfolding relationships ©2001 Square Enix Co., Ltd. Character Design: Tetsuya Nomura.

Missed Opportunity: Real-Time Vocal Adaptation

Currently, NPCs rarely offer real-time back-channel sounds and comments during game play. Revealing more complex awareness of a player as well as reactions to the player through emotion- and information-laden audio cues as play situations unfold could greatly increase the sense of social presence and connection a player feels toward an NPC. Imagine a sidekick or a just-rescued character gasping as the player executes a tricky move or making a subtle noise of doubt and hesitation as the player starts to move in a fruitless direction.

This will become increasingly practical as voice synthesis becomes more and more realistic, eliminating the need for a huge body of prerecorded audio files (see Section 7.8, for more information about speech synthesis).

7.3 Design Pointers

Here are some suggestions for heightening character impressions for players using vocal cues.

7.3.1 Focus on Relationships

As with body language (Chapter 6), it is helpful in audio design to think about how voice cues will reveal relationships among characters—between NPCs as well as between the player-character and NPCs (see Figure 7.9). When crafting audio, think about the ongoing relationships between characters and their social roles in relation to one another, as well as the moment-to-moment game-play state of the player and how the character can respond to what the player is experiencing.

FIGURE
7.9

Final Fantasy X uses vocal cues to heighten the player's sense of characters' relationships.
©2001 Square Enix Co., Ltd. Character Design: Tetsuya Nomura.

7.3.2 *Give NPCs Audio Personality*

If a character has strong personality traits, make sure they come through in
the voice as well. It is possible to create humorous contrasts between voice
and appearance (as in the case of Daxter from *Jak and Daxter*, discussed in
Chapter 2; see Figure 7.10).

7.3.3 *Use Voice (and Music) as an Emotional Regulator*

Character voices can make a player calmer, more enthusiastic, triumphant, so
use voice to shape a player's emotional experience of game play: light-hearted
words after an intense battle sequence from a sidekick, for example, or a gruff

FIGURE
7.10

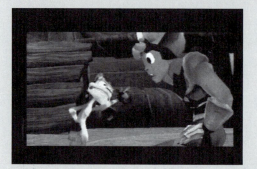

Daxter (from *Jak and Daxter*) has a dominant voice and mannerisms and a small body
(see Clip 2.7). *Jak and Daxter: The Precursor Legacy* is a registered trademark of Sony
Computer Entertainment America Inc. Created and developed by Naughty Dog, Inc.
©2001 Sony Computer Entertainment America Inc.

pep talk from a guide or mentor' if things went badly. Consider using music to bolster the effects of an NPC's words, as well as to help manage player emotions as game play unfolds.

7.3.4 Voice Checklist

When specifying the audio for each character in a game, take a moment to consider each type of social cue. As audio assets are created, revisit the criteria to see if the desired qualities are coming through:

- *Emotional state*. How is this character feeling right now? In general? Toward the player? Toward other NPCs?

- *Social status and context*. What is this character's relationship to the others in the action? In general? What about right now?

- *Interaction logistics with the player and other characters*. How does the character acknowledge the actions and reactions of other characters?

7.4 Future Directions—Emotion Detection

To respond in real time with appropriate emotion, a character needs to know how a player is feeling. Designers can fake this social awareness to some degree because much is known about the state of the player from the game engine itself—did the player just triumph, get badly beaten, and so forth. However, there is work being done on alternative methods for assessing player emotion. Speech researchers have been working for years to be able to detect the traces of emotions in voices. Increases in processing power and in understanding of emotion cues in voices is beginning to lead to results.

7.5 Interview: MIT Media Lab's Zeynep Inanoglu and Ron Caneel

Zeynep Inanoglu and Ron Caneel, graduate students at the MIT Media Laboratory, have created a program and interface for detecting the emotional content of voice messages. The system, called Emotive Alert, looks for vocal patterns indicating valence (positive or negative feelings), activation (level of energy), formality, and urgency. The system is meant to allow the user to sort and prioritize messages and to alert the user to those that are most urgent.

FIGURE
7.11

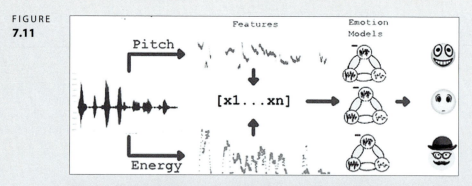

Emotive Alert analyzes the pitch and energy of a voicemail message, applying emotion models to suggest the predominant emotional tone of the message to the user.

Q: What was your inspiration for creating Emotive Alert?

Emotive Alert was mainly inspired by a seminar that we both attended last spring (2004). Both of us had various experiences working with speech signals, so when we came up with the idea, Professor Rosalind Picard, who was giving the seminar, encouraged us to take on this project. It also helped that Zeynep had access to her group's voicemail system and was already using the voicemail data in other projects.

Q: How did you choose the emotions to analyze from the messages?

In addition to the classical valence-arousal dimensions (Russell 1980) (happy/sad and excited/calm) we chose urgency and formality since these are more interesting to look at in the voicemail domain. Since our approach only analyzes prosodic speech features (intonation, perceived loudness, rhythm) we hoped that these features would vary sufficiently in the dimensions that we chose.

Q: Could the method you've evolved for analyzing the messages be helpful for analyzing "trash talk" among players in an online game-play environment?

Our method can be retrained to detect variances from a given speaker's normal speaking style. Acoustically, one would hope that these variances imply unusual behavior (i.e., trash talk in games). However, to make such systems reliable, a key-word spotting capability should also be incorporated along with acoustic tracking.

Q: Where do you think voice analysis and synthesis are heading next? Will there be effective real-time analysis of emotion in conversation? What about lifelike synthesis of emotion in voices?

There is a lot of room to grow in both emotional synthesis and analysis. Effective real-time analysis of emotion in conversation is a possibility, depending on what emotional categories we are tracking. The problem is not only an issue of implementation but also of emotions theories and available emotion data to train these systems on.

7.6 Summary and What Is Next

This chapter described social qualities of voices, including emotion, social context, and identity, and the handling of social logistics in interactions. Design discussion included the power of ongoing vocal feedback, a missed opportunity in making NPCs even more lifelike and engaging, as well as ways to incorporate other social cues into character vocal design. Part IV shifts focus to particular social functions that characters have in games and how these should affect design thinking.

7.7 Exercise: Developing a Social "Ear"

Each person should capture a brief segment from a movie or television show in which two characters are speaking. Take turns listening to (*not* watching) these brief snippets of dialogue in a group and have everyone try to identify the relative social status and relationship of the characters as well as their personality traits, emotional state, and as much of the social context as possible. If there are members of the group fluent in two languages, they should bring snippets from their second language. See if the group can identify status, personality, and emotions regardless of understanding the words. Discuss what it is that you are hearing and which cues are the most legible and accurate (e.g., that the group can most easily identify and agree upon).

7.8 Further Reading

Emotion and Reason

Damasio, A. R. 1994. *Descartes' Error: Emotion, Reason, and the Human Brain.* New York: Quill (an Imprint of HarperCollins Publishers).

Russell, J. A. 1980. A circumplex model of affect. Journal of personality and social psychology 39(1-sup-6) Dec 1980, 1161–1178.

Voice and Emotion

Bachorowski, J. 1999. Vocal expression and perception of emotion. *Current Directions in Psychological Science* 8(2):53–57.

Kappas, A., U. Hess, and K. R. Scherer. 1991. Voice and emotion. In *Fundamentals of Nonverbal Behavior*, eds. R. S. Feldman and B. Rimé, 200–238. Cambridge: Cambridge University Press.

Massaro, D. W., and P. B. Egan. 1996. Perceiving affect from the voice and the face. Psychonomic Bulletin & Review, 3(2), 215–221.

ISCA 2003. *Speech Communication* 40 (1 and 2) April. Special issues on emotion and speech based upon ISCA Speech and Emotion workshop.

van Bezooyen, R. 1984. *Characteristics and Recognizability of Vocal Expressions of Emotion.* Dordrecht, Holland: Foris Publications.

Music and Voice

Juslin, P. N., and P. Laukka. 2003. Communication of emotions in vocal expression and music performance: Different channels, same code? *Psychological Bulletin* 129(5):770–814.

Voice and Social Characteristics

Tepper, D. T., Jr., and R. F. Haase. 2001. Verbal and nonverbal communication of facilitative conditions. In *Helping Skills: The Empirical Foundation* ed. C. E. Hill. Washington, DC: American Psychological Association.

Tusing, K., and J. Dillard. 2000. The sounds of dominance: Vocal precursors of perceived dominance during interpersonal influence. *Human Communication Research* 26:148–171.

Modeling Users from Voice

Fernandez, R., and R. W. Picard. 2003. Modeling Drivers' Speech Under Stress. *Speech Communication* 40:145–149.

Speech Synthesis

Burkhardt, F., and W. F. Sendlmeier. 2000. *Verification of Acoustical Correlates of Emotional Speech Using Formant Synthesis.* In Proceeding ISCA workshop (ITRW) on Speech and Emotion, Belfast 2000. *http://www.qub.ac.uk/en/isca/proceeding.*

Cahn, J. E. 1990. The generation of affect in synthesized speech. *Journal of the American Voice I/O Society* 8 (July):1–19.

Campbell, N. 2004. Getting to the Heart of the Matter: Speech is More Than Just the Expression of Text or Language. LREC Keynote. *http://feast.his.atr.jp/nick/cv.html.*

Murray, I., and J. Arnott. 1993. Toward the simulation of emotion in synthetic speech: A review of the literature on human vocal emotion. *Journal Acoustical Society of America* 2:1097–1108.

Linguistics

Clark, H. H. 1996. *Using Language.* Cambridge: Cambridge University Press.

7.9 Answers to Exercises

See images of the speakers in Clip 7.1(Figure 7.12a) and in Clip 7.2 (Figure 7.12b) below. The person recorded in Clip 7.3 was not smiling; the person in Clip 7.4 was smiling.

FIGURE
7.12

a b

PART Four

Characters in Action

What Is Covered and Why

Part IV asks you to step back from the details of people's social equipment (faces, bodies, voices) to form an integrated understanding of how characters function as a game unfolds. Chapters 8 and 9 introduce psychological concepts relevant to the two major functions that characters play in games: acting as the player's vessel in the game world (player-characters), and providing social companionship and assistance or resistance (nonplayer-characters, or NPCs). Both chapters argue for an integrated approach to character design, working from game-play mechanics upward to develop social and emotional roles for characters that are truly supported in moment-to-moment game play.

As you proceed through these two chapters, you will find that all that has been covered so far factors into the decisions that will be made about character psychology in action. Part IV is, in that sense, the culmination of the theoretical portion of the book. Part V will offer targeted advice about how to apply all of this to the development process, as well as tools for evaluation of character psychology.

Who Will Find Part IV Most Useful

Part IV will be of value to anyone who works on character design (including those who program a character's motion, level designers, and even those creating the physics of the game)! As with the principles in Part III, successful application requires the understanding and engagement of more than the media artists on the project.

Overview of Key Concepts

The Four Layers of Player Characters

Chapter 8 presents four psychological layers in which players experience a player-character.

A player experiences the player-character at many levels while playing. Here are four layers that are useful to consider when making design choices.

Manny from *Grim Fandango,* solving a physical puzzle and chatting with an NPC to glean information.
©1998 Lucasfilm Entertainment Company, Ltd. All rights reserved.

The chapter includes examples from games in various genres, from first-person shooters to adventure games to simulations, with video clips to highlight character features that emerge through play.

Focusing Player-Character Psychology: Tools, Puppets, and Masks

Chapter 8 also discusses subtypes (Section 8.2.3) of player-character that emphasize some layers of the player experience more than others. Examples of tool, puppet, and mask-type player-characters are described, with design criteria.

Super Monkey Ball 2 and *Donkey Kong* are games that have puppet-style player characters. Left image ©Sega Corporation. All rights reserved. Reprinted with permission. Right image courtesy of Nintendo.

Social Roles and Defining Emotional Moments

Chapter 9 presents a concept from social psychology and sociology that can be of great benefit in designing NPCs: social roles. Social roles can provide a framework for predicting where emotional moments with NPCs will be expected by the player and can help designers focus their efforts to achieve maximum effects.

Chapter 9 includes a detailed break-down of the most commonly found social roles in games today, from pets to enemies to audiences, with design pointers focused on creating meaningful social and emotional interactions with the player.

Take-Aways from Part IV

Part IV will give the reader tools drawn from psychological theory for figuring out when and why player-characters and NPCs engage players. Both chapters emphasize the importance of keeping the in-game psychological experience of the player

Aliens from *Space Invaders* are enemies of the player. ©Taito Corporation 1987. All rights reserved.

Crowds watching the action in *Mortal Kombat*. ©Midway Amusement Games, LLC. All rights reserved. *Mortal Kombat*, the dragon logo, Midway, and the Midway logo are registered trademarks of Midway Amusements

in mind and not leaving character development entirely to cut-scenes. The reader will leave with guidelines for focusing development efforts, which should be useful all along the way—from early brainstorming sessions to making tough trade-offs during production—while still preserving the social and emotional impact of characters. As a follow-up, Part V offers concrete advice on how to incorporate these guidelines into the development process.

CHAPTER Eight

Player-Characters

8.1 What Is Covered and Why

Chapter 8 focuses on the central character (in terms of exposure and impact) for the player in most games: the player character. As was mentioned in the preface, one powerful reason for taking a psychological approach to character design is the interactive nature of the gaming experience. Interactivity is at the heart of strong player-character design.

This chapter presents aspects of player psychology—four levels (or layers) at which a player-character will be experienced—that should be considered in an integrated way when designing player-characters. Games that balance these levels well, such as *Half-Life, Max Payne, Grim Fandango,* and *The Sims*™, as well as games which emphasize particular layers with positive effects, are discussed. The chapter includes design tips for tuning player-characters based upon this four-layer model and finishes with an interview with Marc Laidlaw, the writer for *Half-Life* and *Half-Life 2,* about Valve's approach to player-character design.

8.2 The Psychological Principles

Player-characters are at the heart of the interactive experience of gaming. They are the interface through which players experience both the physical and social landscape of the game world. To make good design decisions about a player character, it is helpful to analyze the ways in which the player is reacting to the player character from a psychological point of view.

In everyday life as well as in game play, a person is constantly taking in information from her or his senses and making decisions about what to do next. These decisions are affected by the person's memories and patterns of perception and action that have been developed over a lifetime. While a full discussion of this process is well beyond the limits of this book, this chapter introduces four layers of this psychological process that can provide helpful framing and criteria for player-character design. (To learn more about any of these layers, see Section 8.7 for relevant pointers.)

8.2.1 *The Four Layers*

The four layers of a player's psychological experience of player-characters that this chapter highlights are visceral, cognitive, social, and fantasy (Figure 8.1).

Visceral Feedback

A person experiences the world through the senses. The mind takes in and filters an incredible amount of information—sights, smells, sounds, haptic feedback—and the body is constantly reacting and adapting to what is encountered. The visceral level of a player-character is the sensory experience that a player has of that character, particularly in the sense of feedback from the character to the player as he or she takes action.

When a person "plays" a player-character, she or he takes on the player-character's body in the game world and adapts his or her reactions to the affordances of the game world and to the capabilities of the player-character. Conscious consideration

FIGURE
8.1

A player experiences the player-character at many levels while playing. Here are four layers that are useful to consider when making design choices.

of the visceral qualities of a player-character can produce much higher player satis-faction and engagement with that character.

Facets of visceral feedback include what sorts of physical powers the character has, how it feels to control them and to move through the world, and the general effects that actions have on the senses (usually limited to sight and sound, some-times touch). For example, sports games usually give player-characters a much greater level of athletic ability—strength, speed, and reaction time—than the player likely has in everyday life. Platform-based games often give player-characters much greater leaping capabilities than they would have in real life. Text-based adventure games provide the player with options for witty repartee that she or he would prob-ably not be able to rapidly generate left to his or her own devices. In each case, the player-character provides a pleasurable visceral feedback experience to the player. Every game has a unique visceral style to it, and when there is a player-character, she or he becomes the surrogate body for the player through which the visceral qualities of the game world are experienced.

Cognitive Immersion

A person does not simply react to sensory input in an automatic manner—he or she also considers information that comes in from the world in a more deliberate way and makes decisions about what to do next. Problem solving and taking actions in the world require the player to inhabit the action possibilities of the player charac-ter. What types of actions can this character effect on the game world and on other characters, and how do I build these into a plan of action? The player must map herself or himself cognitively onto the player character. Player-characters that we inhabit intuitively feel this way in part because the player is able to synchronize his or her problem-solving strategies with the capabilities of the character. If the player tries to do things that will not work in the game world, then this mapping is not working well. An example might be a player who tries to talk to an NPC to get help with a puzzle and finds that this is impossible, or a player who tries to use a non-existent jump button to maneuver in a game world.

One aspect of crafting a strong player-character is creating smooth and intuitive cognitive immersion for the player.

Social Affordances

To the extent that a player-character is part of a social world that gives context to the game, either between players or among player-characters and in-game NPCs, designers must also consider the social level at which human beings interpret their world. There are regions of the brain devoted to recognizing social cues—faces and voices and the like (signals that were discussed in Part III). Reading social nuances is an important evolutionary adaptation in human beings, who evolved to live in groups rather than alone (see Section 2.8 for related references). As was discussed in Part II, there is variance in social standards, depending upon gender, culture, and

other variables, which are learned over time. Players will be trying to make sense of the game world in part through the lens of the player-character's social capabilities and context.

Player-characters act as an interesting bridge for the player into a game's social world. First of all, the player-character (when viewed from the third-person perspective) can give a sense of social presence to the player (as with the reactions of the *Super Monkey Ball 2* monkeys when they succeed at a level—see the end of Clip *5.3* and related discussion in Chapter 5). Player-characters also model the social role and emotions the player should be inhabiting in a game through their actions and reactions toward NPCs in cut-scenes. And finally, player-characters offer the player a chance to don a social mask when interacting with other people in a multiplayer game or when manipulating several characters in a party-based game.

An engaging player-character needs the right social affordances for the gameplay situation at hand, from clear social role and personality, as revealed to the player in cut-scenes, to customizability of appearance and social cues in multiplayer situations. The player will feel more immersed in the role of the player-character to the extent that NPCs reflect the player's social role and qualities back to him or her during game play (see Chapter 9, which focuses on NPC social roles).

Fantasy Affordances

The last layer of the psychology of player-characters that should be considered in design takes a step back from modern-day biologically grounded psychology into the territory of Freud and his colleagues. They believed that people's fantasies provided an important window into their past, mental landscape, and action possibilities. Psychologists in the psychoanalytic tradition (such as [Bruno Bettelheim 1989]) have touted the importance of stories and other fantasy vehicles in helping both children and adults come to terms with concerns, explore emotionally laden or thorny problems, or to create a foundation for making an important identity shift. Games advocates such as Gerard Jones describe the ways in which games can provide this sort of outlet for exploration and processing (Jones 2003).

Player-characters are an important component of the fantasy experience of a game. Powerful player-characters are often those that speak to many players' real-life hopes, fears, and issues. They offer players a chance to enact them and explore possibilities.

8.2.2 *Putting It All Together*

Just as the art of game development as a whole lies in the integration of the many components of a game into a fluid and engaging player experience, the crafting of a great player-character lies in the integration of all the layers of the player's experience of the character in action. The player should feel that the character's action possibilities and strategies are engaging and intuitive, that the social

qualities of the character are clear, that she or he can act through this character socially in an intuitive manner, and that his or her fantasy reasons for playing the game are well-supported by this character.

It may help to think of the fantasy layer as a sort of veil or webbing that connects and transforms the other, more bottom-up psychological qualities of the player character. For this reason, it is crucial to make sure, when brainstorming a character's back-story and fantasy persona, that these qualities can emerge for the player out of the game-play experience of that character, given the genre and controller constraints of the core game-play dynamics that the team has in mind. Following are some stellar examples of well-integrated player characters in games from various genres—action, adventure, and simulation.

Two Well-Motivated Killers: Max Payne and Gordon Freeman

Max Payne and *Half-Life* are both games that primarily involve shooting. The player's physical control in the game is limited (for the most part) to choosing and firing weapons and navigating terrain. Yet, unlike many other games in their genre, both *Half-Life* and *Max Payne* manage to weave a compelling social and fantasy kill-or-be-killed world around the player's visceral and cognitive experience. The player's action possibilities feel natural given the constraints of the fantasy world in which she or he is immersed, and interactions with NPCs resonate with and underscore the player's psychological perspective on what is happening.

In *Max Payne*, the title character almost immediately loses his wife and child to burglars who seem to have sinister connections. The opening of the game mingles cut-scenes and game play so that the player almost reaches Max's family before it is too late to save them. Their cries and the aftermath make a strong impression on the player and help to ground Max's vigilante behavior thereafter. The game uses graphic-novel style panels to tell the story of the conspiracy against Max as things progress and to help remind the player of Max's personality and fighting style.

In *Half-Life*, the player-character is Gordon Freeman, low-level scientist in a mysterious facility deep below the desert (see Figure 8.2). After being sent to carry out a dangerous procedure, he and the other scientists find that the ensuing damage to the facility means that its charges (dangerous aliens) have escaped and must be dealt with. Gordon now begins his evolution from lowly lab assistant to competent alien-killer. Along the way, he encounters scientists and lab workers who help him in his mission to escape the facility and warn the authorities. His interactions with these NPCs are brief and practical—there is no time (or need) in the game world for forming relationships. Halfway through the game, he learns that the Marines moving into the facility are actually not on his side, but want to silence him to keep the mess that has occurred in this facility a secret, and so he must begin to fight them as well.

In both games, the "shoot first, ask questions later" tactics of shooter games have been extremely well-motivated by the player-character's persona and positioning within the game world. The fantasy layer of the player-character meshes smoothly with the cognitive and social strategies inherent in the game genre.

207

CHAPTER EIGHT • PLAYER-CHARACTERS

FIGURE
8.2

The player-character in *Half-Life*, Gordon Freeman, is a low-level scientist in a secret government facility who must rise to the challenges of a safety disaster. (The player views Gordon only via the weapon he carries—in this case, a crow bar.) *Half-Life* ©Value Corporation. Used with permission.

Both games use brief and functional interactions with friendly NPCs to help the player stay in character, without distracting from the core game play: killing bad guys. (See Figure 8.3 and Clip 8.4 for an example of a friendly NPC helping the player kill bad guys.) In *Max Payne*, there are very few instances where an

FIGURE
8.3

Players of *Half-Life* learn about the player-character, Gordon Freeman, in part through the actions and reactions of NPCs during game play. (See Clip 8.4 to watch this NPC aid the player in game play.) *Half-Life* ©Value Corporation. Used with permission.

NPC offers to help Max. Usually that character is murdered shortly after providing assistance, underscoring Max's need for vigilance and his reasons for not trusting or getting close to any character in the game.

In *Half-Life*, NPCs that offer their help act frightened and distant and tend to stick to business—plausible reactions to the chaotic situation in the Mesa facility. As in *Max Payne*, NPCs in *Half-Life* have a tendency to be killed rather quickly. The overwhelming majority of interactions with other characters in both games is with enemies that the player must mow down. Both Max Payne and Gordon Freeman are men of action because of circumstances beyond their control, and their minimal social skills and interactions feel perfectly natural in the context of the game world.

The kinesthetic properties of these two characters have been well-chosen to match their social and fantasy personas. Gordon's first weapon is a crow bar—a plausible beginning for a scientist working with what's ready-at-hand as he struggles to figure out what's going on (see Figure 8.4). Killing the crab-like aliens with a crow bar is an extremely satisfying visceral experience for players (see Clip 8.1). By the time Gordon encounters the Marines, he has managed to acquire weapons and expertise that are a match for theirs (see Clip 8.2). The frantic pace of game challenges underscore Gordon's sense of urgency (see Clip 8.3).

Max Payne's nightmarish film-noir world is expressed in game-play kinesthetics as well as cut-scenes. "Bullet time" allows the player to slow time down in the dreamlike style of John Woo movies. Seeing one's breath while trudging along in the snow and other small touches to the physics and visuals of the world help to underscore the isolated, dreamlike feeling of Max's urban-underbelly environment.

FIGURE
8.4

In *Half-Life*, Gordon Freeman's first weapon is the crow bar. *Half-Life* ©Value Corporation. Used with permission.

Some of the game-play scenes are in fact disturbing dream sequences. Max's use of pain killers is a clever way to provide the player with health boosters and to insinuate that Max's sense of reality and time may be distorted.

Overall, both games manage to take the well-worn conventions of the shooter genre and provide the player with a smoothly integrated and immersive psychological experience of the player-character, blending social and fantasy persona, visceral feel and cognitive strategy.

A Man of Wit and Ingenuity: Manny Calivera

Grim Fandango—another game with a player-character that manages to transcend many of the limits of its genre—is an adventure game that consists of puzzle solving in which clues are uncovered through dialogue, exploration, and experimentation (see Figure 8.5).

Manny Calivera, the player-character, is a humorous and sympathetic underdog. He is trapped selling travel packages to the newly dead in order to work off his debt and make the final journey himself. Manny is a small guy who must rely on his wit and ingenuity to get by in a world filled with thugs and goons. His witty patter and cleverness fit the mechanics of an adventure game well—the player enjoys choosing among Manny's dialogue options and seeing what unfolds with NPCs (see Figure 8.8 as well as Clips 7.5, 7.6, and 7.9, discussed in Chapter 7). Manny makes a steady climb in competence and social power as the game progresses, mirroring the player's own growing competence with game play.

Grim Fandango (unlike *Max Payne* or *Half-Life*) keeps things light, despite the dark world of the story, with astute touches such as what happens when a character "dies." In *Grim Fandango*, where everyone is already dead, passing on means being turned into a bed of flowers (Figure 8.6). This helps make the game fit the adventure

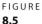
FIGURE
8.5

a b

Manny (from *Grim Fandango*), (a) solving a physical puzzle and (b) chatting with an NPC to glean information. ©1998 Lucasfilm Entertainment Company Ltd. All rights reserved.

FIGURE
8.6

The flowers that Manny is staring at are actually a corpse—in the land of the dead, "killing" someone means turning them into a flower garden. ©1998 Lucasfilm Entertainment Company Ltd. All rights reserved.

genre, where game play is expected to be less viscerally stimulating and more cerebral and where comedy often plays a key role.

Living Dolls: The Sims™

The Sims™, a game discussed already in Chapter 4 in some detail, does a great job of offering players a well-integrated player-character experience of a wholly different sort.

Likened to a "living dollhouse," *The Sims*™ allows a player to tailor individual characters, as well as their living quarters, to his or her own vision. Players make choices about the Sims' jobs and activities and direct their everyday lives—from making sure they are fed and well-rested to engineering the details of their social connections.

The props and underlying simulation space of the game lend themselves to the creation of everyday life environments from affluent suburbs (e.g. Figure 8.7a) to run-down hovels. The Sim characters' interactions with one another are an integral part of game play—the player must keep his or her Sims socially engaged and content (Figure 8.7b). Sim characters do not actually talk—instead they speak an unintelligible language that has very clear emotional range (watch Clip 7.3 from Chapter 7, to see Sim characters conversing). Part of the dynamic of playing the game is making sure that Sims are getting along (or creating conflict between them).

The Sims' flexibility extends from social styles into the fantasy aspect of the game. Sim characters also act as tarot cards for teasing out the fantasies of players, who create stories that arise from the visceral and cognitive activities in the game. Players can record Sim activities and share "family albums" with images of their Sims in

FIGURE
8.7

a b

A day in the backyard—washing the dog, playing chess, and chatting in the hot tub. *The Sims*™ *Unleashed* image ©2005 Electronic Arts Inc. *The Sims* is a registered trademark of Electronic Arts Inc. in the U.S. and other countries. All rights reserved.

action. This feature has been used by players in the aid of creating elaborate graphic novels available online (see Figure 8.8).

Interestingly, players seem to hop between experiencing their Sim characters as extensions of themselves and as separate agents. Will Wright, in an interview with Celia Peirce (Fullerton, Swain, and Hoffman 2004, 133), talks about how players switch from "I" when they are controlling a Sim, to "he" or "she" when the Sim does something unexpected or undesirable. Sims walk the line between self and other, and allow the player to explore identities and fantasies in a flexible and low-risk way.

8.2.3 *Focusing Player-Character Psychology: Tools, Puppets, and Masks*

Not every game needs full treatment of player-characters at all four levels—the core game play of some games can lead to irrelevance or minimal value of a particular layer. This section examines three styles of in-game player representation that emphasize subsets of layers of player psychology.

Tools

Warcraft III and *DDRMAX: Dance Dance Revolution* (see Figure 8.9) are two examples of games that do not require much of a social persona for players—but for different reasons. *Warcraft III* is a real-time strategy game in which the player commands a large number of NPCs in war campaigns. The player does not have a direct character interface to the game—rather she or he uses a heads-up display to observe what is going on and to give troops directions. Given this

FIGURE
8.8

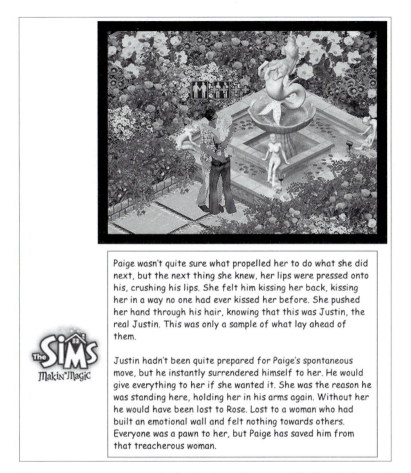

Paige wasn't quite sure what propelled her to do what she did next, but the next thing she knew, her lips were pressed onto his, crushing his lips. She felt him kissing her back, kissing her in a way no one had ever kissed her before. She pushed her hand through his hair, knowing that this was Justin, the real Justin. This was only a sample of what lay ahead of them.

Justin hadn't been quite prepared for Paige's spontaneous move, but he instantly surrendered himself to her. He would give everything to her if she wanted it. She was the reason he was standing here, holding her in his arms again. Without her he would have been lost to Rose. Lost to a woman who had built an emotional wall and felt nothing towards others. Everyone was a pawn to her, but Paige has saved him from that treacherous woman.

Players create stories using the family album feature in *The Sims*™, then upload and share them on the game's Web site. *The Sims*™ *Unleashed* image ©2005 Electronic Arts Inc. *The Sims* is a registered trademark of Electronic Arts Inc. in the U.S. and other countries. All rights reserved.

bird's-eye view of the battles, there is not much need for the player to have a strong social persona.

DDRMAX: *Dance Dance Revolution* is a dancing game in which players step on foot pads trying to match patterns of arrows on screen. There is not any kind of social interaction between the player and anyone in the game world. Usually, two players dance side by side and can interact socially in "real life" if they like, as they dance.

In both cases, including a strong social persona for the player would probably not enhance the game; rather it would detract, as players would not be able to meaningfully integrate the social persona into their understanding of game play. In the case of *Warcraft III*, there is a fantasy layer that explains the history and goals of warring factions within the game world, despite the lack of a social persona for the

FIGURE
8.9

a b

(a) *Warcraft III* and (b) *DDRMAX* do not have visible player-characters. Instead, the game interface acts as a tool in the hands (or feet) of the player. (a) *Warcraft III Reign of Chaos* provided courtesy of Blizzard Entertainment, Inc. (b) *DDRMAX: Dance Dance Revolution* is a registered trademark of KONAMI CORPORATION. ©1998–2005 KONAMI. ©1998–2002 KONAMI. KONAMI is a registered trademark of KONAMI CORPORATION.

player. In *DDRMAX*, there is neither. *Warcraft III* uses cut-scenes to show the player the progression of fantasy campaigns and provides a series of major NPCs as focal points for the plot progression in the absence of a single player-character.

In both cases, the game provides a tool or interface for the player during play, rather than a highly realized player-character. There is no need for the player to try to map his or her visceral and cognitive strategies onto a social or fantasy persona in *DDRMAX*; in *Warcraft III*, the player can play in any style she or he likes between cut-scenes, although the fighting minions have distinctive styles and reactions that help to underscore the fantasy layer of the game.

Puppets

Games with relatively short cycles of play that are mostly about physical prowess may not require much in the way of fantasy and social qualities in player-characters. Instead, player-character personality can come across in the style of movement and visual characteristics, and social persona is defined mostly through nonverbal interaction in real time between the player-character and NPCs. One might refer to this sort of player-character as a *puppet*. The strength of puppet player-characters lies in the joy a player feels in physically manipulating them and in watching the results of his or her actions on-screen. Puppets often have super-human qualities—grace in movement, extreme strength and accuracy, and the like. *Super Monkey Ball 2* and *Donkey Kong* both feature puppet-style player characters (Figure 8.10).

Although there is a framing fantasy world, in *Super Monkey Ball 2* it plays a minor role in game play and is entirely absent in the most common mode of game play (multiplayer). The charm of the player characters in *Super Monkey Ball 2* comes

FIGURE
8.10

(a) *Super Monkey Ball 2* and (b) *Donkey Kong* are games that have puppet-style player characters.
(a) Sega Corporation. All rights reserved. Reprinted with permission. (b) Image courtesy of Nintendo.

primarily from their grace and energy in game play. These characters are a joy to manipulate and provide gratifying reactions to player success (see Clips 5.2 and 5.3 in Chapter 5). Their social qualities take the form of personality as expressed in movement rather than in actual engagement with other characters during game play.

This is also the case for arcade games such as *Donkey Kong* (Figure 8.10b), in which there is little time to give a player an elaborate fantasy context for play and no player-driven social interaction. The tiny hero is a joy to operate because of his kinesthetic characteristics—he is bouncy and indefatigable.

Sports games such as *SSX 3* also have player-characters that serve as puppets for players. Players enjoy having the grace and flair of star athletes, planning and executing moves that they could not perform in real life. (See Clip 6.3 from Chapter 6 for an example of this type of movement.)

Masks

Masks are player-characters found in games that have a major social component. The two examples shown here—*Star Wars Galaxies* and *There*—are both persistent, massively multiplayer worlds (see Figures 8.11 and 8.12). A major component of game play in this sort of game is interacting with other players, as they are represented through their own masks. Improvisational performers (Johnstone 1979) and psychologists (Turkle 1995) agree that donning an alternate social face gives people the opportunity to explore alternate social personas—new versions of the self that may be very different from the everyday. Considerable design effort is typically expended upon tools for customizing the appearance of mask player-characters. It is also highly desirable when crafting a mask character, to provide players with visceral feedback and interface mechanisms for social expressions. In *There*, for example, players can type special characters to make their characters smile, nod, wave, and perform other social gestures (see Chapter 6 for more detail).

215

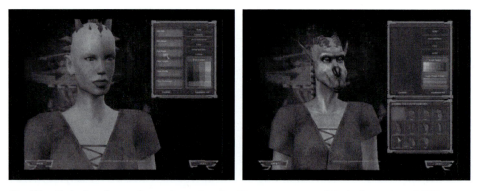

Star Wars Galaxies allows players to customize the appearance of their character. ©2002 Lucasfilm Entertainment Company Ltd. All rights reserved.

Player characters in *There* have many options for tailoring appearance through clothing as well as body and facial adjustment. ©2005 There.com. All rights reserved.

8.3 Design Pointers

Consider all four psychological layers from the beginning, when brainstorming initial game concepts, to ensure that a game has powerful player-characters. A player-character's personality and appeal comes as much from his or her movement in response to the player's real-time controller actions as it does from watching elaborate cut-scenes. The bulk of time spent with the player-character will be in the moment-to-moment unfolding of play. It is my opinion that the strongest player-characters are deeply grounded in the visceral and cognitive layers and that their social and fantasy selves emerge from these

roots rather than being conveyed through a linear story overlayed on an existing genre of game play.

When brainstorming, take the time to set explicit criteria for each of the four layers:

1. *Visceral.* What does it feel like to move as this character? What is fun about it? What powers does the player have that she or he probably does not have in real life? What is it like to watch this character move (if the character is visible)?

2. *Cognitive.* Does the player's own instinct for what to do next in the game mesh well with the cognitive strategies that this character would have? Does the character feel like a natural mental skin for the player, given the game-play mechanics?

3. *Social.* Does the character's social persona fit well with the basic game-play style and motivations? Is the social persona interesting and appealing to the player? Does it mesh well with the cast of NPCs and their social roles? Can the player perform the social actions that he or she wants to, given his or her character?

4. *Fantasy.* Is this a character that the player wants to experiment with being? Does the character's backstory and motivation sit well with game play itself—is this a fantasy persona that is truly well-suited to the core game-play mechanics?

When the four psychological layers of a player-character do not line up, the player may start to feel dissociated and dissatisfied with what is happening. Here are some signs that a player-character needs layer tuning:

- *Visceral out of alignment with fantasy.* "This character looked much cooler on the box and in the opening movie. I can't do the cool stuff I thought I would be able to." (Can be a problem with characters adapted from film.)

- *Cognitive out of alignment with visceral.* "This character is really frustrating to use—I keep trying to do stuff that makes sense, but the game won't let me."

- *Social out of alignment with visceral.* "Why can't I talk to the other characters? How come this character doesn't remember me? I would normally solve this by talking to someone, but I can't do that." Or alternatively, "I don't want to have to talk to him or her. Why can't I just shoot them?"

- *Cognitive out of alignment with fantasy.* "The cut-scenes in this game are really annoying and irrelevant. I wish I could skip them." Or alternatively,

"I really like the cut-scenes in this game but it's really boring to play the game itself because the parts of the characters I like have nothing to do with how I play."

It is also helpful to consider which psychological layers will be most important given a game's core and environment, and whether some layers are unnecessary. If you know that your character is a tool, puppet, or mask, you can apply these criteria:

- *Tool.* The controls feel ready-to-hand and do not interfere with the player's cognitive strategy. There is minimal sense of social or fantasy self to get in the way of play.

- *Puppet.* The character is fun to watch, and the feedback loop between the player's actions and the character's behavior is not just nice to feel and cognitively tuned but also extends and enhances the senses and makes the player feel graceful.

- *Mask.* The character fits a social persona the player wants to try out and offers ways to customize appearance that are fun and interesting. The player can do the things she or he wants to do to communicate with other characters, and his or her character feels socially lifelike.

8.4 Interview: Marc Laidlaw

Q: Gordon Freeman works at all four psychological levels for the player so well. Was there something about the design process of Half-Life that helped make Freeman such a strong and well-crafted player-character?

First, we designed the experience with input from every part of the team so that Gordon would be totally integrated with the type of game we were building. While artists were sketching out various concepts of the character, the programmers and level designers were working out the technical details, such as Gordon's apparent eye height and field of view, his jump distance, and movement speed. We wanted to make sure that the player wouldn't feel as if he's moving too quickly or too slowly, that he wouldn't seem to be living in a fishbowl.

Most of these basic definitions were altered again for *Half-Life* 2. We adjusted the character to suit the more evolved world of the second game. A crucial issue was that of scale: are common objects, familiar to the player, modeled and presented in a manner that feels convincing? In *Quake*, for instance, buttons and switches tended to be

FIGURE
8.13

In addition to authoring numerous short stories and several novels (including International Horror Guild Award winner, *The 37th Mandala*), Marc Laidlaw wrote the hit videogames *Half-Life* and *Half-Life 2*.

enormous. Bringing these conventions directly over to *Half-Life*, we ended up with common light switches that were two feet on a side. So that was something that required a lot of tuning over the course of the two games.

From a narrative point of view, we made sure that the feedback from the world and from the other characters would work to shape their perception of Gordon Freeman. Security guards treated him with familiarity, friendliness, and respect; fellow scientists treated him first with mild condescension, then with desperate pleading, as his role in the Black Mesa Incident became more important. In *Half-Life* 2, the key friendly characters treat you as if they like you, and you end up feeling that you must be a pretty good guy.

Starting with basic ideas for the character, we would always subject each version to lots of play testing, to make sure the experience was coming through for players. The simple first-person viewpoint had already proven itself a strong one. Notably, id software had done the anonymous silent viewpoint character in *Doom* and *Quake*. Your character made various sounds to show exertion and pain; there was no cutting away to show your character grunting and groaning. 3D Realms took this convention and pushed it further, to develop the distinct personality of *Duke Nukem*. Instead of making only wordless sounds, Duke made sarcastic comments and became more of a presence in the world and in the player's mind.

In *Half-Life*, we tried to get the best of both approaches. We knew we wanted to keep the first-person viewpoint without breaking away. We knew Gordon Freeman would be an initially anonymous sort of character, in keeping with id's transparent style. There would be no RPG stats to develop, minimal key commands, and a low level of screen clutter. On the other hand, we wanted to create an actual character—one who was in

some ways the antithesis of *Duke Nukem* or the *Quake* Marine—not a wisecracking man of action, but a silent scientist who gradually assumes the role of action hero. We wanted a character any player could inhabit but one who had a definite place in his world—and a name to go with it.

Valve's process is to mock up the early concept as soon as possible and turn it into something playable, then keep iterating until it's as good as it can be. If we had stopped short of a full realization of the initial vision, we would have ended up with something more motley and unsatisfying. We could have had hybrid third-person views from omniscient cameras, showing a character who inexplicably never spoke. But we ended with something very pure. The rules for Gordon Freeman are simple, but abiding by them is very challenging. So our character design affects our world, game, and story design on every level.

Q: How do you personally go about creating and refining a player-character? What are the important considerations for you in deciding whether a character will work?

In the case of Gordon Freeman, character design was a matter of interface design. We wanted a minimal amount of interference between the player and the game: no branching conversation trees, no complicated superhuman abilities, and a strong connection between Gordon Freeman as the game world sees him and the Gordon Freeman envisioned by the player. We wanted to make sure that Gordon was a product of his environment and also had an interesting role there that tied into the game play in some way. Often his position is exploited for comic or ironic possibilities. Gordon is supposed to be a bright young physicist, and the characters assume he is well trained for his tasks; yet the player really doesn't have a clue what to do, and the things they actually spend time doing often amount to menial tasks. When the player solves puzzles, or finds nonlinear ways of progressing, we can play up the idea that they are somehow inhabiting a brilliant scientist. But the most important thing was to give the player a feeling of being constantly off balance, never quite sure of what was expected of them, to give them the task of continually finding this out for themselves. The world, and all the encounters, were crafted to support this experience. It was a delicate balance, as became clear in the part of *Half-Life 1* where it failed. When Gordon goes off to the borderworld, Xen, he is cut off from human contact and the many little props that helped give him a sense of context. While it was our intention to create an eerie sense of isolation and reinforce the feeling that you had gone beyond the point where anyone could help you, many players faltered at this point. It was no longer obvious that you had to be Gordon Freeman; there was no continual feedback from the world. I think this shift in perspective had much to do with the dissatisfaction that many people felt with the latter part of that game. It also changed the sense of being Gordon as the louder complaint—the fact that it turned into a series of difficult jumping puzzles for which the player had been inadequately trained. We should have left Gordon in constant contact with his scientist allies. This lesson was applied to the Xen sequences of *Blue Shift* and worked much better in my opinion.

Finally, games tend to distinguish themselves first with their visual style, then with their game-play mechanics, and last with their narrative. Visual style may pull people in, but if the game play is no fun, then the pretty faces won't matter very much. If the game play is exciting and fun, then players won't object too much to a weak story. Ideally, all the elements are equally strong, but this is rare. A good game character is one who enables and supports great game play. This is far more important than a strong marketing image. Character is also something that reveals itself only gradually to a player. It is very hard to convey (on a box or a list of features) what that particular character brings to the game that makes the game remarkable.

Q: In the interview with Gamasutra (http://www.gamasutra.com/features/ 20030808/carless-pfu.htm), you talk about infusing a game with personality or a sense of authorship. How do you think this comes across specifically in Gordon Freeman and his interactions with his world? Are there some defining details you would point to?

The game is the result of many authors, and each of them has a strong distinctive stamp that gives the game a feel unlike that of any other studio's work; but we are all aware that there is a certain Valve "vibe" to strive for—something which, when you hit it, is unmistakeable. Originally we didn't have a target outside our imaginations; but we shared an indefinable goal. We didn't know quite what it was, but we certainly recognized it when we reached it. (Rigging up the Test Chamber disaster sequence in *HL1*, and seeing how well it worked, was the turning point for the team—where we realized what we were going to be doing from then on out.)

There are choices that we as a design studio tend to make that another studio might not make, and our original design for Gordon Freeman reflects that. For instance, we like to play on the irony inherent in the fact that the nonplayer-characters make comments about Gordon that the player can't refute. I think our audience looks forward to a certain amount of this sort of thing throughout the game. Another studio making a *Half-Life* game would take a different approach to the problem. That's why I think a game like *Opposing Force*, although it had many of *HL*'s constraints, has a very different flavor reflecting the personalities and interests of the third-party team that created it. Personally, I like to add little nonobvious details to dialogue and scenes, thing that are not required by game play but which reflect the same sort of thinking I'd put into one of my stories. The same can be said for our art design, our animation, and (although I'm a poor judge of this) our code. You can see the individual's handiwork everywhere. Valve allows this to flourish.

Q: How do you make sure your characters stay true to the creative vision that you have as you move through development? Is there any advice you would offer to others for delivering on the promise of initial concepts? For checking up on your work, staying honest, getting feedback?

The creative vision evolves over time. One of the interesting things about game development, as opposed to other fields, is that you cannot foresee what the

technology is going to allow you to create in the near future. Cinematographers know the limits of their lenses and film; writers have a certain vocabulary with which to tell a story, and if they go out and learn more words, those words will still have strong connections to the ones they already know. This is not always the case in computer games. The technology progresses incrementally, but every now and then it will reveal a new type of game play that makes you reevaluate everything, including your initial vision.

8.5 Summary and What Is Next

Chapter 8 introduced four layers of a player's psychological experience of player characters: visceral, cognitive, social, and fantasy. Several examples of well-integrated player-character designs were discussed, and the notion of specialized types of player-characters—tools, puppets, and masks—was also introduced, with examples. The chapter concluded with suggestions for incorporating the four layers into character designs, along with an interview of Marc Laidlaw of Valve. Chapter 9 discusses the other major type of character found in games: non player-characters (NPCs).

8.6 Exercises

8.6.1 *Using the Four Layers to Pinpoint Problems*

Have each person in the group bring in an example of a player-character that they hated and explain what it was about the character that was so annoying or frustrating. Consider the four layers when critiquing and discussing—it is very likely that the character did not have proper integration of these layers. Brainstorm ways that the player-character could have been improved.

8.6.2 *What Kind of Me Is It?*

Using the four layers, analyze your designs of player-characters for game projects. Consider whether the player-character, in the context of this game, is primarily a tool, a puppet, a mask, or some hybrid. How will this affect your design decisions? How will you know whether your design is working for players? (Chapter 11 includes some guidelines for conducting evaluations.)

8.7 Further Reading

Bell, J. 2001. *Puppets, Masks, and Performing Objects*. Cambridge, MA: MIT Press.

Bettelheim, B. 1989. *The Uses of Enchantment: The Meaning and Importance of Fairy Tales*. New York: Vintage Books.

Csikszentmihalyi, M. 1990. *Flow: The Psychology of Optimal Experience*. New York: HarperPerennial.

Davidson, R. J., and W. Irwin. 1999. The functional neuroanatomy of emotion and affective style. *Trends in Cognitive Science* 3(1): 11–21.

Fullerton, T., C. Swain and S. Hoffman. 2004. *Game Design Workshop: Designing, Prototyping, and Playtesting Games*. San Francisco, CA CMP Books.

Johnstone, K. 1979. *Impro: Improvisation and the Theater*. New York Theatre Arts Books.

Jones, G. 2003. *Killing Monsters: Why Children Need Fantasy, Superheroes, and Make-Believe Violence*. New York Basic Books.

Öhman, A., A. Flykt, and F. Esteves. 2001. Emotion drives attention: Detecting the snake in the grass. *Journal of Experimental Psychology: General* 130(3): 466–478.

Rosenzweig, M. R., A. L. Leiman, and S. M. Breedlove. 1999. *Biological Psychology: An Introduction to Behavioral, Cognitive, and Clinical Neuroscience*. Sunderland, MA: Sinauer Associates, Inc.

Turkle, S. 1995. *Life on the Screen: Identity in the Age of the Internet*. New York: Simon and Schuster.

8.8 Acknowledgments

Special thanks to Kevin Hartman for his video capture and research contributions to this chapter.

CHAPTER Nine

Nonplayer-Characters

9.1 What Is Covered and Why

This chapter uses the concept of social roles to explore the connections players make with nonplayer-characters. Designs that make use of role-relevant social cues enhance the chances of stronger emotional experiences for players and create a more game-play-integrated experience of NPCs. The chapter describes examples of NPCs in a range of social roles in games, showing with each how emotional moments arise for players from social relationships with characters. The chapter ends with design pointers for leveraging social roles in design.

9.2 The Psychological Principles

The terrain of the study of human relationships is far too large to cover in a book like this one. Game character interactions are usually short, targeted, functionally based interactions (not dates or marriages or ongoing coworker situations). Therefore, this chapter presents a key concept from the psychological and sociological literature that helps to focus understanding of relatively brief, instrumental interactions: social roles.

Social roles are mutually recognized sets of expected behaviors and reactions that a person will engage in with respect to another person. These roles develop in social situations in which there are predictable patterns of

- interdependence because of overlapping goals and complementary abilities,
- power dynamics within and between social groups (hierarchies and in-group/out-group status), and
- obligations in the form of kinship or other group relations that bind individuals together.

Social roles are valuable in that they help people to engage in interaction with others without having to negotiate everything about how each person will act, and often, without even having to get to know one another very well (see Figure 9.1a). Social roles help to reduce the risk of embarrassment, of confusion, of unwanted conflict (see Figure 9.1b). They help to stabilize social groups—if a person has been trained in how to behave in a given social role, others can count upon this training and then can create and engage in more complex social structures. Social roles can be

FIGURE
9.1

a

b

(a) Social roles help synchronize people's expectations of interactions. (b) Confusion over roles can create frustrating experiences.

barriers to greater intimacy, but they are very helpful in everyday situations in which a person has short and targeted engagement with another (as is the case in most player interactions with NPCs).

The notion of social roles initially emerged from the work of social scientists such as Erving Goffman, who became very interested in understanding the dynamics between people in everyday social situations. These researchers looked for the underlying rules and mechanisms shaping social engagement—things that are hard to see because we are immersed in them. Goffman was one of the first to systematically describe the elaborate "work" going on in social life. He introduced the concept of *face work*—the idea that people try to help each other maintain consistent social identities by ignoring slips out of role-appropriate behavior (see Goffman, 1967). Social psychologists later took up the concept of social roles to help them understand the dynamics of interpersonal interaction and perception and the ways in which people apply generalized knowledge to specific social encounters.

One way to understand social roles is to think of them as social "faces" or masks that a person puts on, signaling that she or he will behave in a certain way toward another. Each person has many of these masks and may even have several that he or she puts on with a particular person, depending upon context. For example, a man may have a friend who is also a coworker. These two may act quite differently with one another in the workplace versus out of it.

Social roles transcend the negotiation of relationship between two individuals; they are part of a larger social structure. As such, they have definite cultural bounds. Even roles that emerge from universal kinship situations—such as brother or mother—are manifested in different ways, depending upon culture (see Chapter 3, p. 54 for more discussion of cultural differences in social norms and roles).

People tend to underestimate the power of social roles in shaping a person's behavior and in shaping their own perceptions of others' abilities and competency. In studies where people are arbitrarily assigned roles (such as manager and worker or quiz show host and contestant), observers will rate the competence and intelligence of those acting out manager or host as higher than worker or contestant because the bias in what they see that comes from the role itself (Ross and Nisbett 1991).

Social roles are useful to keep in mind when designing NPCs because social roles shape a person's expectations about how she or he will relate to others (both human and digital). Out of these expectations arise possibilities for powerful emotions based upon the fulfillment (or betrayal) of mutual goals: gratitude, disappointment, shared excitement and satisfaction, rage, and the like. Imbuing an NPC with seeming awareness of role expectations will enhance the NPC's lifelike qualities for the player tremendously. A person expects an ally to be excited about a mutual victory and expects an enemy to be enraged about that same victory. Social roles are, in a sense, libraries already present in the mind of the player that a designer can tap into to create satisfying interactions with NPCs.

9.3 Dimensions of Social Roles and NPCs

For the purposes of analyzing social roles of NPCs in games, it is helpful to revisit the factors that lead to role formation:

- interdependence because of overlapping goals and complementary abilities,
- power dynamics within and between social groups (hierarchies and in-group/ out-group status), and
- obligations in the form of kinship or other group relations that bind individuals together.

These factors work together to shape a player's social expectations of an NPC and provide the possibilities for creating defining emotional moments between the player and the NPC during game play.

Interdependence: Objectives and Abilities

NPCs have a range of objectives in games, from unthinking service and loyalty to the player (or his or her archenemy) to world domination at the player's expense. An NPC may have various abilities that are useful to the player. Beyond the ability to provide physical or mental assistance in fighting, solving puzzles, or just in learning the ropes of the game world, a friendly NPC may also be able to provide moral support in achieving game goals: cheering, excitement, approval, and the like. NPCs may also provide companionship for the player or may provide a social motivation in the form of somone who needs rescuing. Even unfriendly NPCs have abilities that improve the player's experience, providing opposition and conflict— both physical and emotional—that enhances the player's experience. NPCs in neutral roles can provide social validation for the player when they approve of her or his actions and help spur better play when they boo a bad performance.

Power Dynamics: Agreeableness and Dominance Revisited

Chapter 2 introduced key person-perception variables—what someone notices first when meeting a new person. Among these were assessing someone's relative power compared to one's self and deciding if they are going to be on your side or working against you in some way. These are important initial perceptions because they will help determine how well a person will be able to work with you. These perceptions also form one foundation for social roles:

- *Agreeableness*. If a person is friendly toward you, you will expect that they may try to work with you to achieve mutual goals. If that person is not friendly, you will expect to deal with them at some level as a threat to your goals, or at best as

a neutral or unhelpful force. This will affect any encounter you have with them, as well as how and when you seek out interaction. It will also shape mutually defining moments. With enemies, your success is their loss. With allies, success is something for both to celebrate.

- *Dominance.* Dominance or submissiveness determines who gets to set the agenda in a collaboration. The more dominant person typically determines what will be done, and the less dominant one chooses whether it suits his or her goals to go along. The less dominant party will spend time making it clear to the more dominant one that she or he is on board for the agenda and is excited about the outcome when things go well. Dominance also affects how much attention (and what kind) must be paid to an individual. People look to more dominant others to see whether they are satisfied and to anticipate where they will be going next. People look to less dominant people to see whether they are doing what has been assigned and (ideally) to make sure they are reasonably happy as they do their work. People who are equally dominant are examined for signs that goals are still in alignment and for shifts in status.

Obligations and Investment

NPCs in games are often positioned (through backstory and ongoing cut-scene exposition) as having a preexisting social connection to the player. An NPC may have a kinship role toward the player's character (e.g., the Prince's father in *Katamari Damacy*) or some form of personal and/or social investment due to past circumstances—colleague, companion in arms, childhood friend, or the like. This means that the player already has a sense of obligation toward and investment in the NPC based on their imagined past, and the NPC has been designed to have "obligation" as well. Obligations and investment also grow during the course of the game itself—the most powerful NPC interactions and connections can arise from the building of obligation and investment through mutual actions during game play (e.g., Floyd the robot's famous self-sacrifice for the player in *Planetfall*, an early text adventure game (*http://www.mobygames.com/game/dos/planetfall*)).

9.4 Common Social Roles in Games

Just as social-role templates arise and evolve in everyday interpersonal interaction to fit common situations and relationships, role templates have come into common use in games because of recurring player needs in combination with possibilities for NPC actions. This section includes examples of these common roles but should not be viewed as exhaustive. As new game-play modes, genres, and audiences evolve, designers can look for ways that characters can enhance game play by taking on other social roles, borrowing from analogous situations in real life to guide explorations.

229

If working in a well-defined genre of game, a designer may find the following taxonomy helpful in guiding design and decision-making. The roles are organized along the agreeableness and dominance dimensions, working through friendly characters from least to most dominant, then unfriendly characters from least to most dominant, and concluding with neutral characters working from least to most dominant. For each, objectives and abilities as well as obligations and investment are considered, as are the defining interaction moments based on these factors.

9.4.1 *Minion*

Minions are the least socially dominant of the friendly roles examined in this chapter. Minions always defer to the player character and never challenge his or her authority.

Objectives and abilities

A minion's objective is to help the player accomplish her or his game goals. Minions do not usually have any independent goals, other than meeting their own basic survival needs. They do not typically provide any resistance to the player but offer physical assistance to the player during game play by accomplishing menial tasks that the player assigns them. Minions also provide moral support in the form of unstinting enthusiasm and spunk in the face of adversity and through their delight at accomplishing the player's goals.

Obligations and investment

In most cases, the player is not personally familiar with individual minions—rather, minions are attached to the player in an aggregate sense, and they matter to the player for their actions as a group.

Defining interaction moments

Players will expect minions to mirror their excitement over successes and to cheer the player up with their energy and determination during defeats. If part of the game mechanic is keeping the minions happy, the player will expect unrest if the minion is underfed, has too little rest, or the like. The most frequent player interaction with a minion is to give orders—how a minion reacts has a big impact on the player's impression. Players of *Warcraft III*, for example, so enjoyed the reactions of their minions to being ordered around that they collected audio recordings of peon replies to orders and posted them on fan Web sites. Another design consideration with minions is that they usually travel in groups. The player will not form an impression of each individual minion, given time and attention constraints, so care should be taken to design minions whose aggregate behavior is appealing. (See Figure 9.2. Also see Clip 9.1 for a brief illustration of the charming group behavior of the Pikmen.)

FIGURE
9.2

a b

In (a) *Warcraft III* and (b) *Pikmin*, players control many minions in their campaigns (see also Clip 9.1). (a) *Warcraft III: Reign of Chaos* provided courtesy of Blizzard Entertainment, Inc. (b) Image courtesy of Nintendo.

9.4.2 *Rescuee*

The rescuee is a player-friendly character who is also less dominant than the player—someone in need of the player's aid (see Figure 9.3). This does not mean that the rescuee does not have powers of his or her own. Yorda from *ICO*, for example, reveals powers as the game progresses that are essential to the player, making a transition from helpless rescuee to ally. The fuzzles in *Oddworld: Munch's Odyssee* begin their interaction with the player as victims in need of rescue. In both cases, the player wins the loyalty and devotion of the rescuee by freeing them. Some games (for example the *Mario* series and *Prince of Persia*) include a rescue as strong game-play motivation. Regardless of their powers, rescuees are by definition friendly to the player's character.

Objectives and abilities

A player's assumption about a rescuee is that the character needs saving and will be grateful for aid. A pure rescuee may have no game-play role at all, appearing only to motivate the player toward the end goal of the game (e.g., Princess Toadstool in the *Mario* series). Other rescuees are hybrid characters, moving from the passive role into a more active one when they are freed (e.g. the Fuzzles in *Oddworld*). These characters then transition into other player-friendly roles such as minion or ally.

Obligations and investment

Sometimes the player is given backstory explaining the player-character's relationship and obligation to the rescuee (for example, Jak and Daxter, in which Jak has a hand in Daxter's plunge into a toxic pool that motivates the initial game quest).

FIGURE
9.3

(a) Yorda (from *ICO*), (b) the princess in *Donkey Kong*, and (c) the princess from *Prince of Persia* are all classic examples of rescuees. (a) *ICO* is a trademark of Sony Computer Entertainment America Inc. ©2001 Sony Computer Entertainment America Inc. (b), (c) Images Courtesy of Nintendo.

Sometimes the game relies on protection and nurturing instincts in the player to motivate investment in the rescue (e.g., Mario and the Princess).

Defining interaction moments

It is essential to make the player care about rescuing this character, so a rescuee must be presented in the most empathetic and urgent light—the player should find this character worthy of care. Using cuteness and attraction cues will help (see Part I for an overview of some of these design strategies). Emotional moments with rescuees include seeing the rescuee in pain or fear and wanting to help, or being able to free the character. Including cues of awareness in the rescuee's behavior of the player's attempts to rescue (such as excitement when the player is almost there and disappointment if the rescue fails) will heighten the player's emotions.

9.4.3 *Pet*

Like minions, pets are much less dominant in the game world than the player. However, pets are expected to provide some resistance to the player's desires, as a real-life dog or cat would. Pets are, in general, friendly toward the player, although the player's actions could turn the pet against her or him. The creature from *Black & White: Creature Isle,* the dogs and cats from *Petz* (Figure 9.4), and the pets on the *Neopets* website (Figure 9.5) are examples of NPCs that have this role.

Objectives and abilities

Pets are not typically designed primarily to serve the player. Rather, the objective in engaging with a pet is to enjoy the pet's development and learning and its moments of connection and resistance to the player. A pet provides emotional engagement to the player and challenge in the form of training and meeting the pet's needs.

Obligation and investment

The social contract between player and pet is that of a caretaker—the player will attend to the pet's needs and will expect loyalty and obedience, within reason. The player will expect emergent behavior and surprises from a pet: it is okay for the pet to have a personality of its own to some degree; that is part of the fun. In contrast to minions, pets will evoke a high degree of time and emotional investment from the player. He or she will care quite a lot about the pet as an individual.

FIGURE
9.4

The dogs and cats in *Petz* are trainable and even respond to the player's mouse movements as if they were being petted. ©Ubisoft Entertainment. Ubisoft is a registered trademark of Ubisoft Properties, LLC. *Petz, Catz, Dogz,* and Ubisoft are trademarks of Ubisoft Entertainment, Inc. All rights reserved.

FIGURE
9.5

Defining interaction moments

Interactions with pets center around caregiving and training and on observing the outcome of these actions through the pet's interactions with the larger game world. The player will be watching her or his pet closely, getting to know its personality, and trying to figure out cause and effect in terms of training and care. Attention toward the pet's reactions to player actions, and hinting at the underlying motivational model of the pet, will enhance the player's experience as will displays of loyalty and care from the pet toward the player. If the pet "misbehaves," acknowledging this in some way through the pet's expression (showing that "it knows it did wrong") will make the interaction more engaging and lifelike.

9.4.4 *Sidekick*

A sidekick character typically has more social power and autonomy than a pet within the game world but still is less dominant than the player's character. Sidekicks, like minions, are unequivocally on the player's side. Two strong examples of sidekick characters are Glottis from *Grim Fandango* and Daxter from *Jak and Daxter* (see Figure 9.6).

Objectives and abilities

Sidekicks provide moral support and practical advice to the player as well as some good-natured teasing (for example, Daxter's wise crack in Clip 9.3). They usually

234

FIGURE
9.6

a b

(a) Glottis, Manny's sidekick (from *Grim Fandango*) and (b) Daxter (see also Clip 9.3), Jak's sidekick (from *Jak and Daxter: The Precursor Legacy*). (a) ©1998 Lucasfilm Entertainment Company Ltd. All rights reserved. (b) *Jak and Daxter: The Precursor Legacy* is a registered trademark of Sony Computer Entertainment America Inc. Created and developed by Naughty Dog, Inc. ©2001 Sony Computer Entertainment America, Inc.

do not provide much in the way of physical game-play assistance. The sidekick provides unstinting loyalty but can also provide a second opinion and some valuable perspective to the player—offering hints about what to try next and filling the character in on backstory. Sometimes, sidekicks get themselves into trouble, requiring a rescue by the player.

Obligations and investment

A sidekick is typically present throughout the course of the game, so the player has a pretty high level of investment in this character. Sidekicks are either introduced as characters with strong existing ties to the player's character, or (as in *Grim Fandango*), they are won over by the player-character during game play and accompany him or her for the rest of the game.

Defining interaction moments

Sidekicks are usually more talk than action, so their personality comes through in the things they say and the way they say them as game play unfolds. The more awareness a sidekick can show about the player's performance—commenting on what is going on, providing help when needed, and providing comic relief—the more enjoyable that character will be. Both Glottis and Daxter make heavy use of humor, including meta-comments about how well the player is performing at the game. Giving the player a chance to rescue the sidekick will heighten emotional investment in the character and will motivate a deepening relationship over time in the game between player and sidekick. Some games have used the self-sacrifice of a sidekick (e.g., Floyd in *Planetfall*) to produce powerful emotions in players. If the sidekick does make it

235

all the way through the game, giving the player emotional payoff by way of the sidekick's joy at the victory is essential. Since a sidekick is around for so much of a game, it is worth creating a sense of individuality and motivation for the sidekick, taking it beyond the mindless obedience and unquestioning order-taking of the minion. A sidekick's own quest gives the player a chance to help in a way that strengthens the relationship, creating more powerful emotions in the game itself.

9.4.5 *Ally*

Allies are characters on the player's side who possess the same or almost equivalent physical powers in the game world. They are unquestioningly friendly to the player.

Objectives and abilities

The primary contribution of an ally is in game task support, usually in the form of group combat or sports play. Examples include the guards that fight alongside the player in *Half-Life*, the soldiers that join in the reconnaisance and fighting in *Halo*, and teammates in sports games (see Figure 9.7, also Clip 9.4). Allies can also provide moral support through their reactions to the ongoing action—enthusiasm, determination, egging the player on, and so forth.

Obligations and investment

As with minions, the player probably does not form much of an attachment to individual allies nor does she or he expect to see them for long periods of time in the game. Allies are experienced in the aggregate.

FIGURE 9.7

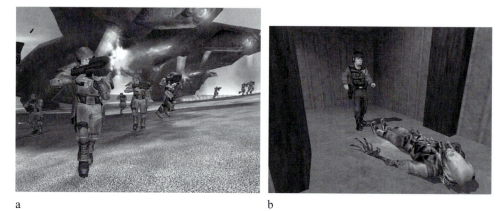

a b

Soldier NPCs fight alongside the player in (a) *Halo* and (b) *Half-Life* (Clip 9.4). (a) Screenshot from *Halo®: Combat Evolved.* ©2005 Microsoft Corporation. All rights reserved. (b) *Half-Life* ©Valve Corporation. Used with permission.

Defining interaction moments

As with minions, allies tend to have brief, functional interactions with the player—their contribution is in the moment. However, there are ways to heighten the player experience with ally actions even in these short encounters. Giving allies the appearance of awareness of the player's goals and emotional reactions to how things are going (in both their physical reactions and in their words) will make the player really feel he or she has back-up and will help give the player the feeling of being on a supportive team. Building up a backstory for the team as a whole, with recurring characters (such as Carol "Foehammer" Rawley in *Halo*, the Echo 419 transport operator who carries the Master Chief around *Halo*) helps add to the realism and engagement for the player.

9.4.6 *Guide*

Guides are unquestioningly on the player's side and usually have at least as much social power and awareness as the player-character in the game world, sometimes more.

Objectives and abilities

Guides can be thought of as the game's help system. A guide is a personified database for the player, and perhaps this is why guides are often portrayed as androids rather than humans (for example, Cortana in *Halo*). However, the guide role is one that offers a chance for emotional connection and humor. Consider Otacon, in *Metal Gear Solid 2: Sons of Liberty*. This character offers the player a humerous proverb each time the player saves, poking fun at the relationship and offering the player a rest from the stressful, dialogue-free stealth play in the game itself. Otacon uses jargon that fits his role as a fellow soldier (see Figure 9.8).

Obligations and investment

Typically, a guide is accessible to the player throughout game play for advice but does not spend major interaction time with the player nor engage directly in core game play. The player may feel invested to the extent that the guide's advice clearly helps the player meet goals and avoid dangers.

Defining interaction moments

Most interactions between guide and player are dominated by the guide, who is filling in the player on important game information. Making these interventions as natural, unmechanical, and unforced as possible is an important goal for designing this type of character. Giving the character a deeper relationship with the player that supports the guide role and a set of motivations for being a guide may help give more social

FIGURE
9.8

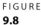

Otacon advises the player's character in *Metal Gear Solid 2: Sons of Liberty*. *Metal Gear, Metal Gear Solid*, and *Sons of Liberty* are registered trademarks of KONAMI COMPUTER ENTERTAINMENT JAPAN, INC. ©1987–2005 KONAMI COMPUTER ENTERTAINMENT JAPAN. KONAMI is a registered trademark of KONAMI CORPORATION.

substance to the interaction. The role has an inherent weakness, in that, unlike the sidekick, the guide is mysteriously exempt from the action in the game. Common devices for addressing this weakness include remote communication or defining the guide as a computer being of some sort. It may be better to split the guide role into two, making use of sidekick and mentor to fulfill this role where possible.

9.4.7 *Mentor*

Mentors are also firmly on the player's side and typically possess far more power in the game world than the player-character.

Objectives and abilities

Mentors function as helpers, as guides do, but they also take a leadership role in guiding the player. Rather than accompanying the player-character on a quest, the mentor usually provides some training and initial advice, followed by mission setting and occasional requests for report by the player. Examples include Chop Chop Master Onion from *Parappa the Rapper* (see Figure 9.9 and Clip 9.6) and Tom Nook from *Animal Crossing* (see Figure 9.10).

Obligations and investment

Typically, a mentor is only periodically accessible to the player and helps to drive the player's core objectives and motivations through filling in backstory, setting

FIGURE
9.9

Chop Chop Master Onion (from *PaRappa the Rapper*) trains the player-character, PaRappa, to fight in time to the music (see Clip 9.6). *PaRappa the Rapper* is a trademark of Sony Computer Entertainment America Inc.©1997 Sony Computer Entertainment America Inc.©Rodney A. Greenblat/Interlink.

FIGURE
9.10

Tom Nook of *Animal Crossing* acts as the player-character's mentor, helping the player find a house and get familiar with the game world and controls. Image courtesy of Nintendo.

objectives, and providing feedback on ongoing performance. The player is fairly invested in the mentor, who is providing feedback and information crucial to the central missions of game play.

Defining interaction moments

As with guides, most interactions between mentor and player are dominated by the mentor. Usually the mentor is offering some information or advice or providing

feedback on the player's actions, so defining interactions often take place in cut-scenes. Ideally, feedback should be adjusted to the player's real performance, to make the player feel the mentor is truly aware and invested. Mentors should, like guides, have a deeper social relationship with the player that justifies their interest in the player's success and should also have a social position powerful enough to justify their commanding the player-character's attention and energies. Mentors are often gruff types whose praise is doubly satisfying for being reluctantly given. However, any sort of relevant feedback and mission setting—gruff, humorous, even ridiculous and capricious (e.g., the king in *Katamari Damacy*)—is the job of and central emotional moment with the mentor.

9.4.8 *Obstacle*

The obstacle is the first social role listed in this chapter that is not agreeable toward the player. Obstacles are characters that do not have the player's best interests at heart and who must be navigated past to meet play goals. Typically, obstacles do not have that much social or physical power within the game—they are nuisances, not major threats. One wonderful example from an older, text-based game is the screening door from *The Hitchhiker's Guide to the Galaxy* (see Figure 9.11 and Clip 9.7).

Objectives and abilities

Obstacles usually have some small game-play ability or token that the player needs in order to proceed. In addition to providing physical resistance and challenge, they sometimes provide a battle of wits and a bit of comic relief.

The Screening Door in *The Hitchhiker's Guide to the Galaxy* requires that the player solve a riddle (see Clip 9.7). © Ed Victor Ltd.

Obligations and investment

An obstacle usually does not care if the player progresses or not but has an agenda that the player must deal with in order to suceed. Obstacles usually have short encounters with the player, and therefore not much investment on either side is required.

Defining interaction moments

An obstacle should be fun to hate and patronize. Making the obstacle's single-minded obsession with its own agenda humorous and persistent will add fun for the player. Obstacles should be funny, not scary or annoying, not depressing. Sometimes an obstacle can be won over by the player's actions, which provides an extra emotional punch (for example, the scene in Clip 2.9 in which Manny reencounters the sea walker, who thanks him for his help in getting unstuck).

9.4.9 *Enemy*

Enemies are one of the most popular and enduring NPC types in games. They were the earliest form of game NPC (for example, the aliens from *Space Invaders*, see Figure 9.12), and marketers still feature them prominently in game advertising. The makers of *Doom 3*, for example, used images of its NPC enemies heavily in marketing the game at launch. Enemy graphics and behavior have continually improved—compare the enemy creatures from the first *Jak and Daxter* game released in 2001 (see Figure 9.13) to the aliens from *Space Invaders* which was released in 1978 (see Figure 9.12)—but their role remains essentially unchanged. Antagonistic toward the player, they are usually not as powerful as the player-character in the game world individually but can often be overwhelming en masse.

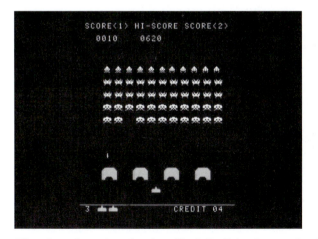

FIGURE
9.12

Aliens from Space Invaders (see Clip 9.8). ©Taito Corporation 1987. All rights reserved.

FIGURE
9.13

Enemy creatures from *Jak and Daxter: The Precursor Legacy. Jak and Daxter: The Precursor Legacy* is a registered trademark of Sony Computer Entertainment America Inc. Created and developed by Naughty Dog, Inc. ©2001 Sony Computer Entertainment America Inc.

Objectives and abilities

Enemies seek to destroy the player and vice versa. Enemies usually do not have the strategic power of the player, although they may have equal or better fire power.

Obligations and investment

Enemies are the antiplayer equivalent of minions—they do not require much time and emotional investment from the player, and their contribution to game play is usually to be cannon fodder.

Defining interaction moments

Enemies are usually dehumanized (portrayed as aliens, faceless nameless soldiers, or crafted in a cartoonlike way), allowing the player to treat them as an "other" and not to become upset by their deaths. Because there is no personal investment on the part of the player in individual enemies and relationships with them, emotional moments arise from brief encounters around combat situations—the first sighting of a new class of enemy, a surprise ambush, the moment of success in killing an enemy, or the sting of being defeated. Much effort is already devoted to making enemy deaths convincing from a physical point of view—accurate flopping, blood gushing, and the like. However, emotional satisfaction for the player could be increased if enemies appeared to be more aware of the game-play situation moment to moment—with grimaces and scowls of defeat, frustrated gestures, a look of surprise when the player appears, a surge of energy when the enemies appear to be

gaining, defeated body language when they appear to be losing, and the like. A goal to strive for might be to leave the player with an impression of the fighting style and spirit of a particular type of enemy—how they handle defeat, how they react in a crisis, how ruthless they are, and so forth—rather than with just the mechanics of weapons and tactics.

9.4.10 *Competitor*

Competitors are opponents in sports and sports-like games (such as *Mortal Kombat*, Figure 9.14). These NPCs usually have skills that are roughly on par with the player-character's. Competitor NPCs often can also be used as player-characters in multiplayer modes.

Objectives and abilities

Competitors have the same objective as the player-character: to win the contest at hand. Their abilities are usually tuned at various levels of difficulty to give different players a reasonable challenge.

Obligations and investment

Competitors in team sports are somewhat like enemies in that players devote little personal energy to getting to know them as individuals. Competitors in one-on-one sports may elicit a bit more investment over time from a player, as she or he gets to know the competitor's personal style and qualities. In neither case is there an expectation of an ongoing relationship outside the context of each round of game play.

FIGURE
9.14

Competing players in *Mortal Kombat.* ©Midway Amusement Games, LLC. All rights reserved. *Mortal Kombat*, the dragon logo, Midway, and the Midway logo are registered trademarks of Midway Amusement Games, LLC.

Defining interaction moments

As with enemies, the majority of interaction with and attention to a competitor comes during moment-to-moment game play and are not particularly emotionally and socially engaging, beyond the thrill of physically besting the opponent. Some sports games show competitor reactions to wins and losses, which increases the social engagement of the player. The satisfaction of victory and the frustration of defeat could be enhanced even more by the extent to which the competitor displays awareness of the shifts in fortune (frustrated shakes of the head, flagging energy, or a surge of "I've almost got him" speed) while play unfolds, as well as between goals, rounds, and the like. It would also increase social and emotional impact if competitor NPCs develop a history with a given player—remembering intense rounds of competition and developing expectations and attitude toward the player based upon their shared experience (e.g., "here comes trouble").

9.4.11 *Boss Monster*

Boss monsters are a form of powerful enemy that has quite a bit more strength than the player-character and which must be defeated through persistence and cleverness.

Objectives and abilities

Boss monsters are usually very territorial since they typically bar the way for a player into the next area of a game (for example, a temple guardian from *The Legend of Zelda: The Windwaker*, Figures 9.15 and Clip 9.9). They seek to prevent the player-character's entry and are happy to cause his or her demise. Bosses are usually very physically powerful but not especially bright.

Obligations and investment

The player is not encouraged to develop any sort of investment in a boss monster. It is something to be beaten and moved past. The player does expect the boss monster to present a much steeper challenge in terms of game play than run-of-the-mill enemies.

Defining interaction moments

The first moment of sighting a boss monster is an important moment, as is the moment of defeat. As with enemies and competitors, having the boss show awareness of winning or losing during the battle could heighten the emotional impact on the player.

FIGURE
9.15

In *The Legend of Zelda: The Windwaker*, the player-character must battle a temple guardian, among other bosses (see Clip 9.9). Image courtesy of Nintendo.

9.4.12 *Archenemy*

Archenemies are also antagonistic to the player-character but possess much more social and physical power in the game world than player-characters—making their defeat a significant accomplishment for the player. Dr. Badboon from *Super Monkey Ball 2* is a classic archenemy (Figure 9.16).

Objectives and abilities

Archenemies usually have some world-changing evil objective that the player-character steps in to block, turning their wrath toward the player-character. Archenemies do not usually engage in actual combat in game play; rather, they have hoards

FIGURE
9.16

Dr. Badboon (from *Super Monkey Ball 2*) is an example of archenemy (see Clip 9.10). ©Sega Corporation. All rights reserved. Reprinted with permission.

of minions that they dispatch to fight the player. An archenemy NPC usually shows up primarily in cut-scenes, revealing reactions to the player-character's progress and provoking reactions with further evil actions and challenges. (See, for example, Clip 9.10, in which Dr. Badboon tries to harangue Mimi into marrying him.)

Obligations and investment

An archenemy is a powerful focal point for the player-character—providing a target for wrath and an embodiment of what must be destroyed in the game. As such, the player has a strong motivation to pay attention to details about the archenemy and her or his objectives. However, the archenemy does not usually spend too much time onscreen, in proportion to length of the overall game. This makes motivation of the player a bit more difficult, in terms of building up antagonism. It is better if the player directly experiences problems due to the archenemy, to increase the emotional punch of the character.

Defining interaction moments

Archenemies mostly appear in cut-scenes. Making those-cut scenes directly relevant to prior or ensuing game play and showing the archenemy's glowering or gloating will help motivate the player. Showing the archenemy as perturbed by the player-character and hesitant could be a powerful motivator for the player as well, as is showing the eventual toppling of the archenemy. It is important to resist making the archenemy more interesting and dynamic than the player-character because the player may feel dissatisfied with his or her role and irritated with the contrast between cut-scenes and game play. Embedding more traces of the archenemy in actual game play (insults delivered by minions, game play road blocks clearly traceable to the archenemy, and so forth) can heighten the player's emotions and make the ultimate defeat more satisfying. As a mundane example, think of a battle between roommates in which one moves the other's belongings—the traces of interference can be the most maddening of provocations.

9.4.13 *Audience*

Audiences are neither for nor against the player and have no power or impact in game play. Their presence provides emotional ambience for what the player is doing.

Objectives and abilities

Audiences are re-creations of sports audiences—they react to good and bad plays on the part of the player and his or her opponents and, in general, appear to appreciate

seeing a good game. They do not have game-play abilities but can influence the emotional tone of the game and player morale with their actions.

Obligations and investment

The player assumes that the audience cares about the outcome and that the audience will applaud stellar moves and will boo mistakes. The player is typically not at all invested in individual audience members.

FIGURE
9.17

Crowds watching the action in *Mortal Kombat*. ©Midway Amusement Games, LLC. All rights reserved. *Mortal Kombat*, the dragon logo, Midway, and the Midway logo are registered trademarks of Midway Amusement Games, LLC.

Defining interaction moments

The player is peripherally aware of the audience's reactions to ongoing game play, and a positive reaction to a brilliant play will heighten the player's feeling of satisfaction. Audiences in games such as *NBA Live 2004* react more appropriately and with more social and emotional variation than in earlier games such as *Mortal Kombat* (Figure 9.17). Studying crowd dynamics and bringing more social and emotional nuances to in-game audience reactions—home team versus away team, cheering a star player, coming from behind versus extending the lead, and so forth—could further increase the realism and satisfaction of sports games.

9.4.14 *Informant/Trader*

Informants and traders have services that they will provide to anyone for a price. They are typically not particularly powerful in the social world of a game, but they

FIGURE
9.18

Traders play a useful role in *The Legend of Zelda* series: (a) *Ocarina of Time* and (b) *Windwaker*. Images courtesy of Nintendo.

have something that the player needs. For example, in *The Legend of Zelda* series, players can purchase useful supplies from traders (Figure 9.18).

Objectives and abilities

Informants and traders have their own agenda independent from the players. Traders want to keep their businesses going; informants have projects that require some form of assistance from the player. These NPCs are usually only involved in side aspects of game play.

Obligations and investment

The player has little investment in an informant or trader and only basic bartering or trading obligations. It is possible to enrich these roles by making the trader or informant part of the player-character's social network in such a way that the player-character can use the trader/informant to find out more about what is going on and to pass along messages to those she or he has a greater investment in.

Defining interaction moments

Informants and traders reveal their personalities and attitudes toward the player-character during brief engagements over the trade of goods or information. It is possible to heighten the player's engagement with these mundane transactions by making the trader or informant very entertaining and engaging in some way, but care should be taken to keep the character plausible within

the game world and to avoid intruding on core game play too much. One way to avoid irritation is to allow the player to choose whether and when to get chatty with an informant or trader and when to just do the business at hand.

9.4.15 *Host*

A host provides ongoing commentary about the game to audience members (either real or imagined). As the moderator of the event at hand, the host has more social power in the game world than the player-character. The host from *You Don't Know Jack* is an example of this role (Figure 9.19, also Clip 9.11).

Objectives and abilities

Hosts aim to inform and sometimes to entertain the audience witnessing the game play. They may direct play but do not get involved in the game itself.

Obligations and investment

The player is invested insofar as she or he hopes to hear the host say positive things about his or her game play. In games where the host directs play itself, the player will be even more emotionally involved with the host's reactions.

FIGURE
9.19

You Don't Know Jack is a game that relies on the charisma and energy of the host (see Clip 9.11). *You Don't Know Jack*. ©Jellyvision, Inc.

Defining interaction moments

The player will particularly enjoy hearing the player-character's exploits praised by the host and hearing her or his persona talked up before and after a game. The host can build a sense of suspense and realism into the game play, making the player feel that he or she is performing in front of a "real" audience. The interplay between the audience and the host creates a synergistic effect for the player (for example, the sound effects in Clip 9.12 when the player chooses the correct answer).

9.5 Design Guidelines

Though each social role presents unique challenges, it is possible to follow some general guidelines for optimizing social-role use in NPCs:

- *Plan social roles.* When creating design documentation, take the time to specify all NPC social roles, including relative social dominance and agreeableness, objectives and abilities, obligations and investment, and defining interaction moments.

- *Test legibility.* Make social roles legible and consistent! Check up on this as game development progresses (see Chapter 11 for evaluation suggestions).

- *Focus on defining moments.* Plan the defining emotional-interaction moments for a character given her or his social role, and focus design and development efforts here. When cuts are made, make sure that the game has not lost all of these defining moments and thus diminished emotional punch for the player.

- *Focus cut-scenes and roles.* Focus use of cut-scenes so that the player is getting useful social role information about NPCs' obligations and investment, in particular, as well as hints about NPC abilities and goals.

- *Embed roles within game play.* When possible, embed at least some obligation and investment into game play itself (not just in backstory). For example, Yorda helps the player-character during game play in *ICO* after being helped so much herself, or Floyd sacrifices himself toward the end of the game in *Planetfall*. Enabling an NPC to react to player actions in role-appropriate ways during game play also increases the emotional impact of the NPC tremendously.

- *Deeper role evolution and crossover.* For characters with extended game-play presence, consider deepening roles and/or giving these characters multiple roles to create additional engagement and immersion for the player. A sidekick can become a rescuee, a mentor can become an ally, or an ally can become an archenemy. Playing multiple roles makes a character richer and more socially interesting.

- *Balance roles*. Take a step back and orchestrate overall balance of social roles within your game. Make sure all player needs (for information, for moral support, or for guidance) are being met; fill in gaps as necessary. Sometimes, NPCs can seem arbitrary or clunky if there is not enough of a social world in the game to support them; considering the cast as a whole can help to prevent this problem.

- *Break social stereotypes*. Often there are patterns that have evolved over time in the qualities of NPCs in given roles (such as rescuees often being female or mentors often being older males). To create fresh and engaging characters, consider turning these stereotypes upside down and making an NPC that does not have the usual personal traits for that role. A young female mentor or an old man who needs to be rescued could be more interesting to the player because they are unique.

9.6 Summary and What Is Next

This chapter introduced the concept of social roles (from sociology and social psychology), extending it into the realm of nonplayer-character design. Common social roles in games were discussed, with examples and suggestions for focusing development efforts to maximize emotional impact upon players. The chapter concluded with some broad design suggestions to help the reader take advantage of social roles regardless of the particular function of an NPC in a game. Part V provides guidance for where in the game development process all these principles can be put to use and includes suggestions for ways to evaluate the social effectiveness of characters.

9.7 Exercises

9.7.1 Role Clarity

Have each person select his or her favorite NPC in a game, and then analyze the character according to social role. What is the character's relative dominance and agreeableness in relation to the player? What abilities and goals does the character have, and what are the obligations and investment of the player in regard to the character? Have each person show (or describe) at least one defining emotional-interaction moment between player and character. You may want to have each person also select a least-favorite NPC and perform the same exercise—you may uncover gaps and discrepancies with these disliked NPCs between the expectations they evoke with their social roles and the emotional and physical behavior they deliver.

9.7.2 *Defining Moments*

When you are crafting plans for NPCs in their games, have group members take a moment to specify defining moments between the player and the NPCs, within the context of game play. Be as specific as possible: include NPC actions and reactions and how these will be conveyed through NPC bodies, faces, and voices (see Part III for some suggestions along these lines). During play testing, test the NPCs for role legibility and get player feedback on whether these key moments hold the impact that the designer hoped for (and consider why or why not).

9.8 Further Reading

Biddle, B. J. 1986. Recent developments in role theory. *Annual Review of Sociology* (12):67–92.

Goffman, E. 1967. Interaction Ritual: Essays on Face-to-Face Behavior. New York: Pantheon Books.

Michener, H. A., and J. D. DeLamater. 1999. *Social Psychology*, 4th ed. Fort Worth, TX: Harcourt College Publishers.

Ross, L., and R. E. Nisbett. 1991. *The Person and the Situation: Perspectives of Social Psychology*. New York: McGraw-Hill.

PART Five

Putting It All Together

What Is Covered and Why

Chapters 10 and 11 offer a bird's-eye view of applying the research presented in the rest of the book while making a game. Chapter 10 builds from a brief overview of the entire development process, linking theory and design suggestions to each step along the way. Chapter 11 introduces evaluation techniques to help ensure that the work the design team does in crafting socially and emotionally engaging character concepts gets reflected in the end results of the development process.

Who Will Find Part V Most Useful

These chapters are a good place for the busy developer to begin considering the application of psychology to his or her own character-crafting work of the moment. These chapters will also be useful to someone who is trying to "evangelize" for using a psychological approach in character design—Chapter 10 includes arguments for the value of this approach that may win over skeptical publishers and managers. Anyone interested in player feedback and issues of usability in games will find Chapter 11 of particular interest.

Overview of Key Concepts

Process

Chapter 10 begins with six arguments for bringing a social-psychological approach to game development. Issues that often come up, such as lack of time and resources, are addressed here. The chapter includes an outline of the game development process, for those new to the industry, and provides a phase-by-phase outline of where specific psychological principles can be used during development. The chapter includes an interview with master character designer Tim Schafer about his own character-development process.

Evaluation

Chapter 11 makes a case for including user evaluation in the game-design process in general and provides specific techniques for testing characters and making sure that the principles suggested in this book are working in the ways that designers intend. The chapter includes interviews with two games usability advocates—Randy Pagulayan, a member of the Microsoft Games Usability team, and Nicole Lazzaro, an independent consultant specializing in next-generation games usability.

Take-Aways from Part V

After finishing Part V, the reader will have a clear understanding of where and when in the development process to apply the psychological principles described in this book and an idea of when and how character evaluation fits into the development cycle. Design teams will have checklists of criteria and methods for social character design, and managers and design advocates will have tools for promoting evaluation and the use of psychological principles while respecting limited time-frames and resources for projects.

CHAPTER Ten

Process

10.1 What Is Covered and Why

This brief chapter maps the pointers from the rest of this book onto the game-development process, providing specific guidelines for how and when to apply the psychological principles in this book to character-design work, from early brainstorming all the way to postrelease planning for a sequel. The chapter also includes rationales for taking a social-psychological approach to character design that can be useful in convincing a team to use the tools and theory from this book.

10.2 Arguments for Bringing a Social-Psychological Approach to Game Development

There is never enough time in the game development cycle—why add complexity with additional design and evaluation tasks? Here are a few reasons to consider:

- *It is not a time sink*. Most tools provided in this book do not add time to the development process, just new metrics and checklists to focus work that would already be done.

- *Better quality*. Using social-psychological evaluation criteria on characters as the game evolves will make the quality of characters better and more consistent.

- *Stronger integration*. Using the concepts and tools in this book will help root characters more deeply in game play, and will minimize the "wish I could skip the annoying cut-scene" phenomenon. This means that the effort put into those scenes is not wasted in terms of overall impact of the game.

- *Broader appeal*. Stronger characters will help make a game's appeal extend beyond graphics and physics junkies to include players who want a more emotionally and socially engaging experience.

- *Shows off technical advances*. Graphics capabilities are highlighted when characters' social expressions are done "right." Conversely, a great graphics engine can make badly crafted character behaviors even more painful to watch.

- *Power in a crowded marketplace.* More appealing and engaging characters in a game make marketing easier and raise the game's chances of attracting a longer-term audience for future sequels.

10.3 The Development Time Line

For those reading this book who are unfamiliar with the process, here is a time line including the steps most developers take in bringing a game to market. Those already familiar with the process can skip to Section 10.4. To learn more about the game development process itself, see *Further Reading* (Section 10.7).

The typical game development cycle can be broken into three major phases: preproduction, production, and postproduction.

10.3.1 *Preproduction*

This phase spans the time from the initial concept brainstorms to the creation of a sufficiently fleshed-out prototype of the game to assure the developer that it is safe to begin staffing up for full production. Tasks in preproduction include

- *Creating a game treatment.* This is done if the game is going to be pitched to a publisher or to internal stakeholders before crafting a prototype.
- *Market analysis.* To make sure a game can be a success with a given audience, there will usually be some market research and competitive analysis at this stage. Early character designs and prototypes may be put in front of the target audience to gauge reactions.
- *Game design.* This task takes early brainstorming all the way to some form of design document along with an art bible.
- *Technical feasibility testing.* In preproduction, any radically new ideas about the game-play programming will also get tested to ensure that they are feasible before committing big resources.
- *Project planning.* By the end of preproduction, there should be a project plan and a production path in place.

10.3.2 *Production*

This phase is the longest and the one in which the game is built out from the design plans laid in the prior phase. Tasks in production include

- *Asset creation.* The animations, sounds, and textures must all be created and placed.

- *Programming.* The game code must be written, and all levels or areas of the game must be assembled and tested.

- *Play-testing.* As the game is being crafted, testers work closely with developers to make sure the play works and is pitched at the right difficulty level and pacing. They also ferret out bugs.

- *Marketing.* In parallel to the development efforts, marketers are crafting a strategy for promoting the game and are releasing material from the game to build excitement and generate sales.

- *Release.* At the end of production, the game is put through some testing by players both internal (alpha) and external (beta) to the company, then code is officially "frozen" and a golden master is created for duplication and distribution.

10.3.3 *Postproduction*

After the game is released, there is still work to be done, including

- *Patches and upgrades.* Sometimes a game requires fixes that are released for download. Online games may have continuing releases and upgrades throughout the life of the persistent game world.

- *Continued marketing efforts.* Based on audience reactions, reviews, and so on, the marketing tactics for a game may shift after release, to extend the lifecycle of the game and take advantage of any unexpected positive factors (or to adapt to negative ones).

- *Postmortems and sequel planning.* Development houses take what time they can to learn from their own successes and mistakes in the design, production, and marketing of the game. If the game is a success, there may be plans to create a sequel or to port it to another platform, beginning the cycle anew.

10.4 Building in the Social-Psychological Approach

Figure 10.1 illustrates how the player experiences a character socially. The player's impression comes from surface qualities of the character as well as from her or his interactions with the character during the course of the game. The player's own qualities (gender, culture, etc.) act as a lens through which he or she experiences the characters. The diagram also shows the developer and the role he or she plays in creating these impressions through design and iteration during

FIGURE
10.1

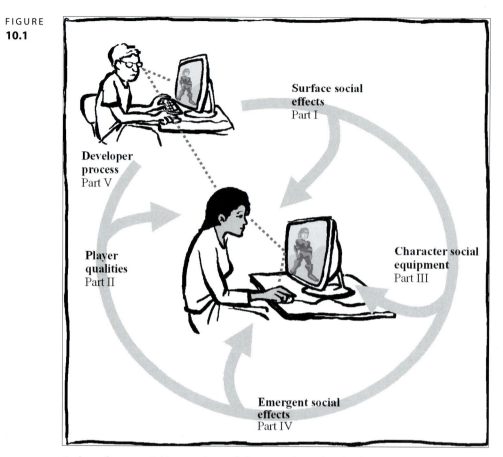

A player forms social impressions of characters based on both surface and emergent effects, which are enhanced through thoughtful crafting of each character's social equipment. The player's own qualities, such as gender and cultural background, affect these impressions as well. Designers can improve social impressions of characters by paying attention to all of these factors during the development cycle.

development based on observations of players engaging with the game. (To learn more about any one of these factors, turn to Parts I through V referenced in the diagram.)

During development, each member of the team helps shape the player's end experience. As Figure 10.1 illustrates, the social impression of a character arises from all aspects of design—visuals, sounds, dialogue, as well as interactions with the player that are coded into game play. Great character design requires a shared team vision, crafted with careful attention to the game's target audience. This vision emerges during the preproduction phase.

10.4.1 *Preproduction*

Taking a social-psychological approach to character design ideally begins when the game development process begins. Here are steps to take in the preproduction phase, when brainstorming and refining a game's design:

1. Consider qualities of target players (gender, culture, and other demographics) and how these qualities can affect the way those players will connect to characters (see Part II for culture and gender design tips). Ideally, build a core design team that includes members of the target player group.

2. When brainstorming, consider expanded notions of social expression for characters. (See Part III: Chapter 5 (*The Face*)—facial mobility, telegraphing intention, controlling player emotions, and enhancing social relationships with NPCs; Chapter 6 (*The Body*)—thinking between characters, touch and interpersonal distance, imitation, group dynamics, and character style palettes; Chapter 7 (*The Voice*)—emotion in voice, social context, identity cues, and interaction logistics.)

3. Take advantage of first-impression effects when drafting visuals and initial inter-action concepts. (See Part I: attractiveness, baby faces, stereotypes, personality and dominance/friendliness.)

4. Think about all four layers of player character(s)—visceral, cognitive, social, and fantasy—when brainstorming and while refining the vision through early proto-typing. (See Part IV: Chapter 8 (*Player Characters*) for tuning the four layers.)

5. Set clear character relationships for your game in your design documents. (See Part I: Chapter 2 for the relationship diagram, including social roles for NPCs, and see Part IV: Chapter 9 on social roles.) Make sure the affordances of your emerging NPC concepts support these relationships in game play as well as in cut-scenes. (See Part IV: Chapter 9 on defining emotional moments.)

By the end of the preproduction phase, the team should have

- a description of who the audience is and how and why each character appeals to this group (guided by Part II),
- a description of each player-character's appeal on all four psychological levels (guided by Part IV),
- a sketch of the social relationships among all the characters in the game, with some ideas about how these will come across in both game play and cut-scenes (guided by Parts I and IV), and
- social expression strategies for each character (face, body, and voice) and between characters (guided by Part III), and

- draft visuals of all characters that have the right social affordances for the social plans the team has for each, including first impressions and ongoing relationship formation (guided by Parts I and III).

These should become part of the game-design document and will be used as social-psychological character benchmarks during the production process.

10.4.2 *Production*

During production, the challenge is to spread the social vision for the game's characters among the larger team and to preserve that vision through the process of iteration, scoping, and testing. Here are specific steps that can be taken:

- *Sharing the vision as the team grows.*
 - Spread the word among the entire production team about the social benchmarks for all characters. Include write-ups in the design document from the preproduction phase and go over them in meetings.
 - Review the key social-expression strategies in the book with asset-creation teams and programmers who will craft character behaviors—if they understand the principles, they can make valuable incremental additions to characters as they work (see Part III on face, body, and voice; Part IV on principles of the four-layers of player-characters, social roles, and emotional moments; and Part I on first impressions).
- *Keeping to the vision.*
 - During level and art reviews, ask whether results meet social guidelines that the team set for characters. Revise accordingly (e.g., better facial expressions or body movement [Part III], better intercharacter game-play dynamics [Part IV], more emotionally and socially relevant dialogue [Part III], etc.).
 - When making the inevitable cuts to the game's size based on time frame, make sure to revisit the core social goals of the game's player- and nonplayer-characters to preserve the integrity of that vision. Pay particular attention to whether NPCs' key emotional moments have been preserved [Part IV] and to the experience of the player-character at all four layers [Part IV].
- *Play-testing.*
 - Include character social qualities in play-testing cycles. Use the benchmarks from preproduction as heuristics for in-house testing, handing out traits on checklists and looking for exceptions and "deal breakers" for the target audience (see Part II for a description of some mistakes to avoid; see Chapter 11

for more details on evaluation techniques). Have play testers identify failure moments and frustration points that can be taken back to asset-creation and programming-team members for modification.

- When possible, do some testing with the target audience and ask them for feedback on the social qualities of the characters in the game (see Chapter 11 for more detail on evaluation techniques).

- *Marketing.*

 - Guide marketers as they release materials so that they highlight the right social qualities of your characters, based on target audience, as determined in preproduction. Provide them with key emotional moments between characters from the game as footage for demos (Part IV).

10.4.3 *Postproduction*

Once the game has been released, if there is talk of a sequel or of expanding to other markets or platforms, the tools in this book can be helpful in refining plans.

- Use fan-site reviews and postrelease surveys that ask players for reactions to characters to identify strengths and weaknesses. Allow for capitalizing on unexpected connections and appeal (see Chapter 11 for more detail).

- Apply the caveats and concerns about culture and gender (Part II) to help identify potential sticking points with new audiences.

- If the game is being considered for another platform with different affordances (for example, *GameBoy* after a release on the PC), rethink whether characters' social equipment will function in the same ways in the new format (Part III on face, body, and voice).

10.5 Interview: Tim Schafer

Tim Schafer is a game designer known for his original and engaging character design work, including the LucasArts adventure classic *Grim Fandango*. Schafer recently completed directing development of a game called *Psychonauts* at his studio, Double Fine Productions (*www.doublefine.com*). He gave a talk at the 2004 Game Developer's Conference on character design, and we caught up with him afterward to ask about his development process in more detail.

FIGURE
10.2

a b

(a) Tim Schafer, longtime LucasArts designer and currently the proprietor of Double Fine Productions. (b) His most recent game is *Psychonauts*. *Psychonauts*. ©2005 Double Fine Productions, Inc.

Q: So, how do you make such great characters anyway? Just kidding (sort of) . . .

Okay, here's my first piece of advice: study! If you are going to be making characters, stories, and settings for games, you should start with an understanding about how to do it on paper. Take some writing classes! If you are in school, sign up for every creative writing class your school has. If you are out of school, you can still take them at a community, junior, or state college. You learn something from every class, and if nothing else, it's very motivating. The only time I really write is when I have a deadline. And it's important that you write every day if you're going to be a writer—whether you're writing short stories or video games. There is a lot of theory you're going to need to know about how to create character, plot, setting, and dialogue. Don't skip that step! I mean, the artists I know that work in games didn't start doing art for games. They started drawing on paper, and long after they had that skill down they transferred it to the computer. Learn the fundamentals, kid!

Q: How do you dream up the initial concepts themselves? What sorts of tools do you use to explore concepts? To put them onto paper to share them?

I seem to start with a desire to bring a certain world to life. Like the world I saw in Mexican folk art. Those little figurines with the skeleton dentist, the skeleton bride and groom, etc. How fun would it be to see a whole city of those skeletons going about their lives? Similarly, someone was telling me stories about a biker friend of theirs, and it was such an exotic (to me) and crazy world, I just wanted to walk around in it for a while (but from the safety of my own house). Then once the world is set, I start to think who would be the STARS of that world? If you're going to drop the player into a world you've created for them, you should make them the star of it! Not just "some dude." There is a

tendency to say, "Okay, you are some dude, in this crazy world..." and that's bad. (See last question, page 266.)

So who would be the star of that world? That's your protagonist. And then who would be a good foil for that character? Who, by standing in opposition to your hero, would give that hero a chance to define him or herself, and demonstrate their heroic qualities? That's your antagonist. And so on. The rest of your characters fall out of these first few, critical decisions.

Q: Do you personally preside over play testing? Over art creation? Over coding? How do you ensure the vision stays true all the way to release?

Well, you work with good people and create a shared vision among all of you for what the game should be. Everyone brings their own take to it, but there are some big issues that you should all agree on. Like the tone of the game, the audience, the complexity level, etc. It's a truly collaborative art form if done correctly. Everybody brings something unique to it. And if you are all moving in compatible directions, then you don't have to oversee every tiny detail yourself. You can just trust the people doing the work.

Q: What kinds of tools do you use to communicate your (and your design team's) vision of your characters to the production team?

That changes a lot from game to game. I used to just use one big Word document. But as the games get more complicated, the design doc turns into more of a "design database." A lot of people I know are using wiki, *http://en.wikipedia.org/wiki/wiki* so they have all their info up on intranet pages that the whole team can read and modify. So that might work for the written spec. But then there is also art. I'll work with the artists to illustrate on paper every character and environment in the game, and then we'll throw all of that up on the wall so everyone can see it and be surrounded by it and inspired by it all the time.

Psychonauts is set in a summer camp for psychic children. We had 20 kids in all, and they all needed unique personalities, abilities, and motivations. Getting it all straight in my head was proving to be very confusing, and beyond that how was I going to convey it to the team? Right about that time, the online social network *Friendster.com* came on-line. It was really popular and new then, and I was spending a lot of time on it. You could put up a profile about yourself, listing your likes and dislikes and other critical information. You could also put up six pictures of yourself (but people often put up pictures of their car or their cats instead), and most importantly, you had an area where you put a collection of your friends, and this collection was a collection of links—little pictures of your friends that if you clicked would take you to that person's profile. You could then see your friend's friends, and your friend's friends' friends! You could kind of surf your social network. It was a perfect format for describing a group of people and their relationships to each other, so I made 20 fake Friendster profiles, one for each camp kid. They had a picture of themselves and links to which camp kids were their friends. They left little "testimonials" on each other's pages, so you could see how they talked to each other. And when it came time to pick which six pictures each camp kid would put up on their

263

profile—that was really fun. I had never thought that way about a character before. What sort of visual collage would that character make about themselves? It was an interesting new way to think FROM THE CHARACTER'S POINT OF VIEW, which is the trick to making your characters real. If you can think from their point of view, you can really flesh them out. It's like character development through role playing, which is often how they do it in theater.

Anyway, when the fake Friendster doc was done, I shared it with the whole *Psychonauts* team, and everybody could read this entertaining, visual, easy-to-browse thing that made the characters seem like real kids who existed out there in the world and had hopes and dreams and love triangles and favorite colors and the whole deal. I think I'm going to do that for every game I make from now on, it was such a big success.

Q: How do your visions adjust as you move into production? Any funny changes, mistakes or catches you would be willing to share?

Q: Do you think user testing is helpful? Why (or why not)?

These two questions go together. We used to have a different main character than we have now in *Psychonauts*. We started with this kid named D'Art (short for D'Artagnan) in the game that seemed pretty cool at first. The idea was that he was kind of an acrobat and a gypsy. So he had these loose, silk clothes and a long stocking cap. We thought that would look cool, the hat, but we just couldn't get the tech right for it, and it always looked like a chunk of rock attached to his head. We were really inspired by artists like Joe Sorren, so we made D'Art's face an interesting, nontraditional color. And then we designed all of the other characters in the game. By the time we came back to this guy, he didn't look so cool anymore. And the animators were having trouble with his stubby little limbs, getting him to move like an acrobat. And then our publisher did a focus-group test and we sat behind one-way glass and watched potential customers look at our guy, D'Art. And they hated him. "Are those pajamas?" they asked. And "That blue face freaks me out." But the worst comment was actually the very first one. As soon as we unveiled D'Art, some kid said, "What's up with her hair?"

"That's a hat," I silently whimpered to myself on the other side of the glass, "And that's not a girl!"

Luckily, Scott Campbell, our art director and designer of all our characters was now done with most of the other characters in the game and was much more clear on what he wanted from the characters than when he started, so he went back to the drawing board and came back with Raz, a much more agile and likeable fellow! So I guess the moral is, don't design your main character first.

Q: Any words of warning about what not to do to your characters when developing the game? Things to watch out for?

Avoid "Bland Lead Character Syndrome," no matter what anyone tells you. You hear people saying all the time that having a blank, bland, boring main character is good because

that makes a "blank slate" that the player can project their own personality onto. It's a dirty lie! A lazy cop out! People just fall back on that because interesting main characters are hard to write (mostly because you're so afraid that people won't like them, you don't put in any spice or risky qualities). If your main character is EXCITING and COOL, then the player will still project themselves (or "ego-invest" as someone more academic than me might say) into your hero. But they'll think, "Hey, I'm that cool guy. I'm awesome."

10.6 Summary and What Is Next

This chapter is meant to serve as a guide for when and how to apply the social-psychological principles discussed in this book. Chapter 11 discusses evaluation techniques for making sure that game characters function socially in the ways that developers intend.

10.7 Exercise: Sequel Planning

Imagine that you have been asked to develop a sequel to a popular game (choose any current best-seller with strong characters in it). Each person should draft a development plan for the sequel, including techniques and guidelines from this book for character development and where they will be used within the plan. Make sure to include the postproduction phase from the current game, as well as preproduction and production phases for the sequel, in your plan. Compare what you wrote. Most likely, each of you will have incorporated a somewhat different set of techniques and tools, partly due to your own focus within development. Trading notes about this can help everyone to understand one another's process and perspective.

10.8 Further Reading

Bates, B. 2001. *Game Design: The Art and Business of Creating Games. Roseville*, CA: Prima Tech.

Saltzman, M. 2004. *Game Creation and Careers: Insider Secrets from Industry Experts*. Indianapolis, IN: New Riders.

CHAPTER Eleven

Evaluation

11.1 What Is Covered and Why

This chapter explains why evaluation is a crucial step in delivering great game characters, and it provides tips for incorporating evaluation into the development process in reasonable and sustainable ways. The chapter also includes interviews with two forward-thinking game usability experts.

11.2 The Psychological Principles

11.2.1 *Importance of Empirical Confirmation*

Getting accurate feedback on whether character designs are succeeding with players is crucial to the development process. Yet this aspect of design is often given short shrift. Tight time lines and a tradition of developers doing double-duty as testers until the latest stages of development mean that games have been losing out on the value of empirical feedback for most of their history. This was less damaging when games were a niche product for a narrow audience whose members were similar to developers themselves in their preferences and reactions.

Here are some reasons why a development team should build evaluation into the process:

- *Need for the right fresh pair of eyes to see what has really been created.* All development team members are biased observers. They have done the work and are highly motivated to believe that they did it right and well. Their familiarity with the content means they can no longer see characters through a beginner's eyes, even if they were able to be objective about what they were seeing. A core principle of the scientific approach is confirming your own intuitions and hypotheses with objectively collected data from the world. Using this approach in character design will help ensure that the team really achieves the intended effects.
- *Finding out what the audience really thinks—external validity.* Particularly if the target audience includes people quite unlike the core development team, it is very

easy to wander during the design process far from an engaging experience for that audience. Doing evaluation along the way reduces the distance between the final design and the audience, avoiding costly disasters. Early audience feedback may also lead to unlikely design innovations or direction shifts based on what's working well, and that can make the game's characters even more powerful.

- *Helps justify design choices to the powers that be, when that is needed.* Sometimes, especially when working with large publishers who wish to reduce risk in a challenging market, some early evaluation data to support design choices can make the difference in getting a concept through. It may also help to thwart efforts to dilute the design in directions that do not truly support the game's core experience.

- *Focus.* A healthy amount of evaluation done at the right times keeps the team's eye on the prize—great experiences with the characters for the player. Evaluation results can be used to help resolve internal conflicts about design directions and keep everyone focused on the player's overall experience instead of on individual innovations or particular content choices.

11.2.2 *Some General Guidelines*

Before delving into specific methods, here are a few practical guidelines for judging the potential usefulness of any kind of evaluation. These rules of thumb will help in avoiding time-consuming and expensive tests with unhelpful results.

- *Make sure questions are clear.* Fuzzy questions produce fuzzy results. Asking the wrong questions can produce answers that do not make sense for the stage of development, or even that make no sense at all. These are basic truths in empirical research. The design team and evaluators need to agree on what questions should be asked, working both from identified concerns and issues and from outcome possibilities.

- *Ask the right people.* Questions should be addressed, whenever possible, to those who will be playing the game at the end of the development process. If there are team members who fit the audience profile, make sure they have relatively fresh eyes for the project if they are asked to be test players. It is not possible to effectively design for a target audience very different than the core development team without using evaluation. As an example, see this article, which describes a game that was way too hard for the adults in the team but worked just fine for the children who were the target audience: *http://www.gamasutra.com/ features/20001106/turnure_pfv.htm.*

- *Have a plan for how and when results will be used (and by whom).* Be ready to fix issues that arise from tests. Rather than waiting to create a summary

document, have the right people in the room so that they can see what is happening in real time and list fixes for their own teams. It is possible, if time is budgeted for it, to plan to make changes as problems occur during testing so that each succeeding test player will engage with the improved version. This helps avoid the problem of several players pointing out the same issue. Microsoft's Game Usability engineers use this method, which they call the RITE method (Fulton and Medlock 2002).

- *Create a team culture that embraces critique.* Make sure everyone is open to and ready to hear about what went wrong, and to make it better. It can be invaluable to have key team members present to witness evaluation (or to show them videotape afterward). Seeing is believing.

11.3 Current Evaluation Practice in Game Design: Market Research and Play Testing

At present, the most common forms of evaluation in the games industry happen at the very beginning and the very end of the process.

11.3.1 *Market Research*

Some publishers work with development houses to conduct market research on initial character and game concepts. This usually involves showing small focus groups of people from the target audience sketches of characters and then walking the audience through the basic structure of the game play. A trained moderator helps ensure that any prior concerns the publisher has about how the audience will react are covered during the discussion that follows. These types of tests are meant to flush out unexpected negative reactions to characters and concepts and to identify interest level. This tactic is relied upon to help uncover culture-specific issues (see, for example, [Tsurumi and Hasegawa 2003], who discuss the ways that *Crash Bandicoot* changed in appearance for the Japanese market).

Pros

- Can be helpful in uncovering cultural faux pas in character design (e.g., inadvertently lewd gestures, unappealing stylization, or alienating physical qualities).
- Can be used early in the design process.
- May provide unexpected design ideas and insights as well as valuable information about reactions to competing games' characters.

Cons

- Can be quite unreliable, if the moderator is not good.

- May not be an effective strategy for testing a game concept with teens or other extremely peer-sensitive audiences who may fall into group dynamics that skew the commentary toward a dominant member's viewpoint.

- May not be a great indicator of game success because focus groups can address what is in front of them but cannot accurately tell you if this will lead to liking the final product or to purchase.

11.3.2 *Play Testing*

The other evaluation method widely used in the games industry at present is play testing. In contrast to market research, play testing comes toward the end of the development cycle. Typically, play testing begins once the project has moved into the latter end of the production stage, when design has already been completed. Play testers ferret out bugs and help to tune the game by pointing out stuck points and boring moments.

Play testing is usually conducted inhouse, and play testers are most often avid gamers eager to break into the game development industry. As such, their demographic profile is typically close to that of the developers themselves.

Play testers can uncover aspects of how a character will be experienced by the player that are difficult to see without being able to play through; for example, overly repetitive dialogue, excessively difficult physical controls, inappropriate interventions by helper characters. They can also log bugs in characters, such as missing dialogue or audio, strange visual artifacts, and other problems.

If asked, a play tester could probably tell the development team a great deal about his or her general impressions of the game's characters. This information comes too late to result in major design changes but could result in helpful tweaks to small-scale issues that really interfere with the desired impressions of characters.

Pros

- Can be helpful in uncovering glitches in character production.

- Can be useful for tuning the in-game feel of characters. If play testers are given the checklists developed in Parts II and IV of this book, they can help ensure that the final characters in a game create the desired effects on players by pointing out production and game-play problems that get in the way of these effects.

Cons

- Can provide some insights about general character qualities too late to be useful.

- Will require a working, reasonably filled-in version of the game.

- Typically done by hard-core players, so may not accurately reflect the impressions that the larger target audience will form.

11.4 Taking Design to the Next Level with Preproduction Evaluation

The methods discussed above come at the beginning and end of the development process, yet many of the crucial design decisions about characters in a game come in the late preproduction stages, when the team is refining concepts from early sketches, doing initial prototyping, and crafting the design vision that will shape the final game. This is the phase where there is room for growth and improvement in use of evaluation. Market testing typically happens too early to affect this stage, and play testing happens too late. As Figure 11.1 shows, testing is crucial in the late preproduction stages of a game, when change is still relatively inexpensive. Subsequent testing should ideally be an integral aid to iteration and refinement, based upon criteria and approaches established in this early phase.

Sections 11.4.1 to 11.4.3 present three evaluation techniques that can be used in the brainstorming and early prototyping stages, as a game's character designs get finalized for production.

11.4.1 *Informal Early Testing of Character Prototype "Hacks"*

It is extremely helpful to put some visualization of the character concepts in a gaming context to show to people in the target audience as early as possible. This can be done even before there is a working prototype of the game. Use paper and pencil sketches of the look and feel of the characters, combined with demonstrating "like" interactions from existing games (e.g., the game mechanics will be like game X, the physics of your character will feel like game Y, and the interactions with the NPCs will work like game Z). Once there are working prototypes of some of the character interactions, these can be substituted in follow-up tests. Use the social roles and defining moments from Part IV to compare with players' initial reactions. Do they come up with a similar set of traits when asked to describe what they see (that is, are the social qualities legible)? Do they ask questions about relationships among characters, or about the abilities and motivations of the player character(s) that can help round out the social design for the characters? Do they express hesitations or frustrations that could mean your concepts are in need of major revision?

FIGURE
11.1

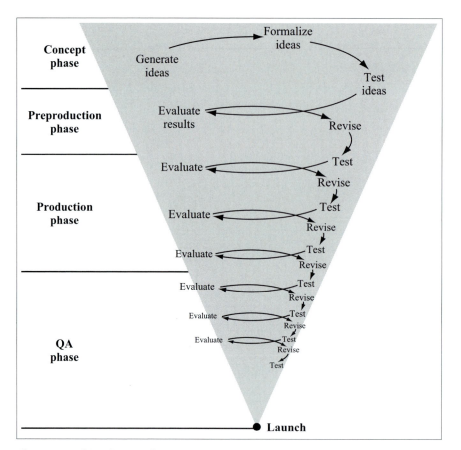

Changes resulting from evaluation get narrower in scope as the development process unfolds. (Based on diagram from Fullerton, Swain, and Hoffman 2004.)

This process helps gauge broad reactions to character concepts. It also provides the development team with a better-integrated picture of how characters will function, even prior to having a working prototype. Because the best characters work both top-down, in terms of surface qualities, and bottom-up, in terms of game-play dynamics, this will help everyone get a feel for whether the characters work overall (instead of just whether the visuals are appealing).

This sort of testing is meant to be informal and conducted in service of the design (not as a "go or no go" tool for publishers). It will work most efficiently if the design team is able to witness the test (either by watching during or by looking at videos as a group later on) rather than waiting for a written report from a testing service. These types of tests can be built into a preproduction schedule alongside internal design reviews. If your development house can cultivate a pool of test candidates from the target audience who can be quickly brought in for some informal

interaction, it is more likely that you will use this technique. These could be friends and relatives of coworkers, so long as they fit the desired demographics. Building it into the process will help reduce unpleasant surprises later on and will keep the team from wandering too far down a character-concept path that looks exciting but does not resonate with players.

11.4.2 *Social Heuristics*

It helps to have guiding qualities by which to judge design iterations even before putting anything in front of players. The suggestions in Part IV can also be used to create heuristics during the design iteration process (see [Nielsen 1994] for empirical validation of the power of design heuristics to catch problems). Asking (as a team) whether a player-character works at all four layers as planned, or whether an NPC is delivering on role expectations and giving the player the right key emotional moments, will keep the overall experience of the characters in mind as designs shift and evolve and will focus development efforts. When there are design reviews, go back to the lists of qualities and relationships you created to see if the desired effects are being achieved, and make changes to these checklists based on new qualities that have emerged from the design process that make the concepts even stronger. These checklists should be used simultaneously—in reviewing artwork, early game physics, and interaction mock-ups—to keep the experience of the characters integrated.

11.4.3 *Preproduction Reality Check*

When the team feels the design is ready to go, it is time for a more formal evaluation using the target audience. Players should be able to clearly "read" the social traits of characters and should find the characters engaging and appealing in the ways that have been outlined by the team. (In particular, the four layers of the player-character should be working well, and interactions with the NPCs should be socially satisfying and emotionally engaging in the ways that have been planned.)

It is very difficult to correct appeal problems once full-scale production begins. Also, if the traits that have been specified are not legible to the target audience testers, they will probably not be clear to developers who are added to the full-scale production team. This means the characters are likely to get even muddier in terms of social traits through the rest of the process, lowering the social clarity of the game and making the overall game experience less engaging and satisfying.

As with the early informal testing, this evaluation process will go most quickly and smoothly if the whole design team is present to see the tests for themselves or to watch video as a group and make joint decisions about any actions. This preproduction reality check is an appropriate tool to use in aiding a "go" or "no go" decision

273

for a publisher, and results can help to bolster the case for a design that may feel risky to a publisher.

11.5 A Note on Postproduction Evaluation

Often a development team is more than ready to stop thinking about a game once it has been released and move on to the next one. However, particularly if there is some talk of a sequel, it is worth doing some postproduction analysis of a game's characters to plan for their evolution in future (and to learn from mistakes made in the current release).

Consider combining an analysis of comments about characters on game-review Web sites with some kind of player survey. Ask registered players questions about the character qualities discussed in this chapter, and in Part IV, along with questions about their own demographics. It is possible to find that the game appeals to an unexpected audience segment or that players are responding powerfully to a character that was not central to the development team or to a trait that seemed very minor. Logging these effects allows the team to capitalize on them in the next release. Why not take advantage of the momentum of release to gather this information?

11.6 Evaluation Checklist

Whether using market research, preproduction audience tests and heuristics, or play testing, there is a common set of social qualities that can be used to guide observations. In combination with the guidelines from Part IV, these can serve as criteria to test at any stage. Be careful to tie the answers to these questions to specific observed interactions with characters whenever possible so that the team knows what to change to fix the problem.

- *General response.*

 Does the player like this character?
 Are they interested in seeing more of this character?
 Does the character seem to come to life or does it seem mechanical?
 Is it fun to play with this character?
 Does the player want to know more about the character?
 What makes the person say so? (Ask them to provide memorable impressions of the character that led to this overall impression.)

- *Emotional direction.*

 Is the player having the desired emotional responses to the character's actions? (Target moments that should be very emotional for a player and look to see if this is actually happening.)

- *Social legibility.*

 If asked to describe the character, does the player describe the traits that were sketched out for this character?
 Can the player identify the social role of each NPC?

- *Affordances.*

 Is the player clear about how to interact with NPCs?
 Does what is possible match up with what the player thinks of doing and/or wants to do?
 Is the player clear on the *use value* of NPCs (that is, what they can do for the player)?
 Is it fun to interact with the NPC, or is it in some way burdensome, annoying, or repetitive?

- *Identification.*

 Does the player enjoy being the player-character?
 Does the experience of being this character work well at all four layers (visceral, cognitive, social, and fantasy—see Part IV)?
 What specific affordances or behaviors of the player-character cause very negative or positive reactions?

- *Connection.*

 Does the player enjoy interaction with NPCs, beyond their functional value?
 Does the player want to see more (or less) of an NPC?
 How connected does the player feel to an NPC?
 How much empathy or antipathy does she or he express toward the NPC?
 What specific behaviors of the NPC cause very negative or positive reactions?

- *Danger signs that a player does not like a character:*

 obvious or expressed boredom,
 rude behavior toward or comments about a character that is supposed to evoke empathy,
 avoidance of interaction with characters when it is optional, and
 expression of dissociation and impatience with the story of the game.

11.7 Games Usability Perspectives

Following are interviews with two practitioners in the emerging field of games usability. Randy Pagulayan is a user research lead at Microsoft, one of the first major development/publishing houses to systematically incorporate user testing into the game-development process. Pagulayan and his colleagues have presented work on user testing at the Game Developers Conference several times in the last few years, helping to broaden interest in incorporating these tactics into the development process.

Nicole Lazzaro founded an independent consultancy that is doing ground-breaking work in understanding player emotions during game play, as well as conducting various forms of user research. She has given talks about the user experience at the Game Developers Conference in 2004 and 2005.

11.8 Interview: Randy Pagulayan

Q: What's your method, in a nutshell, for incorporating user testing and evaluation into a game-design cycle? Where in the cycle and how?

I don't know if we have a method per se, mainly because the game-design cycle can be quite different for different development teams. That said, I guess the philosophy we use . . . could be summed up in a few statements; if it's a researchable question or a situation where the perspective of your audience is required and/or useful, then we can probably provide some value. From concept phase, to user-testing core game mechanics, final game polishing, to evaluations on the finished product, there is usually something we can do to help out.

Q: Why do you think user testing is valuable?

I guess two things come to mind for this question; user testing can be a "sanity check," and it can also be your "Magic 8 Ball." More often than not, the most successful games out there are a result of a large group of extremely passionate individuals. In a lot of ways, your level of passion for a given project is what can make the difference between a good game and a great game. On the other side of that coin though, you run the risk of losing objectivity. User testing done throughout the dev process is like a splash of cold

FIGURE
11.2

Randy Pagulayan, PhD, user research lead, Microsoft Game Studios.

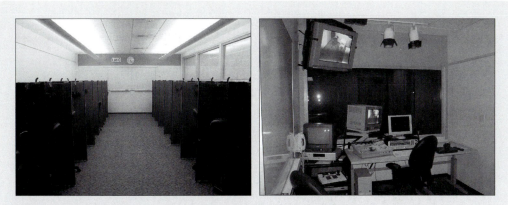

FIGURE
11.3

Microsoft Game Studios (a) Playtest Lab and (b) observation facility of the Usability Lab.

water. It's not hard to reset your viewpoint when you see a new user interacting with your game. It will often remind you of things you forgot, and also uncover new things you couldn't predict.

Regarding the "Magic 8 Ball," well, there will always be questions and assumptions made throughout the entire dev process. For some of these questions, user testing can provide those answers. Will players understand right away how to use that new "energy sword"? How long will it take players to find all "five keys" to open up the treasure chest? Can players discover the new multiplayer feature you implemented? And so on.

Q: How has this created value for the games you've worked on? Bugs you've caught? Broader user appeal? Both specific stories and general information appreciated here.

Good question. Most of our work over the past few years focused on the initial game experience. Our goal was to make sure that the entry point into games was as smooth as possible, so we focused much of our energies on the first hour (give or take a few minutes) of game play. This includes the usability of the game shell (option screens, game setup, etc.), in-game displays, understanding game-play objectives, understanding core game-play mechanics, and making sure the difficulty level was appropriate, that kind of thing, and of course that it was fun! More recently, we've been developing methods for user testing the entire game experience. To use *Halo* as an example, in the original *Halo*, our team focused on core game components (player and vehicle controls, aiming, etc.), did fairly extensive user testing on the first mission and the tutorial and part of the second one, and did usability work on the interface (game shell and in-game display). For *Halo 2*, our team was able to do much more. We did similar types of usability testing on new game-play mechanics (dual-wielding weapons, new weapon usage, new training system, etc.). However, we also provided user-testing coverage on the entire game— at least several iterations on every level—and were able to identify problem areas, make changes, then verify with additional user-testing sessions. More importantly, we were

able to do it within the constraints of a tight shipping schedule by being so integrated with the project team.

Q: Do you specifically test game characters? For example, reactions to characters, legibility of the character's personality and purpose, look and feel of player-characters, controllability of NPCS, and so on? How so?

We do, but more often in the context of a specific game-play mechanic. Take *Brute Force* for example. This is a third-person shooter game where you are part of a squad of four characters. Each character has a unique special ability. You are in control of only one character at a time, but you can give commands to the other three, and you as a player can also hop from character to character as well (i.e., control each character separately). In this case, there were many design challenges to overcome that user testing assisted with: the interface for giving commands to each or multiple characters, understanding the special ability of each character and when and how to use them, etc.

Q: What would you say to a developer who said it is too complicated or too expensive to do user testing?

I guess I'd start with some of the things I've said earlier about why user testing is valuable, then give specific examples and success stories. From there, getting the developer to see it in action is worth more than any discussions or logical arguments you may present. The best part is, giving them a taste of what it's like can cost next to nothing and be fairly simple. In my experience, developers seeing a real user interact with their product the first time is almost like a light switch that turns on. They usually see the value fairly quickly.

Q: What do you think are the most interesting challenges in user testing?

For this question, I'm referring to user testing more broadly, that is, user testing as a discipline as opposed to user testing as an activity or particular methodology.

User testing in games is still in its infancy (relative to other disciplines in the field), so interesting challenges can be widespread, not to mention that the games industry is evolving quite rapidly. So from there, I guess I see two categories of challenges that will always be there: content accessibility challenges and logistical challenges. From the content perspective, there are a ton of research areas that can help game developers and game designers (e.g., sociology, psychology, ethnography, and other related fields regarding human behavior). The problem here is making that information accessible, something that developers can use when thinking about designing their games. It's not an issue of educating them on the differences between the indirect and direct models of perception (for example), but an issue of taking bits and pieces of those models to provide a framework that is useful to them. I'd be very surprised if game designers spent much time reading peer-reviewed journals to see what the latest research is saying. I think the character work you're doing is a good example of this, taking techniques from research that can be applied in their everyday work.

From the logistics side of things, there will always be challenges with how one gets inserted into the development cycle. One thing to recognize is that no matter how much you plan, you never have enough time when trying to get a game on the shelves. The challenges here lie in your ability to integrate yourself as early as you can in the schedule to try and catch potential problems that may surface later. A simple example is doing prototype tests on a UI (user interface) flow before it is coded. But where things get really sticky are in the "crunch," those infamous few months toward the end of the cycle where every second counts. To be successful, you need to have a system that allows you to still collect valuable user-centered data, but still be able to analyze it, and turn it around in time for designers to still utilize. Any user-testing methods you can develop to exist in that kind of an environment should be considered a big win!

Q: Any pitfalls you'd advise readers to watch out for? Methods you think are especially good?

Pitfalls? A couple come to mind, but these are just my personal opinions. For one, I do believe that bad or misleading data is worse than no data. User-testing methods are often suited to answer a particular kind of question, and projecting conclusions based on incorrect methodologies can be dangerous. Leave the data analysis to those trained in it. Another pitfall to watch out for is to not rely on user testing for design. For you designers, know what you are designing and have a strong vision for it. Once you know that, then user testing will help you realize that vision.

Q: Any thoughts on future directions of games usability or testing? New techniques? Technologies? Giving people a hint about the future here would be great.

Games have always been a social experience, whether it's between two friends battling out a game against one another, or a single player against a swarm of digital bad guys. Investigating methods and techniques that can tap into that social element of gaming is definitely a worthy cause. Other future directions? Corner a game designer, ask them what they want to know when designing a game, what information do they need that would persuade them to make a design change? Any methods you come up with to help answer those questions would be a step toward the future as well.

11.9 Interview: Nicole Lazzaro

Q: What's your method, in a nutshell, for incorporating user testing and evaluation into a game-design cycle? Where in the cycle and how?

At XEODesign we call it *Player Experience Research*; because, more than testing users, we look at their experiences playing. Because we focus on improving the game, we think of it as design research rather than market research. It's important to differentiate between market focus groups and usability testing. In usability testing you watch how people learn to play. To do this we watch people play, what they do, what they find difficult, and

FIGURE
11.4

Nicole Lazzaro, founder, XEODesign.

what they find fun or not fun. We want to know how easily players build a mental model of how to play and how closely it matches the designer's intent.

Save money: test early, test often. Clients come to us feeling it's too early to test, and leave wishing they'd hired us a lot sooner. We recommend starting as early as possible in the design cycle starting with paper prototypes and ending with playable builds during alpha and beta testing. The user interface (UI) for most games can be worked out and tested on paper before any of the code is built.

Q: Why do you think user testing is valuable?

Life's full of surprises; your player experience shouldn't be one of them. Seriously, unless you watch people outside of your company play your game, you have no idea what it feels like for someone to play your game for the first time. Player experience testing is one of the most cost-effective methods to improve product quality. The people who design games are fundamentally different than the people who play them. It takes a lot of specialized skills and talent to make a great game. Chances are your customer has a different set of life experiences and expectations than developers. Ironically, most games require experience with other games in the same genre to understand how to play. By testing early with players, a team can identify show-stopping issues before they get built into the game. Customers only have access to what ships, and so what ships needs to be self-explanatory.

Q: How has this created value for the games you've worked on? Bugs you've caught? Broader user appeal? Both specific stories and general information appreciated here.

XEODesign's Player Experience Research adds value by making it possible to serve, support, sell, and satisfy more customers. First, it identifies usability issues so more people are able to play (for example, in one study nine out of ten players could not find the start button!). Second, it reduces support calls. Third, it makes selling easier by creating positive

word of mouth. Fourth, we look at how the game's emotional profile matches player expectations.

Most of the value comes from knowing how players will react to aspects of your game before it ships, so the team can make changes. The developers of a game were surprised to see that it mystified people from the target market (a more casual demographic). It was remarkable to watch how prior experience with other games "filled in the gaps" for some players to succeed, while it left other players in the dark, unsure if they were making progress or what the goal was.

Having a consistent and well-organized UI means that more people will be able to play the game. For another project, the client came to us so late in the development process that they didn't have time to fix the issues players encountered. The subsequent *New York Times* review neatly summarized the usability issues we identified. By knowing earlier in the process, the team would have had time to react and the game would have done much better.

Q: Do you specifically test game characters? For example, reactions to characters, legibility of the character's personality and purpose, look and feel of player-characters, controllability of NPCs, and so on? How so?

We have run focus groups on characters such as how cool they look, what special powers they have, and how they are dressed. There are interesting differences between Asia and the United States in terms of preferences for character design. So it is important to do these types of tests in your major target markets with a large enough sample size.

Beyond aesthetics, I think it is equally if not more important to get feedback on a character interaction—how it feels to be that character. Game characters are a very important part of the player experience and require special attention during testing. Frequently, character action and motion requires such a steep learning curve that many players stop. That's what makes *Grand Theft Auto* and *Katamari Damacy* so easy to start and play. You don't have to be that good at the controller to have fun.

Simply providing "appealing" characters doesn't guarantee engagement. One game concept turned a first-person game into a third-person experience. Even though the characters could be customized to look like the player, this wasn't how they liked playing. You have to make sure the experience of being that character provides the type of fun that your audience wants.

Q: What would you say to a developer who said it is too complicated or too expensive to do user testing?

Given the amount of money at stake and the complexity of today's game designs, who can afford not to do player testing? The cost to obtain player experience feedback is small when you look at the cost of lost sales, product returns, and customer support calls. It surprises me how many games are evaluated based on what the guy in the next cubicle thinks is fun. I ask this of my clients all the time: "If you don't have the time or

budget to do it right, do you have the luxury of doing it wrong?" The cost of not selling units because of usability is high. Most UI issues can be looked at with paper and pencil testing before the first prototype is built. If you find out that players don't like the new innovative game mechanic in late beta or after the game ships, there is not a lot the developer can do.

Q: What do you think are the most interesting challenges in user testing?

Observing the game without influencing the player's experience and not providing help is challenging. It is very easy to bias a game study. Not long ago one of our clients had already done a lot of what they thought was user testing, but because of the way they set it up, they influenced the results. Unfortunately, there were issues that they had no idea were there because of the way they ran their internal testing. We see this a lot.

Q: Any pitfalls you'd advise readers to watch out for? Methods you think are especially good?

Too many people confuse user testing with market testing. It is very important to watch people, who haven't seen your game, play for the first time unassisted. Talking with players seated around a table (as in a marketing focus group), if done well, can answer questions about packaging, price, and positioning. However, this style of testing will yield very little data on player experiences, what it feels like to play your game.

My advice to others is, bring in people from your target market and watch them play. While they play, don't provide help. Instead, give them a card with a basic description of the game and watch to see how much they can discover on their own. Pay attention to how they do so. In looking at your results, don't let players design your game (that's the game designer's job). Do listen to what they have to say, and note what they try to do and how they try to do it. These are clues to increasing usability. Pay attention to what they find fun or not fun. Look for patterns in their needs and interests. If I'm not completely surprised by at least one thing in a study, I run the study again.

Never run your own observation sessions. Watch them, but don't be there in the same room. You'd be surprised at how easy it is to influence the player. Even I have someone else run observations on my own designs. The insights of a neutral third party are highly valuable. Plus, they will come up with angles on your design that you hadn't thought of and others you've forgotten about. Be sure to watch the observations, preferably in person. Don't just rely on the report. Player experiences are qualitative and happen over time. You'll get a deeper visceral understanding of a player's pains and joys by being there.

Q: Any thoughts on future directions of games usability or testing? New techniques? Technologies? Giving people a hint about the future here would be great.

XEODesign is doing a lot of groundbreaking research on how games create emotions through doing (as opposed to story or art). This cross-genre research on why we play games looks at what processes players most enjoy about games and how they produce emotions. We've found that people play games for the experiences that games create.

Whether it's the way the game changes how they feel inside, like blowing off frustrations from work, or the warm feeling of spending time with friends, games affect how players think and feel. What I'm looking forward to is to continue to refine these models to help game designers make player experiences that are more engaging and produce a wider spectrum of emotions than frustration and fear.

The most interesting technology I'm tracking is FMRI (functional magnetic resonance imaging) studies. I'd like to watch what parts of the brain are engaged at different moments in play. It would be fascinating to see what structures are engaged in computer games and compare the activity to what happens during other forms of recreation such as board games or movies.

11.10 Affective Sensing: An Evaluation Method for the Future?

One interesting direction in evaluation that is relevant to character design for games is the physical measurement of emotion. People can be inaccurate (both intentionally and unintentionally) when asked to report their emotional state. Usually they are asked to report emotions after an experience is over, and it can be hard to remember all the feelings that occurred during the course of an experience. Increasingly, scientists are able to detect traces of emotion through physical monitoring—reading galvanic skin response, heart rate, pupil dilation, voice qualities, facial expressions (for example, work at MIT—see Kapoor et al., 2003), and even images of blood flow in the brain (the FMRI that Lazzaro mentions in her interview). It may not be long before such systems are ready for trials in everyday evaluation situations. Being able to trace the arc of a player's emotions during play could help pinpoint moments of frustration, confusion, and boredom, and could give designers a clearer picture of when and where their designs are failing. Of course, these benefits will have to be balanced against concerns about privacy and about potential abuse of such systems.

11.11 Summary

This chapter highlighted the importance of evaluation to the character-design and development process. Common methods in the industry at present—market research and play testing—were discussed, as well as some suggested methods for improving character design in the critical preproduction stage. Guidelines applicable to any character evaluation situation were presented, and the chapter ended with interviews with two user research specialists from the games industry.

11.12 Exercises

11.12.1 *Market Research—Compare and Contrast*

Take a character concept that you have developed and conduct two separate focus groups—one with your target audience and one with an audience you think will definitely not like your designs. Show the sketches, discuss the game concept, and then let the group share their impressions with you. Did you get the results you expected with each audience? Were there surprises? What design choices might you make based upon what you have found?

11.12.2 *Character Quality Control*

At the end of the design phase of your game, use the suggestions regarding player-character and NPC qualities from Part IV to create guidelines for your production team. Share them with the other teams if you are in a class. After your first development milestone, conduct play-testing evaluations for one another, based on these lists. How well did you stick to your goals? Where did you diverge and why? Use this information to guide any necessary course correction.

11.13 Further Reading

Blossom, J., and C. Michaud. 1999. Postmortem: LucasLearning's Star Wars DroidWorks. *Gamasutra.com.* *http://www.gamasutra.com/features/19990813/ droidworks_01.htm.* Originally in *Game Developer Magazine* (August 1999).

Collins, J. 1997. *Conducting in-house playtesting. Gamasutra.com. http:// www.gamasutra.com/features/production/070797/playtest.htm.*

Cornett, S. 2004. *The Usability of Massively Multiplayer Online Roleplaying Games: Designing for New Users.* Presented at CHI 2004, Vienna, Austria.

Dusurvire, H., M. Caplan, and J. A. Toth. 2004. *Using Heuristics to Evaluate the Playability of Games.* Presented at CHI 2004, Vienna, Austria.

Federoff, M. 2003. Improving games with user testing: Getting better data earlier. *Game Developer Magazine* (June 2003).

Fullerton, T., C. Swain, and S. Hoffman. 2004. *Game Design Workshop: Designing, Prototyping, and Playtesting Games.* San Francisco, CA: CMP Books.

Fulton, B. 2002. Beyond Psychological Theory: Getting Data that Improves Games. *Gamasutra.com. http://www.gamasutra.com/gdc2002/features/fulton/fulton_01.htm.*

Fulton, B., and M. Medlock. 2003. *Beyond Focus Groups: Getting More Useful Feedback from Consumers.* Presented at Game Developers Conference 2003.

Kapoor, A., W. Qi, and R. W. Picard. 2003. *Fully Automated Upper Facial Feature Action Recognition*. Technical Report 571, MIT Media Laboratory's Affective Computing Group. In *IEEE International Workshop on Analysis and Modeling of Faces and Gestures*, October 2003.

Kuniavsky, M. 2003. *Observing the User Experience: A Practitioner's Guide to User Research*. San Francisco: Morgan Kaufman Publishers.

Lazarro, N. 2004. *Why We Play Games: The 4 Keys to Player Experience*. Presented at the Game Developers Conference 2004. Slides and paper available online: *http://www.gdconf.com/archives/2004/index.htm*.

Medlock, M. C., Wixon, D., Tewano, M., Romero, R. L., and Fulton, B. 2002. Using the RITE Method to Improve Products; A Definition and a Case Study. Presented at Usability Professionals Association, Orlando, FL, July 2002.

Nielsen, J. 1994. *Guerilla HCI: Using Discount Usability Engineering to Penetrate the Intimidation Barrier. http://www.useit.com/papers/guerrilla_hci.html*.

Tsurumi, R., and R. Hasegawa. 2003. *How to Make Your Game Successful in Japan*. Presented at the Game Developers Conference 2003.

Appendix: Summaries of Games Discussed

Animal Crossing

DEVELOPER:	Nintendo
GENRE:	role-playing
PLATFORM:	Nintendo GameCube
RELEASED:	2002
AWARDS:	2002 Academy of Interactive Arts and Sciences; Console RPG Game of the Year; Innovation in Console Gaming; Outstanding Achievement in Game Design

GAME SUMMARY:

Animal Crossing, though categorized as a role-playing game, has quite a few similarities to the open play-style and customization possibilities of *The Sims.* The player is given a character who is a new arrival to a small town, where she or he must choose and furnish a house and earn a living. "Chatting" with other citizens and helping them is a large part of the game dynamic, as is shopping for clothing and household items. There is an extensive range of collectible objects, from bugs to wallpaper to Nintendo Entertainment System emulator games for your household game console. The game world includes season changes and holiday events, using the system clock to keep time passing. It is possible to travel from your village to a friend's, using memory cards. The game also has components that can be played on a GameBoy when hooked to the GameCube. This game's simple game-play style makes it very approachable. *Animal Crossing* developed a broad grassroots fan base of both male and female players. Image courtesy of Nintendo.

Black & White: Creature Isle

DEVELOPER:	Lionhead Studios Ltd.
GENRE:	rpg/simulation/strategy
PLATFORM:	PC
RELEASED:	2002
AWARDS:	2001 BAFTA (British Academy of Film and Television Arts) Interactive awards for Interactivity and Moving Images

GAME SUMMARY:

Black & White: Creature Isle, is a genre-crossing addition to the real-time strategy game *Black & White* for the PC. This version of the game features a trainable creature that acts as the player's pet and minion, using artificial intelligence so that it can learn and evolve a moral character, depending upon the player's commands and feedback. Peter Molyneaux joined in the development of this game and was the creative visionary behind the use of such extensive AI and adaptability in the creature.

Crash Bandicoot

DEVELOPER: Naughty Dog

GENRE: action, platformer

PLATFORM: PlayStation

RELEASED: 1996

GAME SUMMARY:

This title launched one of the most popular game characters of the 1990s on the original PlayStation platform. *Crash Bandicoot* was a transitional game—partly 3D, partly the more traditional side-scroller game style from whence it evolved. Gameplay involves collecting fruit and crashing into enemies, with a heavy emphasis on jumping. *Crash* was wildly popular in the Japanese market, although it was developed in America. *Crash Bandicot* and related characters are ® and ©Universal Interactive, Inc. and are utilized with permission.

The Curse of Monkey Island

DEVELOPER: LucasArts

GENRE: adventure/2D adventure

PLATFORM: PC

RELEASED: 1997

AWARDS: Adventure Game of the Year (PC Gamer); Adventure Game of the Year (Online Gaming Review—both Editor's Choice and Reader's Choice); Adventure Game of the Year (GameSpot—both Editor's Choice and Reader's Choice); Best Cinematics Award (GameSpot); Adventure Game of the Year (Computer Gaming World); and Adventure Game of the Year (Computer Games Strategy Plus)

GAME SUMMARY:

The Curse of Monkey Island is the third in a popular series of adventure games featuring the escapades of the comic hero Guybrush Threepwood. Guybrush, unlike the typical pirate, relies more upon his wit than his sword. The player meets game-play challenges primarily through a combination of witty repartee with other characters and clever puzzle-solving using collectible items. The game has a Saturday-morning cartoon feel to it—there is an evil archenemy pirate named Le Chuck and a love interest who must be rescued named Elaine. Like other LucasArts adventure games of this era, *The Curse of Monkey Island* features amazing voice talent as well as artful use of 2D graphics. ©1997 Lucasfilm Entertainment Company Ltd. All rights reserved.

DDRMAX: Dance Dance Revolution

DEVELOPER: Konami

GENRE: dance/music/rhythm

PLATFORM: PlayStation 2, arcade

RELEASED: 2002

GAME SUMMARY:

This PlayStation 2 title continues the popular dance game that began as a Japanese arcade machine. Players match their steps to onscreen arrows dictating which direction and which foot to tap onto a pressure-sensitive foot pad. *DDRMAX* is typically played two at a time, side by side. The game has a widespread fan base and tournament culture. Players are given letter grades for their performance and can compete based upon grade. They also sometimes create their own style-based criteria for success, such as dancing facing away from the screen or using two pads at once. KONAMI and *DDRMAX: Dance Dance Revolution* are registered trademarks of KONAMI CORPORATION. *DDRMAX: Dance Dance Revolution* is a trademark of KONAMI CORPORATION. ©1998–2005 KONAMI. ©1998–2002 KONAMI.

Donkey Kong

DEVELOPER: Nintendo

GENRE: platformer

PLATFORM: Coin-op, Apple II, Atari 2600, Game Boy Advance, Atari 7800, Commodore 64, ColecoVision, PC Booter, TI-99/4A, VIC-20, Intellivision, ZX Spectrum, NES

RELEASED: 1981

GAME SUMMARY:

In *Donkey Kong*, the player dodges barrels and monsters while climbing a series of platforms to rescue a damsel in distress from a mad ape. One of the first platform-based game designs, *Donkey Kong* was ported from the arcade to a wide array of home game systems and spawned a popular series of spinoff games, including the recent *Donkey Konga*. Image courtesy of Nintendo.

Doom 3

DEVELOPER: id Software

GENRE: first-person shooter

PLATFORM: PC

RELEASED: 2004

AWARDS: Golden Joystick Awards: Game of the Year and Best PC Game, 2004

GAME SUMMARY:

Hailed for ground-breaking technical advances that resulted in amazingly lifelike graphics, *Doom 3* is at heart a classic, first-person shooter in the tradition of the prior *Doom* games. The player is a space Marine shooting at various demons as she or he works through a series of levels. This game marks the transition of game NPC animation to a whole new level of realism.

Final Fantasy X

DEVELOPER: Square Enix

GENRE: role-playing

PLATFORM: PlayStation 2

RELEASED: 2001

AWARDS: 2001 Game of the Year Award, CESA (Tokyo Game Show)

GAME SUMMARY:

Final Fantasy X is number ten in a long-standing series of role-playing games designed by Japan's Squaresoft. The more recent *Final Fantasy* games are known for their unique combination of extended animated sequences, or "cut-scenes," with turn-based combat that draws upon the old paper-and-pencil *Dungeons and Dragons* model. As with any other role-playing game, players build the skills and powers of their characters slowly over time; however, this version of the game continues to refine Squaresoft's own character-advancement system, which is not modeled strictly upon the *Dungeons and Dragons* rules. Players either love or hate the cut-scenes, which reveal the soap-operaesque relationships among the characters in the player's fighting party and show the complex mythology of the game-world itself. The game requires quite a time investment—it is not something that can be picked up and quickly completed. This game drew great praise for its stunning graphics. *Final Fantasy X* ©2001 Square Enix Co., Ltd. Character Design: Tetsuya Nomura.

Grim Fandango

DEVELOPER: LucasArts

GENRE: adventure, third-person

PLATFORM: PC

RELEASED: 1998

AWARDS: Second Annual Interactive Achievement Awards 1999: Computer Adventure Game of the Year; GameSpot: Game of the Year; GameSpot: Adventure Game of the Year 1998; PC Gamer: Adventure Game of the Year 1998; Computer Gaming World: Adventure Game of the Year 1998; Computer Games: Adventure Game of the Year 1998; E3 1998: Best Adventure Game

GAME SUMMARY:

The player-character, Manny Calavera, has recently passed away in this LucasArts film-noir adventure-game classic, designed by Tim Schafer. *Grim Fandango* is based on Mexican folklore, which suffuses the story line as well as the visuals. According to tradition, the dead spend four years in the underworld, working off debt for their sins before reaching the final resting place. Your mode of travel during this time is determined by your previous life on earth, so a virtuous and wealthy person travels first class, while a poor sinner has to hoof it. In *Grim Fandango,* our hero Manny falls into the latter category—he works in the Department of Death, selling first-class tickets to newly dead customers while working off his own debt.

The story and game play progress as Manny slowly realizes, through point-and-click exploration and dialogue with other characters, that the underworld is plagued by corruption. He sets out to discover what has gone wrong. Leading Manny through the underworld, the player solves various puzzles and encounters many colorful characters en route to solving the mystery and saving the day. To interact, the player chooses lines of dialogue for Manny from carefully crafted menus of options. The writing for this game is revered for its depth, originality, and style. *Grim Fandango* ©1998 Lucasfilm Entertainment Company Ltd. All rights reserved.

Half-Life

DEVELOPER:	Valve
GENRE:	first-person shooter
PLATFORM:	PC
RELEASED:	1998
AWARDS:	PC Gamer 2001: #1 of the top 50 Best Games of All Time; Computer Gaming World: Hall of Fame Member; PCGamer Magazine 2000: #1 Reader's Choice Poll of Top 50 Best Games of All Time

This is the story of Gordon Freeman's quest to save humanity from an extra-dimensional alien invasion. Gordon, a research physicist at an underground facility, inadvertently opens a portal to another dimension. Gordon blasts, shoots, and crowbars his way out of the facility only to encounter Marines and assassins attempting to cover up any evidence of the aliens and the scientists who released them. Gordon is then chased through the facility by both the Marines and aliens, winding his way to the Lambda Core where he enters a portal to take the fight to the aliens' home world.

Gordon finds increasingly lethal weapons as the game progresses. He begins with a crowbar that is only useful for opening ventilation ducts and boarded doorways and for bludgeoning crabs. He finishes with the Gluon Gun, an experimental laser beam straight out of *Ghostbusters,* that tears through everything in a matter of seconds.

Half-Life does an excellent job of integrating story elements into game play. Instead of pulling away from the action and presenting information as a series of cut-scenes or text descriptions, *Half-Life* has them unfold inside the game. The player retains control of Gordon as he watches the Marines mow down a group of scientists that believe they are about to be rescued. Even when the scientists give Gordon mission briefings, he is still free to run and jump around the room or to beat them with his weapons. The option to pay attention is up to the player.

The game mixes minor puzzles with the combat. For instance, at one point Gordon must lead a group of scientists to a retina scanner in order to open the door to the next area. While leading them to the scanner, he must defeat a Special Forces unit that blocks his path. Occasionally, Gordon runs into a "Barney," facility security guards who all look alike, who offers to team up with Gordon. This helper NPC shoots at the enemy with a weak gun but perfect aim and sometimes serves as a distraction so Gordon can sneak around in the midst of the enemy, unharmed. *Half-Life* ©1995–2005 Value Corporation. All rights reserved.

Halo: Combat Evolved

DEVELOPER: Bungie

GENRE: first-person shooter

PLATFORMS: Xbox, PC, Mac

RELEASED: 2001

AWARDS: Fifth Annual Interactive Achievement Awards 2002: Console Game of the Year, Console Action/Adventure, and Visual Engineering Awards; Spike TV's Video Game Awards 2003: Best PC Game; BAFTA (British Academy of Film and Television Arts) Interactive Entertainment Awards 2002: Games—Multiplayer, Games—Console; CESA (Computer Entertainment Supplier's Association): Outstanding Achievement Award; Golden Joystick Awards 2002—Xbox Game of the Year; E3 2000 Award: Best Action Game

GAME SUMMARY:

This science fiction shooter title was released at the launch of the Xbox, helping to push the sales of the console. The player-character is Master Chief, a cyborg soldier fighting aliens known as the Covenant. Master Chief's goal is to prevent the aliens from obtaining an unknown object on the planet Halo. The game requires more strategy on the player's part than perhaps would be the case in its first-person shooter predecessors. The player-character is limited to carrying two weapons at a time, which requires some decisions about which weapons are best to have on hand given each battle situation. In addition, the artificial intelligence of the enemies works to keep the player thinking about tactics; the Covenant work in a

team, in stealth and by sheer force. Replay value is increased as one situation contains many changing variables, such as the placement of objects and enemies, as well as enemy reaction to the player's different strategies.

In addition to the single-player mode, *Halo* supports up to 16 players simultaneously (by hooking up four Xbox consoles each with four controllers). These multiplayer, split-screen modes include games like "capture the flag" and "king of the hill," as well as team-based fighting. Screenshot from *Halo®: Combat Evolved* ©2005 Microsoft Corporation. All rights reserved.

The Hitchhiker's Guide to the Galaxy

DEVELOPER:	Infocom
GENRE:	text adventure
PLATFORM:	Apple II, Atari ST, Commodore 64, DOS
RELEASED:	1984

GAME SUMMARY:

The Hitchhiker's Guide to the Galaxy united Douglas Adams with Steve Meretsky, the programmer of *Planetfall*. The result was perhaps the first game written by a writer instead of a programmer. The text adventure game was not quite a retelling of Adam's classic, but it did present all of the book's major set pieces. The player gets to experience the book's events from the point of view of all of the major characters—Arthur, Ford, Zaphod, and Trillian. The game shows Arthur's house, the pub, the Vogon spaceship, the Heart of Gold, and even Traal.

The game begins in the dark and returns there frequently. The puzzles are extremely difficult, and most of them have lethal consequences if they go unsolved. In fact, the game is very unforgiving and taunts the player for failing to complete it. When the player has been floundering around in the dark for too long, the game informs the player, "Something stinks in here, and it's not just your puzzle-solving ability!" The notice is as much a hint as it is an insult. It is possible to beat the game without knowledge of the book, and it is very likely that knowledge of the book may hinder completing the game since the two deviate from one another a bit. Adams said in an interview that after the game was released, he found that it had an unbalanced difficulty distribution: instead of starting easy and building up to more difficult puzzles later in the game, many of the most difficult and crucial puzzles occur fairly early in the game.

For a text adventure, the game's text engine was relatively successful. It could parse six-word sentences and had clever responses to unexpected commands: after entering a command the game did not have a real response for, the game tells the player that the command caused an interstellar war in which billions died and to be more careful when choosing words in the future.

Hitchhiker's Guide shipped with a box of accessories that included "Peril-sensitive glasses," pocket fluff, a plastic bag containing a microscopic space fleet, and a wearable "Don't Panic" button. *Hitchhiker's Guide to the Galaxy* ©Ed Victor Ltd.

ICO

DEVELOPER: SCEI (Sony Computer Entertainment Incorporated)

GENRE: action, adventure

PLATFORM: PlayStation 2

RELEASED: 2001

AWARDS: Game Developers Choice Awards 2002: Excellence in Level Design; Game Developers Choice Awards 2002: Excellence in Visual Arts; Game Developers Choice Awards 2002: Game Innovation Spotlight; Electronic Gaming Monthly's 2001 Gamers' Choice Award: Best Adventure Game of the Year; Electronic Gaming Monthly's 2001 Readers' Choice Award: Best Adventure Game of the Year; CESA (Computer Entertainment Supplier's Association): Special Award; 5th Annual Interactive Achievement Awards: Art Direction; 5th Annual Interactive Achievement Awards: Character or Story Development

GAME SUMMARY:

ICO is the story of a boy banished from his village because he was born with horns. The boy, Ico, escapes from his confinement within a large castle, soon to find his companion for most of the game, a fairy-like girl named Yorda. The player discovers more of the story line as the game progresses, meanwhile exploring the castle and surroundings, solving puzzles that block the characters' path, battling dark shapeless enemies, and helping both Yorda and Ico escape. To keep Yorda from disappearing down black enemy holes, the player may hold her hand to tug her toward safety . . . or call

301

her to Ico's side. As Ico vigilantly protects Yorda, she returns the favor by unlocking magical doors throughout the game, which Ico cannot do by himself.

ICO is renowned for its elegant, aesthetic environment and ambient sound, adding to the game's immersive quality, similar to the experience within the *Myst* series. The dramatic scale of the environment—vast, vacant rooms and bottomless depths—contrasts with the diminutive size of Ico. This is an interesting choice of hero: a small boy shunned by society, rather than a powerful fighter, as seen in several popular action-adventure games. Although the game was not a best seller, it acquired a strong following and was much appreciated, as evidenced by the numerous awards it has received. *ICO* is a trademark of Sony Computer Entertainment America Inc. ©2001 Sony Computer Entertainment America Inc.

Jak and Daxter: The Precursor Legacy

DEVELOPER:	Naughty Dog
GENRE:	action, platformer, adventure
PLATFORM:	PlayStation 2
RELEASED:	2001
AWARDS:	International Game Developers Association Game Developers Choice Award 2002: Original Game Character of the Year (Daxter)

GAME SUMMARY:

Jak and Daxter are adventurous best friends who disregard warnings against traveling to nearby Misty Island. At the game's beginning, they have set off to investigate the ruins of the ancient Precursor people. Unfortunately, Daxter falls in an evil substance that transforms him into a muskrat. After conferring with their mentor

back at home, Jak, with Daxter on his shoulder, sets out on a quest to find a way to return Daxter to his human form.

Although the game is primarily a 3D platformer, it has a bit of adventure genre game play as well—the player is asked to solve small puzzles, and to retrieve items for characters encountered along the way. These elements, as well as several minigames, are part of the central story line as the two friends close in on the wise sage who holds the muskrat cure. Most of the game play is action-based; Jak can jump, kick, spin, stomp, pilot vehicles, battle enemies, and make use of magical potions to extend his powers of speed, attack range, health, and weapon selection. Daxter is along for the ride, perched on Jak's shoulder, and occasionally offering game-play tips or witty commentary. *Jak and Daxter: The Precursor Legacy* is a registered trademark of Sony Computer Entertainment America Inc. Created and developed by Naughty Dog, Inc. ©2001 Sony Computer Entertainment America Inc.

The Legend of Zelda: The Windwaker

DEVELOPER: Nintendo

GENRE: action, adventure

PLATFORM: Nintendo GameCube

RELEASED: 2003

AWARDS: GameSpot Editor's Choice; and Golden Joystick 2003: GameCube Game of the Year

A continuation of the successful *Zelda* series, Nintendo's colorful *Windwaker* opens with a cut-scene of the main player-character, Link, and his sister playing around their home island. The sister is soon carried away by an evil bird, and Link's adventure begins. Link sets out to save his sister in hopes of eventually realizing the higher goal of defeating a growing evil throughout the islands.

As Link confronts various helpers, enemies, and boss monsters on the several islands throughout the game, he also acquires objects that enable him to perform certain actions and thus progress further in the game. These objects include bombs, arrows, a grappling hook, iron boots, and power bracelets. A key object in the game is its namesake, the windwaker, a baton which allows Link to perform various magical spells, from controlling the direction of the wind to controlling the movements of another character. Game play can be open-ended, especially in the latter half of the game in which the player-character is encouraged to visit various islands to explore, trade, collect, and to engage in minigames. Alternatively, the player may choose to be more direct in following the story line to defeat the pervading evil.

The Legend of Zelda: The Windwaker may initially have shocked some fans of the series by not offering a more realistic art style. Instead, it uses cel-shaded graphics that seem Disneyesque. The effect seems to work, creating a lively 3D cartoon infused with excellent animation and emotion. Image courtesy of Nintendo.

Leisure Suit Larry 7: Love for Sail

DEVELOPER: Sierra Entertainment

GENRE: adventure

PLATFORM: PC

RELEASED: 1996

GAME SUMMARY:

This is a continuation of the popular adventure game series based on an unlikely hero's stereotypical bachelor escapades. The *Leisure Suit Larry* games have always pushed the boundaries of taste with plenty of sexual innuendo along the lines of the TV show *Three's Company*. The player advances by helping Larry choose dialogue artfully with the goal of getting close to a series of women. The first game was a text adventure; this edition of the game allows the player to use the text interface as well as dialogue menu choices. The game takes place on a cruise, hence the subtitle. *Leisure Suit Larry* is provided courtesy of Sierra Entertainment, Inc.

Max Payne

DEVELOPER: 3D Realms, Remedy Entertainment

GENRE: action, third-person shooter

PLATFORM: Windows, PlayStation2, Xbox

RELEASED: 2001

AWARDS: Golden Joystick Awards 2002: Runner-up Game of the Year; Golden Joystick Awards 2002: Runner-up Game Innovation of the Year; Eurogamer "Gaming Globe" Reader Awards 2001: Best Game Cinematography; Eurogamer "Gaming Globe" Reader Awards 2001: Best Game Character; Computer Gaming World 2001: Best Innovation Destined for Overuse; IGN 2001: Best Adventure Game of the Year; IGN 2001: Reacher's Choice for Best Storyline, Graphics, Sound Use, and Game of the Year

GAME SUMMARY:

Max Payne, a young and energetic narcotics cop, arrives home to find his baby and wife being murdered upstairs before he can save them. With nothing to live for, he goes deep undercover in the hopes of rooting out those behind his family's death. The game occurs in real time during the worst snow storm in New York's recent history. Max unleashes his fury-laden brand of justice on an entire drug distribution network, starting at the bottom and ending literally at the top of the empire.

The game embraces graphic-novel motifs to illustrate Max's monologues and dialogues throughout the game with impressionistic images and stereo sound effects. Max provides the voiceover to his own life while annihilating everyone in his path. The game is divided into "chapters" at the beginning of which Max provides the details about what he is about to do and the level of self-loathing and vengeance he is feeling. His words are melodramatic and heavy with metaphor, but it works, and works well.

Max's health indicator is a "pain meter"—a chalk outline graphic that fills with red when enemies harm him. When the meter fills up to its head, Max begins limping around until the level drops to the shoulders. When the meter is red from head to toe, Max dies and the player has to restart from the last saved position. In order to heal himself, Max chomps on painkillers that he takes from medicine cabinets and from his enemies' remains.

Since the game is a retelling of Max's life, the player does not make any decisions about the direction the story takes. The only influence the player has is how long the story takes to unfold and how many people die in the process.

The quality writing holds the game together, and *Max Payne* was also lauded for showing how *The Matrix*'s "bullet time" effect can work in video games. Max has the ability to slow down time so that he can dodge bullets more easily, aim more

precisely, and fly through the air just a little bit longer. The effect inspired a *Matrix* patch that substitutes a Neo-inspired player-character for the *Max Payne* figure.

Metal Gear Solid 2: Sons of Liberty

DEVELOPER:	Konami
GENRE:	action, adventure, strategy
PLATFORM:	PlayStation 2
RELEASED:	2001
AWARDS:	E3 2000 Award: Best of Show; Academy of Interactive Arts and Sciences: Outstanding Achievement in Sound Design, 2002

GAME SUMMARY:

Metal Gear Solid 2 is a continuation of the adventures of Solid Snake, an action hero who combines stealth with fighting prowess. The game was a landmark due to the extensive (some would say too-extensive) use of breathtaking cut-scenes using the game engine itself, directed by Hideo Kojima and rivaling the cinematography in an action movie. The game was also noteworthy for a sound-track develped by a Hollywood sound designer, which adjusted to shifts in game play. Play primarily takes place in third-person perspective, although the player can shift to first-person for easier targeting. *Metal Gear, Metal Gear Solid, and Sons of Liberty* are registered trademarks of KONAMI COMPUTER ENTERTAINMENT JAPAN, INC. ©1987–2005 KONAMI COMPUTER ENTERTAINMENT JAPAN. KONAMI is a registered trademark of KONAMI CORPORATION.

Mortal Kombat

DEVELOPER: Midway Games

GENRE: action, fighting

PLATFORM: DOS, SNES, Game Boy, Sega Master System, Sega Genesis, Sega CD

RELEASED: 1992

GAME SUMMARY:

Mortal Kombat brought video motion capture and gratuitous gore to the arcades and consoles. The game pits the player against a series of fighters in a tournament-style competition. Each character has a standard set of punches and kicks and a set of special and unique moves that influence the character's fighting style. For instance, Johnny Cage's special moves tend to be effective only at close range, while Scorpion's tend to work well at a distance, and Sonya's rarely work well at all. The special moves are activated by pressing the attack and directional buttons in a certain order for each character, which gives an edge to the experienced player.

At the end of each match, the player has an opportunity to execute his opponent with a "fatality" move. After pressing the buttons in an order specific to that character, the player kills the opponent via moves like super uppercuts, electric shocks, and deadly kisses. Players can also forgo the tournament mode and its tenuous story line to play head-to-head with a human opponent.

When the characters get punched or kicked, they scream and, in the noncensored version, they spurt blood. *Mortal Kombat*'s popularity in the arcades and on the Sega systems made Nintendo reconsider its ban on realistic violence. Nintendo released the game as a heavily censored fighter, changed all of the fatalities to be more "family friendly," and replaced the blood with a white liquid that was interpreted as sweat. Nintendo's version did not sell nearly as well as Sega's, which kept the blood and gore. The game's graphic violence was cited as the cause for formation of the

industry's Entertainment Standards Review Board, after a public critique by Senators Joe Lieberman and Herb Kohl. Mortal Kombat ©Midway Amusement Games, LLC. All rights reserved. *Mortal Kombat* ©Midway Amusement Games, LLC. All rights reserved. *Mortal Kombat*, the dragon logo, Midway, and the Midway logo are registered trademarks of Midway Amusement Games, LLC.

NBA Live 2004

DEVELOPER: Electronic Arts

GENRE: sports

PLATFORM: PlayStation 2, Xbox, Nintendo GameCube, PC

RELEASED: 2003

GAME SUMMARY:

NBA Live 2004 continues a tradition of NBA basketball games from developer Electronic Arts. This popular series focuses on realistic team basketball in which you play as one NBA team against another. Teams are composed of the real-life 2004 season NBA rosters. For example, you could be playing as the 2004 Sacramento Kings against the Los Angeles Lakers, complete with realistic statistics for every player. Other modes of play include one-on-one practice and dynasty, in which you build up a team franchise.

During the game, the currently activated player is indicated by a blue circle at his feet. The player can execute offensive or defensive moves or can switch to control another player on his or her team. Players on your team who you are not controlling act as one might expect on the court, positioning themselves to cover an opponent or to accept a pass.

The game, and its predecessors in the series, have focused on a realistic NBA basketball experience, from the player's probability of making that three-point shot and the realistic arena representations down to the accuracy of players' tattoos and brands of sneakers. Commentary is provided by well-known Marv Albert and Mike Fratatello, and hip-hop music supplies an upbeat backdrop for the game. Animations in *NBA Live 2004* are successful, thanks to 10-man motion capture during production, and famous athlete faces also seem realistic.

Neopets

DEVELOPER: Neopets (www.neopets.com)

GENRE: online, multiplayer

PLATFORM: Web

RELEASED: 1999

AWARDS: 2003 "Best of the Web" from *WiredKids.Org*

GAME SUMMARY:

Neopets is a Web-based "virtual pet community," where children (and some adults) choose and care for a virtual pet. They engage in a variety of pet-related activities, such as feeding, training, and caring for pets as well as entering them in contests and games. The game's developers earn revenue through targeted advertising as well as through expansion into a real-world card set, plush toys, CD-Rom games, and porting of the pets to handheld and mobile platforms. *Neopets*, characters, logos, names, and all related indicia are trademarks of Neopets, Inc., ©1999–2005. All rights reserved.

PaRappa the Rapper

DEVELOPER: NaNaOn-Sha

GENRE: action, rhythm

PLATFORM: PlayStation

RELEASED: 1996

AWARDS: IGDA Developers Choice Awards: Best Game Soundtrack, 1998; Japan Game of the Year, 1997

GAME SUMMARY:

This game confused those who first viewed it at games trade shows—some speculated that it was designed to teach players how to operate the buttons on the PlayStation controller. The rest is history: *PaRappa* launched the rhythm-game genre—games in which the player must hit buttons in time to music. The player's button-mashing in *PaRappa* causes the player-character to rap, and he must rap well enough to make it through the game's simple story. *PaRappa* was also noteworthy for its original art style—characters rendered in 3D but resembling flexible cardboard cutouts that the player could see the edges of as they moved onscreen. The game was designed by Masaya Matsuura, now a legend for his innovations in the rhythm-game genre. ©1997 Sony Computer Entertainment America Inc. *PaRappa the Rapper* is a trademark of Sony Computer Entertainment America Inc. ©Rodney A. Goldenblat/Interlink.

Petz

DEVELOPER: PF.Magic/Ubisoft

GENRE: virtual pet

PLATFORM: PC

RELEASED: 1995, 1998, 2003

AWARDS: Design Distinction in I.D. Magazine's 1997 Interactive Media Review Issue for "Catz"; 1998 Interactive Design award from Communicaion Arts for "Petz"; Bronze in 1998 NewMedia Invision children's entertainment awards for "Petz"; Best Animation, 1997 Int'l Digital Media Awards for "Petz"; Platinum Award from 1997 Oppenheimer Toy portfolio for "Petz"; Silver for Best Overall Design, CDRom, 2000 NewMedia Invision awards for "Babyz".

GAME SUMMARY:

Originally released in 1995, with sequels released in 1998 and 2003, Dogz and Catz were the world's first virtual pets, on the scene before Tamagotchi and Nintendogs. These artificially intelligent, emotional, 3-D characters, rendered in a cartoony style, come in a wide variety of breeds and personalities including grumpy bulldogs, finicky siamese cats, lovable mutts, snooty poodles, crazy alley cats, and so on. The

animation and behavior of the Petz are very fluid and dynamic, allowing players to directly touch, pet, and pick up the characters using a mouse hand-cursor, causing the Petz to react in very immediate and lifelike ways. Players adopt them as puppiez and kittenz at an adoption center, and they grow up over the course of several weeks to full adult size. Although they never die, if neglected or abused, they can run away. Players feed and nurture their Petz, play with a variety of toys in or outside a house, and dress them up in a wide selection of clothin. Through positive and negative reinforcement (treats and a water squirt-bottle), as well as voice recognition, Petz can be trained to do tricks and to modify their their behavior in general. Petz can mate and produce offspring, inheriting the characteristics of their parents. Over 2 million copies of Petz have been sold worldwide; other products include Oddballz (1997) and Babyz (1999). ©Ubisoft Entertainment. Ubisoft is registered trademark of Ubisoft Properties, LLC. Petz, Catz, Dogz, and Ubisoft are tradmarks of Ubisoft Entertainment, Inc. All rights reserved.

Pikmin

DEVELOPER: Nintendo

GENRE: Strategy

PLATFORM: Nintendo GameCube

RELEASED: 2001

AWARDS: BAFTA 2002 (British Academy of Film and Television Arts) for Interactivity; 2001 CGN Gamer's Choice Award: Best "Other" Game; 2001 *GameSpy* GameCube Game of the Year; 2001 Japan Media Arts Festival Excellence Prize

GAME SUMMARY:

Created by design heavyweight Shigeru Miyamoto of *Mario Brothers* fame, *Pikmin* provides a cute and fun game experience that has become synonymous with Nintendo releases. In this strategy and problem-solving game, the player instructs small lemming-like creatures to engage in certain tasks to achieve the goals of the main character, Captain Olimar. This space cadet has crashed on an unknown planet that is inhabited by tiny creatures resembling carrots, which he has named "Pikmin." Captain Olimar uses the creatures to find parts to fix his broken ship, which allows him to further explore uncharted territory.

Certain numbers of Pikmin are required for a given task. For example, a mechanical part may require 20 Pikmin to carry it back to the ship. In addition, different Pikmin have different skill sets. Some Pikmin can carry bombs, some survive in water, and others are fire-resistant. A smart player delegates the Pikmin efficiently to get the tasks accomplished before the end of the day. At dusk, all remaining Pikmin must beam up into the space ship for a safe night's sleep. Pikmin left on the ground overnight will die. Pikmin are also killed by various other creatures in the world or by natural elements such as fire and water. *Pikmin* provides a lush environment steeped in nature, with colorful, entertaining characters and ambient sound. Image courtesy of Nintendo.

Planetfall

DEVELOPER: Infocom

GENRE: text adventure

PLATFORM: DOS, Amiga, Apple II, Atari ST, Commodore 64, PC Booter, TRS 80

RELEASED: 1983

GAME SUMMARY:

Listed as Infocom's first "Comedy Adventure," *Planetfall* is a classic text adventure. The player navigates through interstellar challenges using text commands which must be supplemented (for most players) by a large sheet of paper upon which you try to reconstruct the terrain of the game. *Planetfall* was written by Steve Meretsky and includes the famous NPC Floyd—a robot who becomes the player's sidekick. Many players still remember the powerful feelings they had when Floyd sacrificed himself during play—early evidence of the possiblity for strong player feelings toward NPCs. *Planetfull* ©Activision, Inc. Image reprinted with permission.

Prince of Persia

DEVELOPER:	Nintendo
GENRE:	action, platform
PLATFORM:	Apple II, Mac, DOS, NES, Game Boy, Atari, Sega Master System, Genesis
RELEASED:	1990
AWARDS:	*PC Gamers* Ranked 43rd "Best Games of All Time," 1999; "Game of the Decade," *Generation 4/Canal,* 1997

GAME SUMMARY:

The Prince of Persia has 60 minutes to break out of the kingdom's dungeon in order to save the Princess Jazmin from marrying the evil vizier, Jaffar. The Prince runs, jumps, climbs, and fights his way through the dungeon's levels by avoiding traps and using a variety of helpful potions to gain strength and replenish his health.

Prince of Persia uses the natural-looking character animations that Jordan Mechner pioneered in *Karateka*. The Prince really looks like he strains to hold on to the ledges and is slow to recover when he takes damage from a fall. He leans forward when running and throws out his arms when leaping across chasms. Even in the black and white version, the Prince comes across as a sympathetic character that the player is compelled to take care of to ensure he rescues the princess. He cries out in pain when he is injured, screams as he plummets to his death, and groans when he runs into a wall.

Along the way to the princess, the Prince encounters an interesting helper, increasingly challenging enemy guards, and more and more difficult jumps and

traps. At regular intervals, cut-scenes of the princess are shown to reinforce the Prince's mission, and the ever-running clock appears at the beginning of each level to remind the player of the time pressure. The game's difficulty comes more from the time limit than from the obstacle courses and enemies. Image courtesy of Nintendo.

The Sims™

DEVELOPER: Electronic Arts Inc.

GENRE: simulation

PLATFORM: PC, PlayStation 2, Nintendo GameCube, Xbox

RELEASED: 2000

AWARDS: Game Developers Choice Awards 2001: Game of the Year; Game Developers Choice Awards 2001: Excellence in Programming; 3rd Annual Interactive Achievement Awards: Outstanding Achievement in Game Design; 3rd Annual Interactive Achievement Awards: Outstanding Achievement in Game Play Engineering; 3rd Annual Interactive Achievement Awards: Game of the Year

GAME SUMMARY:

The Sims™ is the social simulation game from the creators of the *SimCity*™ series, the city simulator. The goals of the game are largely determined by its player; one player may choose to strive for optimal wealth and power for his or her character, while another may seek to maintain a balance of social, work, and personal lives. The player is in control of how the game characters, called "Sims," lead their lives.

The player begins by selecting a ready-made Sim, or by customizing one or more Sims by adjusting gender, age, physical build, face, hairstyle, clothes, and personality traits such as playfulness and neatness. Next, the Sim or Sim family is moved into an existing house in the game's neighborhood, or the player constructs and decorates a house for the Sims. Objects are purchased and placed in the house for the Sims to use, such as a sofa, toilet, bed, and kitchen appliances. Basic game play involves controlling the Sims' lives in a household and directing them towards various actions with objects or characters while monitoring the Sims' life meters. These meters measure hunger, social, bladder, energy, fun, hygiene, room, and comfort needs. Keeping these values in the green keeps the Sim happy.

The life meters are intertwined with other systems within the game, each affecting others. These include social relations with family members and neighbors, job performance, ability to improve skills, and, ultimately, money. For example, if a Sim has not eaten, the "hunger" meter becomes increasingly red, causing his overall mood score to go down; he will not want to socialize with other Sims, and he may refuse to go to work. As a result, job performance will suffer, as will the family's cash flow. If the goal is to amass wealth and material possessions, influence people and win friends, the Sim will eventually have to eat.

The Sims is the best selling PC game ever, keeping fans playing with numerous expansion packs such as *The Sims Hot Date* and *The Sims Vacation*. About half of the players of these games are women, a small breakthrough for this relatively untapped market.

Space Invaders

DEVELOPER: Taito

GENRE: shooter

PLATFORM: arcade/coin-op, Commodore 64, Amiga, Atari ST, DOS, ZX Spectrum, Sega Master System

RELEASED: 1978

GAME SUMMARY:

Space Invaders was a wildly popular early arcade game that helped to launch the home-gaming revolution of the 1980s. Initially released in Japan, the game was brought to the United States by Midway, and some estimate that 300,000 machines were produced. The player shoots at aliens as they descend from the top of the screen, using the base at the bottom of the screen as a defense. The steady thumping sound of the aliens as their rows inexorably march downward effectively produced a relentless and ominous feeling, despite the simple graphics of the time period. *Space Invaders* ©Taito Corporation 1987. All rights reserved.

SSX™ 3

DEVELOPER: Electronic Arts

GENRE: action, racing

PLATFORM: PlayStation 2, Xbox, Nintendo GameCube

RELEASED: 2003

GAME SUMMARY:

SSX™ 3 is the third in a series of snowboarding games developed by Electronic Arts. The game brings back familiar characters from the previous two games in addition to some new faces. Each character has his or her own repertoire of special tricks and "Übertricks" (i.e., "super" tricks). Successfully pulling off ubertricks unlocks additional moves and more power. Accessories such as outfits and board styles for the character can be purchased within the game as well. The characters' ratings in areas such as speed, acceleration, and tricks improve as you play.

The third game introduces the concept of "you against the mountain," with all game play taking place on three different peaks of the same mountain. As the character progresses in races on the lower peaks, she or he advances up while the mountain conditions continue to deteriorate. This provides more obstacles, such as racing avalanches or jumping off of chunks of snowing falling out from under the snowboarder. Each peak has a lot to explore, such as shortcuts, alternative paths, and the back country. In addition to the mountain as competition, other snowboarders provide challenges. You have the option to attack other characters during races, by punching to either side of the player-character's body. Verbal responses are entertaining, as are the other characters' increasing attempts to knock you down if you are riding "dirty."

Visuals in this game are well done, offering beautiful vistas and realistic environments and movement. The lifelike snow stands out in particular as a testament to the game's amazing graphics. The snow has different textures and consistencies, which affect the characters' ride and can be detected visually by the player. Rounded off with a great soundtrack full of famous artists, the game offers an adrenaline-filled snowboarding experience.

Star Wars: Knights of the Old Republic

DEVELOPER:	BioWare Corp and LucasArts
GENRE:	role-playing, action/adventure
PLATFORM:	Xbox, Windows
RELEASED:	2003
AWARDS:	PC Gamer 2003: Game of the Year; Computer Gaming World 2003: Game of the Year

GAME SUMMARY:

Taking place 4,000 years before the *Star Wars* movies, *Knights of the Old Republic* chronicles the fall or redemption of a great Jedi. The story begins with the player-character waking up in the midst of a space battle and ends with the character defeating Malak, a dark Jedi in control of a powerful fleet capable of destroying the Republic. How the story unfolds from the beginning to the end is up to the player. As an RPG, the player chooses the character's name, face, gender, stats, and

powers. The player then adjusts the character's alignment through interactions with the game's NPCs. At a basic level, all interactions can be seen as good, neutral, or evil. Good choices lead to Lightside points being awarded, and evil decisions lead to Darkside points. A character's goodness or evilness manifests itself in the character's face. A good character has a healthy tone in its face, while an evil character is so pale, you can see its veins through the skin. At the end of the game, the player must choose whether the character is good or evil, and the final outcome is revealed accordingly.

Like *Planescape, KotOR* uses a *party system* where the companion NPCs have skills and abilities that complement those of the main character. The player can select two NPCs to tag along on the adventure, and the other NPCs remain on the ship or at the hideout in case the player wants to switch them out later.

The game blends several genres of both video games and cinema. *KotOR* has three minigames to break up the action and provide a respite from lengthy dialogues: a card game, a space combat game, and a racing game. The latter two games are important in order to advance the main story line, while the card game is a way to earn money but is not essential. The game tells tales of redemption, love and loss, epic battles, unsolved mysteries, and trust and betrayal. At one point, the main character is asked to solve a CSI-type of murder mystery. Later, the main character must deal with party members that have lied to it.

The companion NPCs occasionally steal the initiative from the player and engage in conversations with each other or minor character NPCs. The game also prompts the player to ask the companion NPCs about their backgrounds and histories by noting something along the lines of "Carth looks like he has something on his mind. Would you like to talk to him?"

The planets of *KotOR* are so rich and detailed that the game provides area maps and automatically labels important landmarks when they are encountered. It also gives important NPCs proper names and gives scenery NPCs labels like "Man," "Droid," and "Guard." *Knights of the Old Republic* ©2003 Lucasfilm Entertainment Company Ltd. All rights reserved.

Super Monkey Ball 2

DEVELOPER: Sega

GENRE: action, party

PLATFORM: Nintendo GameCube

RELEASED: 2002

GAME SUMMARY:

Second in a series that started with a GameCube launch title, *Super Monkey Ball 2* provides an arcade-like party-game experience. Players can select a single-player game, throughout which a story unfolds as levels are completed. Reminiscent of *Marble Madness,* each level consists of various obstacles for a monkey to negotiate while running inside a ball to get to the goal within the specified time. Levels usually hang high in the sky, threatening a long drop if the monkey falls off the edge. Instead of providing a strictly action-based game, this game goes a bit further to require the player to think strategically within each maze in order to complete it. For example, a player must have the monkey roll over a series of switches in order to raise platforms necessary to reach the goal. Also provided are several multiplayer party games, such as races, boxing matches, bowling, billiards, and golf. The easy mechanics of these games allow them to be quickly accessible to games of varying abilities.

The game is popular for its lively arcade feel, its humorous monkey reactions to failure and success, and its party-game options. Graphics are well rendered, illustrating themed levels, such as the inside of a volcano, outer space, and a jungle. Animations of monkey interactions and activities are also entertaining. The music and arcade-like annotations provide a heart-thumping complement to the fast pace

of the game. *Super Monkey Ball 2* ©Sega Corporation. All rights reserved. Reprinted with permission.

There

DEVELOPER: There, Inc.

GENRE: online, 3D world

PLATFORM: PC

RELEASED: 2003

GAME SUMMARY:

There is described by its makers as "an online getaway for socializing." A lushly rendered 3D environment offers players the opportunity to explore, shop, attend events, make connections, and try out various forms of transportation (dune buggies, hoverboards, and the like). Players can customize their avatar appearance to a great degree, including purchasing clothes created and sold by other *There* denizens. Through sales of in-game objects to other players, you can obtain credits from the company. These "Therebucks" can also be traded for real dollars, creating a virtual economy that actually sustains some players in the real world. *There* ©2005 There.com. All rights reserved.

Twisted Metal: Black

DEVELOPER: Incog, Inc.

GENRE: action, racing

PLATFORM: PlayStation 2

RELEASED: 2001

GAME SUMMARY:

Fifth in a series of combat racing games, *Twisted Metal: Black* centers on an escaped mental hospital inmate named Calypso. This crazy individual gathers other characters, also inmates of the psych ward, to compete in a race called "Twisted Metal." This release stands out as the most popular in the series. The game features excellent graphics and music that adds to its macabre, gothic theme. Players can play in ten different arenas, in multiplayer competitive or cooperative modes, or through a three-part, single-player game.

Game play consists of various races in which the player-character drives a vehicle equipped for shooting at opponents. The player also has to avoid oncoming attacks by other characters in their own vehicles. Each level consists of a race to defeat all of the opponents for the particular level. The player has two lives for each level but can increase health by finding objects throughout the environment. Weapons and weapon *power-ups* can also be found throughout the levels, bringing an element of exploration to this battle game. *Twisted Metal: Black* is a registered trademark of Sony Computer Entertainment America Inc. ©2001 Sony Computer Entertainment America Inc.

Warcraft III: Reign of Chaos

DEVELOPER: Blizzard Entertainment

GENRE: real-time strategy

PLATFORM: Mac, PC

RELEASED: 2002

AWARDS: Computer Strategy Game of the Year—Academy of Interactive Arts and Sciences; Best Cinematic—IGN; Best CG Cinematics (tie)—Gamespy's Best of E3 2002 Awards Game of the Year—Gamespot; Game of the Year—*Macworld;* Game of the Year—Xsages; Game of the Year—Fragland; Game of the Year—Cinescape; Game of the Year—Gaming Illustrated; Best PC Game of the Year—GameNOW; Best Real-Time Strategy Game of the Year—PC Gamer; Best Multiplayer Strategy Game of the Year—Gamespot; Best PC Strategy Game of the Year—GameNOW; Best PC Strategy Game of the Year—Game Revolution; Best PC Strategy Game of the Year—Telefragged; Best PC Strategy Game of the Year—OCAddiction; Best PC Strategy Game of the Year (Reader's Choice) —GameSpot; Readers' Choice 2002: Best PC Game of the Year—GamePro; Strategy Game of the Year—Gamer's Pulse; Gamer's Choice: Overall PC Game of the Year—Gamespy; Gamer's Choice: PC Strategy Game of the Year—Gamespy; Best Non-Interactive 3D Game Cinematics—International 3D Awards

GAME SUMMARY:

Warcraft III: Reign of Chaos is a sequel to a real-time strategy game classic. Play consists of gathering resources, taking over neighboring lands, and protecting your land from attacks. Players choose from one of the four available factions within the game. Each faction consists of certain types of characters (elves, orcs, trolls, minotaur, etc.) with differing abilities, strengths, and weaknesses. For example, the humans have the most advanced technology, while the orcs provide brute strength. A player acts as a commander within the game, instructing units to attack or defend. Players may also lead hero characters, whose abilities progress throughout the game, providing a valuable game resource.

Warcraft III was highly anticipated before its release, with two successful prior versions, as well as the popular *Starcraft* game. Fans of the game continue to play *Reign of Chaos*, as well as its expansion pack, *Warcraft III: The Frozen Throne*, years after their release. *Warcraft III: Reign of Chaos* provided courtesy of Blizzard Entertainment, Inc.

INDEX